Robert J. Nemiroff / Jerry T. Bonnell

THE UNIVERSE 365 DAYS

+ **TRAVEL TO MERCURY. SEE PLANET EARTH FROM THE MOON. WATCH AS STARS ARE BORN AND DIE. DISCOVER THE COSMOS! HOW? READ THIS BOOK.**

The images in this book comprise three hundred and sixty-five of the authors' selections from the popular website Astronomy Picture of the Day (APOD). The best and most interesting entries from six years of these daily web offerings have now been gleaned, groomed, and otherwise made presentable in print. Many of the pictures are presented here in finer detail than ever before. The book does not represent a major advance for galactic civilization . . . but it does have galaxies in it.

As a website, APOD was first conceived during a freewheeling brainstorming session on the future and value of the World Wide Web, then in its infancy. The setting was NASA's Goddard Space Flight Center where the authors shared an office in the Compton Observatory Science Support Center in 1995. One perspective that repeatedly emerged from the often calm and occasionally well-reasoned discussion was that the web could be viewed as a continually developing encyclopedia that still lacked many of the significant entries. How could we contribute?

We agreed that a simple presentation of an astronomy picture with a supporting hyperlinked text, ultimately an astronomy picture of the day, would be the most practical for us, considering that we were actually supposed to be professional astronomers. So, following a long-standing tradition in science, we immediately went back to our normal work and ongoing research projects and did nothing about it.

Several lunches later, however, we still liked the idea. We were having a slow month, which gave us time to cobble together a few entries. Since that seemingly harmless series of events on planet Earth in June 1995, the APOD website has presented Internet audiences with a different astronomy and space science-related image

and explanatory text on a daily basis, along with links to other websites chosen to further inform, educate, and entertain. The two of us are now usually proud to acknowledge that we've written every page. We are also happy to acknowledge the support of our colleague, friend, and mentor, Jay Norris. Jay saw value in APOD from the start and has supported its development at every step.

An early criticism of the web project, voiced by friends and colleagues as a frequently asked question was, "Won't you run out of images to use?" But it was apparent to both authors that by 1995 NASA was making use of the internet and electronic media to offer selections from its vast image archives of manned and unmanned space missions. Astronomy Picture of the Day might have been in danger of becoming the Lunar Orbiter Picture of the Day, but there was no danger of running short of images. Stunning pictures from the Hubble Space Telescope were also making a splash, and NASA seemed to appreciate the advantages of presenting the images on the web as a way to take the public along on its voyages of exploration.

Things evolve, though. Beautiful photographs and scientific discovery continue to find a convergence in the field of astronomy. Over the years the authors have found that compelling images of the cosmos are not limited to those taken from orbit, or even to those taken by professional astronomers, just as they are not limited to pictures made in visible light or only in human-perceived color. Most hopefully, the website and now this book will entertain, educate, and expand the appreciation of the broad spectrum of humanity's efforts to explore the universe. It has for us.

ROBERT J. NEMIROFF / MICHIGAN TECHNOLOGICAL UNIVERSITY

JERRY T. BONNELL / UNIVERSITIES SPACE RESEARCH ASSOCIATION

+ UNIVERSE	+ NUMBER (Uncertainty Estimate)
Age	13 billion years (2 billion years)
Size	13 billion light-years (2 billion light-years)
Temperature	2.728 Kelvins (0.004 Kelvins)
Expansion Rate	65 kilometer/sec/Mpc (10 kilometers/sec/Mpc)
Composition	70% Dark Energy (70%) 25% Dark Matter (15%) 5% Normal Matter (3%)
Dark Energy Composition	?
Dark Matter Composition	?
Normal Matter Composition	73.4% Hydrogen (3%) 24.9% Helium (3%) 1.7% "Heavy Elements" (0.3%)

Dating the oldest objects in the universe and projecting the big bang expansion backwards.

(Age) times (speed of light) This size is only for the "visible universe," the part we can see. Other parts of the universe are mostly conjecture.

Measuring the temperature to which cosmic background light would heat a perfectly absorbing object. This is very cold—most large objects in our universe generate more heat and so are hotter. The universe was much hotter in the past and continues to cool.

Measuring how fast galaxies move away. 1 Mpc means 1 Megaparsec or 1 million parsecs, which is roughly the distance to the next major galaxy. One Megaparsec is about 3 million light-years.

Measuring the brightness and distance of supernova explosions.
Attributing the cosmic-scale motions of visible matter to the influence of gravity.
Measuring element and isotope production in the early universe.

Currently unknown. Its existence is still controversial.

Currently unknown, but dark matter properties are growing more constrained by observational astrophysics. Its existence is no longer controversial.

Observations of the Sun, stars, and the gas between stars.
Computation of element production in the early universe.
Includes all other elements such as oxygen and carbon.

+ **Welcome to Planet Earth**

WELCOME TO PLANET EARTH, THE THIRD PLANET FROM A STAR NAMED THE SUN. EARTH IS SHAPED LIKE A SPHERE AND composed mostly of rock. Over 70 percent of Earth's surface is water. The planet has a relatively thin atmosphere composed mostly of nitrogen and oxygen. Earth has a single large moon that is about one-fourth of its diameter and, from the planet's surface, appears almost exactly the same size as the Sun. With its abundance of liquid water, Earth supports a large variety of life forms, including potentially intelligent species such as dolphins and humans. Please enjoy your stay on planet Earth.

CREDIT: APOLLO 17 CREW, NASA

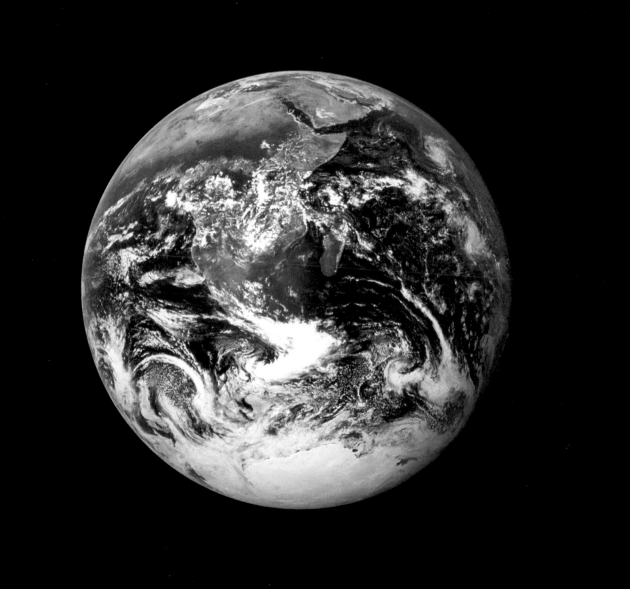

+ Mercury: A Cratered Inferno

MERCURY'S SURFACE LOOKS SIMILAR TO OUR MOON'S. EACH IS HEAVILY CRATERED AND MADE OF ROCK. MERCURY'S DIAMETER is about 4,800 km, while the Moon's is slightly less, at about 3,500 km (compared with about 12,700 km for Earth). But Mercury is unique in many ways. Mercury is the closest planet to the Sun, orbiting at about one-third the radius of Earth's orbit. As Mercury slowly rotates, its surface temperature varies from an unbearably cold –180 degrees Celsius to an unbearably hot 400 degrees Celsius. The place nearest the Sun in Mercury's orbit changes slightly with each orbit—a fact used by Albert Einstein to help verify the correctness of his then newly discovered theory of gravity: General Relativity. This picture was taken in 1974 by the only space-craft ever to pass Mercury: Mariner 10. CREDIT: MARINER 10, NASA

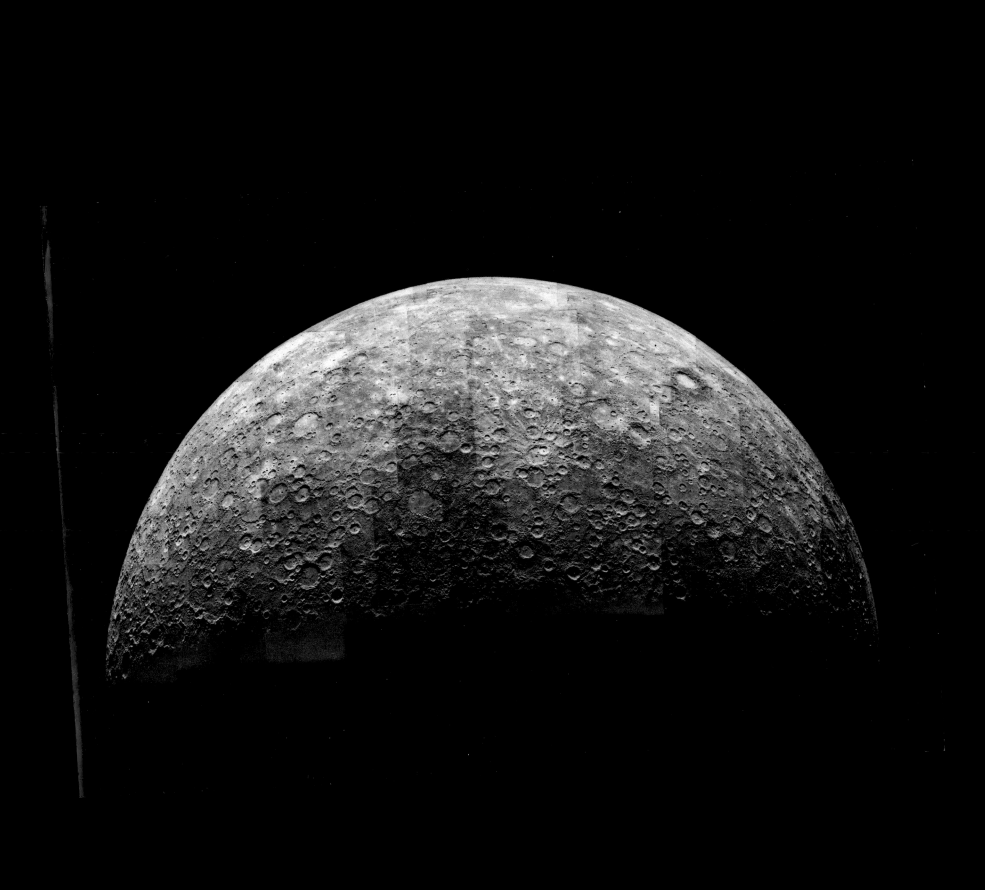

01
02
03
+
04
05 + Orion's Horsehead Nebula
06
07
08 THE HORSEHEAD NEBULA IS ONE OF THE MOST FAMOUS NEBULAS ON THE SKY. IT IS VISIBLE AS THE BLACK INDENTATION IN
09
10 the red emission nebula seen just to the right of center of this photograph. The bright star near the center is located in the belt
11
12 of the familiar constellation Orion. The horsehead feature is dark because it is really an opaque dust cloud that lies in front of
13
14 the bright red emission nebula. The emission nebula's red color is caused by electrons recombining with protons to form hydro-
15
16 gen atoms. Also visible in the picture are blue reflection nebulas, which preferentially reflect the blue light from nearby stars.
17
18 Like clouds in Earth's atmosphere, this cosmic cloud has assumed a recognizable shape by chance. After many thousands of
19
20 years, the internal motions of the cloud will alter its appearance. CREDIT & COPYRIGHT: (AAO), AATB, ROE, UKS TELESCOPE
21
22
23
24
25
26
27
28
29
30
31

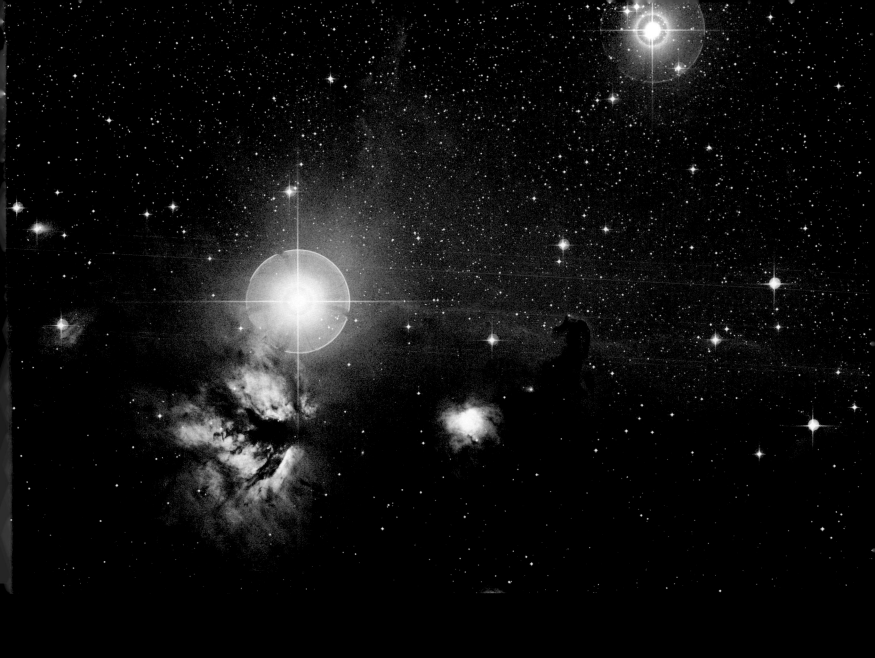

01
02
03
+ 04
05
06
07
08
09
10
11
12
13
14
15
16
17
18
19
20
21
22
23
24
25
26
27
28
29
30
31

+ **Galaxies Cluster toward the Great Attractor**

GALAXIES DOT THE SKY LIKE JEWELS IN THE DIRECTION OF A MASS SO LARGE IT IS KNOWN SIMPLY AS THE GREAT ATTRACTOR.

The galaxies pictured here are part of a cluster of galaxies called ACO 3627, near the center of the Great Attractor. A diffuse mass concentration fully 250 million light-years away, the Great Attractor is so large it pulls our own Milky Way galaxy and millions of other galaxies toward it. Many of the galaxies in ACO 3627 are slowly heading toward collisions with each other. CREDIT: 2P2 TEAM, WFI,

MPG/ESO 2.2-M TELESCOPE, LA SILLA, ESO

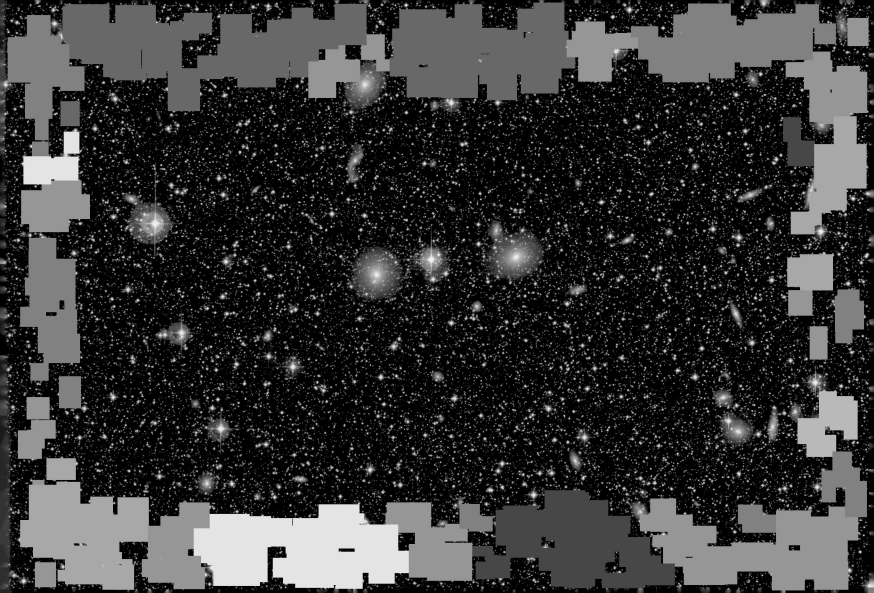

+ **Earth's Richat Structure**

WHAT ON EARTH IS THAT? THE RICHAT STRUCTURE IN THE SAHARA DESERT OF MAURITANIA IS EASILY VISIBLE FROM SPACE because it is nearly 50 km across. Once thought to be an impact crater, the Richat Structure's flat middle and lack of shock-altered rock indicate otherwise. The possibility that the Richat Structure was formed by a volcanic eruption also seems improbable because of the lack of a dome of igneous or volcanic rock. Rather, the layered sedimentary rock of the Richat Structure is now thought by many to have been caused by rock uplifted by volcanism and sculpted by erosion. Why the Richat Structure is nearly circular remains a mystery. CREDIT: NASA/GSFC

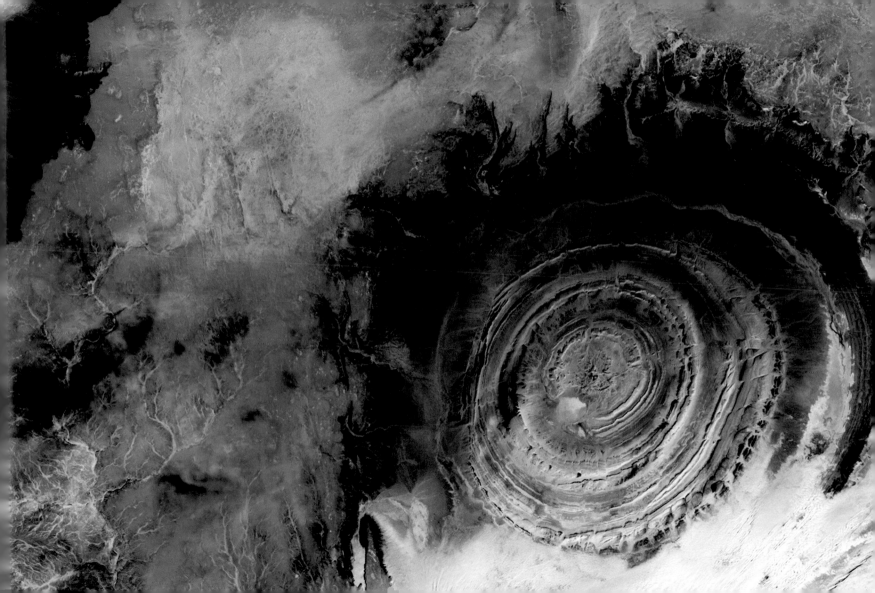

+ **M2-9: Wings of a Butterfly Nebula**

ARE STARS BETTER APPRECIATED FOR THEIR ART AFTER THEY DIE? ACTUALLY, STARS USUALLY CREATE THEIR MOST ARTISTIC

displays as they die. In the case of low-mass stars like our sun and M2-9 pictured here, the stars transform themselves from nor-

mal stars to white dwarfs by casting off their outer gaseous envelopes. The expended gas frequently forms an impressive display

called a planetary nebula that fades gradually over thousands of years. M2-9, a butterfly planetary nebula 2,100 light-years away

shown in representative colors, has wings that tell a strange but incomplete tale. In the center, two stars orbit inside a gaseous

disk with 10 times the diameter of the orbit of Pluto. The expelled envelope of the dying star breaks out from the disk, creating

the bipolar appearance. Much remains unknown about the physical processes that cause planetary nebulae. CREDIT: B. BALICK (U.

WASHINGTON) ET AL., WFPC2, HST, NASA

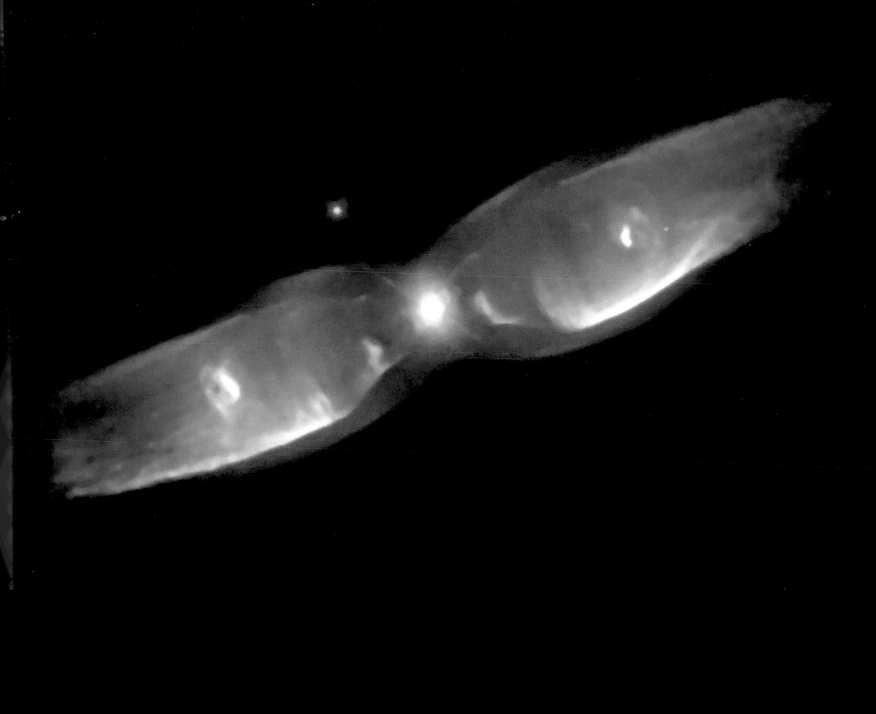

+ The Mysterious Cone Nebula

SOMETIMES THE SIMPLEST SHAPES ARE THE HARDEST TO EXPLAIN. FOR EXAMPLE, THE ORIGIN OF THE MYSTERIOUS CONE-shaped region seen on the far left of this image remains a mystery. The interstellar formation, dubbed the Cone Nebula, is located about 2,500 light-years away. Other features in the image include red emission from diffuse interstellar hydrogen, wispy filaments of dark dust, and bright star S Monocerotis, visible on the far right. Blue reflection nebulas surround the brighter stars. The dark Cone Nebula region clearly contains much dust that blocks light from the emission nebula and open cluster NGC 2264 behind it. One hypothesis holds that the Cone Nebula is formed by wind particles from an energetic source blowing past the Bok Globule at the head of the cone. CREDIT & COPYRIGHT: ROBERT GENDLER

+ **Cone Nebula Close Up**

CONES, PILLARS, AND MAJESTIC, FLOWING SHAPES ABOUND IN STELLAR NURSERIES WHERE NATAL CLOUDS OF GAS AND DUST are buffeted by energetic winds from newborn stars. A well-known example, the Cone Nebula within the bright galactic star-forming region NGC 2264, was captured in this close-up view from the Hubble Space Telescope's Advanced Camera for Surveys. While the Cone Nebula, about 2,500 light-years away in Monoceros, is around 7 light-years long, the region pictured here surrounding the Cone's blunted head is merely 2.5 light-years across. In our neck of the galaxy, that distance is just over halfway from the Sun to its nearest stellar neighbor, Alpha Centauri. The massive star NGC 2264 IRS, seen by Hubble's infrared camera in 1997, is the likely source of the wind sculpting the Cone Nebula and lies off the top of the image. The Cone Nebula's reddish veil is produced by glowing hydrogen gas. CREDIT: ACS SCIENCE & ENGINEERING TEAM, NASA

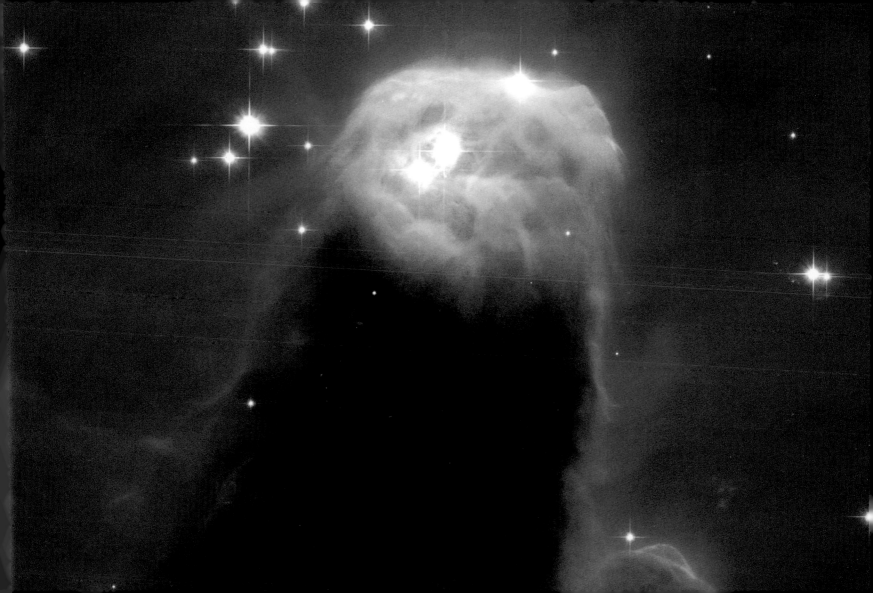

01
02
03
04
05
06
07
08
09
10
11
12
13
14
15
16
17
18
19
20
21
22
23
24
25
26
27
28
29
30
31

+ **Green Flash**

MANY THINK IT IS JUST A MYTH. OTHERS THINK IT IS TRUE BUT THAT ITS CAUSE ISN'T KNOWN. ADVENTURERS PRIDE THEMSELVES on having seen it. It's a green flash from the Sun. The truth is the green flash does exist, and its cause is well understood. Just as the setting Sun disappears completely from view, a last glimmer appears startlingly green and sometimes even blue. The effect is typically visible only from locations with a low, distant horizon, and lasts just a few seconds. A green flash is also visible for a rising sun, but takes better timing to spot. A slight variant of this was caught in this photograph, where much of the Sun was still visible, but the very top appeared green momentarily. The Sun itself does not turn partly green; the effect is caused by layers of Earth's atmosphere acting as a prism. CREDIT & COPYRIGHT: MARIO COGO

+ **Brown Sun Bubbling**

+

OUR SUN MAY LOOK SOFT AND FLUFFY, BUT IT'S NOT. IT IS AN EXTREMELY LARGE BALL OF BUBBLING, HOT GAS, MOSTLY

hydrogen. This picture was taken in the single specific color of light emitted by hydrogen gas, called Hydrogen-alpha. Granules

cover the solar photosphere surface like shag carpeting, interrupted by bright regions containing dark sunspots. Visible at the left

edge is a solar prominence. Our sun glows because it is hot, but it is not on fire. Fire is the rapid acquisition of oxygen, and there

is very little oxygen on the Sun. The energy source of our sun is the nuclear fusion of hydrogen into helium deep within its core.

CREDIT & COPYRIGHT: ROBERT GENDLER

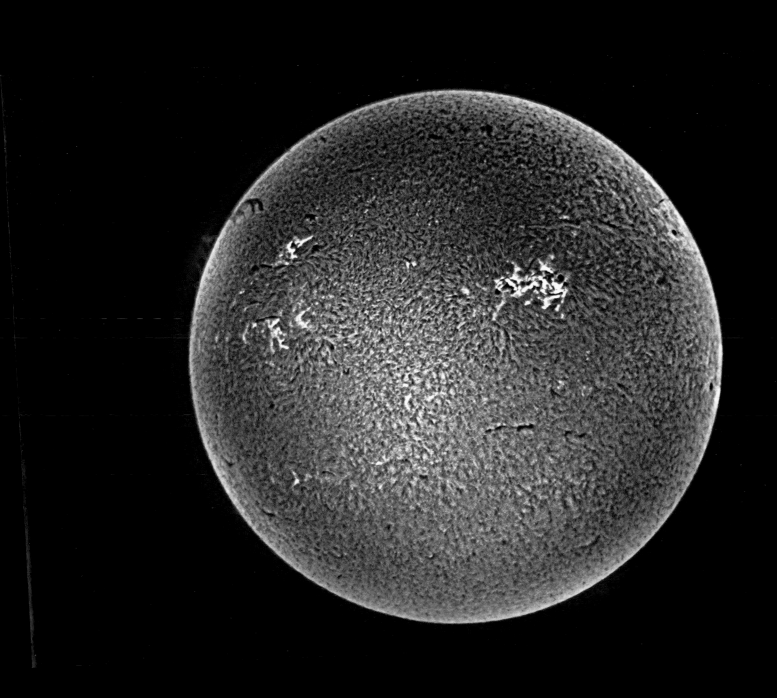

01
02
03
04
05
06
07
08
09
10
11
12
13
14
15
16
17
18
19
20
21
22
23
24
25
26
27
28
29
30
31

+ The Great Nebula in Orion

FEW ASTRONOMICAL SIGHTS EXCITE THE IMAGINATION LIKE THE NEARBY STELLAR NURSERY KNOWN AS THE ORION NEBULA.

The nebula's glowing gas surrounds hot young stars at the edge of an immense interstellar molecular cloud only 1,500 light-years away. The Great Nebula in Orion can be found with the unaided eye just below and to the left of the easily identifiable belt of three stars in the popular constellation Orion. This image has been contrast-balanced to bring out Orion's detail in spectacular fashion. Visible simultaneously are the bright stars of the Trapezium in Orion's heart, the sweeping lanes of dark dust that cross the center, the pervasive red-glowing hydrogen gas, and the blue-tinted dust that reflects the light of newborn stars. The whole Orion Nebula cloud complex, which includes the Horsehead Nebula, will slowly disperse over the next 100,000 years.

CREDIT & COPYRIGHT: ROBERT GENDLER

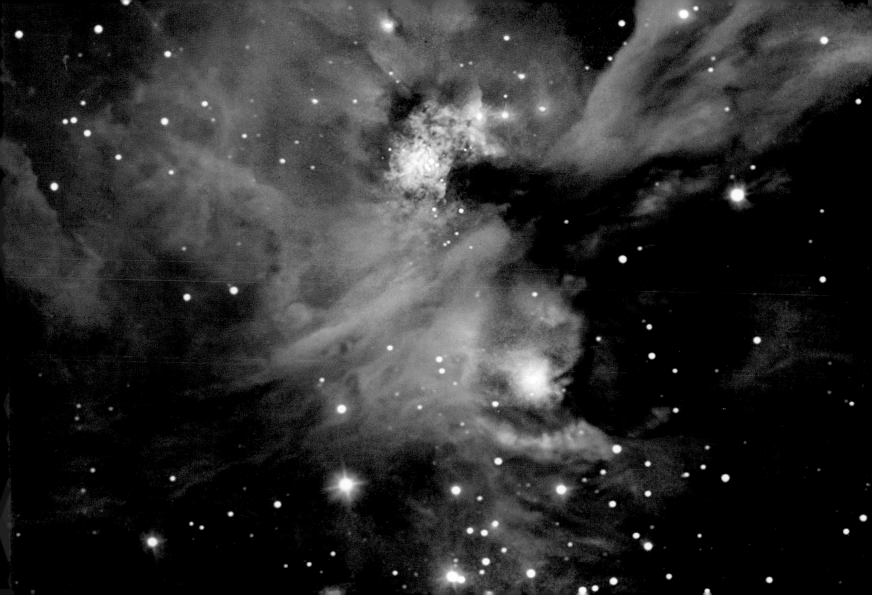

+ **The Wind on Mars**

WIND EROSION HAS BEEN DISCOVERED ON MARS. PICTURES OF REGIONS SURROUNDING THE NORTH POLAR CAP SHOW SAND dunes covered in frost. In places, however, this frost has been eroded to uncover the dark sand underneath. Since this frost can only be as old as the martian winter is long, this erosion must have taken place within the past martian year. This established, it is easy to visualize that much of the appearance of the pictured region has been sculpted by wind-blown dust. Although these martian winds are very fast, because the martian atmosphere is so thin, a person standing on Mars would not get blown over.

CREDIT: MOC TEAM, MGS, NASA

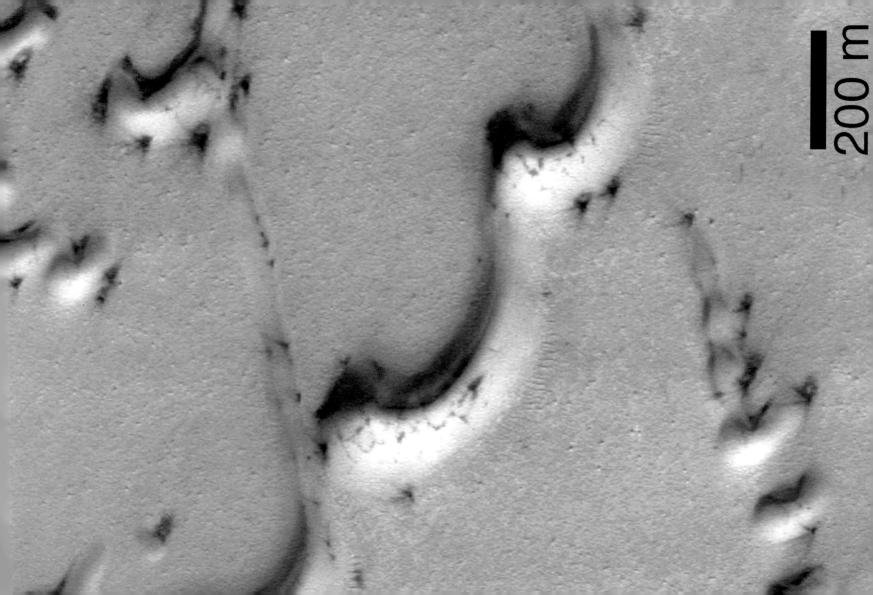

+ **Lunokhod: Moon Robot**

ON NOVEMBER 17, 1970, THE SOVIET LUNA 17 SPACECRAFT LANDED THE FIRST ROVING REMOTE-CONTROLLED ROBOT ON THE Moon. Known as Lunokhod 1, it weighed just less than 2,000 pounds and was designed to operate for 90 days while guided in real time by a five-person team at the Deep Space Center near Moscow. The futuristic-looking eight-wheeler, below, rode on top of a descent module that extended ramps from both sides, offering alternative routes to the surface in case one side was blocked by boulders, seen opposite in a rare view from the surface of the Moon. Lunokhod 1 actually toured the lunar Mare Imbrium (Sea of Rains) for 11 months in one of the greatest successes of the Soviet lunar exploration program. This Lunokhod's operations officially ceased on October 4, 1971, 14 years after the launch of Sputnik.

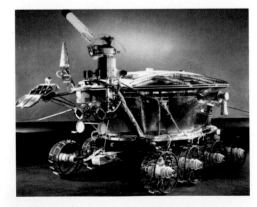

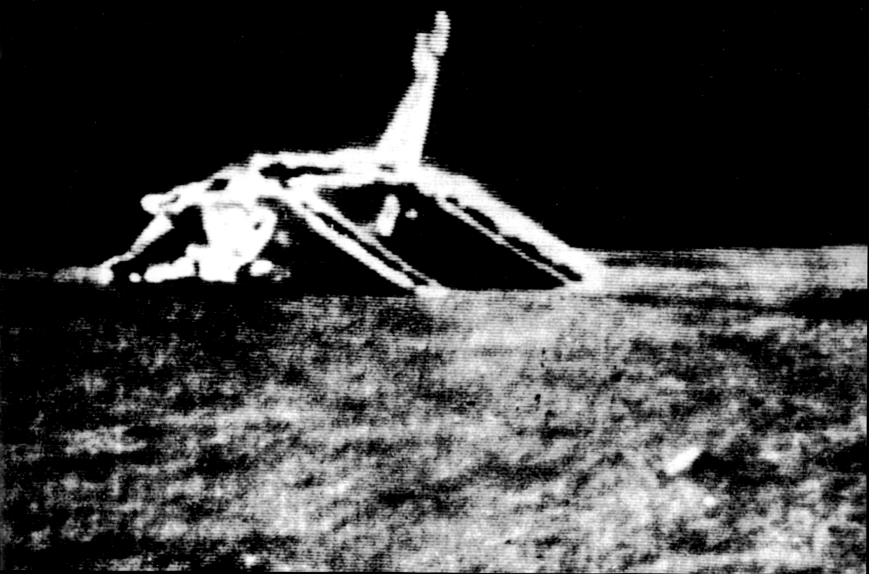

+ **M57: The Ring Nebula**

EXCEPT FOR THE RINGS OF SATURN, THE RING NEBULA (M57) IS PROBABLY THE MOST FAMOUS CELESTIAL BAND. THIS PLANE-tary nebula's simple, graceful appearance is thought to be due to perspective—our view from planet Earth looking straight into what is actually a barrel-shaped cloud of gas shrugged off by a dying central star. Astronomers of the Hubble Heritage Project produced this strikingly sharp image from Hubble Space Telescope observations using natural-appearing colors to indicate the temperature of the stellar gas shroud. Hot, blue gas near the energizing central star gives way to progressively cooler green and yellow gas at greater distances, with the coolest red gas along the outer boundary. Dark, elongated structures can also be seen near the nebula's edge. The Ring Nebula is about 1 light-year across and 2,000 light-years away in the northern constellation Lyra.

CREDIT: H. BOND ET AL., HUBBLE HERITAGE TEAM (STSCI /AURA), NASA

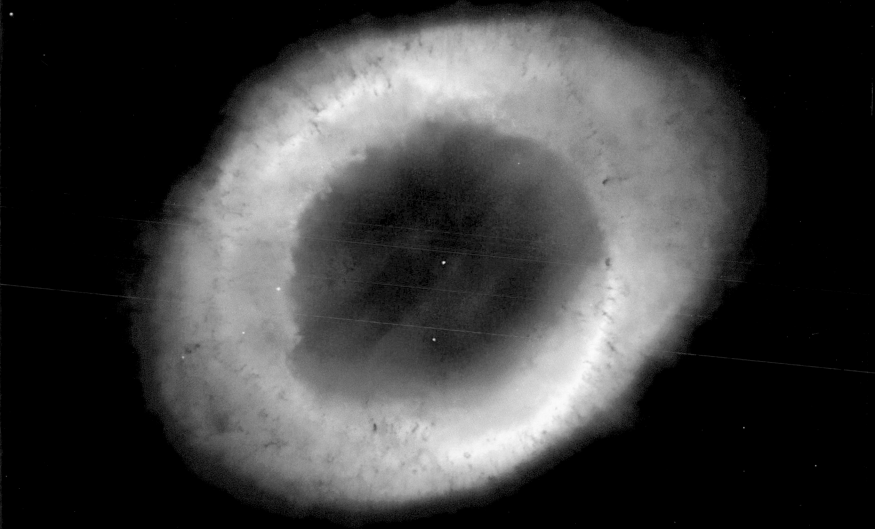

+ **The Sun Also Rises**

SUNRISE SEEN FROM LOW EARTH ORBIT CAN BE VERY DRAMATIC INDEED (AND THE AUTHORS DON'T APOLOGIZE TO HEMINGWAY for using his title!). In this breathtaking view from the space shuttle Endeavour, the Sun is just visible peaking over towering anvil-shaped storm clouds. The silhouetted cloud tops mark the upper boundary of the troposphere, the lowest layer of planet Earth's atmosphere. Sunlight filtering through suspended dust causes this dense layer of air to appear red. In contrast, the blue stripe marks the stratosphere, the tenuous upper atmosphere, which preferentially scatters blue light. CREDIT : STS-47 CREW, NASA

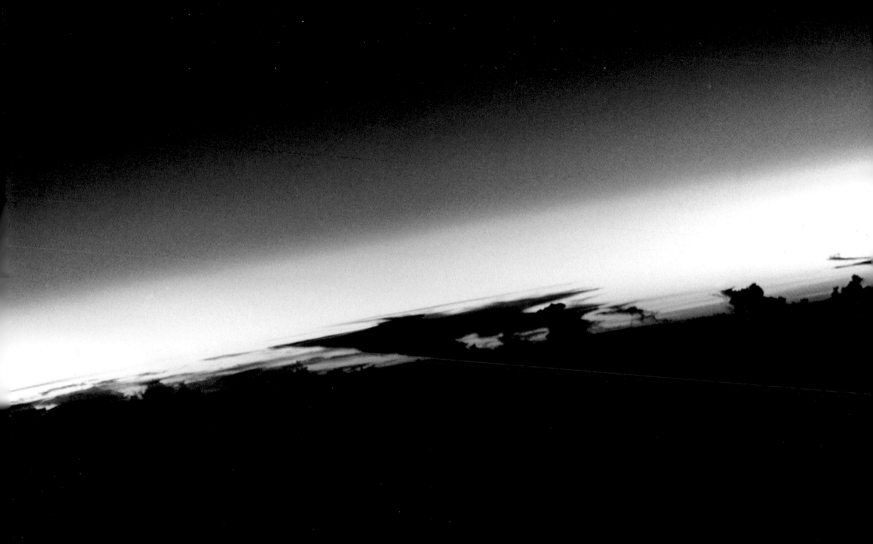

+ **The Bubbling Cauldron of NGC 3079**

SPIRAL GALAXY NGC 3079, SEEN FROM THE SIDE, IS A MERE 50 MILLION LIGHT-YEARS AWAY TOWARD THE CONSTELLATION

Ursa Major (Big Bear). Shown in this stunning false-color Hubble Space Telescope image, the galaxy's disk—composed of spectac-

ular star clusters in winding spiral arms and dramatic dark lanes of dust—spans some 70,000 light-years. Still, NGC 3079's most

eye-catching features are the pillars of gas that tower above a swirling cosmic cauldron of activity at the galaxy's center. Seen in

close-up, the pillars rise to a height of about 2,000 light-years and seem to lie on the surface of an immense bubble rising from

the galactic core. Measurements indicate that the gaseous pillars are streaming away from the core at 6 million km per hour.

What makes this galaxy's cauldron bubble? Astronomers are exploring the possibility that the superbubble is formed by winds

from massive stars. If so, these massive stars were likely born all at once as the galactic center underwent a sudden burst of star

formation. CREDIT: GERALD CECIL (UNC/CHAPEL HILL) ET AL., NASA

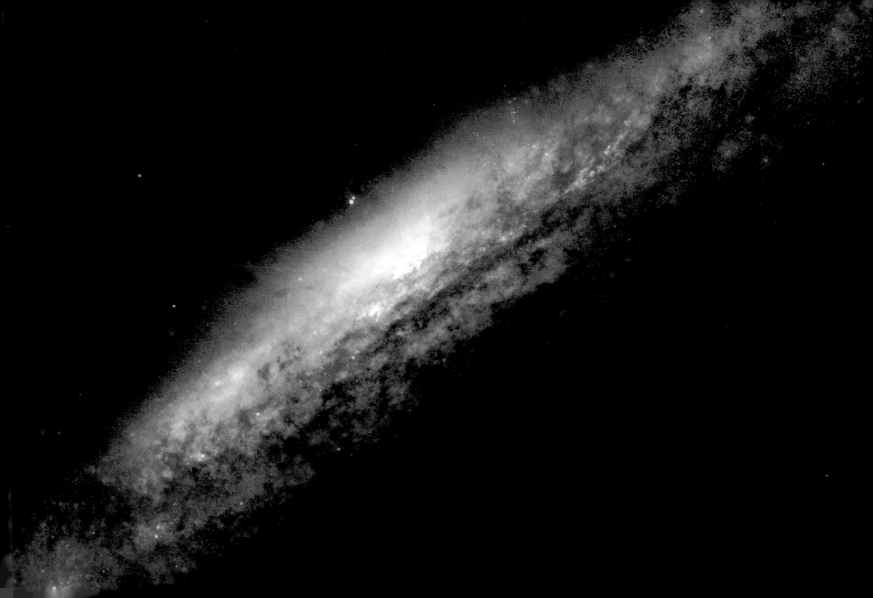

+ **NGC 1818: A Young Globular Cluster**

GLOBULAR CLUSTERS—HUGE BALLS OF STARS—ONCE RULED THE MILKY WAY. BACK IN THE OLD DAYS, BACK WHEN THE MILKY WAY first formed, perhaps thousands of globular clusters roamed our galaxy. Today, there are perhaps two hundred left. Many globular clusters were destroyed over the eons by repeated fateful encounters with each other or the galactic center. Surviving relics are older than any Earth fossil, older than any other structures in our galaxy, and limit the universe itself in raw age. There are few, if any, young globular clusters in our Milky Way galaxy because conditions are not ripe for more to form. Things are different next door, however, in the neighboring galaxy, the Large Magellanic Cloud. Pictured here is a young globular cluster residing there: NGC 1818. Observations show it formed only about 40 million years ago—just yesterday compared to the 12-billion-year-old globular clusters in our own Milky Way. CREDIT: DIEDRE HUNTER (LOWELL OBS.) ET AL., HST, NASA

+ **Moonset, Planet Earth**

DURING THE SPACE SHUTTLE 70 MISSION OF JULY 1995, ASTRONAUTS PHOTOGRAPHED THIS STUNNING VIEW OF THE SETTING full moon poised above the Earth's limb. In the foreground, clouds of condensing water vapor mark the extent of the troposphere, the lowest layer of the planet's life-sustaining atmosphere. Strongly scattering blue sunlight, the upper atmospheric layer, the stratosphere, fades dramatically to the black background of space. Moon and clouds are strong visual elements of many well known portraits of planet Earth, including Ansel Adams's famous Moonrise, Hernandez, New Mexico, photographed in 1941.

CREDIT: STS-70 CREW, NASA

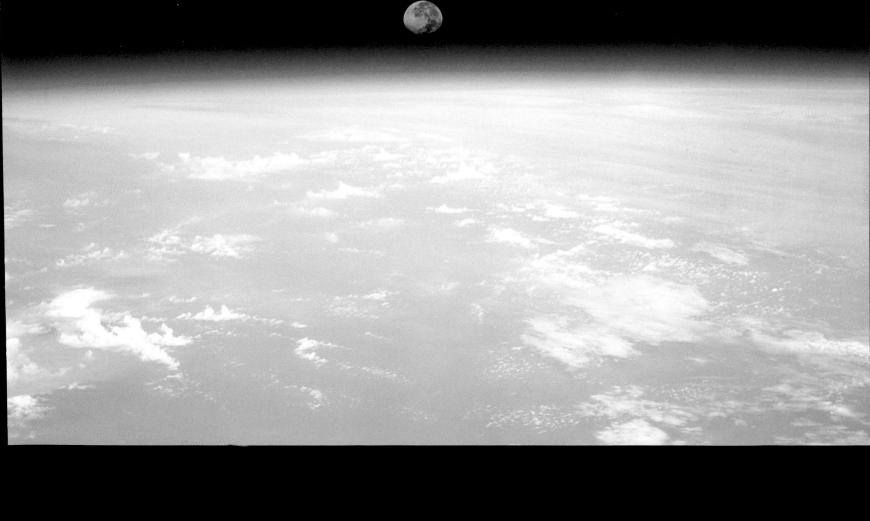

01
02
03
04
05
06
07
08
09
10
11
12
13
14
15
16
17
18
19
20
21
22
23
24
25
26
27
28
29
30
31

+ **Telescope with Lightning**

TELESCOPES ARE NOT VERY USEFUL DURING LIGHTNING STORMS. NEVERTHELESS, WITH LIGHTNING ILLUMINATING A DARK landscape, the picturesque dome of the famous Kitt Peak 2.1-meter Telescope makes for a dramatic photograph. A passing car created the red and yellow streaks visible in the foreground. The 2.1-meter Telescope has participated in many important astronomical discoveries, including the Lyman-alpha forest, the first gravitational lens, and the first pulsating white dwarf star.

CREDIT & COPYRIGHT: NOAO/AURA/NSF

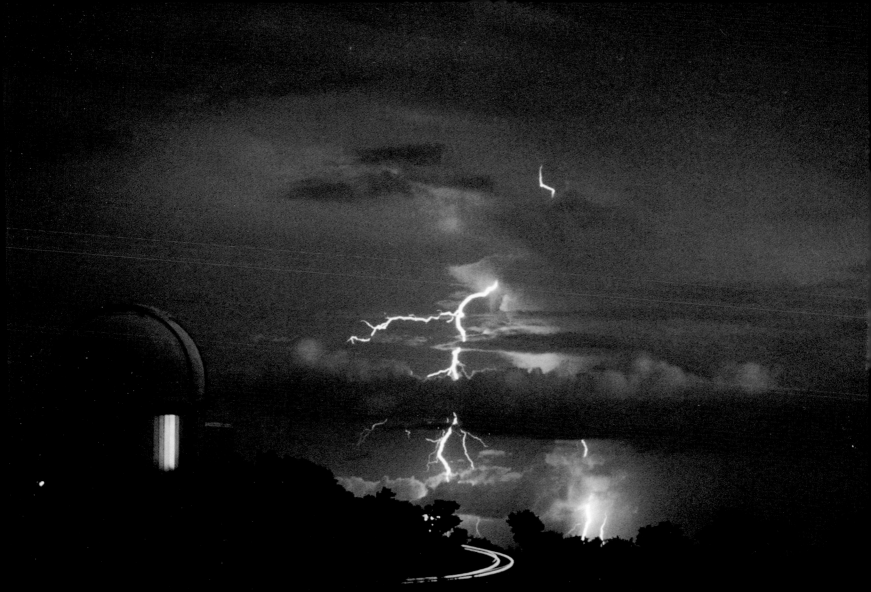

+ **Callisto Full Face**

CALLISTO'S SURFACE SHOWS ITS AGE. WHILE PROBABLY FORMED AT THE SAME TIME AS IO, THE DIFFERENCE BETWEEN THE

surfaces of these two moons of Jupiter could hardly be greater. Io's surface is young, shows practically no impact craters, and is

continually being repaved by the lava exploding from its many large volcanoes. Callisto's surface is old, shows the highest density

of impact craters in the solar system, and has no volcanoes or even any large mountains. Callisto's surface is one large ice field,

laced with cracks and craters from billions of years of collisions with interplanetary debris. This image was taken in May 2001,

and is, so far, the only complete global color image taken by the Jupiter-orbiting Galileo spacecraft. CREDIT: GALILEO PROJECT, VOYAGER

PROJECT, JPL, NASA

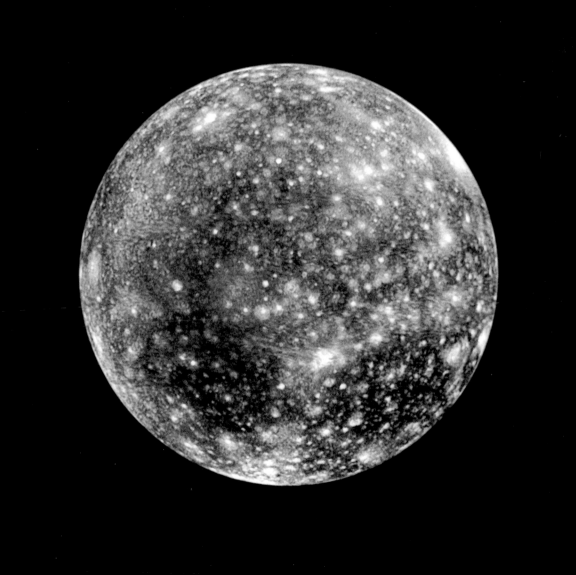

+ **Our Dusty Universe**

WHAT'S BLACK AND WHITE AND RED ALL OVER? ADD OUR UNIVERSE TO THIS LIST. ADRIFT IN A VAST SEA OF DARKNESS ARE not only familiar bright stars but also dust that glows predominantly in far-infrared light. This cosmological dust was recently discovered in data taken previously by the COBE satellite, and is visible as a diffuse glow in this image. The amount of dust in the universe is important because it is a measure of the number of stars that created it, of the number of stars that are cloaked by it, and of the amount of distortion created in measurements of the distant universe. CREDIT: DIRBE TEAM, COBE, NASA

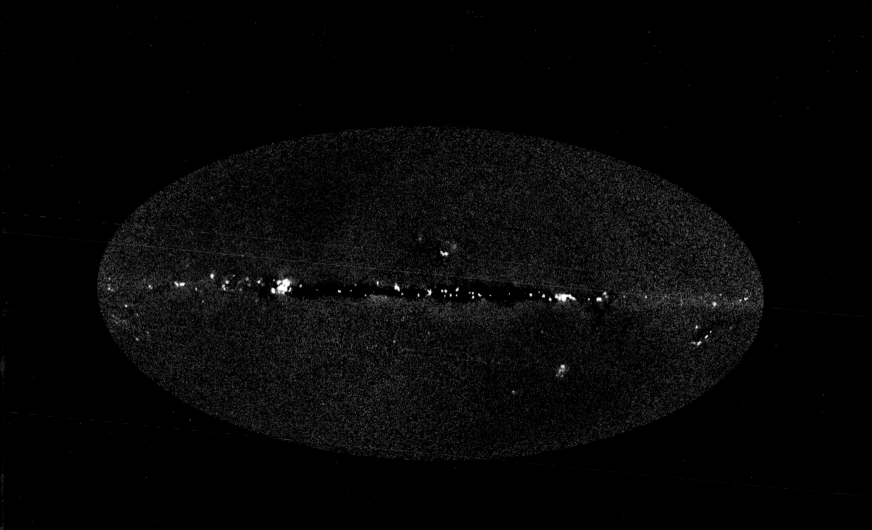

+ **In the Realm of the Small**

IF YOU COULD ZOOM IN TO THE SMALLEST SCALES OF FUNDAMENTAL MATTER, WHAT WOULD YOU SEE? PARTICLES SUCH AS electrons are so small that their true structure remains unknown. A modern branch of physics now models particles in the realm of the small not as points but rather as strings. Pictured here is a false-color surface that might be created by the evolution of a one-dimensional string. By describing fundamental particles as tiny strings, many physicists are working toward the creation of a truly quantum theory of gravity, the only force in the universe that cannot yet be described with the inclusion of quantum mechanics. Such a theory, as yet just a goal, would hopefully allow key insight into many of the standing mysteries of the realm of the large. CREDIT: MARK BOWICK (U. SYRACUSE) ET AL., NPAC

+ **Saturn Aurora**

SATURN'S RINGS ARE ONE OF THE MOST SPECTACULAR SIGHTS FOR EARTHBOUND TELESCOPES. THIS IMAGE OF THE SECOND largest planet in the solar system from the orbiting Hubble Space Telescope offers a striking view of another kind of ring around Saturn—pole-encircling rings of ultraviolet aurora. Towering more than 1,500 km above the cloud tops, these saturnian auroral displays are analogous to Earth's. On Saturn, energetic, charged particles in the solar wind are funneled by the planet's magnetic field into polar regions where they interact with atmospheric gases. Following the ebb and flow of Saturn's aurora, researchers can remotely explore the planet's atmosphere and magnetic field. In this false-color image, the dramatic red aurora identifies emission from atomic hydrogen, while the more concentrated white areas identify hydrogen molecules. In 2004, NASA plans to begin making close-up studies of the saturnian system with the Cassini spacecraft. CREDIT: J. TRAUGER (JPL), NASA

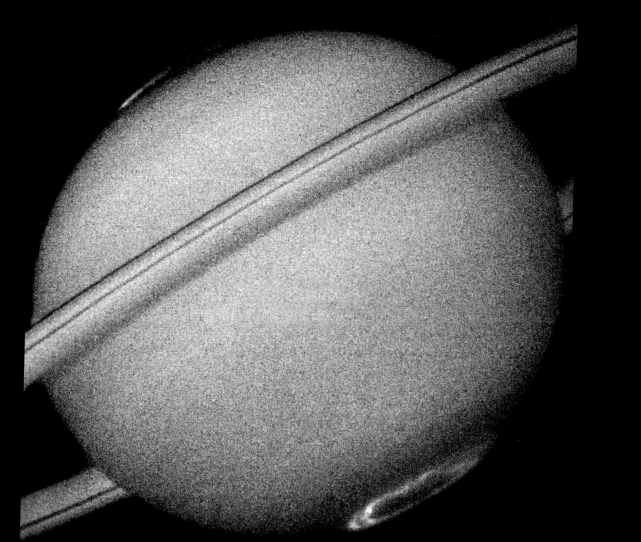

+ **The Eskimo Nebula from Hubble**

IN 1787, ASTRONOMER WILLIAM HERSCHEL DISCOVERED THE ESKIMO NEBULA (NGC 2392). FROM THE GROUND, NGC 2392 resembles a person's head surrounded by a parka hood. In 2000, the Hubble Space Telescope captured this image of the Eskimo Nebula. From space, the nebula displays gas clouds so complex they are not fully understood. The Eskimo Nebula is clearly a planetary nebula, and the gas seen here composed the outer layers of a sun-like star only 10,000 years ago. The inner filaments visible are being ejected by a strong wind of particles from the central star. The outer disk contains unusual light-year-long orange filaments. The Eskimo Nebula lies about 5,000 light-years away and is visible with a small telescope in the constellation Gemini. CREDIT: ANDREW FRUCHTER (STSCI) ET AL., WFPC2, HST, NASA

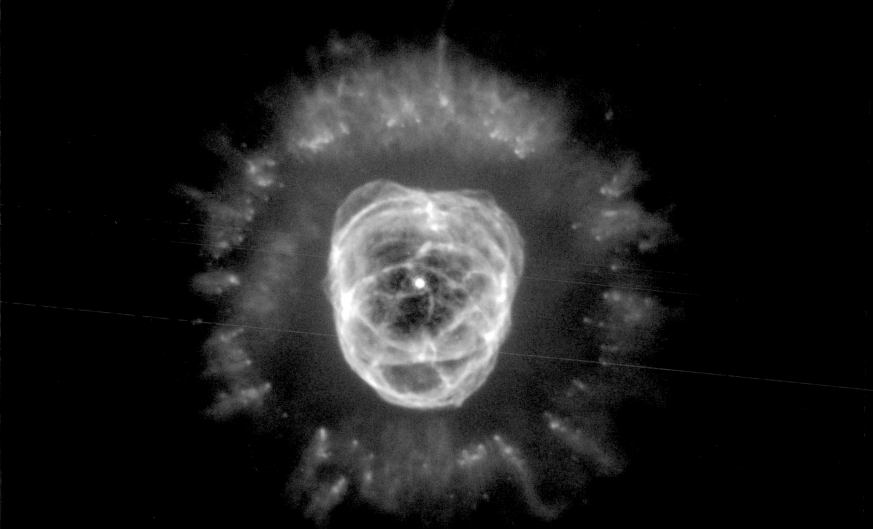

+ **A Lunar Eclipse in Three Exposures**

OUR MOON TURNED RED IN JANUARY 2000. THE REASON WAS THAT DURING THE NIGHT OF JANUARY 20, A TOTAL LUNAR ECLIPSE occurred. These digitally superimposed photographs captured the Moon three times during this lunar eclipse, once just as the Moon entered Earth's shadow, once when the Moon was near the middle of the shadow, and once just before the Moon exited. The red tint of the eclipsed Moon is created by sunlight first passing through Earth's atmosphere—which preferentially scatters blue light (making the sky blue) but passes and refracts red light—before reflecting back off the Moon. Differing amounts of clouds and volcanic dust in Earth's atmosphere make each lunar eclipse appear different. CREDIT & COPYRIGHT: STEPHEN BARNES

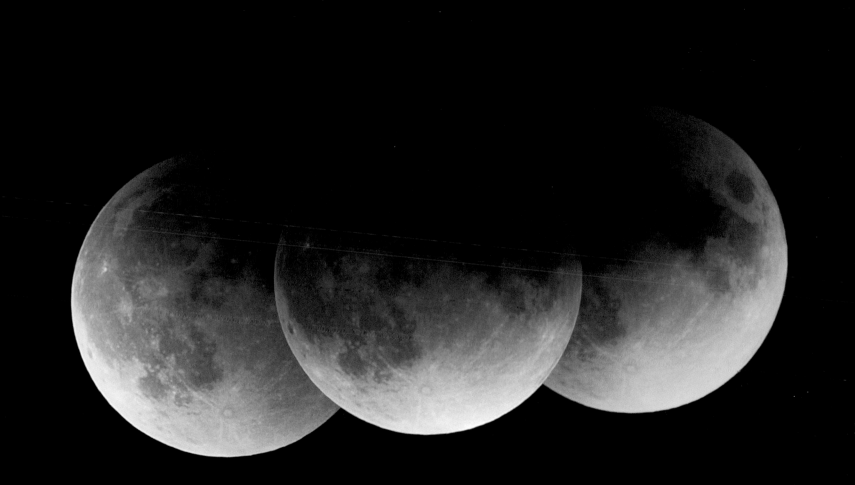

+ **Venus's Once-Molten Surface**

IF YOU COULD LOOK AT VENUS WITH RADAR EYES—THIS IS WHAT YOU MIGHT SEE. THIS COMPUTER RECONSTRUCTION OF THE surface of Venus was created with data from the Magellan spacecraft. Magellan orbited Venus and used radar to map our neighboring planet's surface between 1990 and 1994. Magellan found many interesting surface features, including the large circular domes, typically 25 km across, that are depicted here. Volcanism is thought to have created the domes, although the precise creation scenario remains unknown. Venus's surface is so hot and hostile that no surface probe has lasted more than a few minutes.

CREDIT: E. DE JONG ET AL. (JPL), MIPL, MAGELLAN TEAM, NASA

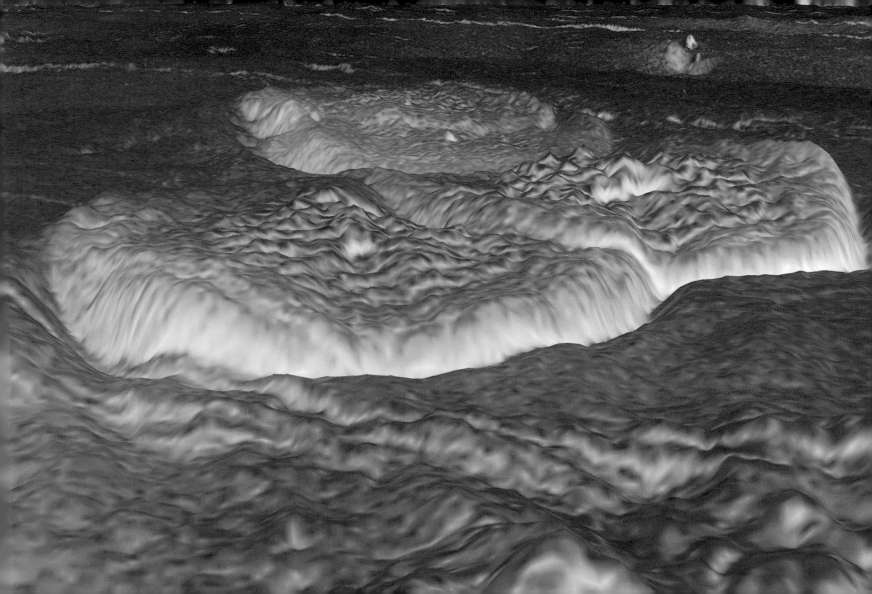

+ **The Hubble Deep Field**

GALAXIES LIKE COLORFUL PIECES OF CANDY FILL THE HUBBLE DEEP FIELD—ONE OF HUMANITY'S MOST DISTANT OPTICAL views of the universe. The dimmest objects, some as faint as 30th magnitude (about 4 billion times fainter than stars visible to the unaided eye), are very distant galaxies and represent what the universe looked like in the extreme past, perhaps less than 1 billion years after the Big Bang. To make the Hubble Deep Field image, astronomers selected an uncluttered area of the sky in the constellation Ursa Major and pointed the Hubble Space Telescope at a single spot for 10 days, accumulating and combining many separate exposures. Fainter objects were revealed with each additional exposure. The final result can be used to explore the mysteries of galaxy evolution and the infant universe. CREDIT: R. WILLIAMS, THE HDF TEAM (STSCI), NASA

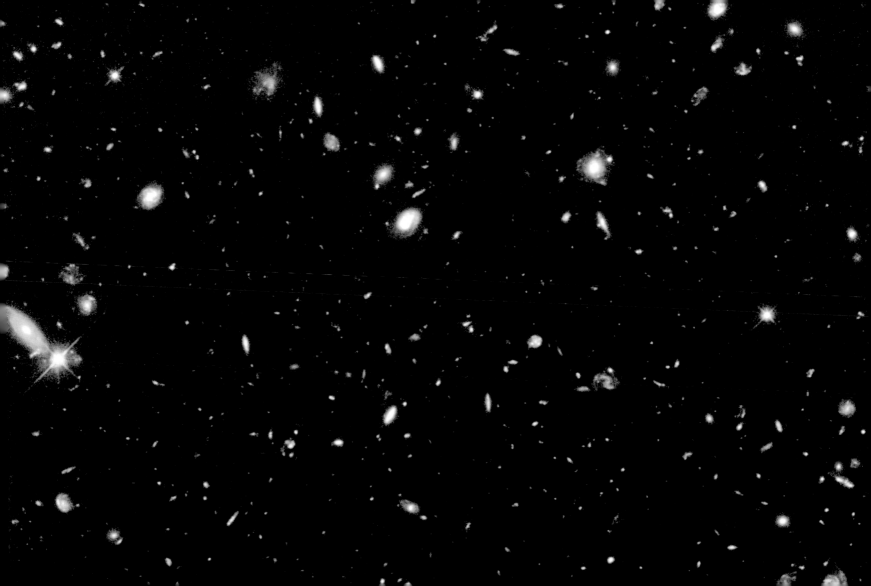

+ **CMB Dipole: Speeding through the Universe**

OUR EARTH IS NOT AT REST. THE EARTH MOVES AROUND THE SUN, THE SUN ORBITS THE CENTER OF THE MILKY WAY GALAXY, and the Milky Way galaxy orbits in the local group of galaxies. The local group falls toward the Virgo Cluster of galaxies. But these speeds of orbit are less than the speed that all of these objects together move at relative to the cosmic microwave background. In this all-sky map, radiation in Earth's direction of motion appears blueshifted and hence hotter, while radiation on the opposite side of the sky is redshifted and hence colder. The map indicates that the local group moves at about 600 km per second relative to this CMB primordial radiation. This high speed was initially unexpected, and its magnitude is still unexplained. Why are we moving so fast? What is out there? CREDIT: DMR, COBE, NASA, FOUR-YEAR SKY MAP

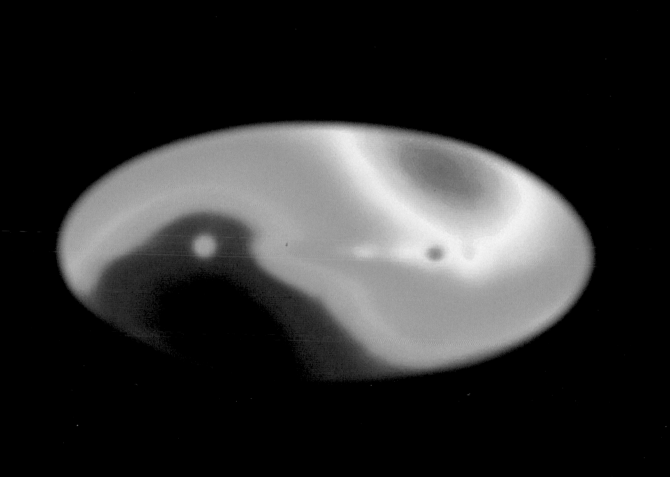

01
02
03
04
05
06
07
08
09
10
11
12
13
14
15
16
17
18
19
20
21
22
23
24
25
26
27
28
29
30
31

+ **An Airplane in front of the Sun**

SOMETIMES, GOOD PLANES COME TO THOSE WHO WAIT. EXPERIENCED SOLAR PHOTOGRAPHER THIERRY LEGAULT HAD NOTICED planes crossing in front of the Sun from his home in suburban Paris. He then got the idea for this photograph, but had to wait through many near misses. On January 29, 2001, he got his wish: a jet crossed directly in front of the Sun when his solar-imaging equipment was set up. The resulting image, shown here, was taken in a specific color of red light called Hydrogen-alpha, and the picture's contrast has been enhanced digitally. Dark prominences can be seen lacing the Sun's busy surface. The airplane is an MD-11 jet airliner. CREDIT & COPYRIGHT: THIERRY LEGAULT, HTTP://PERSO.CLUB-INTERNET.FR/LEGAULT/

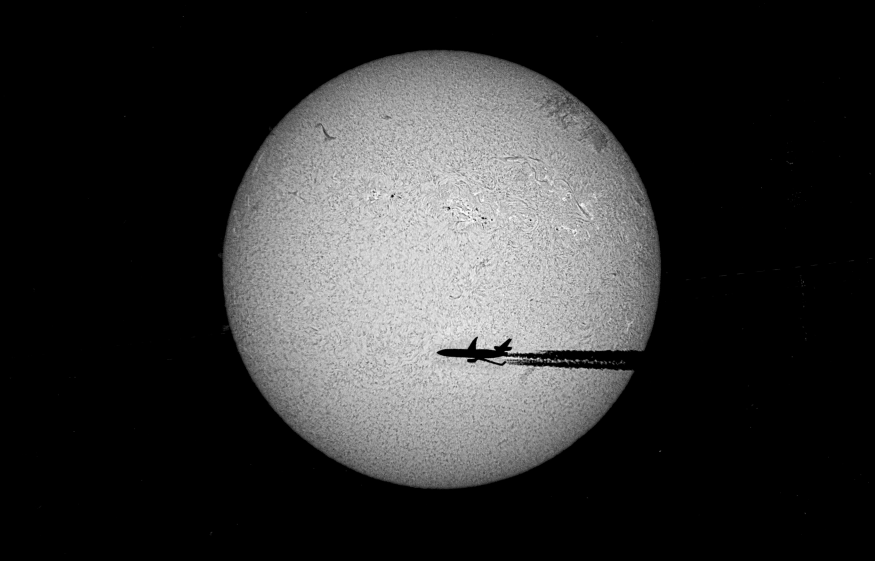

+ **Moonrise over Seattle**

IS THE MOON LARGER WHEN NEAR THE HORIZON? NO. AS SHOWN HERE, THE MOON APPEARS TO BE VERY NEARLY THE SAME size no matter its location on the sky. Oddly, the cause or causes for the common Moon Illusion—where the Moon appears larger when near the horizon—are still being debated. Two leading explanations both hinge on the illusion that foreground objects make a horizon Moon seem farther in the distance. Historically, the most popular explanation holds that the mind interprets more distant objects as wider, while a more recent explanation adds that the distance illusion may actually make the eye focus differently. Either way, the angular diameter of the Moon is always about 0.5 degree. In this time-lapse sequence taken near the end of 2001, the Moon was briefly reimaged every 2.5 minutes, with the last exposure of longer duration to bring up a magnificent panorama of the city of Seattle. CREDIT & COPYRIGHT: SHAY STEPHENS

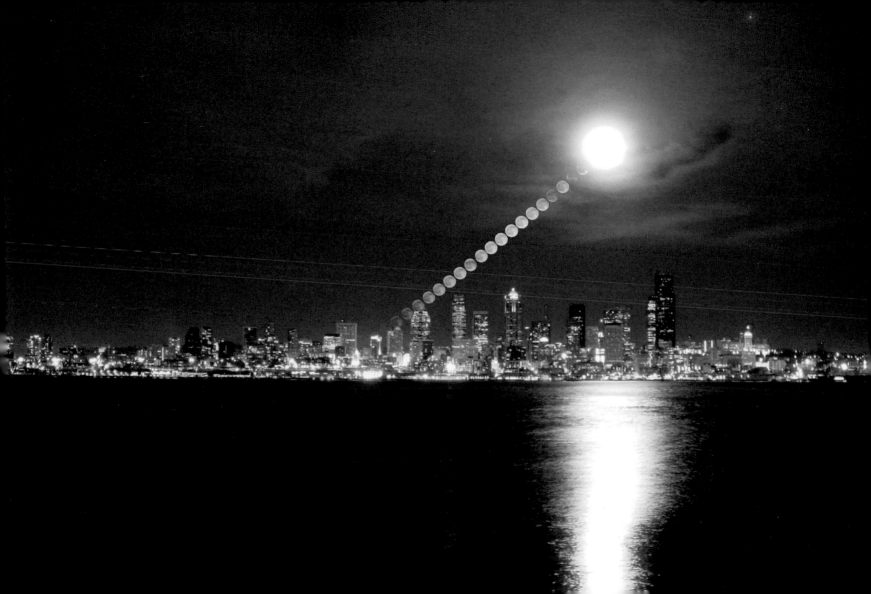

+ **Floating Free in Space**

NASA ASTRONAUTS CAN FLOAT FREE IN SPACE WITHOUT ANY CONNECTION TO A SPACESHIP. HERE ASTRONAUT BRUCE MCCANDLESS

maneuvers outside the space shuttle Challenger by firing nitrogen gas thrusters on his manned maneuvering unit (MMU). This picture

was taken in 1984 and records this first untethered spacewalk. The MMU was developed because astronauts found tethers restrictive.

CREDIT: NASA, STS-41B CREW

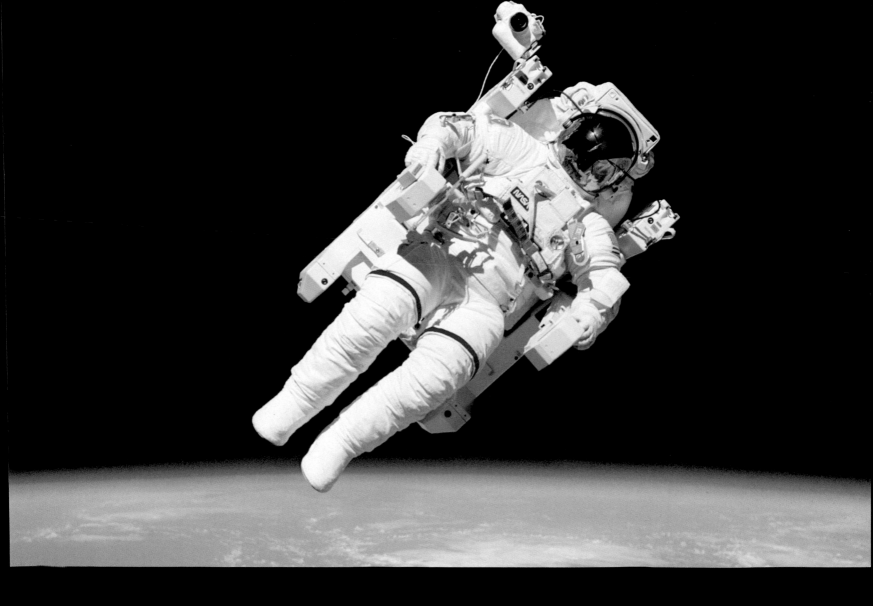

+ **Rocket Trail at Sunset**

BRIGHT LIGHT FROM THE SETTING SUN AND PALE GLOW FROM THE RISING MOON BOTH CONTRIBUTE TO THIS STUNNING picture of a rocket exhaust trail twisting and drifting in the evening sky. Looking west, this digital telephoto view was recorded from Table Mountain Observatory near Wrightwood, California, on September 19, 2002, four days before the autumnal equinox. The rocket, a Minuteman III solid fuel missile, was far down range when the image was taken. Launched from Vandenberg Air Force Base, it carried its test payload thousands of miles out over the Pacific Ocean. The red/orange color from the setting Sun dramatically intensifies near the top of the rocket trail, but below the sunset line, the very bottom of the trail is faintly illuminated from the east by a nearly full moon. Still in full sunlight, the bright diffuse cloud at the top of the trail, the result of a rocket stage separation, is tinged with rainbows likely produced by high altitude ice crystals forming in the exhaust plume. Astronomer James Young comments that the cloud takes on the appearance of a white dove flying from right to left across the sky. CREDIT: JAMES W. YOUNG (TMO, JPL, NASA) USED WITH PERMISSION

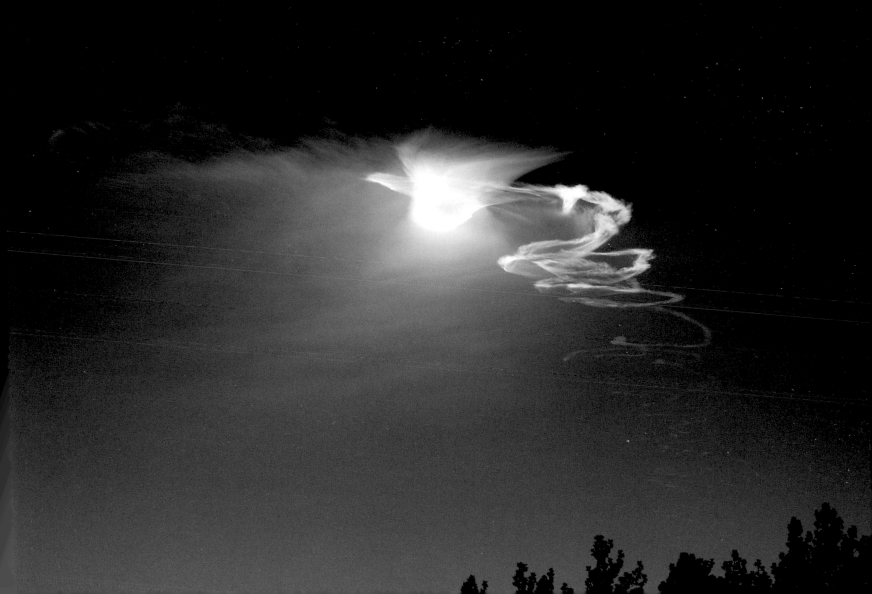

+ **All-Sky Panorama**

THIS QUITE STUNNING PANORAMA OF THE ENTIRE SKY IS A MOSAIC OF FIFTY-ONE WIDE-ANGLE PHOTOGRAPHS. MADE OVER A

3-year period from locations in California, South Africa, and Germany, the individual pictures were digitized and "stitched"

together to create an apparently seamless 360- by 180-degree view. Using a mathematical prescription like one often employed

to map the whole Earth's surface onto a single, flat image, the complete digital mosaic was distorted and projected onto an oval

shape. The image is oriented so the plane of our Milky Way galaxy runs horizontally through the middle, with the galactic center

at image center and galactic north at the top. Most striking are the "milky" bands of starlight from the multitude of stars in the

galactic plane cut by dark, obscuring dust clouds strewn through the local spiral arms. In fact, almost everything visible here

is within our own Milky Way galaxy. Two fuzzy patches in the lower right quadrant of the mosaic do correspond to external

galaxies, though. Known as the Magellanic Clouds, these are small, nearby satellite galaxies of the magnificent Milky Way.

CREDIT & COPYRIGHT: AXEL MELLINGER

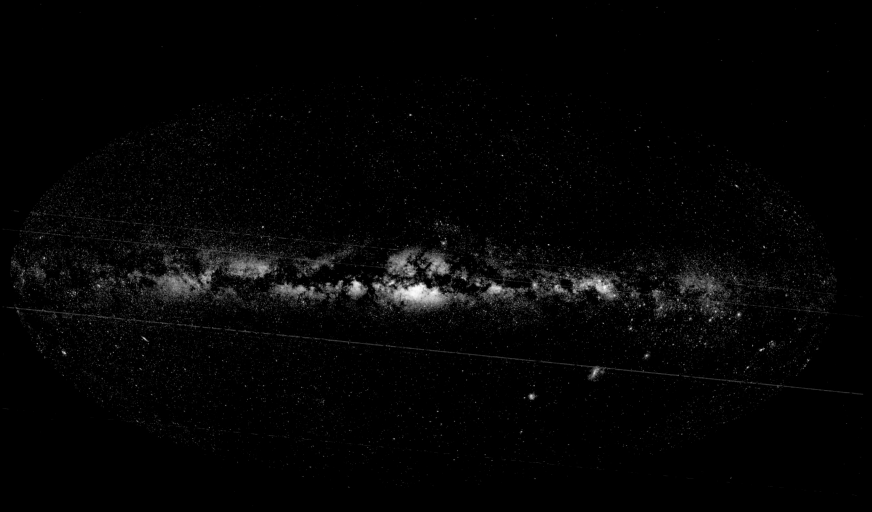

+ **Colorful Clouds of Carina**

TUMULTUOUS CLOUDS OF THE CARINA NEBULA, 8,000 LIGHT-YEARS AWAY, GLOW IN PLANET EARTH'S SOUTHERN SKY.

Striking and detailed, this close-up of a portion of the famous nebula is a combination of exposures through six different filters taken with the Hubble Space Telescope's Wide Field Planetary Camera 2 in April 1999. The dramatic, dark, dust knots and complex features revealed are sculpted by the winds and radiation of Carina's massive and energetic stars. How were this picture's colors generated? Astronomical images produced from Hubble Space Telescope data can be composed of exposures made using relatively narrow filters that don't match the color responses of the human eye. Some of the filters even transmit wavelengths of light outside the visible spectrum. Exposures made with different, narrow filters, as in this case, are translated to a visible color where shorter wavelengths are assigned bluer colors and longer wavelengths assigned redder ones. This scheme is a "chromatically ordered" way of presenting the image data. CREDIT: HUBBLE HERITAGE TEAM (AURA/ STSCI), NASA

+ + Jupiter's Brain

GAS GIANT JUPITER IS THE SOLAR SYSTEM'S LARGEST WORLD, WITH APPROXIMATELY 320 TIMES THE MASS OF PLANET EARTH.

Famous for its Great Red Spot, Jupiter is also known for its regular, equatorial cloud bands, visible in very modest-size tele-scopes. The dark belts and light-color zones of Jupiter's cloud bands are organized by planet-girdling winds that reach speeds of up to 500 km per hour. On toward the jovian poles though, the cloud structures become more mottled and convoluted until, as in this Cassini spacecraft mosaic of Jupiter, the planet's polar region begins to look something like a brain! This striking equator-to-pole change in cloud patterns is not presently understood, but may be due in part to the effect of Jupiter's rapid rota-tion or to convection currents generated at high latitudes by the massive planet's internal heat loss. The Cassini spacecraft recorded this dramatically detailed view of Jupiter during its turn-of-the-millennium flyby en route to Saturn. CREDIT: CASSINI IMAGING TEAM, CASSINI PROJECT, NASA

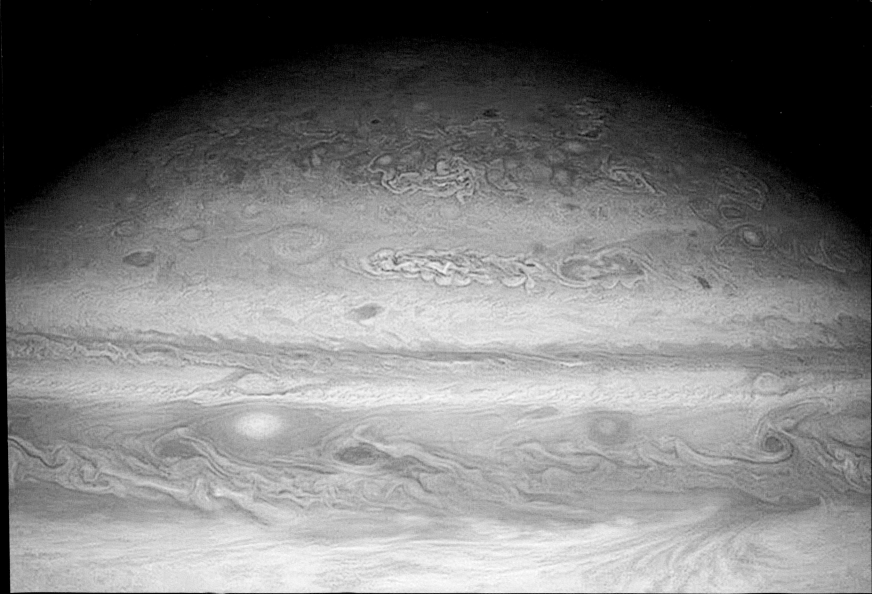

+ **Planetary Nebula Mz3: The Ant Nebula**

WHY ISN'T THIS ANT A BIG SPHERE? PLANETARY NEBULA MZ3 IS BEING CAST OFF BY A STAR SIMILAR TO OUR SUN THAT IS,

surely, round. Why then would the gas that is streaming away create an ant-shaped nebula that is distinctly not round?

Clues might include the high 1,000-km-per-second speed of the expelled gas, the light-year-long length of the structure, and

the magnetism of the star visible at the nebula's center. One possible answer is that Mz3 is hiding a second, dimmer star that

orbits close in to the bright star. A competing hypothesis holds that the central star's own spin and magnetic field are channel-

ing the gas. Since the central star appears to be so similar to our own sun, astronomers hope that increased understanding

of the history of this giant space ant can provide useful insight into the likely future of our own sun and Earth.

CREDIT: R. SAHAI (JPL) ET AL., HUBBLE HERITAGE TEAM, ESA, NASA

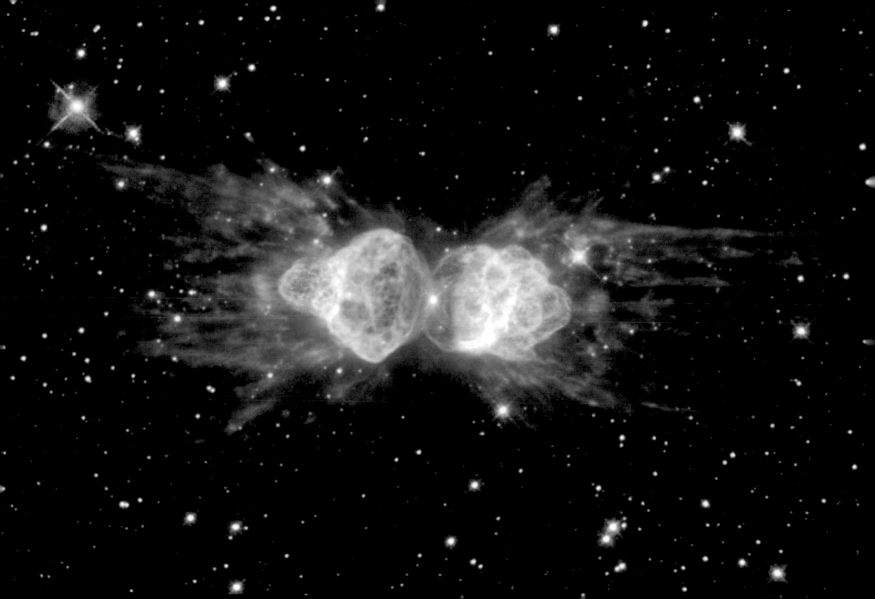

+ **A Message from Earth**

+

WHAT ARE THESE EARTHLINGS TRYING TO TELL US? THIS MESSAGE WAS BROADCAST FROM EARTH TOWARD THE GLOBULAR star cluster M13 in 1974. During the dedication of the Arecibo Observatory—still the largest radio telescope in the world—a string of 1s and 0s representing this diagram was sent. This attempt at extraterrestrial communication was mostly ceremonial—although humanity regularly broadcasts radio and television signals out into space accidentally. Even were this message received, M13 is so far away we would have to wait almost 50,000 years for an answer. This message gives a few simple facts about humanity and its knowledge: from left to right are numbers from 1 to 10, atoms including hydrogen and carbon, some interesting molecules, DNA, a human with description, basics of our solar system, and basics of the sending telescope. Several searches for extraterrestrial intelligence are currently under way, including Project Phoenix and SETI@home, which can make use of a home computer.

CREDIT: FRANK DRAKE (UCSC) ET AL., ARECIBO OBSERVATORY (CORNELL, NAIC)

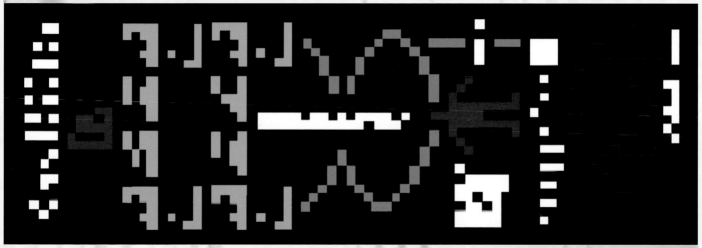

+ **Coronal Hole**

THIS OMINOUS, DARK SHAPE SPRAWLING ACROSS THE FACE OF THE ACTIVE SUN IS A CORONAL HOLE—A LOW-DENSITY REGION extending above the surface where the solar magnetic field opens freely into interplanetary space. Studied extensively from space since the 1960s in ultraviolet and X-ray light, coronal holes are known to be the source of the high-speed solar wind, atoms, and electrons that flow outward along the open magnetic field lines. During periods of low activity, coronal holes typically cover regions just above the Sun's poles. But this coronal hole, one of the largest seen so far in the current solar activity cycle, extends from the south pole (bottom) well into the Northern Hemisphere. Coronal holes like this one may last for a few solar rotations before the magnetic fields shift and change configuration. Shown in false color, this picture of the Sun on January 8, 2002, was made in extreme ultraviolet light by the Extreme ultraviolet Imaging Telescope onboard the SOHO observatory.

CREDIT: SOHO - EIT CONSORTIUM, ESA, NASA

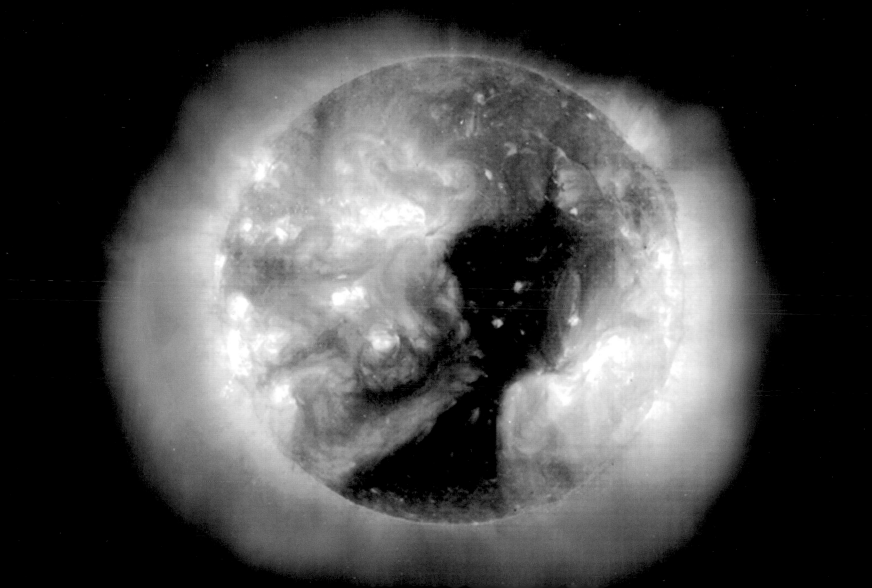

+ **Happy Birthday, Jules Verne**

ON FEBRUARY 8, 1828, JULES VERNE WAS BORN IN NANTES, FRANCE. INSPIRED BY A LIFELONG FASCINATION WITH MACHINES, Verne wrote visionary works about extraordinary voyages, including Around the World in Eighty Days, Journey to the Center of the Earth, and Twenty Thousand Leagues under the Sea. In 1865, he published the story of three adventurers who undertook a journey from Earth to the Moon. Verne's characters rode a "projectile-vehicle" fired from a huge cannon constructed in Florida. Does that sound vaguely familiar? A century later, the Saturn V rocket and NASA's Apollo program finally turned this work of fiction into fact, propelling adventuresome trios on what was perhaps Verne's most extraordinary voyage. This image shows the Apollo 11 space vehicle atop its Saturn V as it is being transported to its launch pad. Launched from a spaceport in Florida in 1969, the Apollo 11 crew was the first to land on the moon. CREDIT: NASA

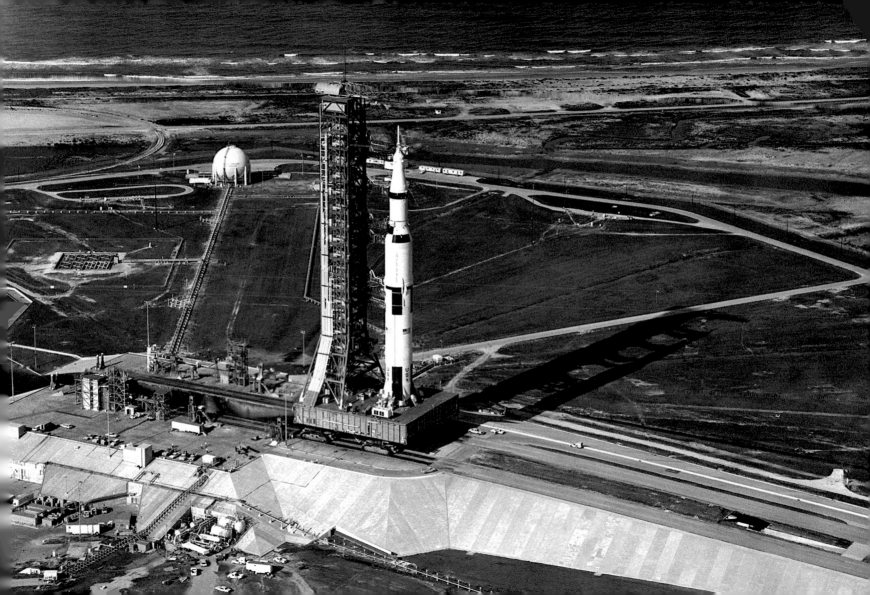

+ **Saturn the Giant**

ON MAY 25, 1961, U.S. PRESIDENT JOHN F. KENNEDY ANNOUNCED THE GOAL of landing Americans on the moon by the end of the decade. Kennedy's ambitious speech triggered a nearly unprecedented peacetime technological mobilization, one result of which was the Saturn V moon rocket. Its development, directed by rocket pioneer Wernher von Braun, resulted in the three-stage Saturn V that stood over 36 stories tall. It had a cluster of five first-stage engines fueled by liquid oxygen and kerosene that together were capable of producing 7.5 million pounds of thrust. Giant Saturn V rockets ultimately hurled nine Apollo missions to the Moon and back again, with six successfully landing on the lunar surface. The first landing, by Apollo 11, occurred on July 20, 1969, achieving Kennedy's goal. Here, it is 9:32 A.M. E.D.T., July 16, 1969, and the Apollo 11 Saturn V is lifting off for its historic mission. CREDIT: NASA

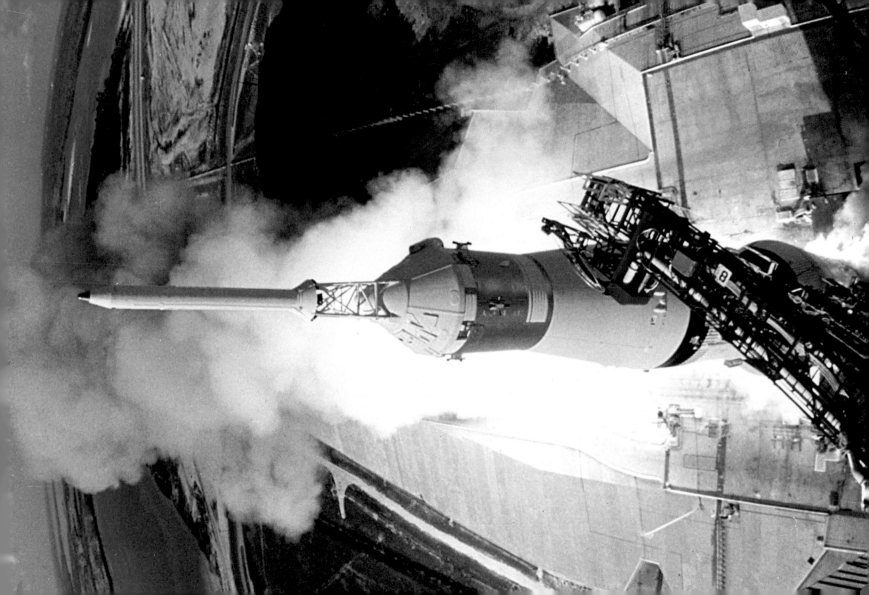

+ **The Earth–Moon System**

THIS EVOCATIVE MOSAIC IMAGE OF THE EARTH–MOON SYSTEM WAS RECORDED BY NASA'S NEAR EARTH ASTEROID RENDEZVOUS (NEAR) spacecraft in January 1998. The relative sizes shown are appropriate for viewing both the Earth and Moon from a distance of approximately 250,000 miles, although the apparent brightness of the Moon has been increased by about a factor of five for the sake of appearances. This space-based perspective is a unique one, the bland and somber Lunar Southern Hemisphere contrasting strongly with blue oceans, swirling clouds, and the bright icy white continent of Antarctica on planet Earth. Though its lack of atmosphere and oceans make it relatively dull looking, the Earth's moon is one of the largest moons in the solar system—even larger than the planet Pluto. During this flyby of the Earth–Moon system, the NEAR spacecraft used Earth's gravity to deflect it towards its ultimate destination, the Asteroid 433 Eros. CREDIT: NEAR SPACECRAFT TEAM, JHUAPL, NASA

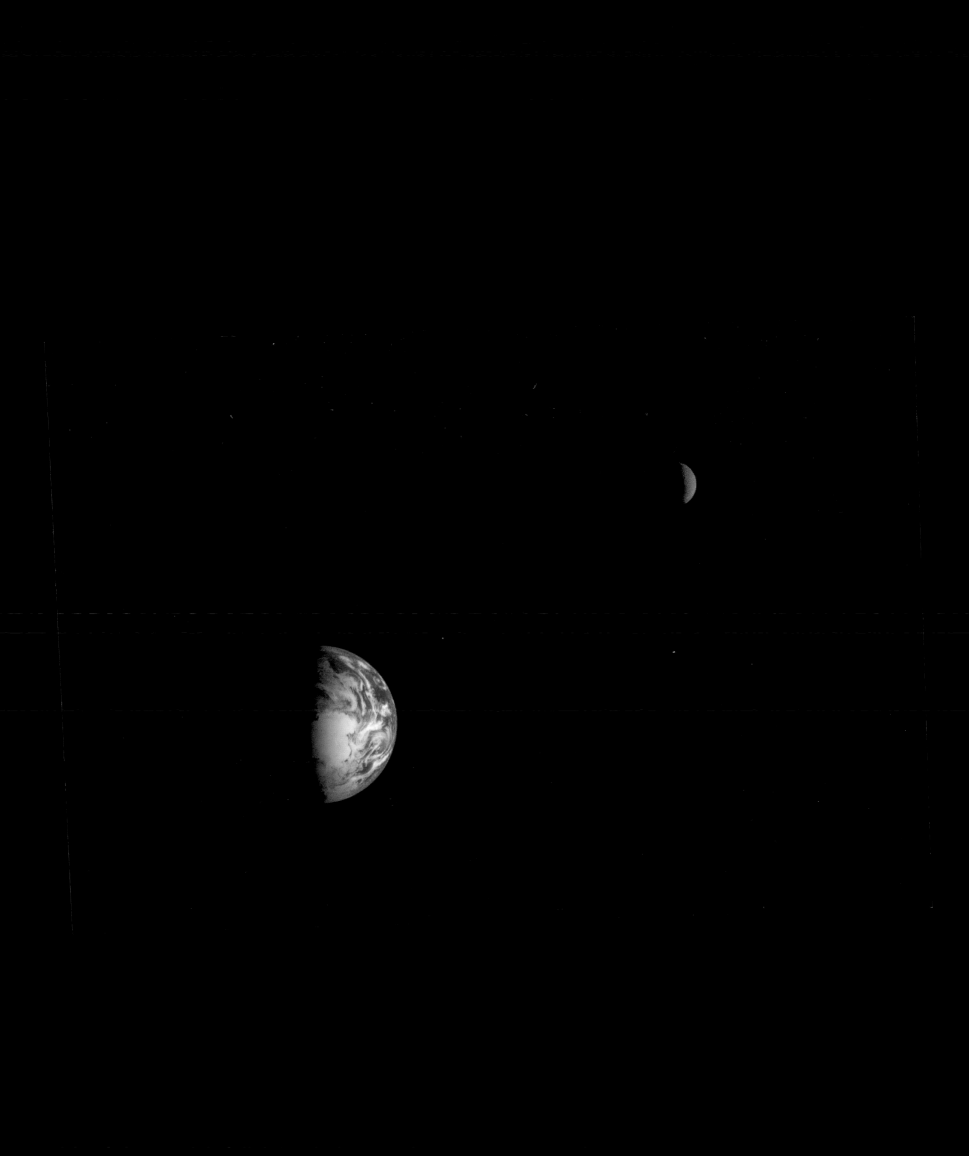

01
02
03
04
05
06
07
08
09
10
11
12
13
14
15
16
17
18
19
20
21
22
23
24
25
26
27
28

+ **Reflection Nebula M78**

AN EERIE, BLUE GLOW AND OMINOUS COLUMNS OF DARK DUST HIGHLIGHT M78, ONE OF THE BRIGHTEST REFLECTION NEBULAS on the sky. M78 is visible with a small telescope, toward the constellation Orion. The interstellar dust tends to scatter and reflect blue light more than red, giving the nebula its bluish hue. The same physical process causes Earth's daytime sky to appear blue, although the scatterers are molecules of nitrogen and oxygen. M78 is about 5 light-years across and appears here as it was 1,600 years ago—that is how long it takes light to go from there to here. M78 belongs to the larger Orion Molecular Cloud Complex that contains the Great Nebula in Orion and the Horsehead Nebula. CREDIT & COPYRIGHT: S. LEE, C. TINNEY, & D. MALIN, AAO

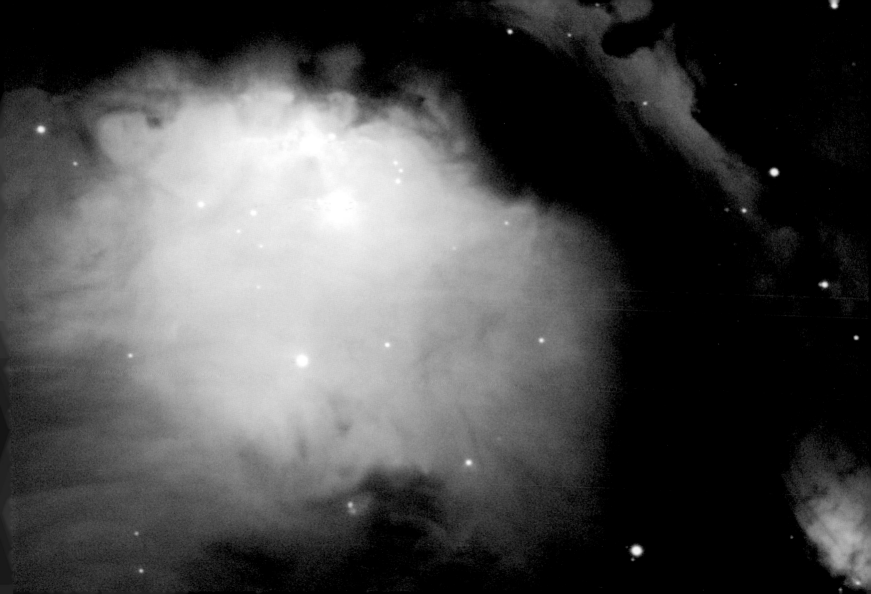

+ **The Dust and Ion Tales of Comet Hale-Bopp**

IN 1997, COMET HALE-BOPP'S INTRINSIC BRIGHTNESS EXCEEDED ANY COMET'S SINCE 1811. BECAUSE IT PEAKED ON THE OTHER side of Earth's orbit, however, the comet only appeared brighter than any comet in 2 decades. Visible here in a photograph from March 1997 are the two tails shed by comet Hale-Bopp. The blue ion tail is composed of ionized gas molecules, of which carbon monoxide particularly glows blue when reacquiring electrons. This tail is created by particles from the Solar Wind interacting with gas from the comet's head. The blue ion tail points directly away from the Sun. The white dust tail is created by bits of grit that have come off the comet's nucleus and are being pushed away by the pressure of light from the Sun. This tail points nearly away from the Sun. CREDIT & COPYRIGHT: JOHN GLEASON, CELESTIAL IMAGES

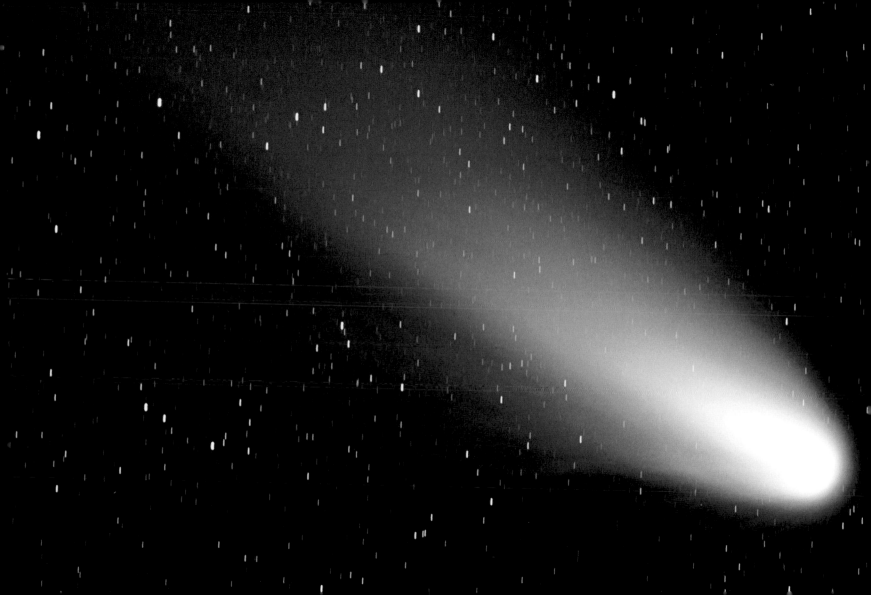

+ **Saturn: Lord of the Rings**

+

BORN IN PISA, ITALY, IN 1564, GALILEO USED A TELESCOPE TO EXPLORE THE SOLAR SYSTEM. IN 1610, HE BECAME THE FIRST to be amazed by Saturn's rings. Four hundred years later, Saturn's magnificent rings still offer one of the most stunning astronomical sights. Uniquely bright compared to the rings of the other gas giants, Saturn's ring system is about 250,000 km wide, but in places only a few tens of meters thick. Modern astronomers believe the rings are perhaps only a 100 million years young. But because of accumulating dust and dynamically interacting with Saturn's moons, the rings may eventually darken and sag toward the gas giant, losing their luster over the next few hundred million years. Since Galileo, astronomers have subjected the entrancing rings to intense scrutiny to unlock their secrets. Still mesmerized, some take advantage of favorable lunar occultations of Saturn to search for evidence of ring material outside the well-known boundaries of the ring system. The presence of such a "lost" ring of Saturn was first hinted at in reports dating back to the early twentieth century. CREDIT: HUBBLE HERITAGE TEAM (AURA / STSCI) R.G. FRENCH (WELLESLEY COLLEGE), J. CUZZI (NASA/AMES), L. DONES (SWRI), J. LISSAUER (NASA/AMES)

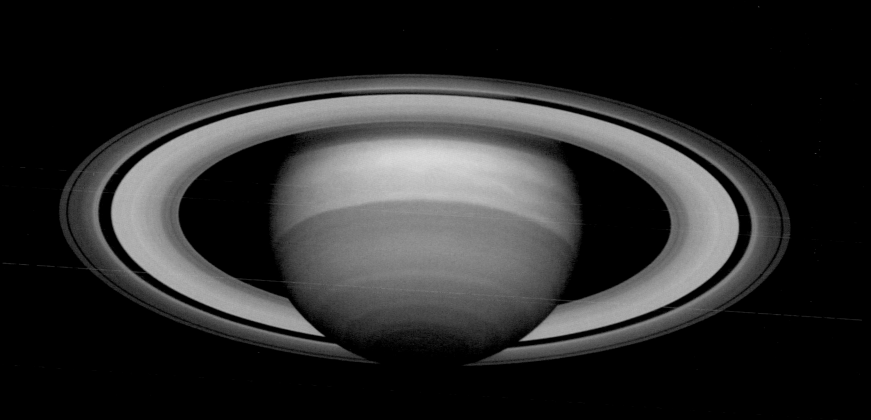

+ **The Rosette Nebula**

+

WOULD THE ROSETTE NEBULA BY ANY OTHER NAME LOOK AS SWEET? THE BLAND NEW GENERAL CATALOG DESIGNATION OF

NGC 2237 doesn't appear to diminish the appearance of this flowery emission nebula. Inside the nebula lies an open cluster of

bright, young stars designated NGC 2244. These stars formed about 4 million years ago from the nebular material, and their

stellar winds are clearing a hole in the nebula's center, insulated by a layer of dust and hot gas. Ultraviolet light from the hot

cluster stars causes the surrounding nebula to glow. The Rosette Nebula spans about 100 light-years, lies approximately 5,000

light-years away, and can be seen with a small telescope, toward the constellation Monoceros. CREDIT & COPYRIGHT: ROBERT GENDLER

+ **NGC 2244: A Star Cluster in the Rosette Nebula**

IN THE HEART OF THE ROSETTE NEBULA LIES A BRIGHT, OPEN CLUSTER OF STARS THAT LIGHTS UP THE NEBULA. THE STARS of NGC 2244, formed from the surrounding gas only 4 million years ago, emit the light and wind that define the nebula's appearance today. High-energy light from the bright, young stars of NGC 2244 ionizes the surrounding hydrogen gas clouds to create the red glow of the emission nebula. The hot wind of particles that streams away from the cluster stars contributes to an already complex menagerie of gas and dust filaments, while slowly evacuating the cluster center. NGC 2244 measures about 50 light-years across. CREDIT & COPYRIGHT: CANADA–FRANCE–HAWAII TELESCOPE/JEAN-CHARLES CUILLANDRE/1999

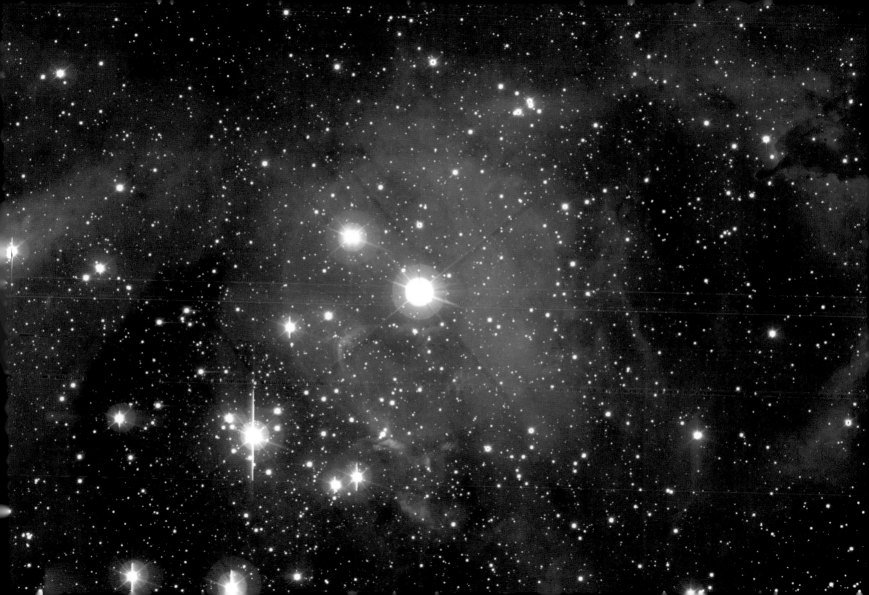

+ **The Rosette Nebula in Hydrogen, Oxygen, and Sulfur**

THE ROSETTE NEBULA IS A LARGE EMISSION NEBULA LOCATED 5,000 LIGHT-YEARS AWAY. THE GREAT ABUNDANCE OF HYDROGEN gas gives NGC 2237 its red color. The wind from the open cluster of stars known as NGC 2244 has cleared a hole in the nebula's center. This photograph, however, was taken in the light emitted by three elements of the gas ionized by the energetic central stars. Here green light originating from oxygen and blue light originating from sulfur supplements the red from hydrogen. Filaments of dark dust run through the nebula's glowing gases. The origin of recently observed fast-moving molecular knots in the Rosette Nebula remains under investigation. CREDIT: T. A. RECTOR, B. WOLPA, M. HANNA (NOAO/AURA/NSF)

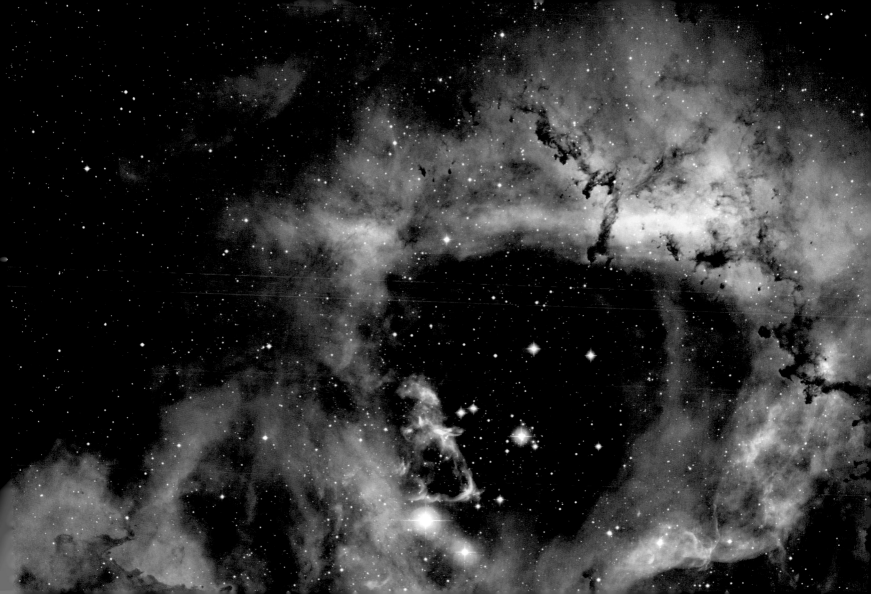

+ **The Cosmic Infrared Background**

WHAT COSMIC WALLPAPER IS ON THE SKY? RECENTLY, THE TWO MICRON ALL-SKY SURVEY (2MASS) PROJECT IMAGED THE cosmic background of infrared light at high resolution. The results confirmed earlier estimates that it is more than twice as bright as originally expected. A small section of the cosmic infrared background is shown here in representative colors— the black spots indicate places where there were no measurements. Shown is the light emitted from the very first stars and galaxies in the universe, emitted when the universe was less than half its current age. During that epoch, the universe was more uniform, and the brightness of the background indicates that many more stars were forming. CREDIT: A. KASHLINSKY (SSAI) & S. ODENWALD (RAYTHEON), 2MASS, NSF, NASA

+ **A Wind from the Sun**

A WIND FROM THE SUN BLOWS THROUGH OUR SOLAR SYSTEM. THE BEHAVIOR OF COMET TAILS AS THEY FLAPPED AND WAVED

in this interplanetary breeze gave astronomers the first hint of the Solar Wind's existence. Streaming outward at 400–650 km per

second, electrons and ions boiling off the Sun's incredibly hot but tenuous corona account for this wind—now known to affect

Earth and other planets along with voyaging spacecraft. Rooted in the Solar Magnetic Field, the structure of the corona is

visible extending a million miles above the Sun's surface in this composite image from the EIT and UltraViolet Coronagraph

Spectrometer instruments onboard the SOHO spacecraft. The dark areas, known as coronal holes, represent the regions where

the highest-speed Solar Wind originates. CREDIT: SOHO CONSORTIUM, UVCS, EIT, ESA, NASA

01
02
03
04
05
06
07
08
09
10
11
12
13
14
15
16
17
18
19
20
21
22
23
24
25
26
27
28

+ Shuttle Plume Shadow Points to Moon

WHY WOULD THE SHADOW OF A SPACE SHUTTLE LAUNCH PLUME POINT toward the Moon? In February 2001, during the launch of Atlantis, the Sun, Earth, Moon, and rocket were all properly aligned for this photogenic coincidence. First, for the space shuttle's plume to cast a long shadow, the time of day must be either near sunrise or sunset. Next, just at sunset, the shadow is the longest and extends all the way to the horizon. Finally, during a full moon, the Sun and Moon are on opposite sides of the sky. Just after sunset, for example, the Sun is slightly below the horizon, and, in the other direction, the Moon is slightly above the horizon. Therefore, as Atlantis blasted off, just after sunset, its shadow projected away from the Sun toward the opposite horizon, where the full moon just happened to be. CREDIT: NASA

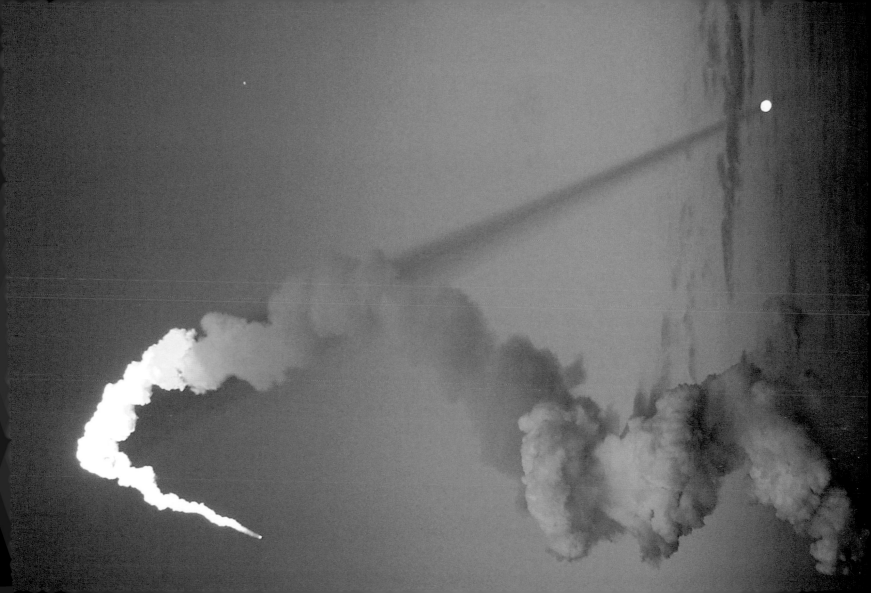

+ **Saturn at the Lunar Limb**

GLIDING THROUGH THE SKY ON WEDNESDAY EVENING, FEBRUARY 20, 2002, A FIRST QUARTER MOON SEEMED TO RUN OVER bright planet Saturn as viewed from much of North America. In this sharp sequence of telescopic digital images from the Powell Observatory near Louisburg, Kansas, Saturn is seen reappearing from behind the bright lunar limb over a period of about 2 minutes. The ringed planet emerges above the dark, smooth lunar Mare Crisium (Sea of Crises). This lunar occultation, the Moon's disk blocking the line of sight to Saturn, was widely anticipated in part because the ringed planet and the brilliant Moon are both spectacular celestial sights. European sky gazers had their turn as the Moon occulted the solar system's largest planet, Jupiter, in early morning hours on Saturday, February 23 of that same year. CREDIT & COPYRIGHT: TOM MARTINEZ

(ASTRONOMICAL SOCIETY OF KANSAS CITY)

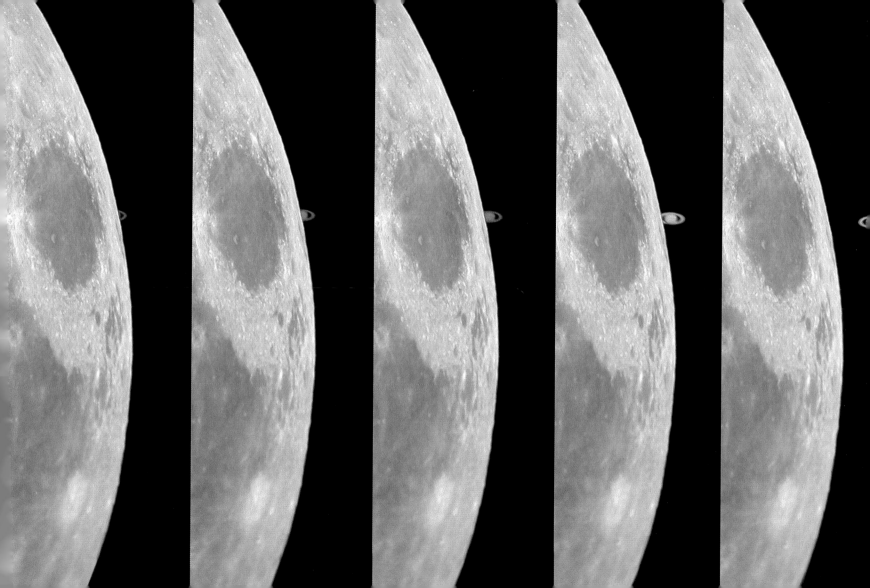

+ **A Sonic Boom**

MANY PEOPLE HAVE HEARD A SONIC BOOM, BUT FEW HAVE SEEN ONE. WHEN AN AIRPLANE TRAVELS AT A SPEED FASTER THAN sound, density waves of sound emitted by the plane cannot precede the plane, and so accumulate in a cone behind it. When this shock wave passes, a listener hears all at once the sound emitted over a longer period: a sonic boom. As a plane accelerates to just break the sound barrier, however, an unusual cloud might form. The origin of this cloud is still debated. A leading theory is that a drop in air pressure at the plane, described by the Prandtl-Glauert Singularity, occurs, so that moist air condenses there to form water droplets. Here, an F/A-18 Hornet was photographed just as it broke the sound barrier. Large meteors and the space shuttle frequently produce audible sonic booms before they are slowed to below sound speed by Earth's atmosphere.

CREDIT: ENSIGN JOHN GAY, USS CONSTELLATION, U.S. NAVY

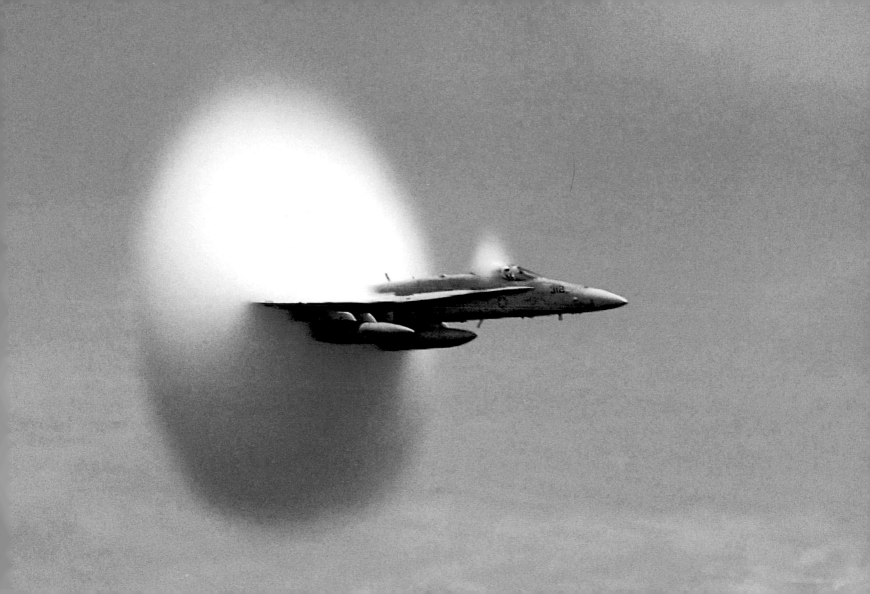

+ **The Gamma-Ray Sky**

WHAT IF YOU COULD "SEE" GAMMA RAYS? IF YOU COULD, THE SKY WOULD SEEM TO BE FILLED WITH A SHIMMERING HIGH-energy glow from the most exotic and mysterious objects in the universe. In the early 1990s, NASA's orbiting Compton Observatory produced this premier vista of the entire sky in gamma rays—photons with more than 40 million times the energy of visible light. The diffuse gamma-ray glow from the plane of our Milky Way galaxy runs horizontally through the false-color image. The brightest spots in the galactic plane (right of center) are pulsars—spinning, magnetized neutron stars formed in the violent crucibles of stellar explosions. Above and below the plane, quasars, believed to be powered by supermassive black holes, produce gamma-ray beacons at the edges of the universe. The nature of many of the fainter sources of the cosmic gamma rays remains unknown. CREDIT: EGRET TEAM, COMPTON OBSERVATORY, NASA

01
02
03
04
05
06
07
08
09
10
11
12
13
14
15
16
17
18
19
20
21
22
23
24
25
26
27
28

+ **Astro 1 in Orbit**

IN DECEMBER 1990, THE SPACE SHUTTLE COLUMBIA CARRIED AN ARRAY OF astronomical telescopes high above Earth's obscuring atmosphere to observe the universe at ultraviolet and X-ray wavelengths. The mission's goal was to study solar system, galactic, and extragalactic sources. The telescopes, known by the acronyms UIT (Ultraviolet Imaging Telescope), HUT (Hopkins Ultraviolet Telescope), WUPPE (Wisconsin Ultraviolet Photo-Polarimeter Experiment), and BBXRT (Broad Band X-ray Telescope), together comprise the Astro 1 Observatory. Here, they are seen as erected in the cargo bay of the Columbia Orbiter. CREDIT: NASA

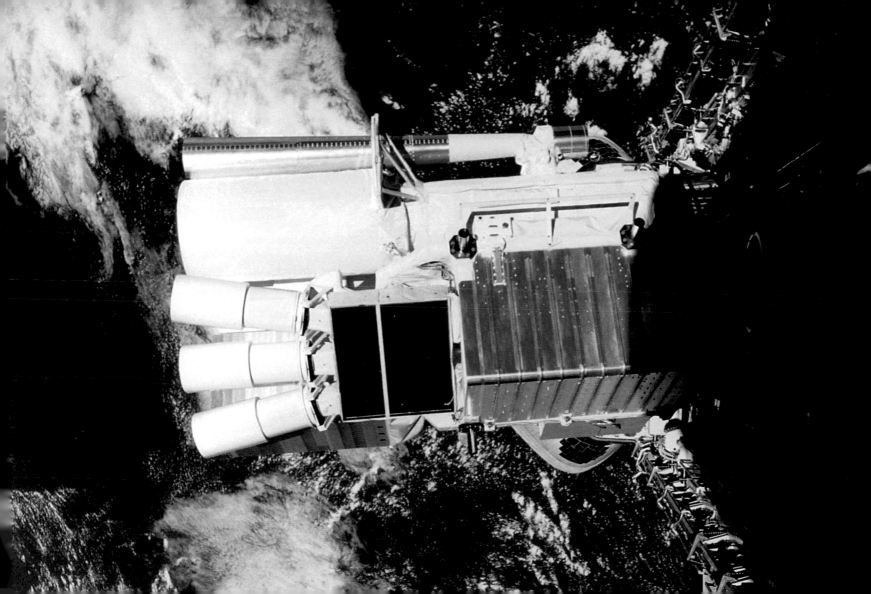

+ **The Lyman-alpha Forest**

WE LIVE IN A FOREST. STREWN THROUGHOUT THE UNIVERSE ARE "TREES" OF HYDROGEN GAS THAT ABSORB LIGHT FROM distant objects. These gas clouds leave numerous absorption lines in a distant quasar's spectra, together called the Lyman-alpha forest. Distant quasars appear to be absorbed by many more Lyman-alpha clouds than nearby quasars, indicating a Lyman-alpha thicket early in our universe. This image depicts one possible computer realization of how Lyman-alpha clouds were distributed in the early universe, at a redshift of 3. Each side of the box measures 30 million light-years across. Much remains unknown about the Lyman-alpha forest, including the real geometry and extent of the clouds, and why there are so many fewer clouds today. CREDIT & COPYRIGHT: J. SHALF, Y. ZHANG (UIUC) ET AL., GCCC

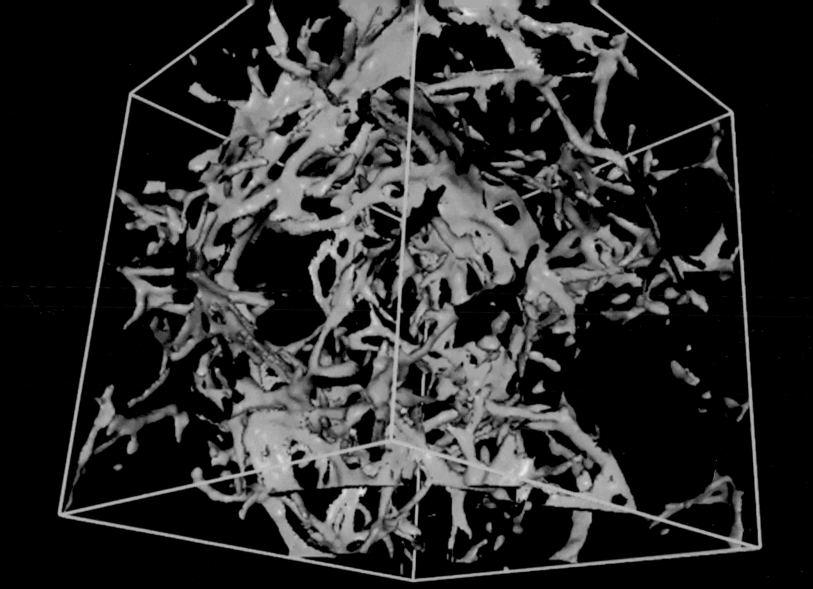

+ **Crescent Europa**

ALTHOUGH THE PHASE OF THIS MOON MIGHT APPEAR FAMILIAR, THE MOON ITSELF MIGHT NOT. IN FACT, THIS CRESCENT shows part of Jupiter's moon Europa. The passing robot spacecraft Voyager 2 captured this image in 1979. Visible are plains of bright ice, cracks that run to the horizon, and dark patches that likely contain both ice and dirt. Raised terrain is particularly apparent near the terminator, the line between Europa's day and night sides, where it casts long shadows. Europa is nearly the same size as Earth's moon, but much smoother, showing few highlands or large impact craters. In the late 1990s, evidence and images from the Galileo spacecraft orbiting Jupiter indicated that liquid oceans might exist below the icy surface. To test speculation that these seas hold life, NASA has started preliminary development of the Europa Orbiter, a spacecraft that would use radar to help determine the thickness of the surface ice. If the surface ice is thin enough, a future mission might drop hydrobots to burrow into the oceans and search for life. CREDIT: VOYAGER 2, NASA

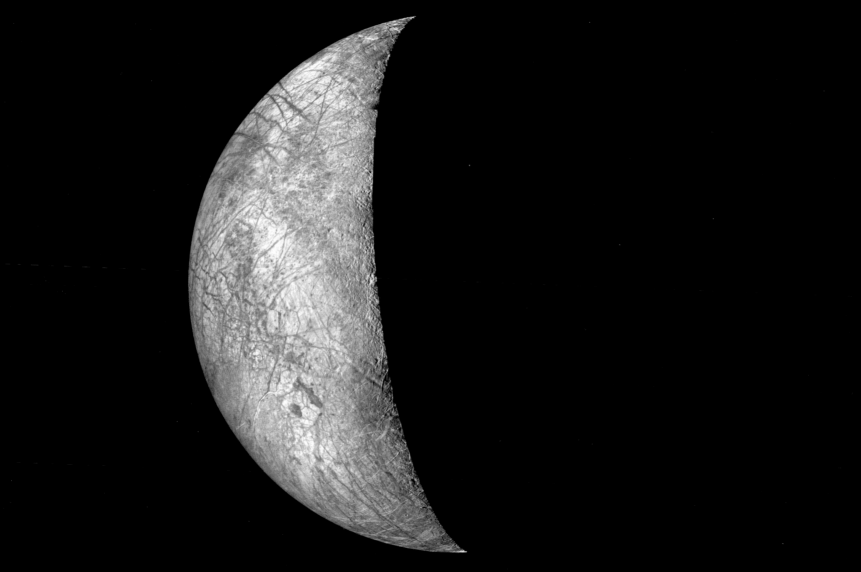

+ **Sungrazer**

ARCING TOWARD A FIERY FATE, THIS SUNGRAZER COMET WAS RECORDED BY THE SOHO SPACECRAFT'S LARGE ANGLE SPECTROMETRIC

COronagraph (LASCO) on December 23, 1996. LASCO uses an occulting disk, visible at picture center, to block out the otherwise

overwhelming solar disk, allowing it to image the inner 8 million km of the relatively faint corona. The comet is seen as it enters

a bright equatorial region. Spots and blemishes on the image are background stars and camera streaks caused by charged particles.

Positioned in space to continuously observe the Sun, SOHO has detected several hundred sungrazing comets. Based on their orbits,

they are believed to belong to a family of comets created by successive breakups from a single, large parent comet that passed very near

the sun in the twelfth century. The bright comet of 1965, Ikeya-Seki, was also a member of the sungrazer family, coming within about

650,000 km of the Sun's surface. Passing so close to the Sun, sungrazers are subjected to stress from destructive gravitational tidal

forces along with intense solar heat. This comet, known as SOHO 6, did not survive. CREDIT: LASCO, SOHO CONSORTIUM, NRL, ESA, NASA

+

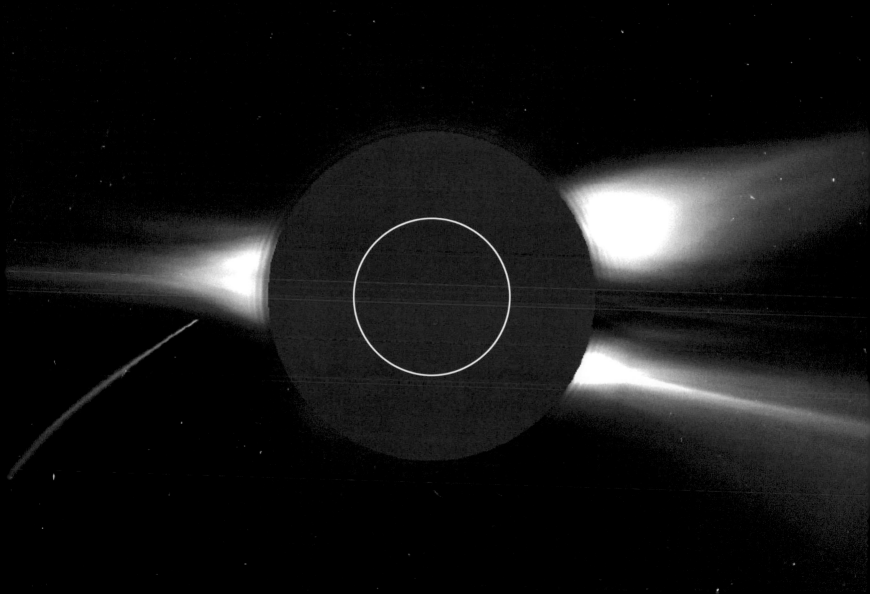

+ **The Pleiades Star Cluster**

THE PLEIADES IS THE MOST FAMOUS STAR CLUSTER ON THE SKY AND CAN BE SEEN WITHOUT BINOCULARS FROM EVEN THE depths of a light-polluted city. Also known as the Seven Sisters and M45, the Pleiades is one of the brightest and closest open clusters. The Pleiades contains over 3,000 stars, is about 400 light-years away, and only 13 light-years across. Quite evident in this photograph are the blue reflection nebulas that surround the bright cluster stars. Low mass, faint, brown dwarf stars have recently been found in the Pleiades. CREDIT & COPYRIGHT: DAVID MALIN (AAO), ROE, UKS TELESCOPE

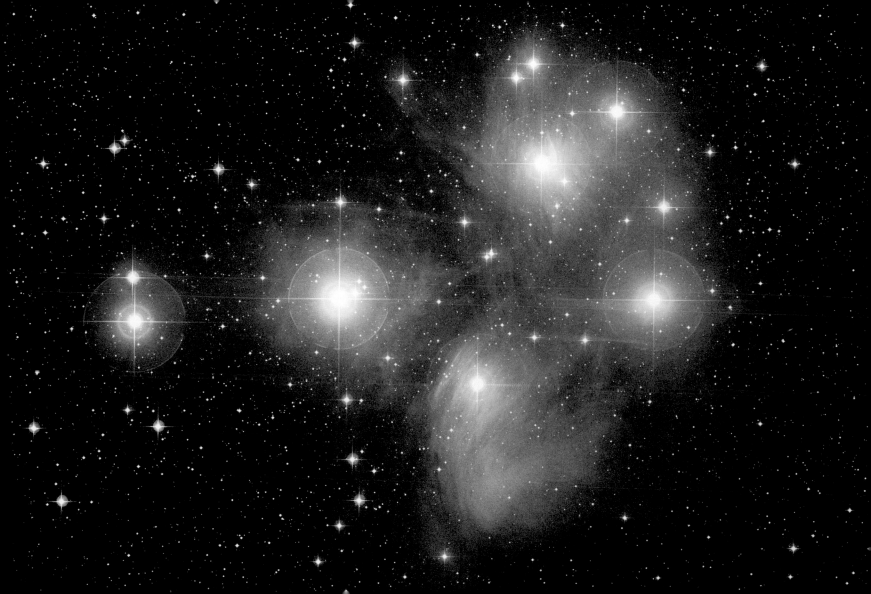

+ **ESO 184-G82: Supernova–Gamma-Ray Burst Connection**

MODERN ASTRONOMERS KEEP A LONG LIST OF THINGS THAT GO BUMP IN THE NIGHT. NEAR THE TOP ARE SUPERNOVAS—THE death explosions of massive stars—and gamma-ray bursts—the most powerful explosions seen across the universe. Intriguingly, the galaxy in this Hubble Space Telescope image may have been host to both a supernova and a gamma-ray burst that were one and the same event. ESO 184-G82 is a spiral galaxy with a prominent central bar and loose spiral arms dotted with bright star-forming regions. The inset shows an expanded view of one of the star-forming regions, about 300 light-years across. Indicated is the location of an extraordinarily powerful supernova explosion whose light first reached planet Earth on April 25, 1998. That location and date also correspond to the detection of an unusual gamma-ray burst, which may be representative of a peculiar class of these cosmic high-energy flashes. So far, this combination is unique and makes barred spiral ESO 184-G82, at a distance of only 100 million light-years, the closest known gamma-ray burst host galaxy. CREDIT: S. HOLLAND, J. HJORTH, J. FYNBO (SURVEY OF HOST GALAXIES OF GRBS TEAM), ESA, NASA

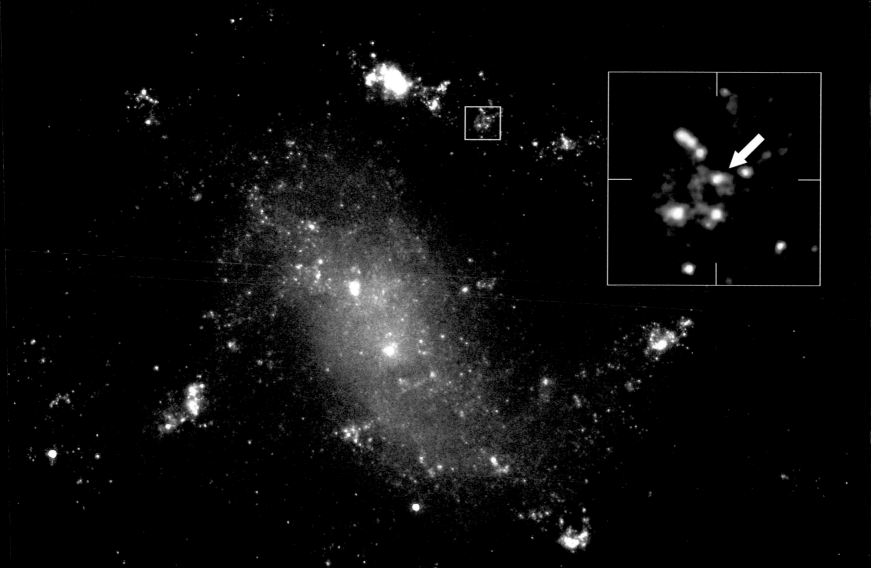

+ **Galaxy Dwingeloo 1 Emerges**

SOMETIMES YOU CAN'T SEE THE FOREST FOR THE TREES. BUT IF YOU LOOK CLOSELY AT THE CENTER OF THIS PHOTOGRAPH, you will see a whole spiral galaxy behind the field of stars. Named Dwingeloo 1, this nearby galaxy was only discovered in 1994—before that time, much of its light was obscured by dust, gas, and the bright stars of our own Milky Way galaxy. In fact, all the individually discernible stars in this photograph are in our galaxy. Dwingeloo 1 turned out to be a large galaxy located only 5 times as distant as the closest major galaxy—M31. CREDIT: S. HUGHES & S. MADDOX (IOA, CAMBRIDGE) ET AL., ISAAC NEWTON TELESCOPE

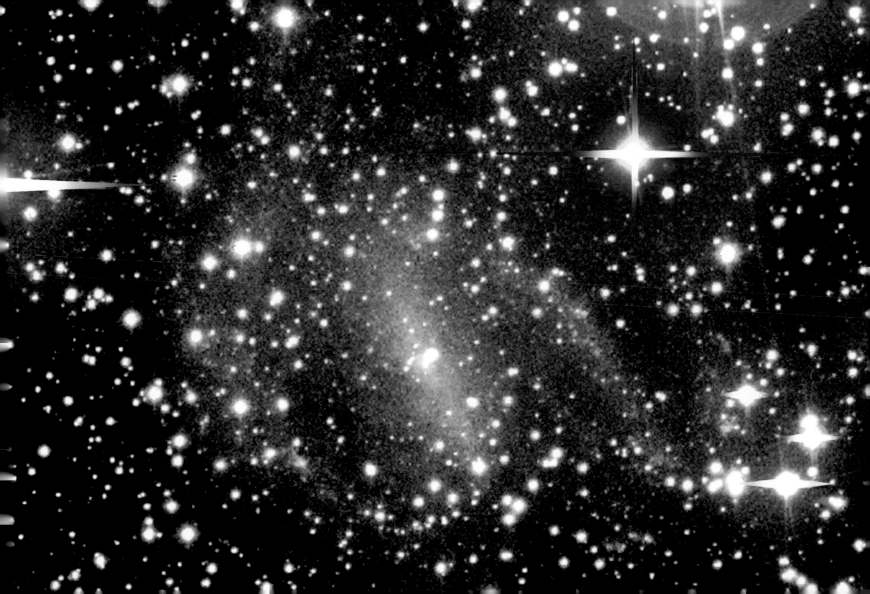

+ Rumors of a Strange Universe

THREE YEARS AGO, RESULTS WERE FIRST PRESENTED INDICATING THAT MOST OF THE ENERGY IN OUR UNIVERSE IS NOT IN STARS or galaxies but tied to space itself. In the language of cosmologists, a large cosmological constant is directly implied by observations of new distant supernovas. Suggestions of a cosmological constant (lambda) are not new—they have existed since the advent of modern relativistic cosmology. Such claims are not usually popular with astronomers, though, because lambda is so unlike known universe components: lambda's value appears constrained by other observations, and less-strange cosmologies without lambda have previously done well in explaining past data. What is noteworthy here are the seemingly direct and reliable method of the observations and the good reputation of the scientists conducting the investigations. Over the past 3 years, two independent teams of astronomers have continued to accumulate new data that appears to confirm the unsettling result that lambda really exists. This picture of a supernova that occurred in 1994 on the outskirts of a spiral galaxy was taken by one of these collaborations. Still, extraordinary claims require extraordinary evidence, and so cosmologists around the world continue to await more data and confirmation by independent methods. CREDIT: HIGH-Z SUPERNOVA SEARCH TEAM, HST, NASA

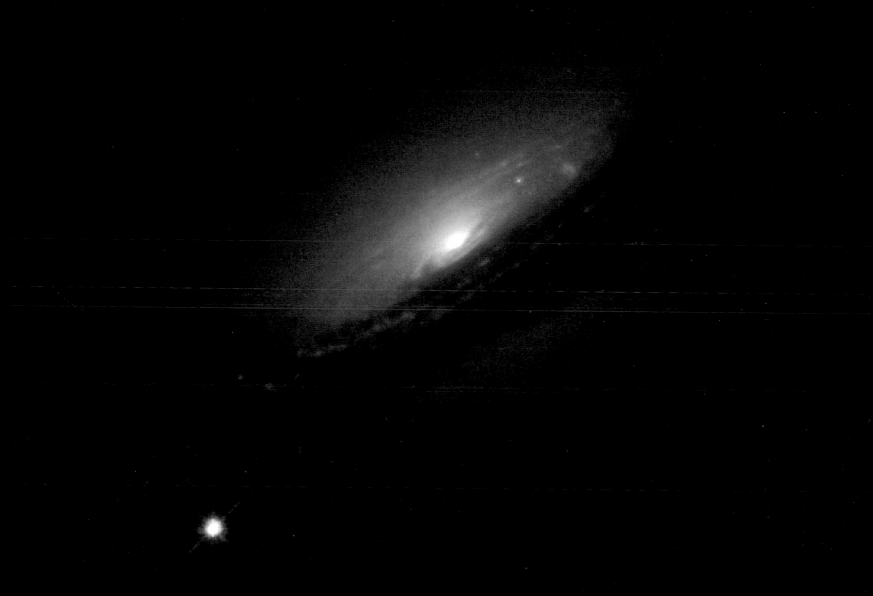

+ **The Regolith of Asteroid Eros**

FROM 50 KM ABOVE ASTEROID EROS, THE SURFACE INSIDE ONE OF ITS LARGEST CRATERS APPEARS COVERED WITH AN UNUSUAL substance: regolith. The thickness and composition of the surface dust comprised of regolith remains a topic of much research.

Much of the regolith on 433 Eros was probably created by numerous small impacts during its long history. In this representative-color view taken by the robot spacecraft NEAR-Shoemaker that orbited Eros in 2000 and 2001, brown areas indicate regolith that has been chemically altered by exposure to the Solar Wind during micrometeorite impacts. White areas are thought to have undergone relatively less exposure. The boulders visible inside the crater appear brown, indicating either that they are old enough to have a surface itself tanned by the Solar Wind, or that they have somehow become covered with some dark surface regolith.

CREDIT: NEAR PROJECT, JHU APL, NASA

+ Ganymede Mosaic

GANYMEDE, ONE OF THE FOUR GALILEAN MOONS OF JUPITER, IS THE LARGEST MOON IN THE SOLAR SYSTEM. WITH A DIAMETER of 5,260 km, it is even larger than planets Mercury and Pluto, and just over three-fourths the size of Mars. Ganymede is locked in synchronous rotation with Jupiter. This detailed mosaic of images from the Galileo spacecraft shows the trailing hemisphere of this planet-size moon. Speckled with bright, young craters, Ganymede's surface shows a mixture of old, dark, cratered terrain and lighter regions laced with grooves and ridges. Ganymede's true colors tend toward subtle browns and grays, but this mosaic's colors have been enhanced to increase surface contrasts. The violet hues extending from the top and bottom are likely due to frost particles in Ganymede's polar regions. CREDIT: GALILEO PROJECT, DLR, JPL, NASA

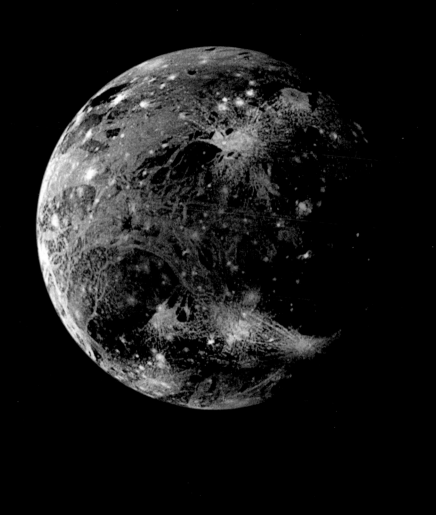

01
02
03
04

$+$ The Pipe Nebula

$+$ 05
06
07
08
09
10
11
12
13
14
15
16
17
18
19
20
21
22
23
24
25
26
27
28
29
30
31

THE DARK NEBULA PREDOMINANT AT THE LOWER LEFT OF THIS PHOTOGRAPH IS KNOWN AS THE PIPE NEBULA. THE DARK clouds, suggestively shaped like smoke rising from a pipe, are caused by absorption of background starlight by dust. These dust clouds can be traced all the way to the Rho Ophiuchi nebular clouds on the right. The brightest star in the field is Antares. Many types of nebulas are highlighted here: the red are emission nebulas, the blue are reflection nebulas, and the dark are absorption nebulas. This picture has been enhanced digitally. CREDIT & COPYRIGHT: JERRY LODRIGUSS

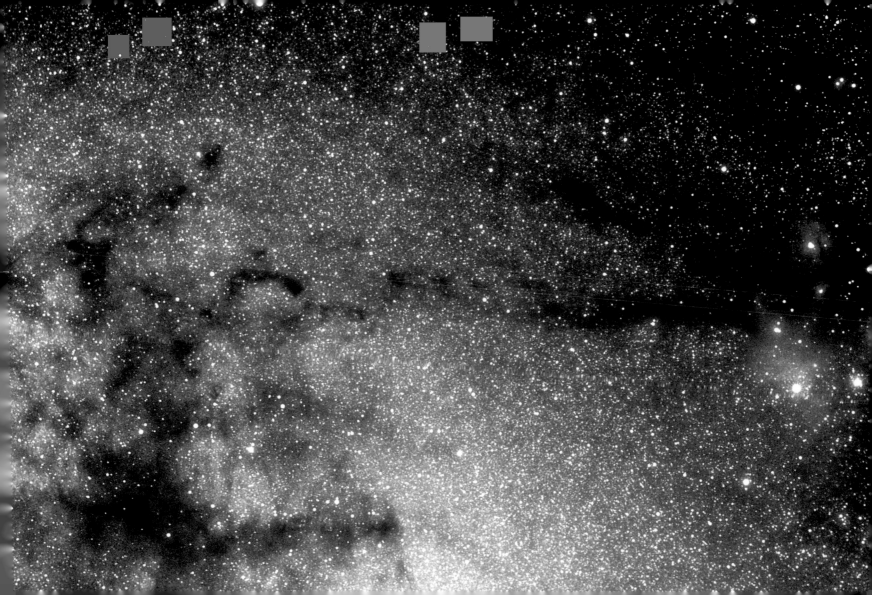

+ **Hubble Floats Free**

WHY PUT OBSERVATORIES IN SPACE? MOST TELESCOPES ARE ON THE GROUND WHERE HEAVIER AND MORE EASILY UPGRADABLE instruments can be deployed. The trouble is that Earthbound telescopes must look through Earth's atmosphere, which creates a number of obstacles to overcome. First, Earth's atmosphere blocks out a broad range of the electromagnetic spectrum, allowing only a narrow band of visible light to reach the surface. Telescopes that explore the universe using light beyond the visible spectrum, such as those onboard the Compton Observatory (gamma rays), the ASCA satellite (X rays), or the new ultraviolet and infrared instruments on the pictured Hubble Space Telescope, need to be carried above the absorbing atmosphere. Second, Earth's atmosphere blurs the light it lets through. The blurring is caused by the varying density and continual motion of air, so by orbiting above Earth's atmosphere, the Hubble can get clearer images. In fact, even though HST has a mirror 15 times smaller than large Earthbound telescopes, it can still resolve detail almost 100 times finer. CREDIT: STS-82 CREW, HST, NASA

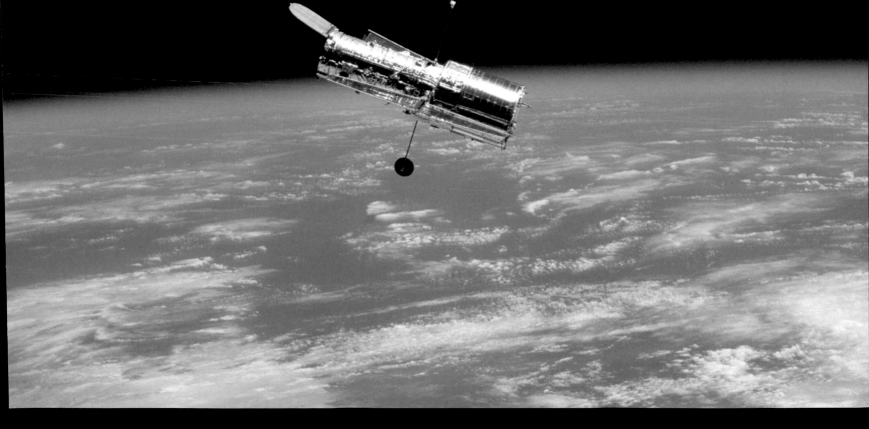

+ **Apollo 12 Visits Surveyor 3**

+

APOLLO 12 WAS THE SECOND MISSION TO LAND HUMANS ON THE MOON. THE LANDING SITE WAS PICKED TO BE NEAR THE location of Surveyor 3, a robot spacecraft that had landed on the Moon 3 years earlier. In this photograph, taken by lunar module pilot Alan Bean, mission commander Pete Conrad retrieves parts from Surveyor. The lunar module is visible in the distance. Apollo 12 brought back many photographs and moon rocks. Among the milestones achieved by Apollo 12 was the deployment of the Apollo Lunar Surface Experiments Package, which carried out many experiments, including one that measured the Solar Wind.

CREDIT: APOLLO 12 CREW, NASA

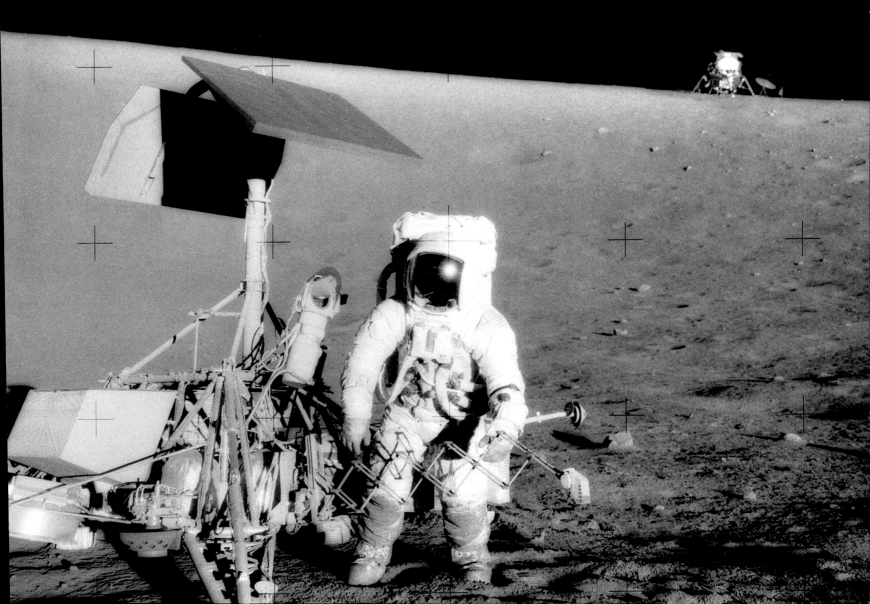

+ **Columbia Dawn**

TRAILING A THICK COLUMN OF EXHAUST, THE SPACE SHUTTLE COLUMBIA BLASTED INTO THE TWILIGHT MORNING SKY ON March 1, 2002, its thundering rockets briefly flooding a cloudbank with the light of a false dawn. The event marked the start of an 11-day mission to upgrade the Hubble Space Telescope. Hubble's upgrades included the installation of new solar arrays and a new camera. Columbia's crew completed the work on March 8 in the last of five space walks. Columbia's launch also marks the first flight of the oldest operating space shuttle after receiving extensive upgrades designed to increase its capability for missions to low Earth orbit. The shuttle landed at Kennedy Space Center on March 12. CREDIT: A. BARRETT, KSC, NASA

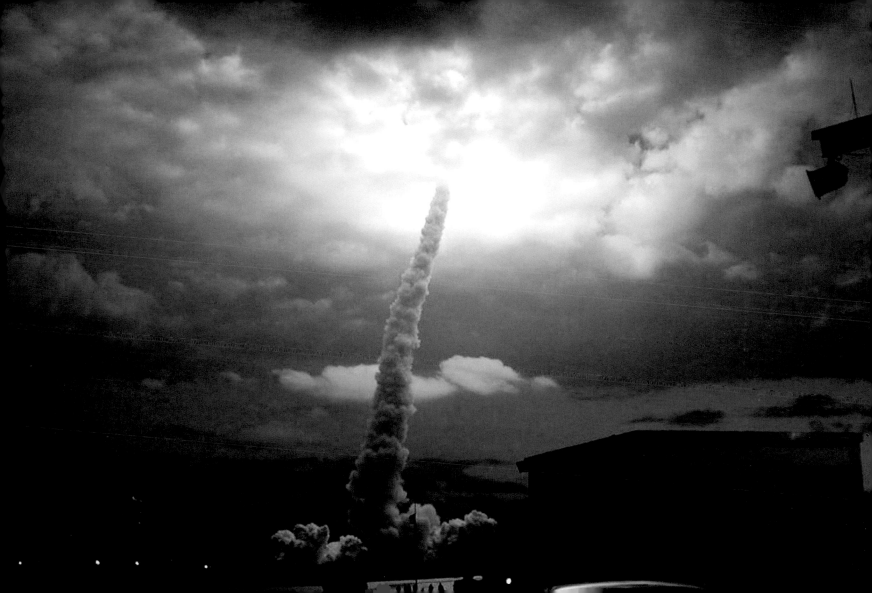

+ Sirius: The Brightest Star in the Night

SIRIUS IS THE BRIGHTEST STAR IN THE NIGHT SKY. SIRIUS IS VISIBLE ON THE FAR LEFT OF THIS PHOTOGRAPH, TO THE LEFT of the constellation Orion and comet Hale-Bopp. Intrinsically, Sirius is over 20 times brighter than our sun and over twice as massive. As Sirius is 8.7 light-years distant, it is not the closest star system—the Alpha Centauri system holds this distinction. Sirius is called the Dog Star because of its prominence in the constellation Canis Majoris (Big Dog). While studying Sirius in 1718, Edmond Halley discovered that stars move with respect to each other. In 1862, Sirius was discovered to be a binary star system with a companion star, Sirius B, 10,000 times dimmer than the bright primary, Sirius A. The first white dwarf star to be discovered, Sirius B is a type of star first hypothesized by Subrahmanyan Chandrasekhar in 1930. There is conflicting evidence that Sirius appeared redder only 2,000 years ago. CREDIT & COPYRIGHT: JUAN CARLOS CASADO

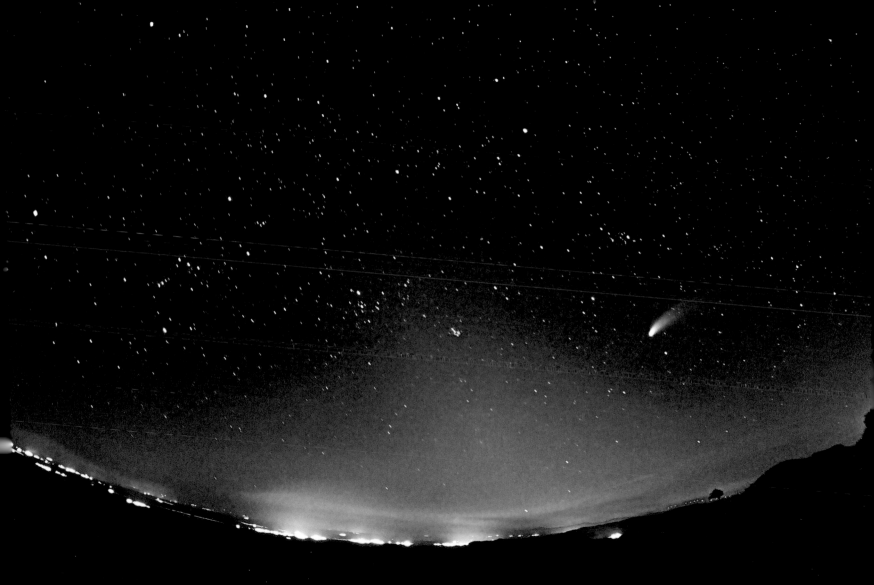

+ **A Southern Sky View**

ON MARCH 22, 1996, A GALAXY AND A COMET SHARED THE SOUTHERN SKY. THEY WERE CAPTURED TOGETHER, FROM HORIZON TO horizon, in the night sky above Loomberah, New South Wales, Australia, by astronomer Gordon Garradd. Garradd used a homemade all-sky camera with a fish-eye lens, resulting in a circular 200-degree field of view. The luminous band of our Milky Way galaxy, cut by dramatic, dark interstellar dust clouds, dominated this gorgeous sky view. Along with the bright stars of our galaxy, the Large Magellanic Cloud is visible at the lower left. That night sky was also graced by the long, lovely, bluish tail of comet Hyakutake, which can be seen toward the top of the image, near the bright star Arcturus. Bright city lights from nearby Tamworth glow along the northwestern horizon. CREDIT & COPYRIGHT: GORDON GARRADD

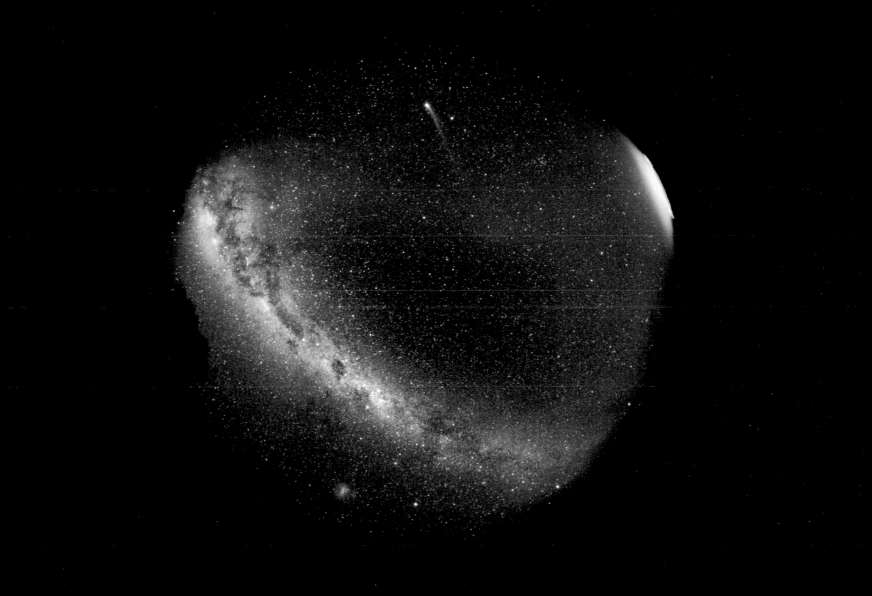

+ **Plains and Ridges on Europa**

COLD-WATER VOLCANOES MAY BE THE CAUSE OF THE RIDGES ON EUROPA. ONE OF THE LARGEST MOONS OF JUPITER, EUROPA has been the source of intense scrutiny to discover if oceans lie beneath its icy surface. In 1998, the Galileo spacecraft orbited Jupiter on an extended mission designed, in part, to study Europa's surface in greater detail. This image highlights features common to the moon's surface: pure blue water ice beneath lighter ridges that run for many kilometers. These ridges may result from volcanic cracks in the ice where emerging liquid water froze upon exposure to the cold of deep space. The reasons for the colors of the ridges remain uncertain. CREDIT: GALILEO PROJECT, JPL, NASA

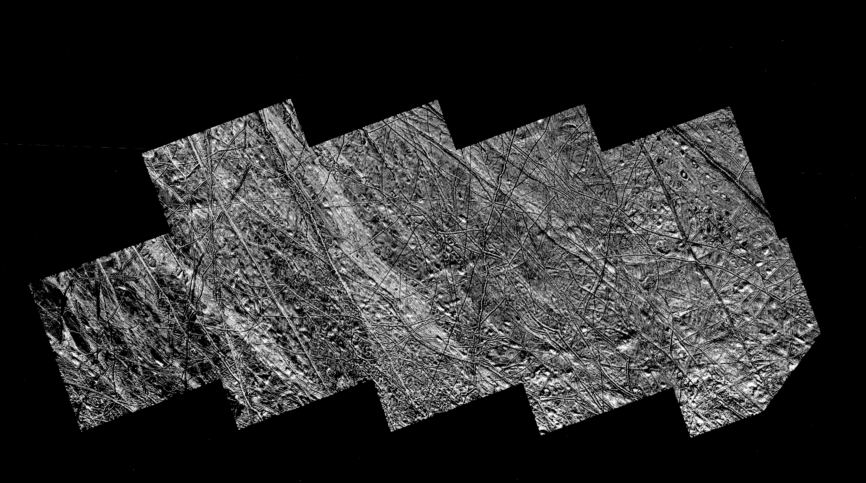

+ **Cracks and Ridges on Europa**

WHICH WAY TO THE INTERSTATE? WHAT APPEARS TO BE A CARICATURE OF A COMPLEX HIGHWAY SYSTEM ON EARTH IS ACTUALLY a system of ridges and cracks on the icy surface of Jupiter's moon Europa. The distance between parallel ridges in this photograph is typically approximately 1 km. The complexity of the cracks and ridges tells a story of Europa's past that is mostly undecipherable—planetary geologists struggle to understand just the general origin of the features. One noteworthy characteristic is the overall white sheen, possibly indicating the presence of frost. Another is the dark center between parallel ridges, which might indicate that dirty water from an underground ocean recently welled up in the cracks and froze. CREDIT: GALILEO PROJECT, JPL, NASA

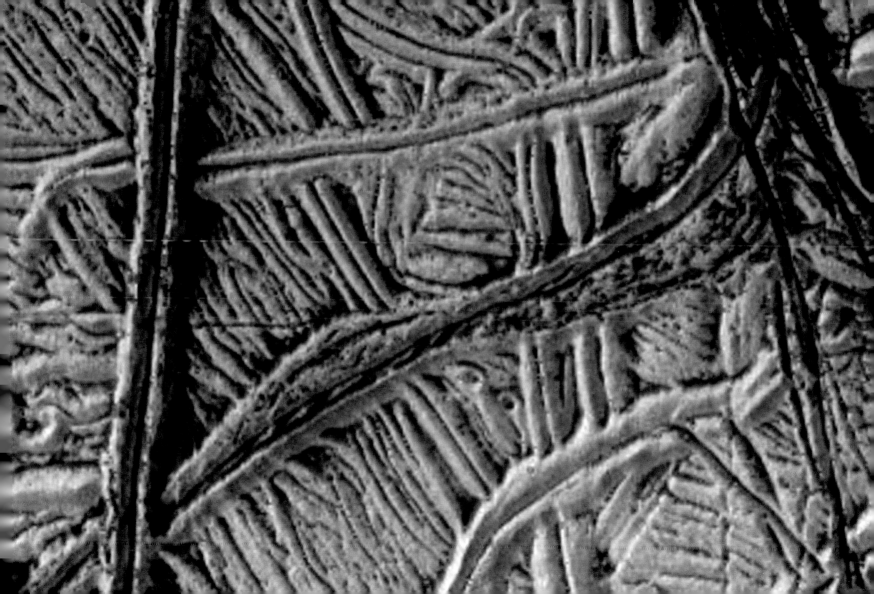

+ **M27: The Dumbbell Nebula**

THE FIRST HINT OF WHAT WILL BECOME OF OUR SUN WAS DISCOVERED INADVERTENTLY IN 1764. AT THAT TIME, CHARLES Messier was compiling a list of "annoying" diffuse objects not to be confused with "interesting" comets. The 27th object on Messier's list, now known as M27 or the Dumbbell Nebula, is a planetary nebula, the type of nebula our sun will produce when nuclear fusion stops in its core. M27 is one of the brightest planetary nebulas in the sky, and can be seen with binoculars in the constellation Vulpecula. It takes light approximately 1,000 years to reach us from M27, shown here in representative colors. Understanding the physics and significance of M27 was well beyond eighteenth-century science. Even today, many things remain mysterious about bipolar planetary nebulas like M27, including the physical mechanism that expels a low-mass star's gaseous outer envelope, leaving an X-ray hot, white dwarf. CREDIT & COPYRIGHT: MICHAEL PIERCE (INDIANA U.) ET AL., WIYN, NOAO/AURA/NSF

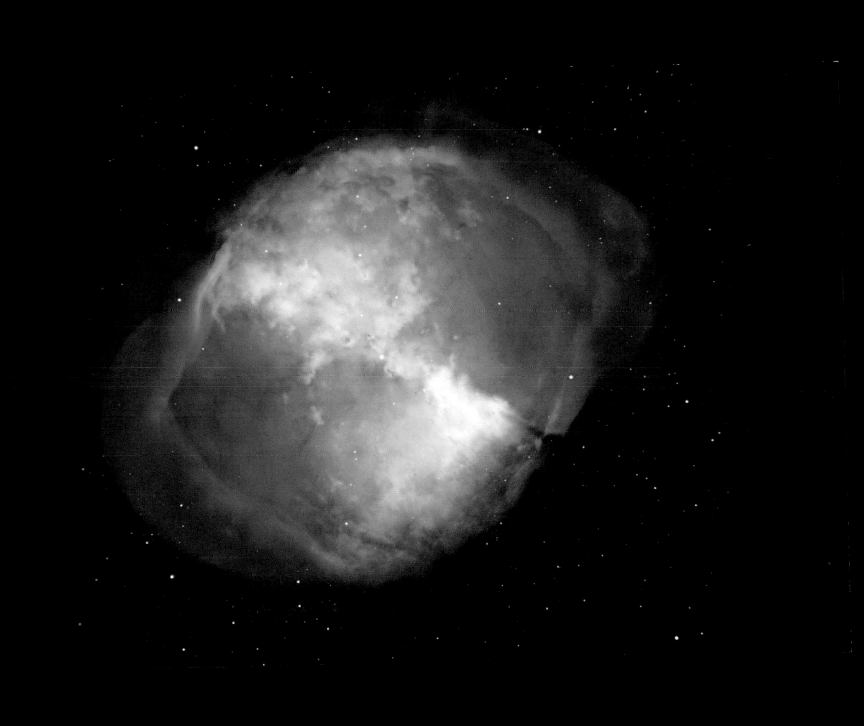

+ **A GRB 000301C Symphony**

A NEARLY UNPRECEDENTED SYMPHONY OF INTERNATIONAL OBSERVATIONS BEGAN ABRUPTLY ON MARCH 1, 2000, WHEN EARTH-orbiting RXTE, Sun-orbiting Ulysses, and asteroid-orbiting NEAR all detected a 10-second burst of high-frequency gamma radiation. Within 48 hours, astronomers using the 2.5-meter Nordic Optical Telescope chimed in with the observation of a middle-frequency optical counterpart that was soon confirmed with the 3.5-meter Calar Alto Telescope in Spain. By the next day, the explosion was picked up in low-frequency radio waves by the European IRAM 30-meter dish in Spain, then by the VLA Telescopes in the United States. The Japanese 8-meter Subaru Telescope interrupted a maiden engineering test to trumpet in infrared observations. The Hubble Space Telescope captured this image of a spot of light (left) that wasn't there previously and has since faded from view. The spot is coincident in time and location with a gamma-ray burst GRB 000301c. The HST was the first to obtain an accurate distance to the explosion, placing it near redshift 2, most of the way across the visible universe. The Keck II Telescope in Hawaii quickly confirmed and refined the redshift. Even today, no one is sure what type of explosion this was. Unusual features of the light curve are still being studied. CREDIT: ANDREW FRUCHTER (STSCI) ET AL., STIS, HST, NASA

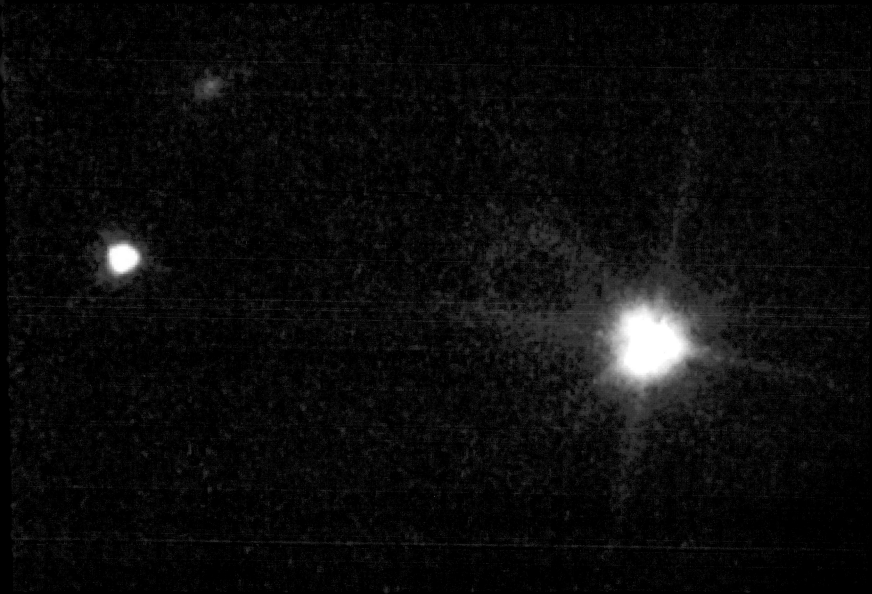

+ **Happy-Face Crater on Mars**

EVEN MARS CAN PUT ON A HAPPY FACE. THE MARTIAN CRATER GALLE HAS INTERNAL MARKINGS REMINISCENT OF A SMILEY face symbol. Such markings were originally discovered in the late 1970s in pictures taken by the Viking Orbiter. A large meteor impacted the martian surface to form the crater. Conventional wisdom holds that the markings inside the crater are placed by chance by natural processes. The Mars Global Surveyor (MGS) spacecraft orbiting Mars took this picture in March 1999. Soon after, MGS began the global surveying phase of its mission. CREDIT: MALIN SPACE SCIENCE SYSTEMS, MGS, NASA

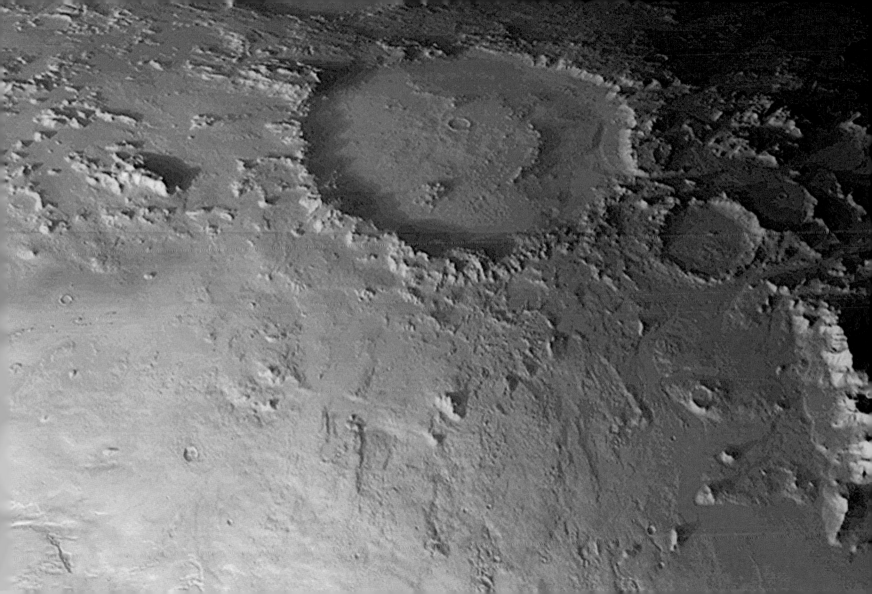

+ **Asteroids in the Distance**

ROCKS FROM SPACE HIT EARTH EVERY DAY. THE LARGER THE ROCK, THOUGH, THE LESS OFTEN EARTH IS STRUCK. MANY KILO-grams of space dust pitter to Earth daily. Larger bits appear initially as bright meteors. Baseball-sized rocks and ice balls streak through our atmosphere, most evaporating quickly to nothing. Significant threats do exist for rocks near 100 meters in diameter, which strike Earth roughly every 1,000 years. An object this size could cause significant tidal waves were it to strike an ocean, potentially devastating even distant shores. A collision with a massive asteroid, over 1 km across, is more rare, occurring typically millions of years apart, but could have truly global consequences. Many asteroids remain undetected. The discovery of several, however, was announced in March 1998; one is shown as the long blue streak in this photograph. Were the Earth to collide with such an asteroid, it would not affect its orbit so much as raise dust that would affect its climate. One likely result would be the global extinction of many species of life, possibly dwarfing the ongoing extinction occurring now. CREDIT: R. EVANS & K. STAPELFELDT (JPL), WFPC2, HST, NASA

+ LL Orionis: When Cosmic Winds Collide

THIS ARCING, GRACEFUL STRUCTURE IS ACTUALLY A BOW SHOCK APPROXIMATELY ONE HALF A LIGHT-YEAR ACROSS, CREATED AS the wind from young star LL Orionis collides with the Orion Nebula flow. Adrift in Orion's stellar nursery and still in its formative years, variable star LL Orionis produces a wind more energetic than the wind from our own middle-aged sun. As the fast stellar wind runs into slow moving gas a shock front is formed, analogous to the bow wave of a boat moving through water or a plane traveling at supersonic speed. The slower gas is flowing away from the Orion Nebula's hot central star cluster, the Trapezium, located off the lower right edge of this picture. The complex stellar nursery in Orion shows a myriad of similar fluid shapes associated with star formation, including the bow shock surrounding a faint star at the upper right. The Hubble Space Telescope recorded this composite color image in 1995. CREDIT: HUBBLE HERITAGE TEAM (AURA / STSCI), C. R. O'DELL (VANDERBILT), NASA

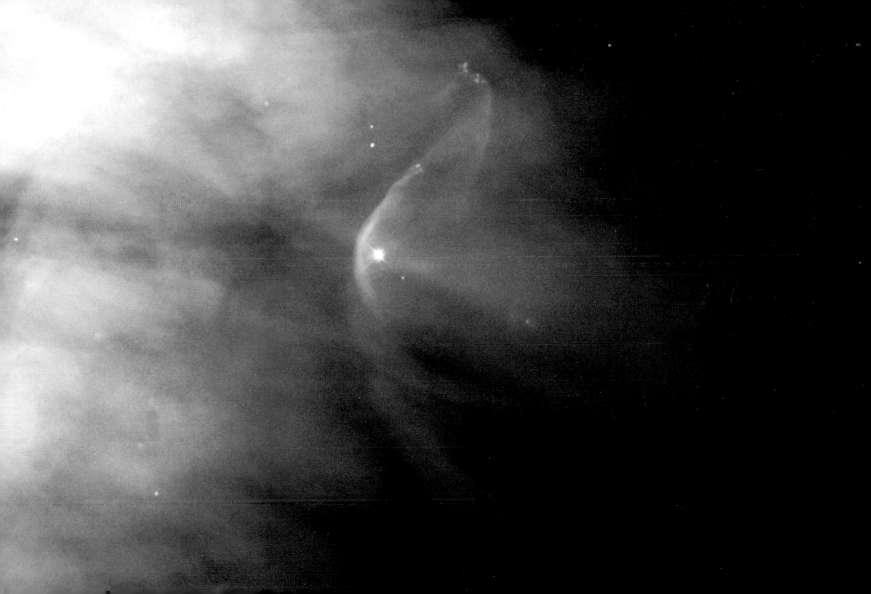

\+ **Interstellar Dust Bunnies of NGC 891**

WHAT IS GOING ON IN NGC 891? THIS GALAXY APPEARED PREVIOUSLY TO BE VERY SIMILAR TO OUR OWN MILKY WAY GALAXY: a spiral galaxy seen nearly edge-on. However, recent high-resolution images of NGC 891's dust show unusual filamentary patterns extending well away from its galactic disk. Because dust is so fragile, its appearance after surviving disk expulsion can be very telling. This surviving interstellar dust was probably thrown out of the galactic disk toward the halo by stellar supernovas' explosions. Newly discovered phenomena, however, sometimes appear so complex that more questions are raised than are answered.

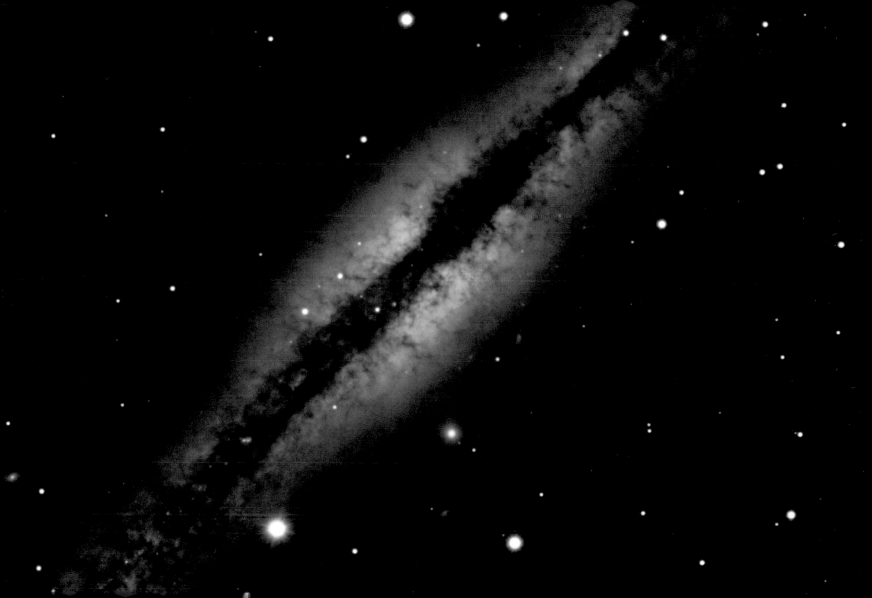

\+ **Breaking Distant Light**

IN THE DISTANT UNIVERSE, TIME APPEARS TO RUN SLOWLY. SINCE TIME-DILATED LIGHT APPEARS SHIFTED TOWARD THE RED end of the spectrum (redshifted), astronomers are able to use cosmological time slowing to help measure vast distances in the universe. Here, the light from distant galaxies has been broken up into its constituent colors (spectra), allowing astronomers to measure the redshift of known spectral lines. The novelty of this image is that the distance to hundreds of galaxies can now be measured on a single frame using the Visible MultiObject Spectrograph that has begun operating at the Very Large Telescope array in Chile. Analyzing the space distribution of distant objects will allow insight into when and how stars, galaxies, and quasars formed, clustered, and evolved in the early universe. CREDIT: VIMOS, VLT, ESO

+ **Antares and Rho Ophiuchi**

WHY IS THE SKY NEAR ANTARES AND RHO OPHIUCHI SO COLORFUL? THE COLORS RESULT FROM A MIXTURE OF OBJECTS AND processes. Fine dust illuminated by starlight produces blue reflection nebulas. Gaseous clouds whose atoms are excited by ultra-violet starlight produce reddish emission nebulas. Backlit dust clouds block starlight and so appear dark. Antares, a red super-giant and one of the brighter stars in the night sky, lights up the yellow-red clouds on the upper left. Rho Ophiuchi lies at the center of the blue nebula on the right. The distant globular cluster M4 is visible just below Antares and to the left of the red cloud engulfing Sigma Scorpii. These star clouds are even more colorful than humans can see, emitting light across the electro-magnetic spectrum. CREDIT & COPYRIGHT: D. MALIN (AAO), AATB, ROE, UKS TELESCOPE

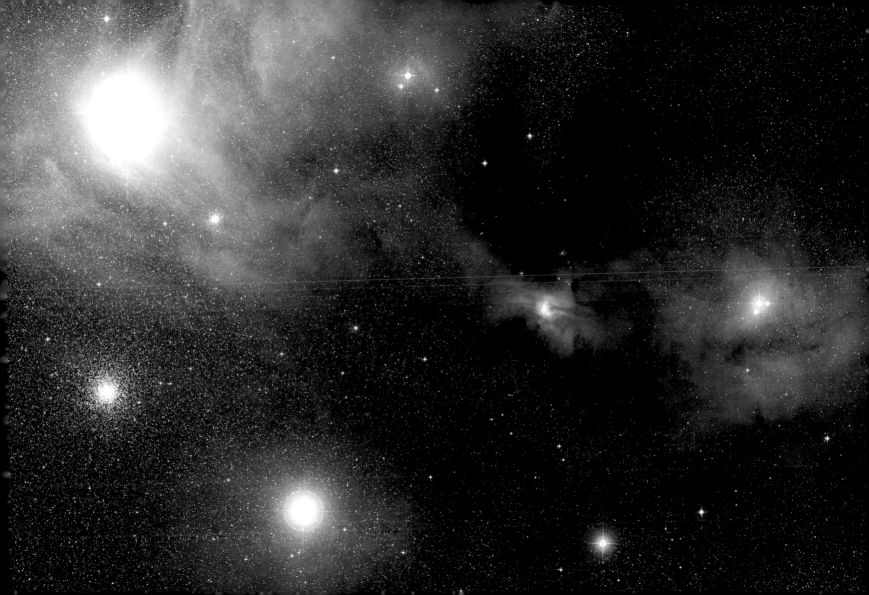

+ **Equinox + 1**

TWICE A YEAR, AT THE SPRING AND FALL EQUINOX, THE SUN RISES DUE EAST. IN AN EMPHATIC DEMONSTRATION OF THIS celestial alignment, photographer Joe Orman recorded this inspiring image of the Sun rising exactly along the east/west oriented Western Canal, in Tempe, Arizona. But he waited until March 21, 2000, one day after the equinox, to photograph the striking view. Why was the rising Sun due east one day after the equinox? At Tempe's latitude the Sun rises at an angle, arcing southward as it climbs above the horizon. Because the distant mountains hide the true horizon, the Sun shifts slightly southward by the time it clears the mountaintops. Waiting 24 hours allowed the Sun to rise just north of east and arc back to an exactly eastern alignment for the photograph. Orman also notes that this picture carries a special significance near the maximum of the solar activity cycle. The electricity and telephone transmission lines along the canal symbolize power and communications grids that are most vulnerable to outbursts from the active Sun. CREDIT & COPYRIGHT: JOE ORMAN

+ **A Spherule from Outer Space**

WHEN A METEORITE STRIKES THE MOON, NOT ONLY IS A CRATER FORMED, BUT THE ENERGY OF THE IMPACT ALSO MELTS SOME OF the splattering rock, a fraction of which sometimes cools into tiny glass beads. Many of these glass beads were present in lunar soil samples returned to Earth by the Apollo missions. Pictured here is one such glass spherule that measures only one-quarter of a millimeter across. This spherule is particularly interesting because it has been victim to a much smaller impact. A miniature crater is visible on the upper left, surrounded by a fragmented area caused by the shockwaves of the small impact. By dating many of these impacts, some astronomers estimate that cratering on our moon was much greater roughly 500 million years ago but continues even today. CREDIT: TIMOTHY CULLER (UCB) ET AL., APOLLO 11 CREW, NASA

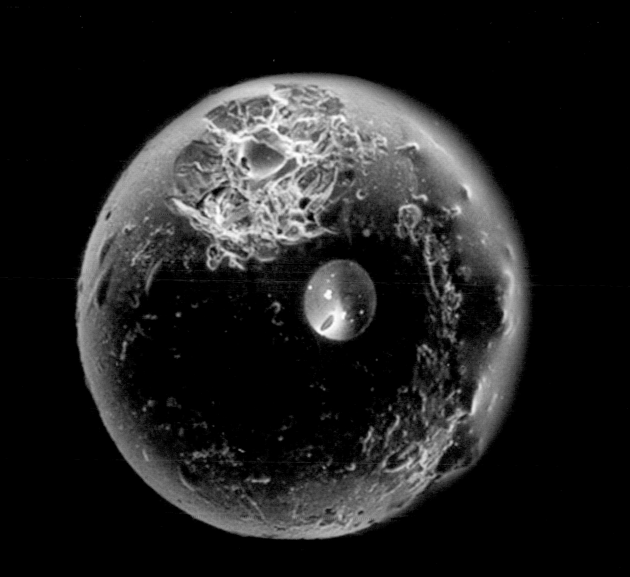

+ **A Chamaeleon Sky**

A PHOTOGENIC GROUP OF NEBULAS CAN BE FOUND TOWARD CHAMAELEON, A CONSTELLATION VISIBLE PREDOMINANTLY IN skies south of Earth's equator. Celestial objects visible there include the blue reflection nebulas highlighted by thin dust surrounding the bright stars in the center of this image. Toward the top and lower right, dark molecular clouds laced with thick dust block light from stars in the background. The parent molecular cloud Chamaeleon I is located about 450 light-years from Earth.

CREDIT: FORS TEAM, 8.2-METER VLT ANTU, ESO

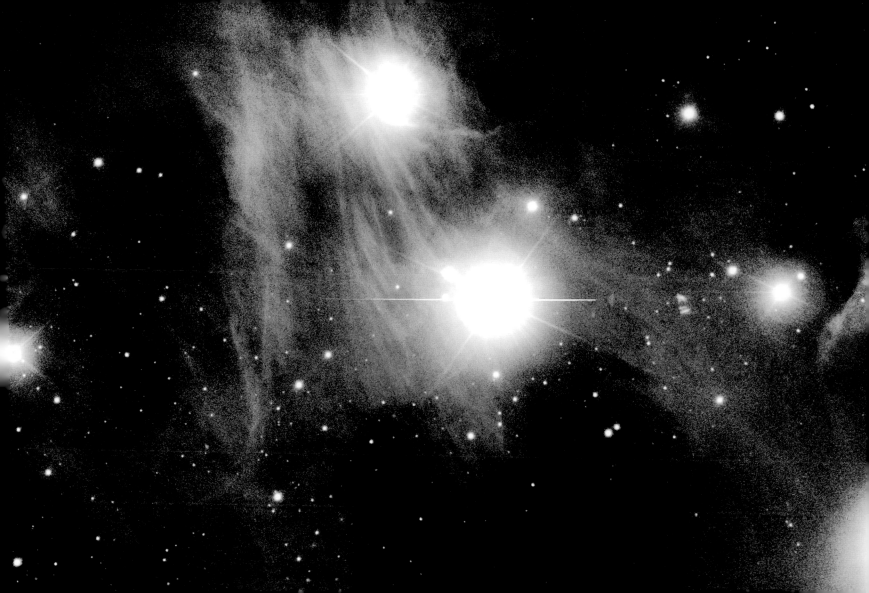

+ **The Cat's Eye Nebula**

THREE THOUSAND LIGHT-YEARS AWAY, A DYING STAR THROWS OFF SHELLS OF GLOWING GAS. THIS IMAGE FROM THE HUBBLE Space Telescope reveals the Cat's-Eye Nebula to be one of the most complex planetary nebulas known. In fact, the features seen in the Cat's-Eye are so complex that astronomers suspect the bright central object may actually be a binary star system. The term *planetary nebula*, used to describe this general class of objects, is misleading. Although these objects may appear round and planet-like in small telescopes, high-resolution images reveal them to be stars surrounded by cocoons of gas blown off in the late stages of stellar evolution. CREDIT: J.P. HARRINGTON AND K.J. BORKOWSKI (U. MARYLAND), HST, NASA

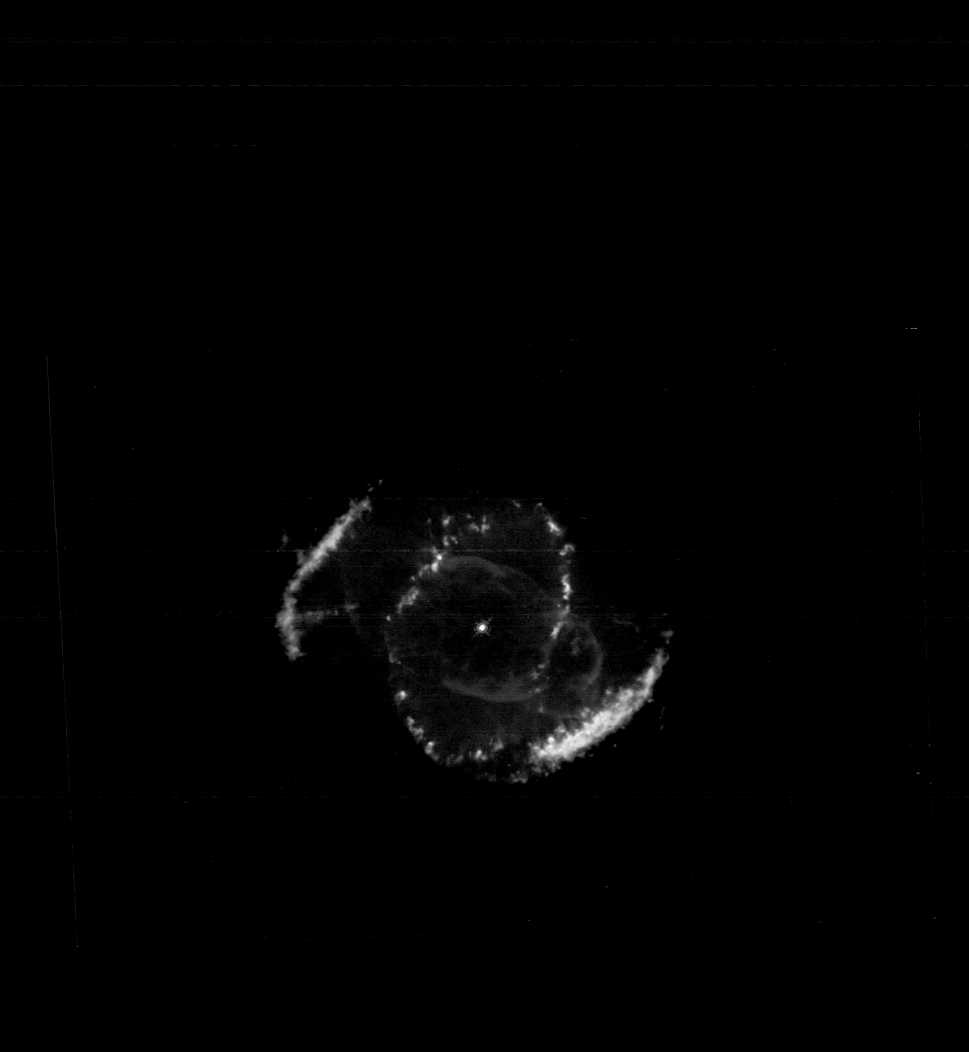

+ **The Crab Nebula from VLT**

THE CRAB NEBULA, FILLED WITH MYSTERIOUS FILAMENTS, IS THE RESULT OF A STAR THAT WAS SEEN TO EXPLODE IN A.D. 1054.

This spectacular supernova explosion was recorded by Chinese and, quite probably, Anasazi astronomers. The filaments are mysterious because they appear to have less mass than was expelled in the original supernova and higher speed than expected from a free explosion. In this picture, taken in 2001 from a Very Large Telescope, the color indicates what is happening to the electrons in different parts of the Crab Nebula. Red indicates the electrons are recombining with protons to form neutral hydrogen, while blue indicates the electrons are whirling around the magnetic field of the inner nebula. In the nebula's very center lies a pulsar: a neutron star rotating, in this case, 30 times per second. CREDIT: FORS TEAM, 8.2-METER VLT, ESO

+

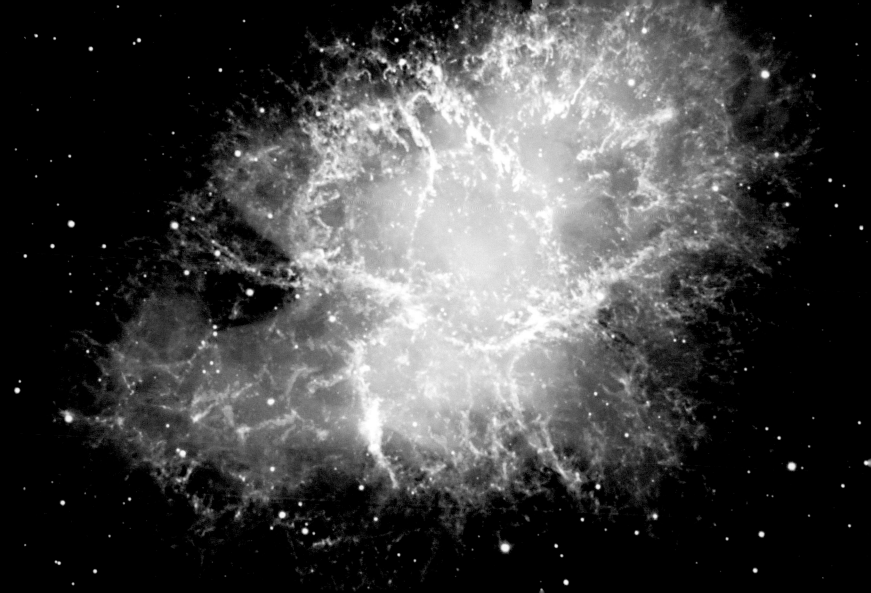

+ **The Pulsar-Powered Crab**

IN THE SUMMER OF A.D. 1054, CHINESE ASTRONOMERS REPORTED THAT A STAR IN THE CONSTELLATION TAURUS SUDDENLY became as bright as the full Moon. Fading slowly, it remained visible for over a year. It is now understood that a spectacular supernova explosion—the detonation of a massive star whose remains are now visible as the Crab Nebula—was responsible for the apparition. The core of the star collapsed to form a rotating neutron star or pulsar, one of the most exotic objects known to modern astronomers. Like a cosmic lighthouse, the rotating Crab pulsar generates beams of radio, visible, X-ray, and gamma-ray energy that, as the name suggests, produce pulses as they sweep across our view. Using a stunning series of visible-light images taken with the Hubble Space Telescope in 1995, astronomers have discovered spectacular pulsar-powered motions within the Crab Nebula. Highlights of this HST Crab "movie" show wisps of material moving away from the pulsar at half the speed of light, a scintillating halo, and an intense knot of emission dancing, spritelike, above the pulsar's pole. Only 10 km wide but more massive than the sun, the pulsar's energy drives the dynamics and emission of the nebula itself, which is more than 10 light-years across. CREDIT J. HESTER AND P. SCOWEN (ASU), NASA

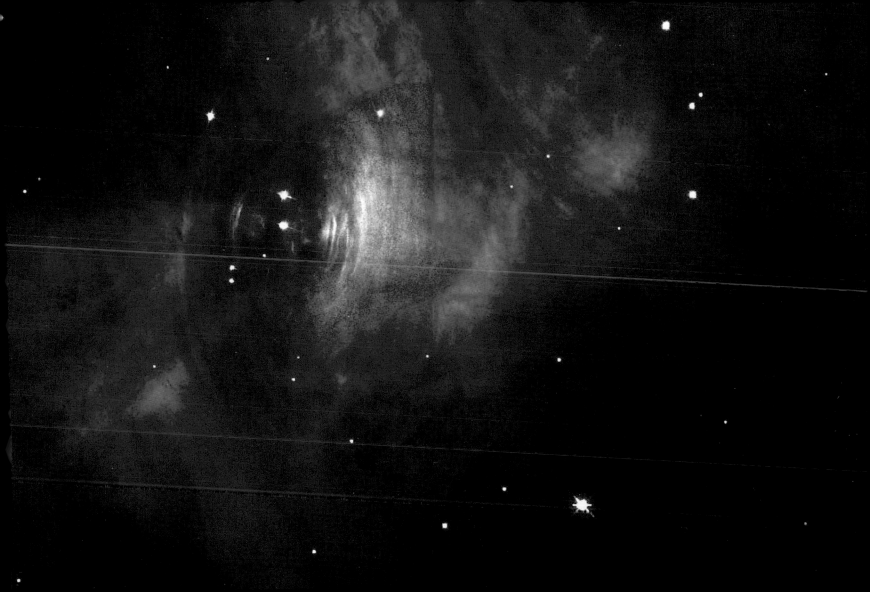

+ **A Radio Vista of Cygnus**

SHELLS OF ANCIENT SUPERNOVAS, COCOONS SURROUNDING NEWBORN STARS, AND SPECKS FROM DISTANT QUASARS HIGHLIGHT this tremendous vista toward the constellation Cygnus. The representative-color image covers about 10 degrees across on the sky, but is only a small part of the Canadian Galactic Plane Survey in radio light. Diffuse bands of ionized gas flow though a dominating region of star formation, located about 6,000 light-years away. Two prominent supernova shells visible in this photograph include the brown globule on the lower left and the white, bumpy sphere on the upper right. To the left of the brown globule is the entire North America Nebula. Prominent stellar cocoons are visible throughout the image as bright white knots. Some of these stars will likely generate future supernova shells. Far in the distance, visible here as only red dots, quasars glow. CREDIT & COPYRIGHT: JAYANNE ENGLISH (U. MANITOBA) ET AL., CGPS, CNRC

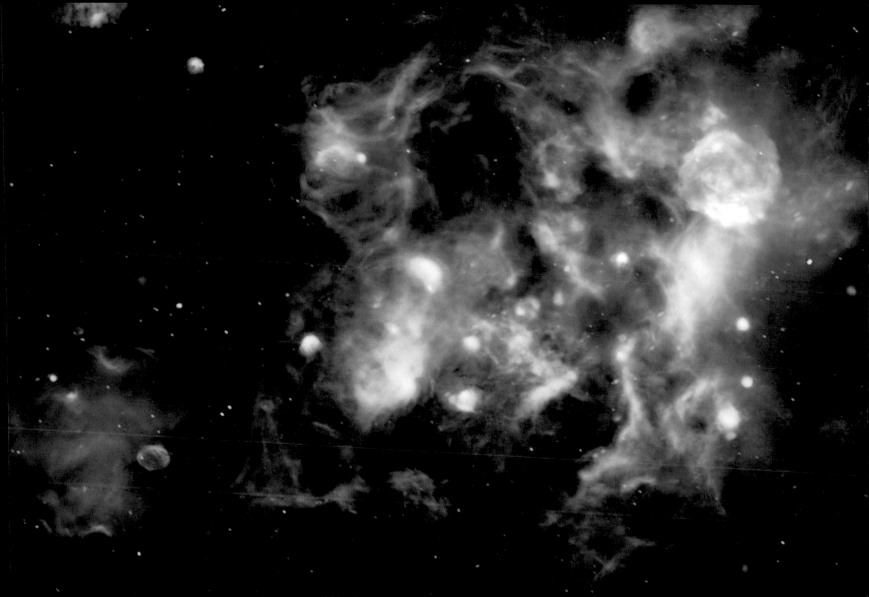

\+ **NGC 6369: The Little Ghost Nebula**

18TH-CENTURY ASTRONOMER WILLIAM HERSCHEL DISCOVERED THIS PRETTY PLANETARY NEBULA, CATALOGUED AS NGC 6369, as he used a telescope to explore the constellation Ophiucus. Round and planet-shaped, the nebula is relatively faint and has acquired the popular moniker of Little Ghost Nebula. Planetary nebulas in general are not at all related to planets, but instead are created at the end of a sun-like star's life as its outer layers expand into space while the star's core shrinks to become a white dwarf. The transformed white dwarf star, seen near the center, radiates strongly at ultraviolet wavelengths and powers the expanding nebula's glow. Surprisingly complex details and structures of NGC 6369 are revealed in this delightful color image composed from Hubble Space Telescope data. The nebula's main ring structure is approximately a light-year across and the glow from ionized oxygen, hydrogen, and nitrogen atoms is colored blue, green, and red respectively. Over 2,000 light-years away, the Little Ghost Nebula offers a glimpse of the fate of our sun, which should produce its own pretty planetary nebula approximately 5 billion years from now. CREDIT: HUBBLE HERITAGE TEAM, NASA

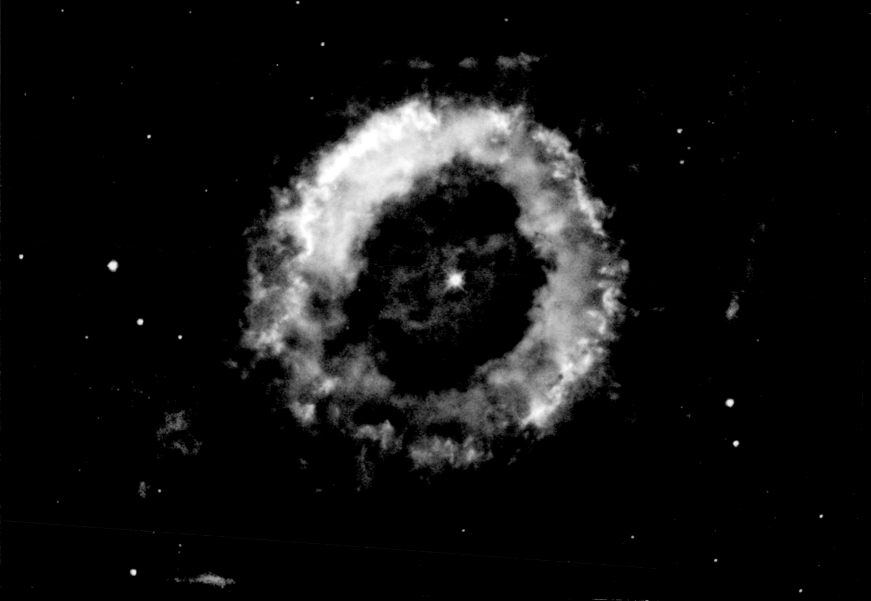

+ Fullerenes as Miniature Cosmic Time Capsules

SCIENTISTS HAVE FOUND, UNEXPECTEDLY, TINY TIME CAPSULES FROM BILLIONS OF YEARS IN THE PAST. THE DISCOVERY involves small molecules that can apparently become trapped during the formation of large, enclosed molecules known as fullerenes, or buckyballs. Luann Becker of the University of Hawaii and collaborators recently found fullerenes in an ancient meteorite that fell to Earth approximately 30 years ago. Extraterrestrial fullerenes inside the meteorite survived and, upon inspection, were not empty inside. The small molecules trapped inside give a glimpse of what the solar system was like during its formation. Pictured here is a computer simulation showing a relatively small fullerene (60 atoms of carbon) situated above a hydrogenated silicon surface. How these fullerenes formed, how they survived, where else they can be found, and what else might be found inside these tiny time capsules is developing into an exciting area of research. CREDIT & COPYRIGHT: KEITH BEARDMORE, PRINCIPAL STAFF PHYSICIST, PHYSICAL SCIENCES RESEARCH LABORATORIES, MOTOROLA INC.

+ **A Supernova Star Field**

BRIGHT STARS DON'T LAST FOREVER. A BRIGHT STAR SIMILAR TO OTHERS IN THIS FIELD EXPLODED IN A SPECTACULAR

supernova that was witnessed on Earth in 1987. The result is visible even today as unusual rings and glowing gas. This picture

is a composite of recent images taken over several years. The explosion originated from a bright massive star that ran out of

nuclear fuel. SN1987A occurred in the Large Magellanic Cloud, a satellite galaxy only 150,000 light-years from our Milky Way

galaxy. The rings of SN1987A are currently excited by light from the initial explosion. CREDIT: HUBBLE HERITAGE TEAM (AURA/ STSCI/ NASA)

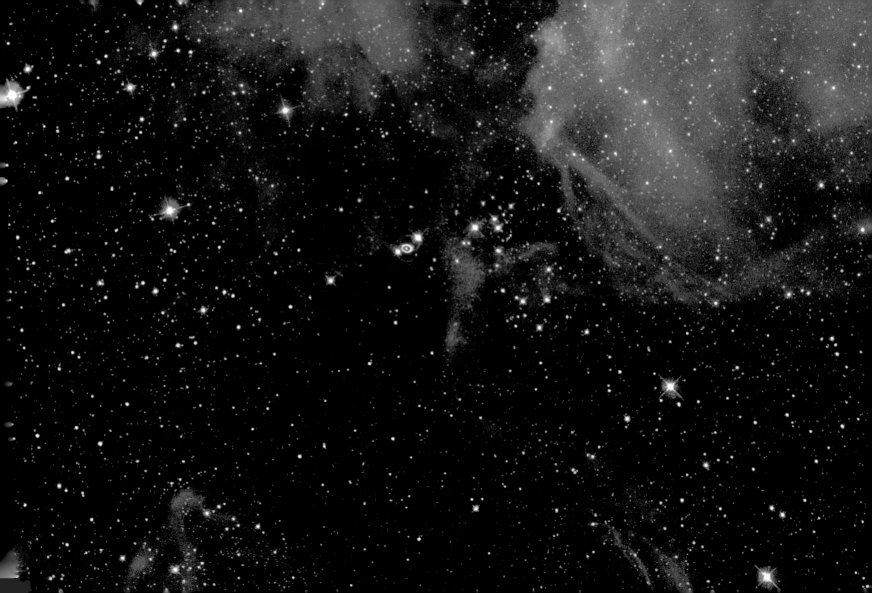

+ **The Mysterious Rings of Supernova 1987A**

WHAT'S CAUSING THOSE ODD RINGS IN SUPERNOVA 1987A? IN 1987, THE BRIGHTEST SUPERNOVA IN RECENT HISTORY OCCURRED in the Large Magellanic Clouds. In the middle of the picture is an object central to the remains of the violent stellar explosion.

When the Hubble Space Telescope was pointed at the supernova remnant in 1994, however, the existence of curious rings was confirmed. The origin of these rings still remains a mystery; speculation into their cause includes beamed jets emanating from a dense star left over from the supernova, and the intersection of two stellar winds ionized by the supernova explosion.

CREDIT: (ESA/ STSCI), HST, NASA

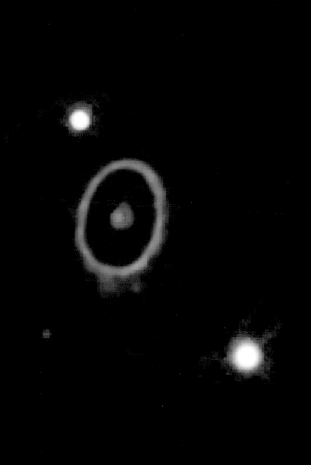

+ **Hubble Resolves Expiration Date for Green Cheese Moon**

USING THE NEW CAMERA ON THE RECENTLY REFITTED HUBBLE SPACE TELESCOPE, ASTRONOMERS HAVE BEEN ABLE TO CONFIRM that the Moon is in fact made of green cheese. The telling clue was the resolution of a numeric date after which the Moon may go bad. Controversy still exists, however, over whether the date resolved is truly an expiration date or just a "sell by" date. "To be cautious, we should completely devour the Moon by tomorrow," a spokesperson advised. The popular "Moon is made of green cheese" myth can be traced back almost 500 years. It has been used rhetorically to indicate a claim so clearly false that no one—not even April Fools—believes it. This image was actually taken in 1965 by the Ranger 9 probe minutes before impact. The Ranger series of spacecraft (1961–1965) were the first to obtain close-up images of the Lunar surface—they were designed to fly into the Moon, sending back images before they hit the surface. CREDIT: RANGER 9 SPACECRAFT, NASA

+ **Dark Sky, Bright Sun**

IN LOW EARTH ORBIT THERE IS NOT ENOUGH ATMOSPHERE TO DIFFUSE AND SCATTER SUNLIGHT, SO SHADOWS ARE BLACK AND the sky is dark—even when the Sun shines. The harsh lighting produced this dramatic effect as mission specialist Gregory Harbaugh photographed colleague Joseph Tanner during their second space walk to service the Hubble Space Telescope in February 1997. The aft section of the space shuttle Discovery is visible in the background with the Sun hanging over a delicate crescent of Earth's limb. A checklist is attached to Tanner's left arm, and Harbaugh's reflection is just visible in Tanner's visor. CREDIT: STS-82 CREW, NASA

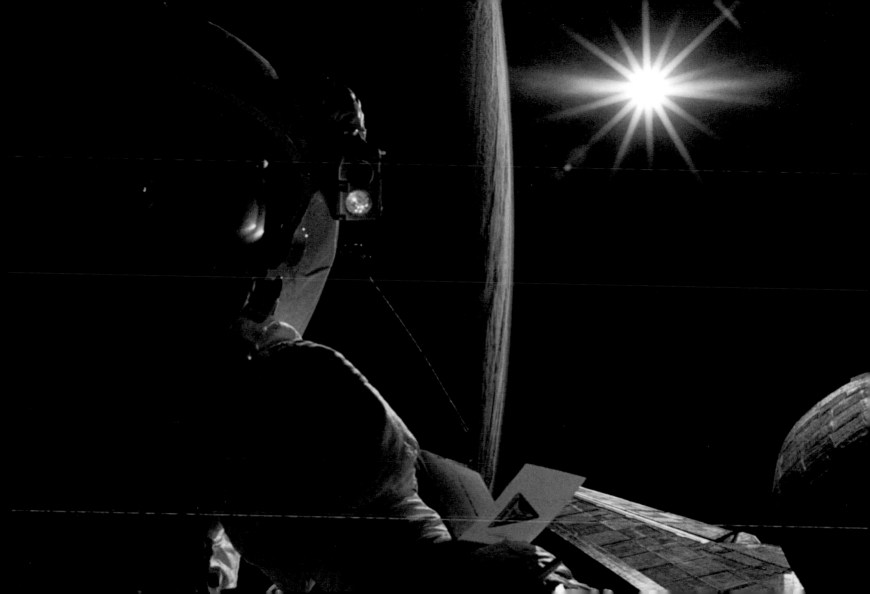

+ **The Radio Sky: Tuned to 408MHz**

TUNE YOUR RADIO TELESCOPE TO 408MHZ (408 MILLION CYCLES PER SECOND) AND CHECK OUT THE RADIO SKY! YOU SHOULD find that frequency on your dial somewhere between United States broadcast television channels 13 and 14. In the 1970s, large dish antennas at three radio observatories, Jodrell Bank, MPIFR, and Parkes Observatory, were used to do just that—the data were combined to map the entire sky. Near this frequency, high-energy electrons spiraling along magnetic fields generate cosmic radio waves. In the resulting false-color image, the galactic plane runs horizontally through the center, but no stars are visible. Instead, many of the bright sources near the plane are distant pulsars, star-forming regions, and supernova remnants, while the grand looping structures are clouds of interstellar gas shaped by local stellar activity. External galaxies like Centaurus A, located above the plane to the right of center, and the Large Magellanic Cloud (below and right) also shine in the Radio Sky.

CREDIT: C. HASLAM ET AL., MPIFR, SKYVIEW

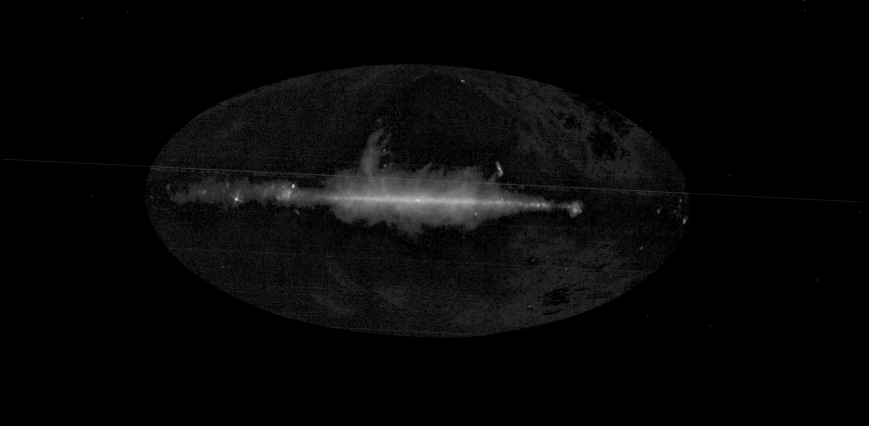

+ 04

+ **A Superwind from the Cigar Galaxy**

WHAT'S LIGHTING UP THE CIGAR GALAXY? WHEN M82, AS THIS IRREGULAR GALAXY IS ALSO KNOWN, PASSED NEAR LARGE spiral galaxy M81, the gravity pulled and stretched M82. This doesn't fully explain the source of the red-glowing, outwardly expanding gas, however. Recent evidence indicates that this gas is being driven out by the combined, emerging particle winds of many stars, together creating a galactic "superwind." This photograph from the Subaru Telescope highlights the specific color of red light strongly emitted by ionized hydrogen gas, showing detailed filaments of this gas. The filaments extend for over 10,000 light-years. The 12-million-light-year-distant Cigar galaxy is the brightest galaxy in the sky in infrared light, and can be seen in visible light with a small telescope toward the constellation Ursa Major. CREDIT: FOCAS, SUBARU 8.3-M TELESCOPE, NAOJ

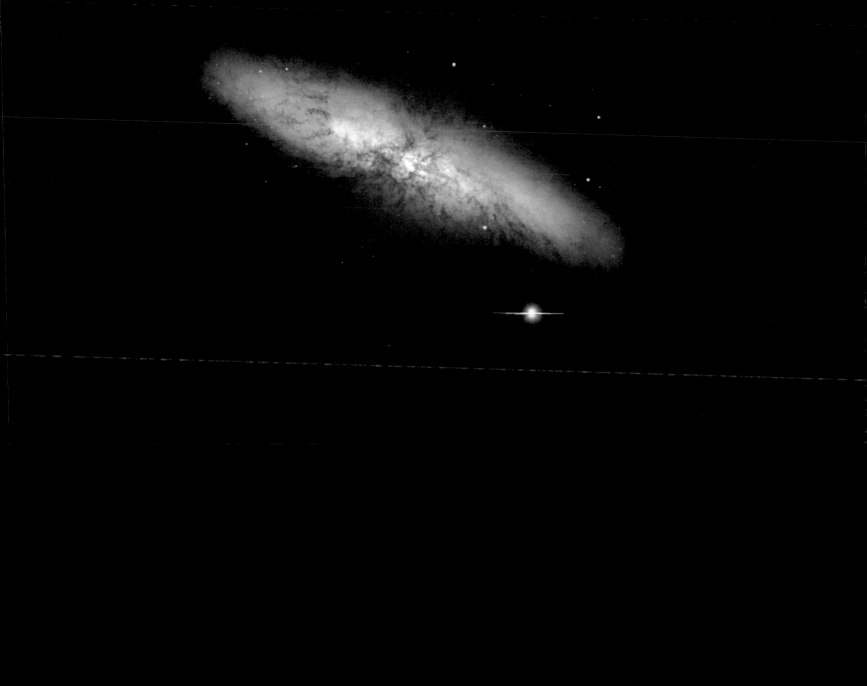

+ A Jet from Galaxy M87

WHAT'S CAUSING THIS HUGE, GLOWING JET TO EMANATE FROM THE CENTER OF GALAXY M87? ALTHOUGH THE UNUSUAL JET was first noticed early in the twentieth century, the exact cause is still debated. This picture, taken by the Hubble Space Telescope, shows clear details, however. The most popular hypothesis holds that the jet is created by energetic gas swirling around a massive black hole at the galaxy's center. The result is a 5,000-light-year-long blowtorch where electrons are ejected outward at near light-speed, emitting eerily blue light during a magnetic spiral. M87 is a giant elliptical galaxy residing only 50 million light-years away in the Virgo Cluster of galaxies. The faint dots of light surrounding M87's center are large, ancient globular clusters of stars. CREDIT: J. A. BIRETTA ET AL., HUBBLE HERITAGE TEAM (STSCI /AURA), NASA

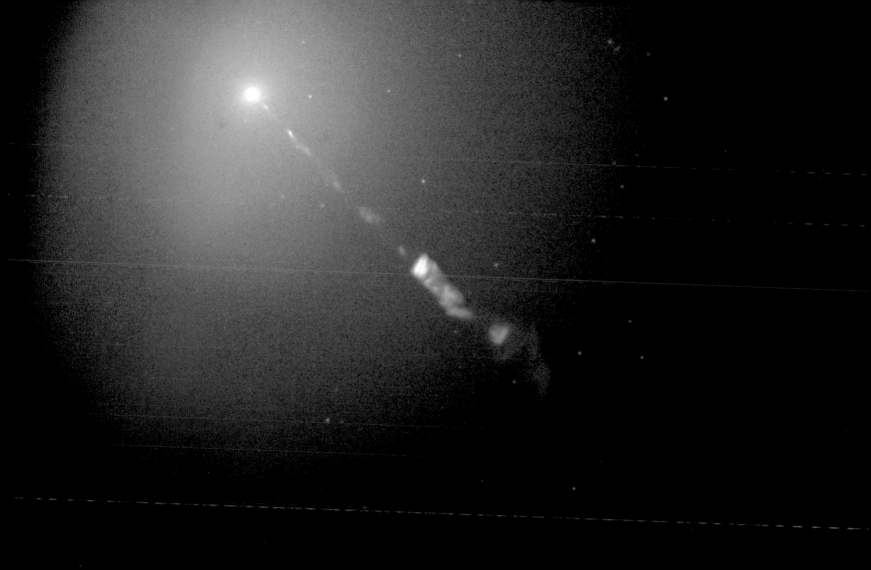

01
02
03
04
05
06
07
08
09
10
11
12
13
14
15
16
17
18
19
20
21
22
23
24
25
26
27
28
29
30
31

+ **An Anomalous SETI Signal**

NO ONE KNOWS FOR SURE WHAT CAUSED THIS SIGNAL. THERE IS A SLIGHT POSSIBILITY THAT IT JUST MIGHT ORIGINATE from an extraterrestrial intelligence. The bright colors on the blue background indicate that an anomalous signal was received here on Earth by a radio telescope involved in a search for such intelligence. A search for these signals is ongoing by several groups including volunteer members of the Search for Extraterrestrial Intelligence (SETI) League. Time labels the vertical axis of the shown plot, and frequency marks the horizontal axis. Although this strong signal was never positively identified, astronomers have detected in it many attributes characteristic of a more mundane and ultimately terrestrial origin. In this case, a leading possibility is that the signal originates from an unusual modulation between a GPS satellite and an unknown Earth-based source. Many unusual signals from space remain unidentified. No signal has yet been strong enough or run long enough to be unambiguously confirmed as originating from an extraterrestrial intelligence. CREDIT & COPYRIGHT: SETI LEAGUE

01
02
03
04
05
06
07
08
09
10
11
12
13
14
15
16
17
18
19
20
21
22
23
24
25
26
27
28
29
30

+ **The Tails of Comet Hyakutake**

+

WHAT MAKES COMET TAILS SO COLORFUL? THIS PHOTOGRAPH OF COMET HYAKUTAKE WAS TAKEN THE NIGHT OF APRIL 18, 1996,

and highlights different components of the tail. The gold and red tail features are dust, made predominantly of little bits of rock

and carbon. The dust tail shines by reflecting sunlight. Extending past the dust tail is the comet's ion tail, shown here glowing in

blue. The ion tail is composed mostly of ions of water, carbon monoxide, and cyanogen. The ion tail glows by emitting light when

electrons recombine with electrically charged ions to make uncharged molecules. The photograph was taken just north of Kansas

City, Missouri. CREDIT AND COPYRIGHT: VIC WINTER, COURTESY ICSTARS

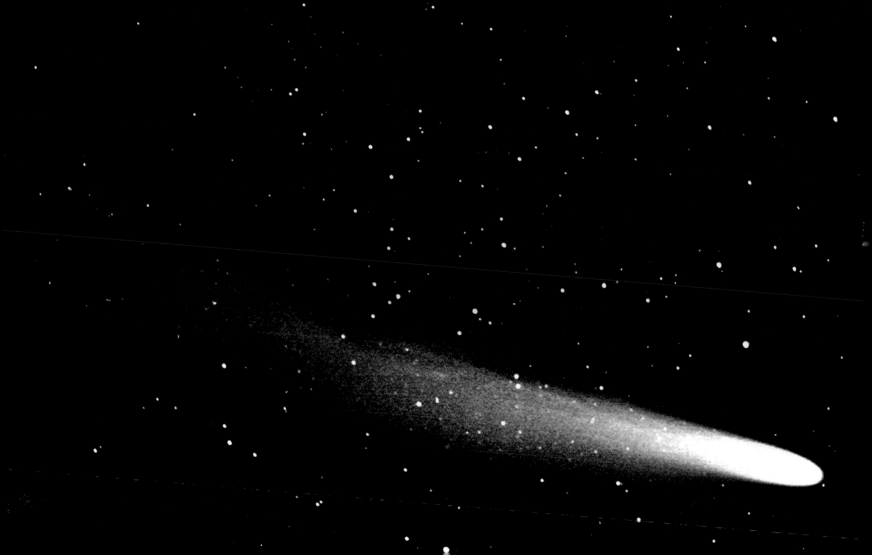

+ **Compton Observatory in Orbit**

IN APRIL 1991, THE MASSIVE COMPTON GAMMA-RAY OBSERVATORY WAS DEPLOYED IN LOW EARTH ORBIT. SPARKLING INTERIOR reflections and the bright limb of Earth are visible in this window view of Compton's release by the crew of the space shuttle Atlantis. Lofted above the protective atmosphere, Compton's instruments could explore the extreme high-energy universe in gamma rays, photons with 100,000 times or more the energy of visible light. The premier gamma-ray observatory far exceeded expectations for a 2- to 5-year mission, but a gyroscope failure ultimately prompted NASA to decide to steer the satellite safely back into the atmosphere in June 2000. Compton's lasting legacy of discovery includes the detection of more than 400 celestial gamma-ray sources, 10 times more than were previously known, and more than 2,500 gamma-ray bursts. CREDIT STS-37 CREW, NASA

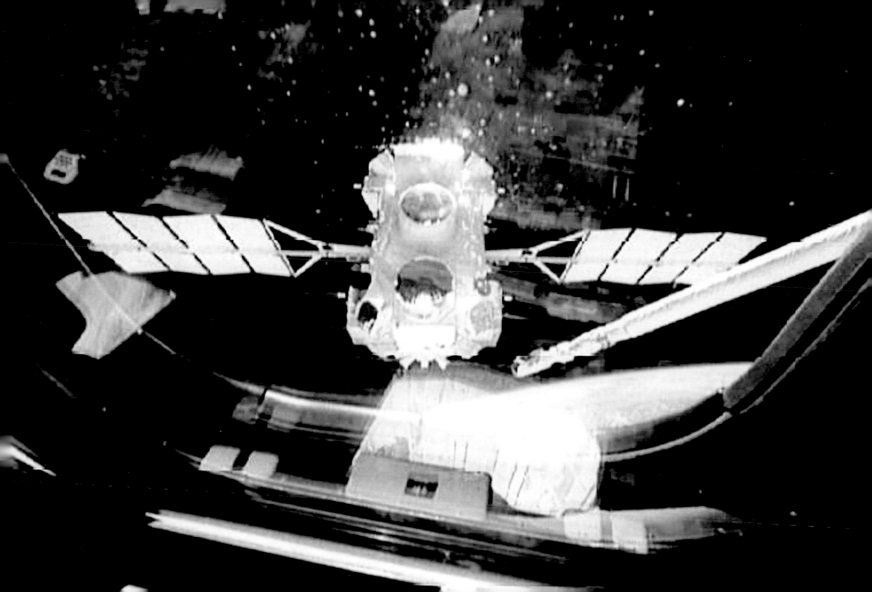

01
02
03
04
05
06
07
08
09
10
11
12
13
14
15
16
17
18
19
20
21
22
23
24
25
26
27
28
29
30

+ **The Snake Nebula from CFHT**

WHAT SLITHERS OVERHEAD? THE DARK WINDING LANES VISIBLE IN THE CONSTELLATION OPHIUCHUS BELONG TO THE

Snake Nebula. Also known as Barnard 72, the Snake Nebula is a series of dark absorption clouds made up of molecular gas and

interstellar dust. Interstellar dust grains—composed predominantly of carbon—absorb visible starlight and convert much of it to

heat, glowing in invisible infrared light. This absorption causes stars behind the clouds to be obscured from view, hence the

appearance of starless voids on the sky. Molecular clouds like the Snake Nebula are places where new stars are likely to form. The

Snake Nebula, pictured here, lies approximately 650 light-years away and covers an area on the sky about the size of a full moon.

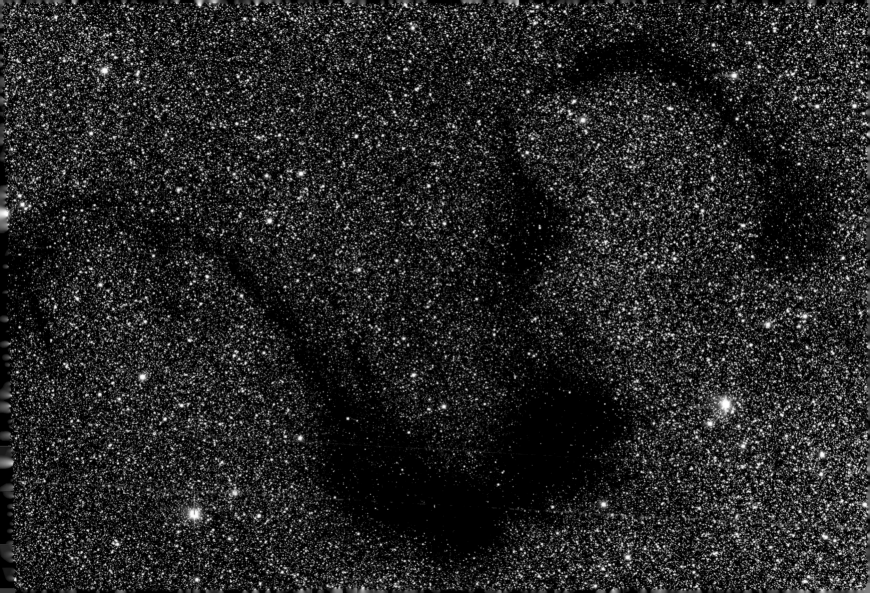

+ **M51: The Whirlpool Galaxy in Dust and Stars**

THE WHIRLPOOL GALAXY IS A CLASSIC SPIRAL GALAXY. AT ONLY 30 MILLION LIGHT-YEARS DISTANT AND FULLY 60,000 LIGHT-YEARS across, M51, also known as NGC 5194, is one of the brightest and most picturesque galaxies on the sky. This image is a digital combination of a ground-based image from the 0.9-meter Telescope at Kitt Peak National Observatory and a space-based image from the Hubble Space Telescope, highlighting sharp features normally too red to be seen. Anyone with a good pair of binoculars, however, can see the Whirlpool galaxy toward the constellation Canes Venatici. M51 is a spiral galaxy of type Sc and is the dominant member of a whole group of galaxies. Astronomers speculate that M51's spiral structure is primarily due to its gravitational interaction with a smaller galaxy just off the top of this image. CREDIT: N. SCOVILLE (CALTECH), T. RECTOR (NOAO) ET AL., HUBBLE HERITAGE TEAM, NASA

01
02
03
04
05
06
07
08
09
10
11
12
13
14
15
16
17
18
19
20
21
22
23
24
25
26
27
28
29
30

+ **Canaries Sky**

THIS GORGEOUS VIEW OF STARS, NEBULAE, AND THE MILKY WAY COMES FROM THE DARK NIGHT SKY ABOVE THE LOVELY island of La Palma in the Canaries archipelago. The picture was made by a group of experienced astrophotographers who traveled there to take advantage of the ideal observing conditions near La Palma's Observatorio del Roque de los Muchachos. Sky gazers can easily pick out several of their favorite astronomical objects in this wide-angle time exposure that covers about 40 degrees on the winter sky. Faint stars along the plane of our galaxy compose the delicate, luminous band of the Milky Way stretching across the image from the bottom left. The familiar constellation Orion, the Hunter, is also easy to find, with glowing nebulas highlighting the Hunter's belt and sword. Orion's famous red, giant star, Betelgeuse, near picture center, has a yellowish cast, and Rigel is the bright star in Orion at lower right. Brilliant white Sirius, near the bottom, is the brightest star in the picture (and in Earth's night sky). Sirius is part of the constellation Canis Major. Across the Milky Way, above and to the left of Sirius, is slightly less brilliant Procyon, the brightest star of Canis Minor. A V-shaped group of yellowish stars at the upper right, part of Taurus, the Bull, is dominated by the red giant Aldebaran. CREDIT & COPYRIGHT: A. VANNINI, G. LI CAUSI, A. RICCIARDI, A. GARATTI

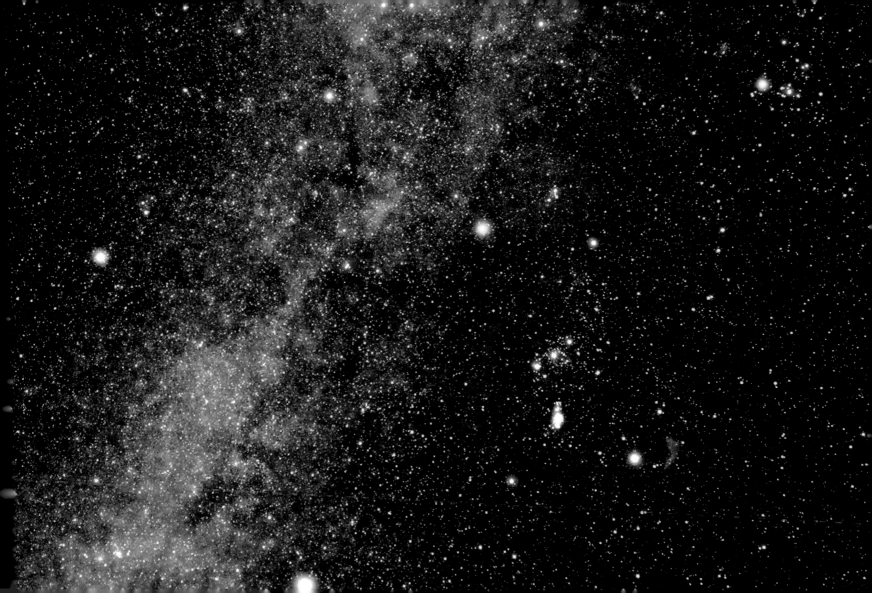

+ STS-1: First Shuttle Launch

ON APRIL 12, 1981, THE SPACE SHUTTLE COLUMBIA BECAME THE FIRST SHUTTLE TO ORBIT EARTH. IN THIS STRIKING TIME exposure, floodlights play on the Columbia and service structures (left) as it rests atop Complex 39's Pad A at Kennedy Space Center in preparation for its first launch. Flown by Commander John W. Young and Pilot Robert L. Crippen, Columbia spent 2 days aloft on its check-out mission, STS-1, which ended in a smooth landing, airplane-style, at Edwards Air Force Base in California. Ferried back to Kennedy by a modified Boeing 747, Columbia was launched again 7 months later on STS-2, becoming the first piloted reusable orbiter. The oldest operating shuttle, Columbia's 1981 debut was followed by shuttles Challenger in 1982 (destroyed in 1986), Discovery in 1983, Atlantis in 1985, and Challenger's replacement, Endeavour, in 1991. This shuttle fleet has now accomplished more than a hundred orbital missions. CREDIT: KSC, NASA

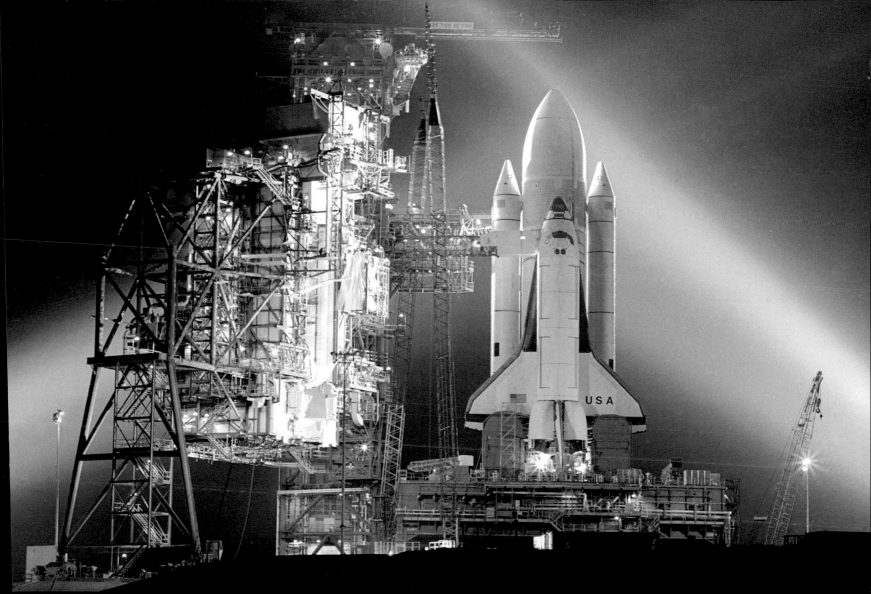

+ **A Galaxy Is Not a Comet**

THIS GORGEOUS GALAXY AND COMET PORTRAIT WAS RECORDED ON APRIL 5, 2002, IN THE SKIES OVER THE ORIENTAL PYRENEES near Figueres, Spain. From a site above 1,100 meters, astrophotographer Juan Carlos Casado used fast film and a telephoto lens while tracking the stars over a long time exposure to capture the predicted conjunction of the bright comet Ikeya-Zhang (right) and the Andromeda galaxy (left). This stunning celestial scene would also have been a rewarding one for the influential eighteenth-century comet hunter Charles Messier. While Messier scanned French skies for comets, he carefully catalogued positions of things that were fuzzy and cometlike in appearance, but did not move against the background stars and so were definitely not comets. The Andromeda galaxy, also known as M31, is the 31st object in his famous not-a-comet catalogue. Not-a-comet object number 110, a late addition to Messier's catalogue, is one of Andromeda's small satellite galaxies, and can be seen here just below M31. Our modern understanding holds that the Andromeda galaxy is a large, spiral galaxy some 2 million light-years away. The photogenic comet Ikeya-Zhang, then a lovely sight in early morning skies, was about 80 million km (4 light-minutes) from planet Earth.

CREDIT & COPYRIGHT: JUAN CARLOS CASADO

+ **A Cloud Shadow Sunrise**

WHAT COULD CAUSE A RAY OF DARK? SUCH A RAY WAS CAUGHT IN SPECTACULAR FASHION FROM MIAMI BEACH, FLORIDA, IN THE year 2000. The cause is something surprisingly familiar: a shadow. The gold-tinged cloud near the horizon blocked sunlight from reflecting off air behind the cloud, making that column of air appear unusually dark. Cloud shadows can be thought of as the inverse of the more commonly highlighted crepuscular rays, where sunlight pours though gaps in cloud banks. CREDIT & COPYRIGHT: KEE HINCKLEY

+ **Pluto in True Color**

PLUTO IS REDDISH BROWN. NO SPACECRAFT HAS YET VISITED THIS MOST DISTANT PLANET IN OUR SOLAR SYSTEM, BUT THIS picture, actually a high-resolution map, captures its true colors. This map was created by tracking Pluto's change in brightness during times when it was being partially eclipsed by its moon, Charon. The map therefore shows the hemisphere of Pluto that faces Charon. Pluto's reddish brown surface is thought to be dominated by frozen methane metamorphosed by faint but energetic sunlight. The dark band below Pluto's equator is seen to have rather complex coloring, however, indicating that some unknown mechanisms may have affected the planet's surface. CREDIT: ELIOT YOUNG (SWRI) ET AL., NASA

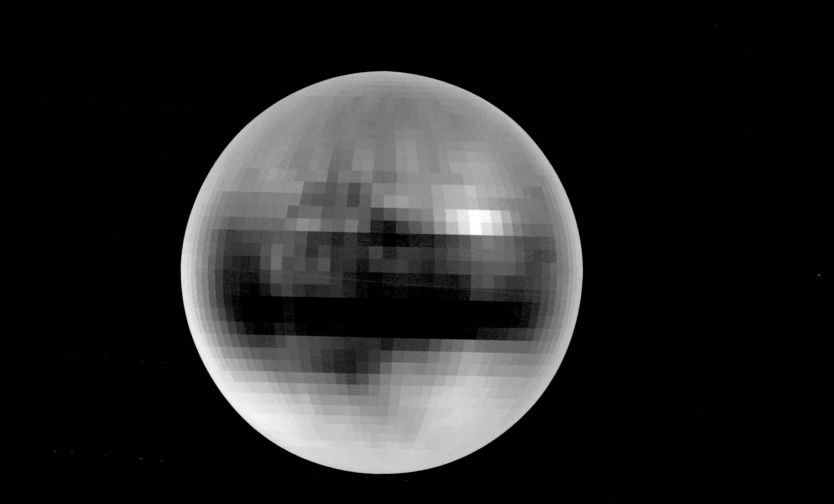

+ **Pluto: New Horizons**

PLUTO'S HORIZON SPANS THE FOREGROUND IN THIS ARTIST'S VISION, GAZING SUNWARD ACROSS THAT DISTANT AND NOT YET explored world. Titled New Horizons, the painting also depicts Pluto's companion moon, Charon, as a darkened, ghostly apparition with a luminous crescent against a starry background. Beyond Charon, the diminished pointlike Sun is immersed in a flattened cloud of zodiacal dust. Pluto's ruddy colors are based on existing astronomical observations while imagined, but scientifically tenable, details provided by the artist include high atmospheric cirrus clouds and dark plumes from surface vents, an analogy to Neptune's large moon, Triton, explored by the Voyager 2 spacecraft in 1989. Craters suggest bombardment by Kuiper Belt objects, a newly understood population of icy, outer solar system bodies likely related to the Pluto-Charon system. NASA is now planning a future robotic reconnaissance mission to Pluto-Charon and the Kuiper Belt. PAINTING CREDIT & COPYRIGHT: DAN DURDA (SWRI)

+ Blue Marble 2000

THIS DIGITAL PORTRAIT OF OUR PLANET IS REMINISCENT OF THE APOLLO-ERA PICTURES OF THE "BIG BLUE MARBLE," EARTH,

from space. To create it, researchers at Goddard Space Flight Center's Laboratory for Atmospheres combined data from a

Geostationary Operational Environmental Satellite (GOES), the Sea-Viewing Wide Field-of-View Sensor (SeaWiFS), and the Polar

Orbiting Environmental Satellites (POES), with a United States Geological Survey (USGS) elevation model of Earth's topography.

Stunningly detailed, the planet's Western Hemisphere is cast so that heavy vegetation is green and sparse vegetation is yellow,

while the heights of mountains and depths of valleys have been exaggerated by 50 times to make vertical relief visible. Hurricane

Linda is the dramatic storm off North America's West Coast. And what about the Moon? The lunar image was reconstructed from

GOES data and artistically rescaled for this visualization. CREDIT: R. STOCKLI, A. NELSON, F. HASLER, NASA/ GSFC/ NOAA/ USGS

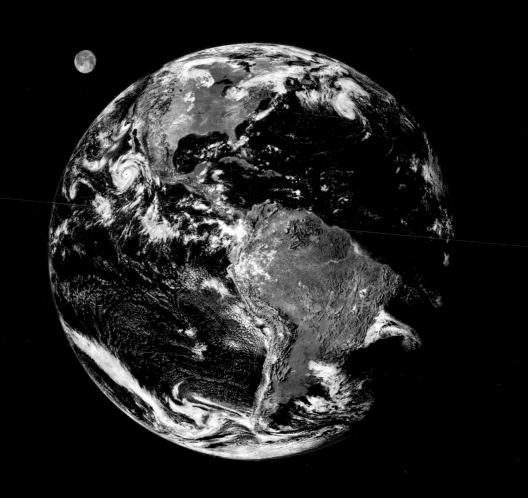

+ **NGC 2266: Old Cluster in the New General Catalog**

THE NEW GENERAL CATALOG OF STAR CLUSTERS AND NEBULAS REALLY ISN'T SO NEW. IN FACT, IT WAS PUBLISHED IN 1888—

an attempt by J. L. E. Dreyer to consolidate the work of astronomers William, Caroline, and John Herschel, along with others,

into a useful, single, complete catalogue of astronomical discoveries and measurements. Dreyer's work was successful and is still

important today as this famous catalogue continues to lend its "NGC" to bright clusters, galaxies, and nebulas. Take for example

this star cluster known as NGC 2266 (item number 2,266 in the NGC compilation). It lies approximately 10,000 light-years

distant in the constellation Gemini and represents an open or galactic cluster of stars. With an age of about 1 billion years,

NGC 2266 is old for a galactic cluster. Its evolved red giant stars are readily apparent in this gorgeous three-color image.

CREDIT: TILL CREDNER & SVEN KOHLE, BONN UNIVERSITY

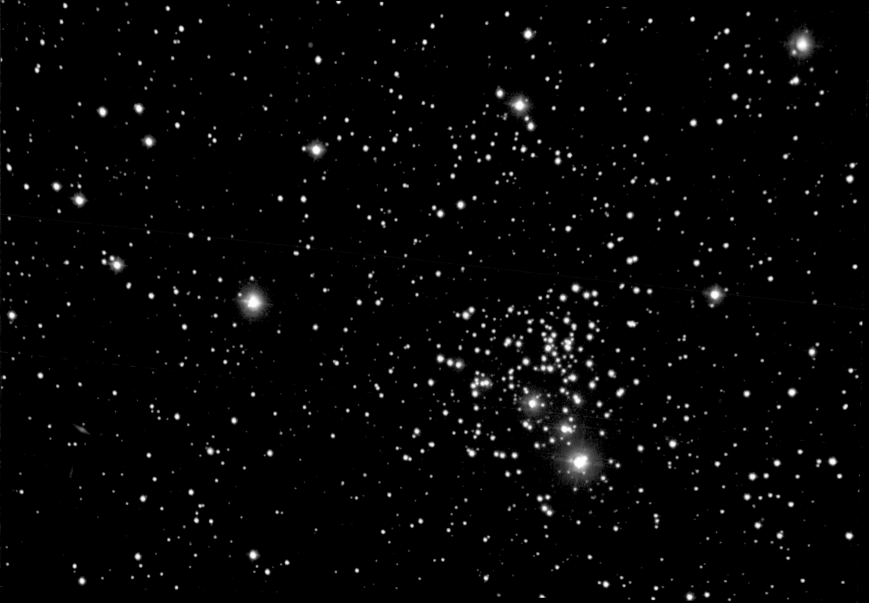

+ **The Old Moon in the New Moon's Arms**

ALSO KNOWN AS THE MOON'S "ASHEN GLOW" OR "THE OLD MOON IN THE NEW MOON'S ARMS," EARTHSHINE IS EARTHLIGHT

reflected from the Moon's night side. This dramatic image of earthshine and a young crescent Moon was taken by astrophotog-

rapher Laurent Laveder from the remote Pic du Midi Observatory on planet Earth. But the view from the Moon would have

been stunning, too. When the Moon appears on Earth's sky as a slender crescent, a dazzlingly bright, nearly full Earth will be

seen from the lunar surface. Earth's brightness, due to reflected sunlight, is strongly influenced by cloud cover. Recent studies

of earthshine indicate that it is more pronounced during the months of April and May. Leonardo da Vinci wrote a description

of earthshine, defined as sunlight reflected by Earth's oceans, in turn illuminating the Moon's dark surface, 500 years ago.

CREDIT & COPYRIGHT: LAURENT LAVEDER

01
02
03
04
05
06
07
08
09
10
11
12
13
14
15
16
17
18
19
20
21
22
23
24
25
26
27
28
29
30

+ Io: Moon over Jupiter

HOW BIG IS THE JOVIAN MOON IO? THE MOST VOLCANIC BODY IN THE SOLAR SYSTEM, IO IS 3,600 KM IN DIAMETER, ABOUT THE

size of planet Earth's single, large natural satellite—the Moon. Gliding past Jupiter at the turn of the millennium, the Cassini

spacecraft captured this awe-inspiring view of active Io with the largest gas giant as a backdrop, offering a stunning demonstration

of the ruling planet's relative size. Although in the picture Io appears to be located just in front of the swirling jovian clouds, it

hurtles around its orbit once every 42 hours at a distance of 420,000 km or so from the center of Jupiter. That puts it nearly

350,000 km above Jupiter's cloud tops, roughly equivalent to the distance between Earth and Moon. The Cassini spacecraft itself

was about 10 million km from Jupiter when recording the image data. CREDIT: CASSINI IMAGING TEAM, CASSINI PROJECT, NASA

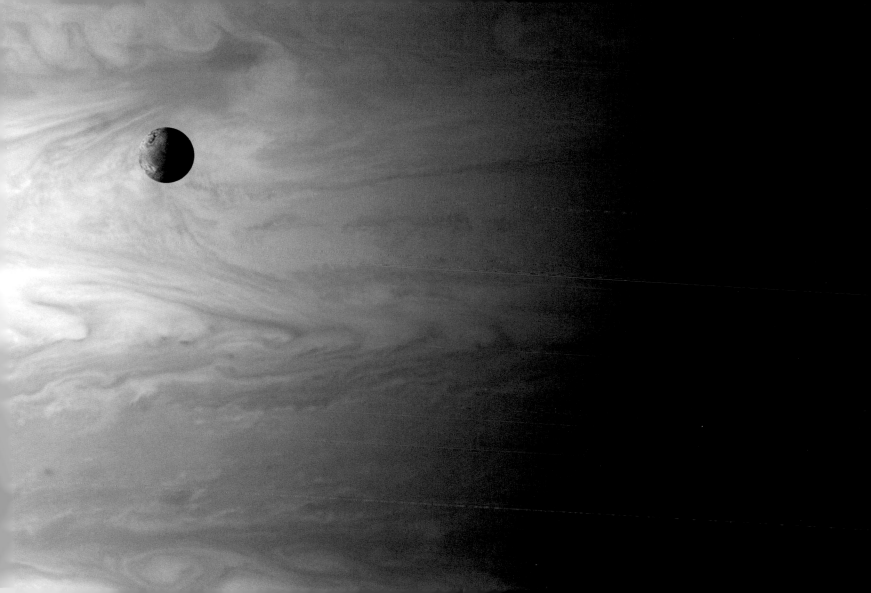

+ **The Center of Centaurus A**

A FANTASTIC JUMBLE OF YOUNG, BLUE, STAR CLUSTERS, GIGANTIC GLOWING GAS CLOUDS, AND IMPOSING DARK DUST LANES surrounds the central region of the active galaxy Centaurus A (NGC 5128). This mosaic of Hubble Space Telescope images taken in blue, green, and red light has been processed to present a natural-color picture of this cosmic maelstrom. Infrared images from the Hubble have also shown that hidden at the center of this activity are what seem to be disks of matter spiraling into a black hole with a billion times the mass of the Sun. Centaurus A itself is apparently the result of a collision of two galaxies, and the left-over debris is steadily being consumed by the black hole. Astronomers believe that such black hole central engines generate the radio, X-ray, and gamma-ray energy radiated by Centaurus A and other active galaxies. For an active galaxy, Centaurus A is close to Earth, a mere 10 million light-years away, and is a relatively convenient laboratory for exploring these powerful sources of energy.

CREDIT: E.J. SCHREIER (STSCI) ET AL., HST, NASA

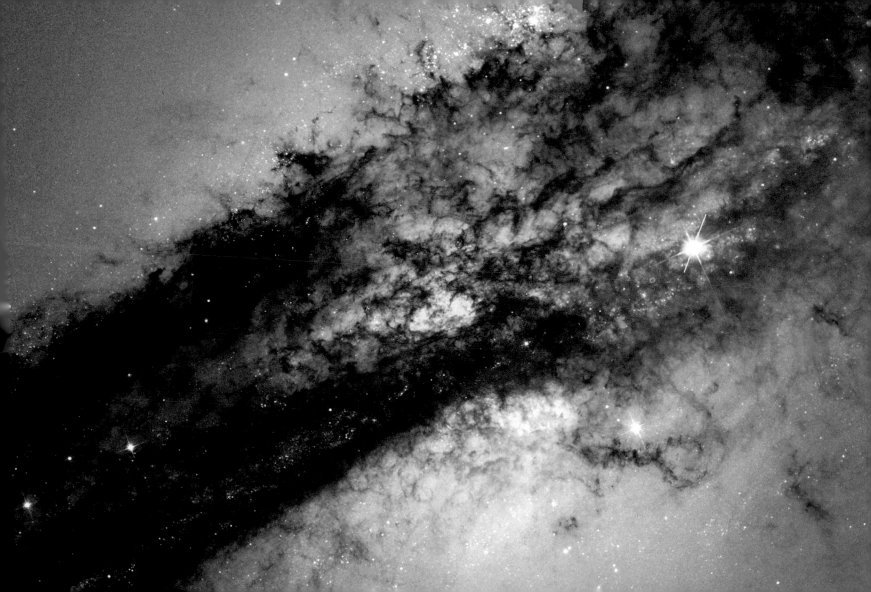

+ **Centaurus A: X Rays from an Active Galaxy**

ITS CORE HIDDEN FROM OPTICAL VIEW BY A THICK LANE OF DUST, THE GIANT ELLIPTICAL GALAXY CENTAURUS A WAS AMONG the first objects observed by the orbiting Chandra X-ray Observatory. Astronomers were not disappointed, as Centaurus A's appearance in X rays makes its classification as an active galaxy easy to appreciate. Perhaps the most striking feature of this Chandra false-color X-ray view is the jet, 30,000 light-years long. Blasting toward the upper left corner of the picture, the jet seems to arise from the galaxy's bright central X-ray source—suspected of harboring a black hole with a million or so times the mass of the Sun. Centaurus A is also seen to be teeming with other individual X-ray sources and a pervasive, diffuse X-ray glow. Most of these individual sources are likely to be neutron stars or solar-mass black holes accreting material from their less exotic, binary companion stars. The diffuse high-energy glow represents gas throughout the galaxy heated to temperatures of millions of degrees Celsius. At approximately 10 million light-years distant in the constellation Centaurus, Centaurus A is the closest active galaxy. CREDIT: R.KRAFT (SAO) ET AL., CXO, NASA

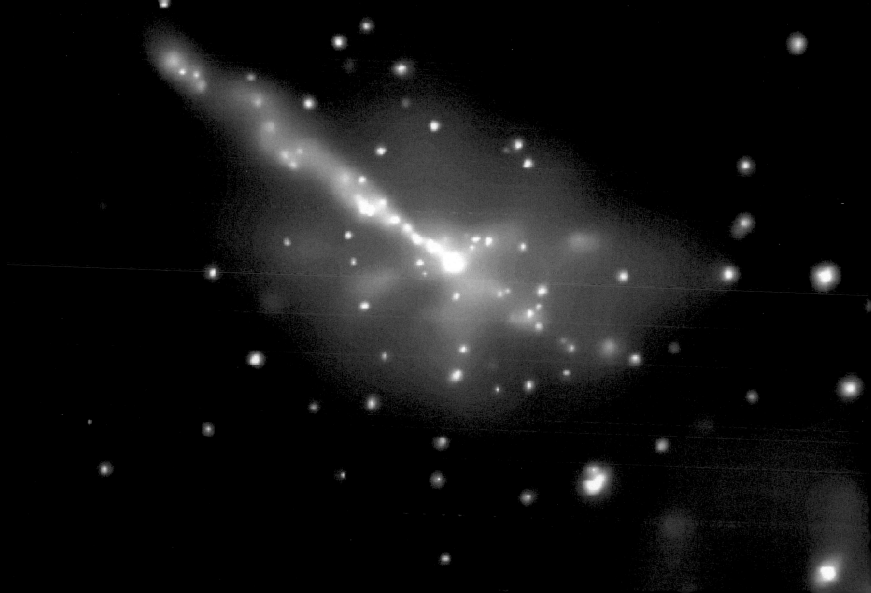

+ **The Expanding International Space Station**

WHAT DOES THE DEVELOPING INTERNATIONAL SPACE STATION LOOK LIKE? AFTER DELIVERING AND DEPLOYING A CRUCIAL FIRST backbone-like component in April 2002, the space shuttle Atlantis took an inspection lap around the space station. The then newly installed truss is visible toward the center of this image. Also visible are many different types of modules, a robotic arm, several winglike solar panels, and a supply ship. Construction began on the ISS in 1998, and the core structure, consisting of the basic modules for operating, living, and working within it should be in place before 2005. CREDIT: STS-110 SHUTTLE CREW, NASA

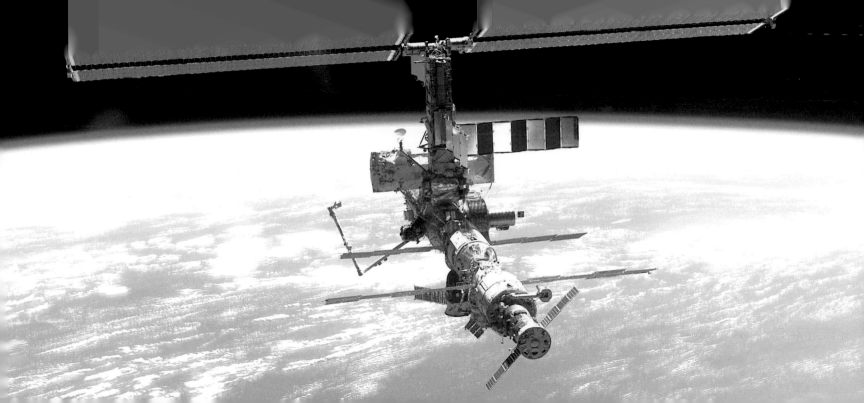

+ The Trifid Nebula from AAO

UNSPEAKABLE BEAUTY AND UNIMAGINABLE BEDLAM CAN BE FOUND TOGETHER IN THE TRIFID NEBULA. ALSO KNOWN AS M20, this photogenic nebula is visible with good binoculars toward the constellation Sagittarius. The energetic processes of star formation create not only the colors but also the chaos. The red-glowing gas results from high-energy starlight striking interstellar hydrogen gas. The dark dust filaments that lace M20 were created in the atmospheres of cool giant stars and in the debris from supernovas' explosions. Astronomers are still investigating which bright young stars light up the blue reflection nebula. The light from M20 we see left perhaps 3,000 years ago, although the exact distance remains unknown—light takes approximately 50 years to cross M20. CREDIT & COPYRIGHT: ANGLO-AUSTRALIAN OBSERVATORY, PHOTOGRAPH BY DAVID MALIN

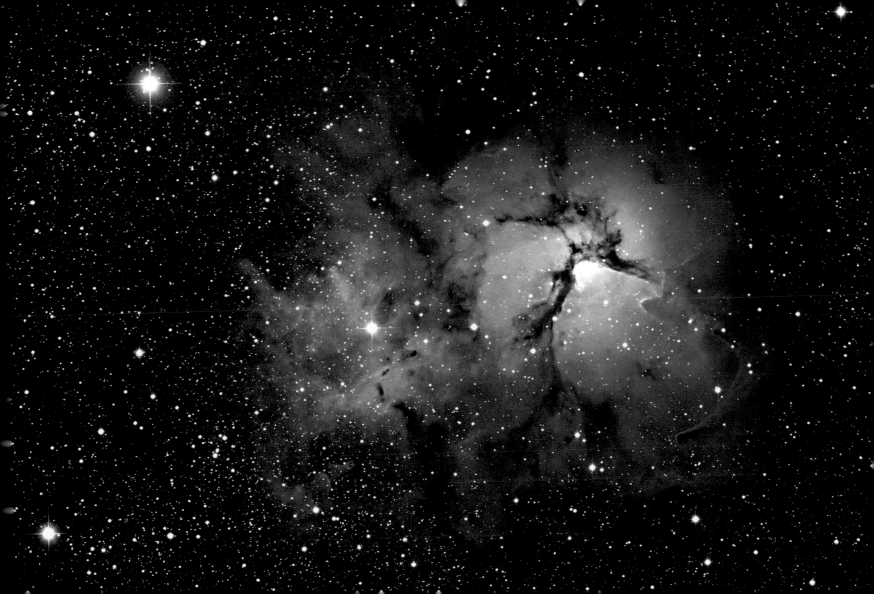

01
02
03
04
05
06
07
08
09
10
11
12
13
14
15
16
17
18
19
20
21
22
23
24
25
26
27
28
29
30

+ **Southern Cross in Mauna Loa Skies**

GAZING ACROSS THIS GORGEOUS SKYSCAPE, THE SOUTHERN CROSS AND STARS OF THE CONSTELLATION CENTAURUS ARE SEEN above the outline of Mauna Loa (Long Mountain), planet Earth's largest volcano. Unfamiliar to sky gazers north of about 25 degrees north latitude, the Southern Cross, constellation Crux, is near the horizon to the left of Mauna Loa's summit. A compact constellation of bright stars, the long axis of the cross conveniently points south toward the southern celestial pole. The lovely, pale red star, Gamma Crucis, a red giant star approximately 120 light-years away, marks the top of the cross. Stars of the grand constellation Centaurus almost engulf the Southern Cross, with blue giant Beta Centauri and yellowish Alpha Centauri appearing as the brightest stars to the left of Gamma Crucis. At a distance of 4.3 light-years, Alpha Centauri, the closest star to the Sun, is actually a triple-star system that includes a star similar to the Sun. But what caused the reddish streaks in the foreground of this time exposure? Alas, it is the mundane glow of lights from cars (not molten lava) traveling the road to Hilo, Hawaii.

CREDIT & COPYRIGHT BARNEY MAGRATH

01
02
03
04
05
06
07
08
09
10
11
12
13
14
15
16
17
18
19
20
21
22
23
24
25
26
27
28
29
30

+ NGC 2440: Cocoon of a New White Dwarf

LIKE A BUTTERFLY, A WHITE DWARF STAR BEGINS ITS LIFE BY CASTING OFF THE COCOON THAT ENCLOSED ITS FORMER SELF.

In this analogy, however, the star would be a caterpillar and the ejected shell of gas would become the prettiest of all! This cocoon, the planetary nebula designated NGC 2440, contains one of the hottest white dwarf stars known. The white dwarf can be seen as the bright dot near the photographs center. Our Sun will eventually become a "white dwarf butterfly," but not for another 5 billion years. CREDIT: H. BOND (STSCI), R. CIARDULLO (PSU), WFPC2, HST, NASA

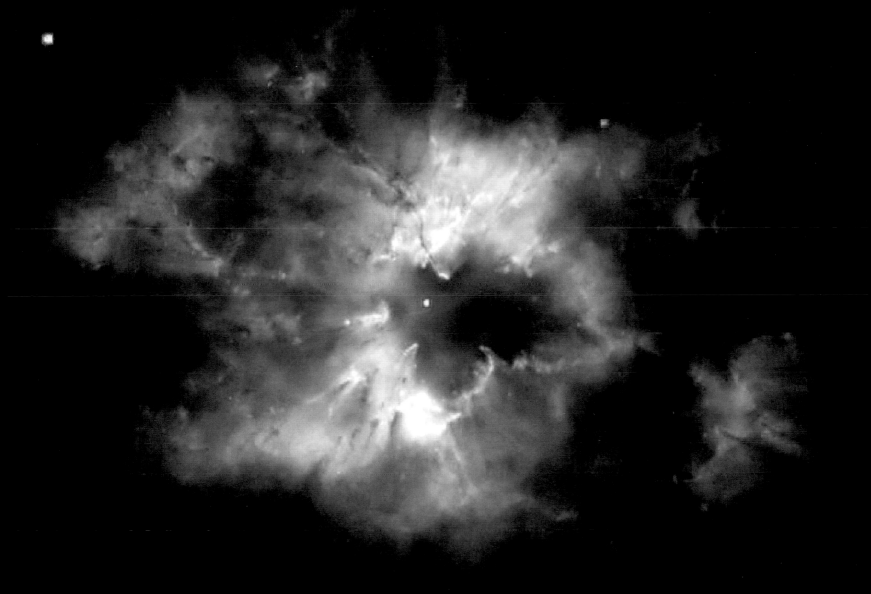

+ Ski Enceladus

A SMALL, INNER MOON OF SATURN, ENCELADUS IS ONLY APPROXIMATELY 500 KM IN DIAMETER. BUT THE COLD, DISTANT WORLD does reflect over 90 percent of the sunlight it receives, giving its surface about the same reflectivity as newly-fallen snow. Seen here in a mosaic of Voyager 2 images from 1981, Enceladus shows a variety of surface features and very few impact craters—indicating that it is an active world even though this ice moon should have completely cooled off long ago. In fact, the fresh, resurfaced appearance of Enceladus suggests that an internal mechanism, perhaps driven by tidal pumping, generates heat and supplies liquid water to geysers or water volcanoes. Since Enceladus orbits within the tenuous outer E ring of Saturn, the moon's surface may be kept snow-bright because it is continuously bombarded with icy ring particles; eruptions on Enceladus itself would in turn supply icy material to the E ring. Interplanetary ski bums take note: on tiny Enceladus you would have only about one-hundredth your weight on planet Earth. CREDIT: VOYAGER PROJECT, NASA

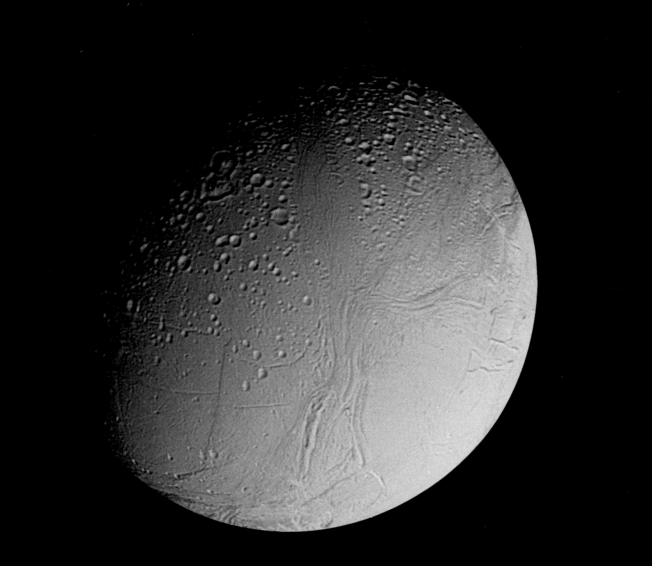

+ **Betelgeuse, Betelgeuse, Betelgeuse**

BETELGEUSE (SOUNDS A LOT LIKE "BEETLE JUICE"), A RED SUPERGIANT STAR APPROXIMATELY 600 LIGHT-YEARS DISTANT, IS seen in this Hubble Space Telescope image—the first direct picture of the surface of a star other than the Sun. In this historic image, a bright hot spot is revealed, indicating Betelgeuse has strong variations in surface brightness. While Betelgeuse is cooler than the Sun, it is more massive and over 1,000 times larger. If placed at the center of our solar system, it would extend past the orbit of Jupiter. Betelgeuse is also known as Alpha Orionis, one of the brightest stars in the familiar constellation Orion. As a massive red supergiant, it is nearing the end of its life and should eventually become a supernova. CREDIT: A. DUPREE (CFA), R. GILLILAND (STSCI), NASA

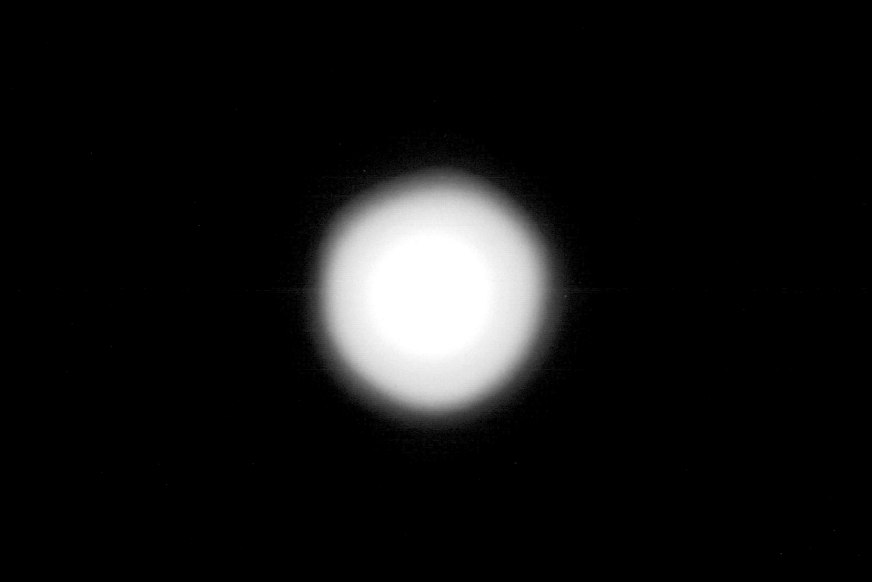

+ **Resolving Mira**

MOST STARS APPEAR ONLY AS POINTS OF LIGHT. IN 1995, BETELGEUSE BECAME THE SECOND STAR, AFTER OUR SUN, TO HAVE A direct image recorded showing details of its surface. Later that year, Mira A was added to the list. Discovered to be the first variable star about 400 years ago by German astronomer David Fabricius, Mira is a red giant star undergoing dramatic pulsations, causing it to become more than 100 times brighter over the course of a year. Mira can extend to over 700 times the size of our sun, and is only 400 light-years away. This photograph, taken by the Hubble Space Telescope, shows the true face of Mira. But what are we seeing? The unusual extended feature off the lower left of the star remains somewhat mysterious. Possible explanations include gravitational perturbation and/or heating from Mira's white dwarf star companion. CREDIT: M. KAROVSKA (HARVARD-SMITHSONIAN CFA) ET AL., FOC, ESA, NASA

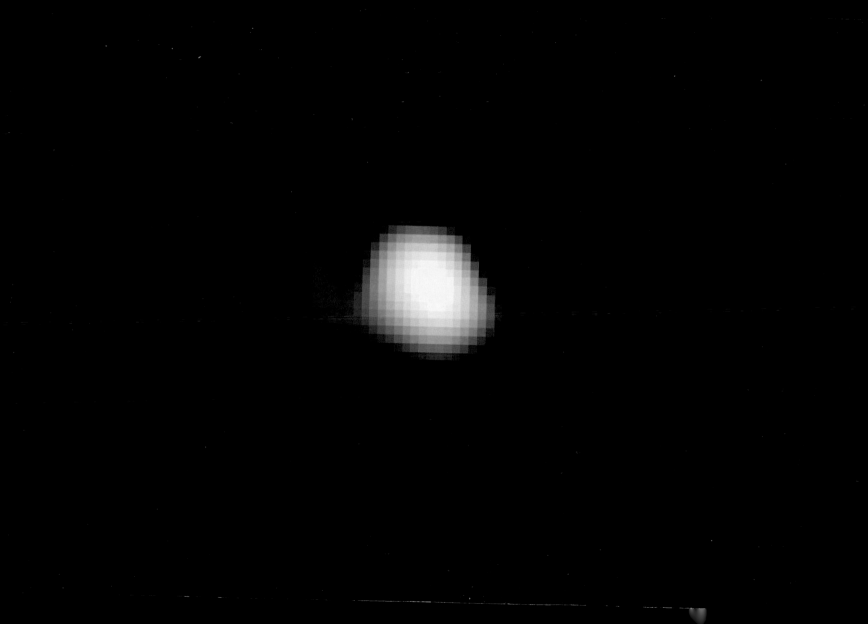

+ **The Holographic Principle**

IS THIS IMAGE WORTH A THOUSAND WORDS? ACCORDING TO THE HOLOGRAPHIC PRINCIPLE, THE MOST INFORMATION YOU could get from this image would be approximately 3×10^{65} bits if viewed on a normal-size computer monitor. The Holographic Principle, yet unproven, states that there is a maximum amount of information content held by regions adjacent to any surface. Therefore, counterintuitively, the information content inside a room depends not on the volume of the room but on the area of the bounding walls. The principle derives from the idea that the Planck length, the length scale where Quantum Mechanics begins to dominate classical gravity, is one side of an area that can hold only about one bit of information. The limit was first postulated by physicist Gerard 't Hooft in 1993. It can arise from generalizations of seemingly distant speculation that the information held by a black hole is determined not by its enclosed volume but by the surface area of its event horizon. The term holographic arises from a hologram analogy where a three-dimensional image is created by projecting light though a flat screen. By the way, some people looking at this image may see a teapot. CREDIT & COPYRIGHT: CALTECH COMPUTER GRAPHICS GROUP, 1994, AL BARR, KURT KLEISCHER, DAVID LAIDLAW, PRESTON PFARNER, ERIK WINFREE

+ **In the Center of the Omega Nebula**

IN THE DEPTHS OF THE DARK CLOUDS OF DUST AND MOLECULAR GAS KNOWN AS THE OMEGA NEBULA, STARS CONTINUE TO FORM. This image from the Hubble Space Telescope's newly installed Advanced Camera for Surveys shows unprecedented detail in the famous star-forming region. The dark dust filaments that lace the center of Omega Nebula were created in the atmospheres of cool, giant stars and in the debris from supernova explosions. The red and blue hues arise from glowing gas heated by the radiation of massive nearby stars. The points of light are the young stars themselves, some brighter than a hundred suns. Dark globules mark even younger systems, clouds of gas and dust just now condensing to form stars and planets. The Omega Nebula lies approximately 5,000 light-years away, toward the constellation Sagittarius. The region shown (opposite) spans approximately 3,000 times the diameter of our solar system. CREDIT: ACS SCIENCE & ENGINEERING TEAM, NASA

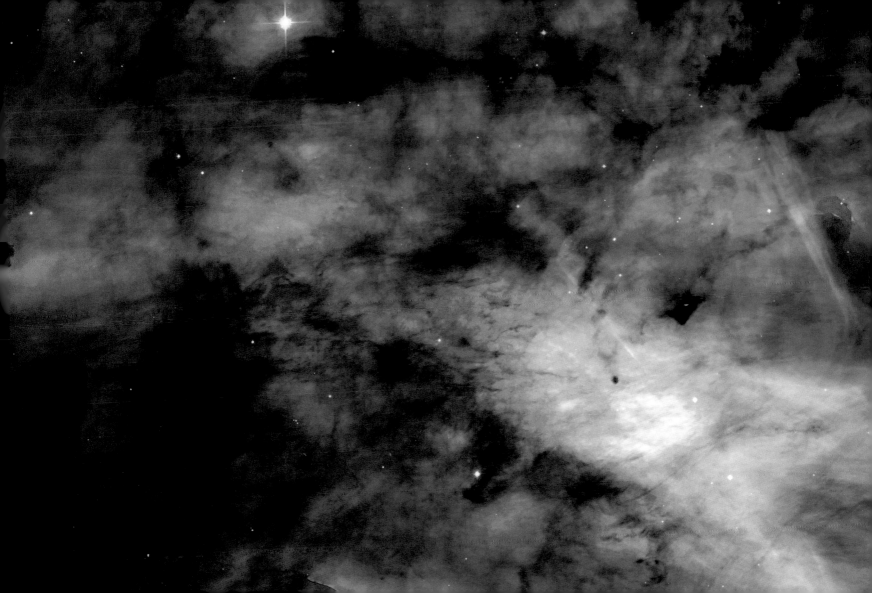

+ **Arp 188 and the Tadpole's Tidal Tail**

IN THIS STUNNING VISTA RECORDED WITH THE HUBBLE SPACE TELESCOPE'S ADVANCED CAMERA, DISTANT GALAXIES FORM A dramatic backdrop for disrupted spiral galaxy Arp 188, the Tadpole galaxy. The cosmic Tadpole is a mere 420 million light-years distant, toward the northern constellation Draco. Its eye-catching tail is approximately 280, 000 light-years long and features massive, bright blue star clusters. One explanation for the appearance of its tail is that a more compact intruder galaxy crossed in front of Arp 188—from left to right in this view—and was slung around behind the Tadpole by their gravitational attraction. During the close encounter, tidal forces drew out the spiral galaxy's stars, gas, and dust, forming the spectacular tail. The intruder galaxy itself, estimated to lie about 300, 000 light-years behind the Tadpole, can be seen through foreground spiral arms at the upper left. Like its terrestrial namesake, the Tadpole galaxy will likely lose its tail as it grows older, and the tail's star clusters will form smaller satellites of the large spiral galaxy. CREDIT: ACS SCIENCE & ENGINEERING TEAM, NASA

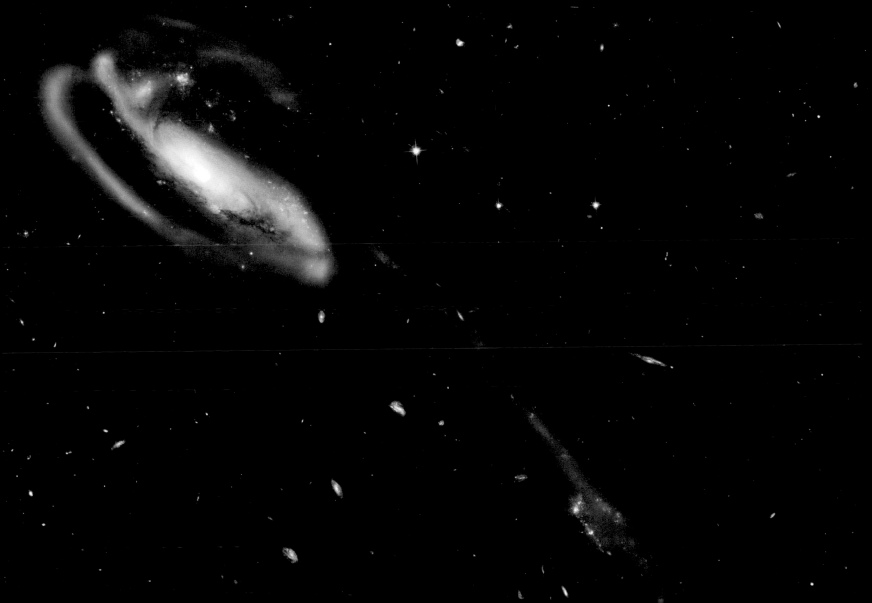

+ Thackeray's Globules

RICH STAR FIELDS AND GLOWING HYDROGEN GAS SILHOUETTE DENSE, OPAQUE CLOUDS OF INTERSTELLAR GAS AND DUST IN

this Hubble Space Telescope close-up of IC 2944, a bright, star-forming region in Centaurus, 5,900 light-years away. The largest

of these dark globules, first spotted by South African astronomer A. D. Thackeray in 1950, is likely two separate but overlapping

clouds, each more than 1 light-year wide. Combined, the clouds contain material equivalent to about 15 times the mass of

the Sun, but will they actually collapse to form massive stars? Along with other data, the sharp Hubble images indicate that

Thackeray's globules are fractured and churning as a result of intense ultraviolet radiation from young, hot stars already energiz-

ing and heating the bright emission nebula. These and similar dark globules known to be associated with other star-forming

regions may ultimately be dissipated by their hostile environment—like cosmic lumps of butter in a hot frying pan. The

chevron shape of the picture outlines the detectors of the Hubble's WFPC2 camera. CREDIT: HUBBLE HERITAGE TEAM (STSCI/AURA), NASA

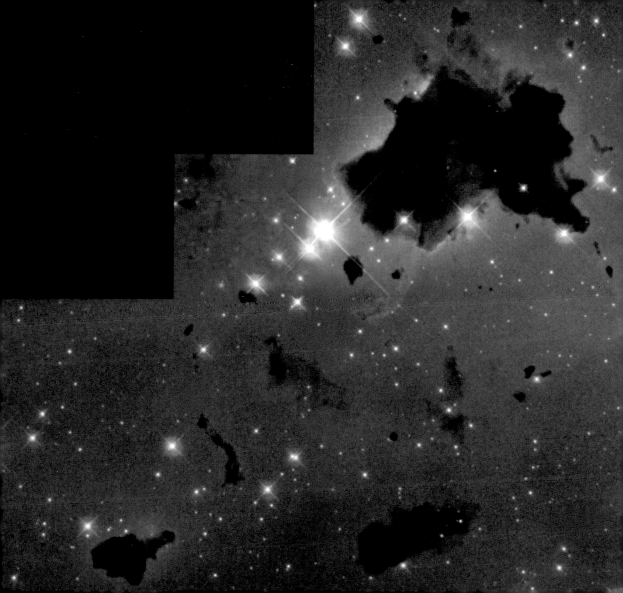

+ Barred Spiral Galaxy NGC 2903

NGC 2903 IS A SPIRAL GALAXY SIMILAR TO OUR OWN MILKY WAY GALAXY. SIMILARITIES INCLUDE ITS GENERAL SIZE AND A BAND OF stars across its center called a central bar. One striking difference, however, is the appearance of mysterious hot spots in NGC 2903's core. Upon inspection of this image and of similar images taken by the Hubble Space Telescope, these hot spots were found to be bright, young globular clusters, in contrast to the uniformly old globular clusters found in our Milky Way galaxy. Further investigation has indicated that current star formation is most rampant in a 2,000-light-year-wide circumnuclear ring surrounding NGC 2903's center. Astronomers hypothesize that the gravity of the central bar expedites star formation in this ring. NGC 2903 lies about 25 million light-years away and is visible with a small telescope toward the constellation Leo. CREDIT: ALMUDENA ALONSO-HERRERO (U. HERTFORDSHIRE) ET AL., HST, ESA, NASA

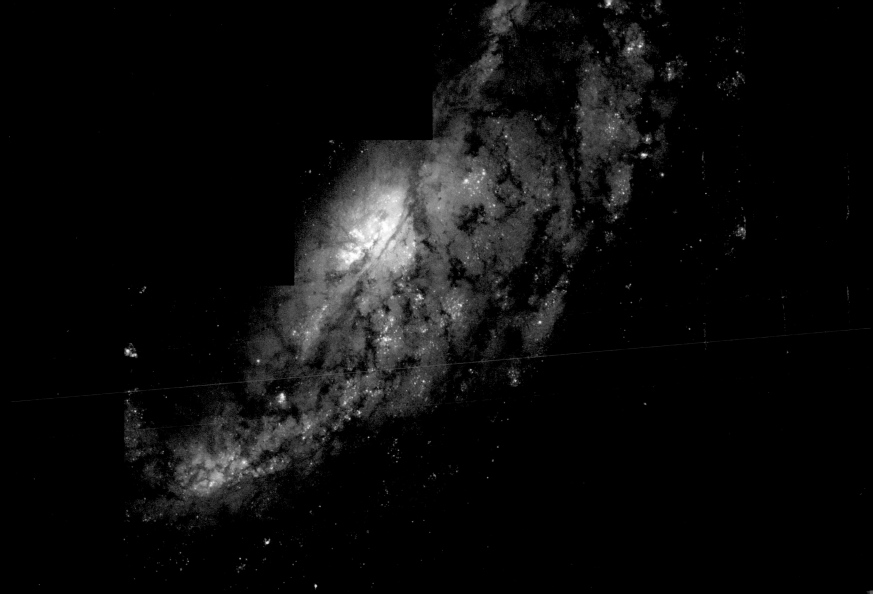

+ **A Solar System Portrait**

AS THE VOYAGER 1 SPACECRAFT HEADED OUT OF OUR SOLAR SYSTEM, IT LOOKED BACK AND TOOK A PARTING FAMILY PORTRAIT of the Sun and planets. From beyond Pluto, our solar system looks like a bright star surrounded by faint dots. In this picture, the Sun is so bright it needed to be blocked out for contrast. The innermost dots visible, labeled "E" and "V" for Earth and Venus, are particularly hard to discern. Gas giants Jupiter (J) and Saturn (S) are much more noticeable. The outermost planets visible are Uranus (U) and Neptune (N). Each planet is shown labeled and digitally enhanced in an inset image. Voyager 1 is only one of four man-made objects to leave our solar system, the other three being Voyager 2, Pioneer 10, and Pioneer 11. CREDIT: VOYAGER 1 TEAM, NASA

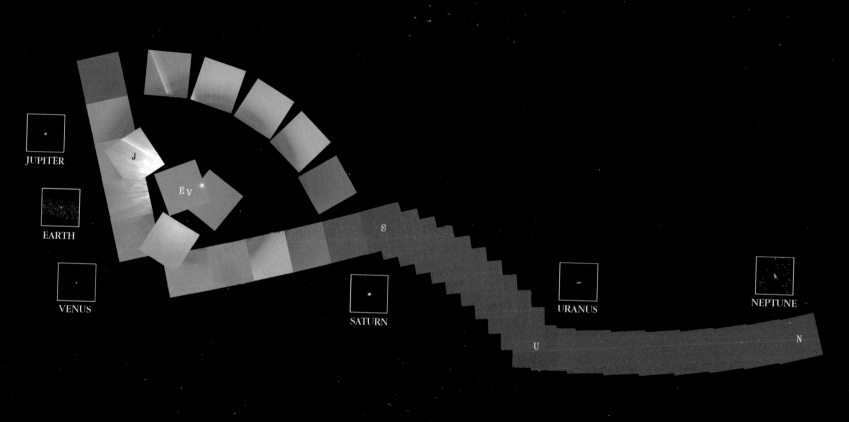

JUPITER

EARTH

VENUS

SATURN

URANUS

NEPTUNE

+ NGC 4676: When Mice Collide

THESE TWO GALAXIES ARE PULLING EACH OTHER APART. KNOWN AS "THE MICE" BECAUSE THEY HAVE SUCH LONG TAILS, each spiral galaxy has likely already passed through the other; they will probably collide again and again until they coalesce. The long tails are created by the relative difference between gravitational pull on the near and far parts of each galaxy. Because the distances between the galaxies are so large, the event takes place in seemingly slow motion—over hundreds of millions of years. NGC 4676 lies approximately 300 million light-years away from Earth, toward the constellation Coma Berenices, and "The Mice" are likely members of the Coma cluster of galaxies. This picture was taken with the Hubble Space Telescope's new Advanced Camera for Surveys that is more sensitive and images a field larger than previous Hubble cameras. The camera's increased sensitivity has captured, serendipitously, galaxies far in the distance, scattered about the frame.

CREDIT: ACS SCIENCE & ENGINEERING TEAM, NASA

+ **Venus Unveiled**

THE SURFACE OF VENUS IS PERPETUALLY COVERED BY A VEIL OF THICK CLOUDS AND REMAINS HIDDEN FROM EVEN THE powerful telescopic eyes of Earthbound astronomers. But in the early 1990s, using imaging radar, the Venus-orbiting Magellan spacecraft was able to lift the veil from the face of Venus and produced spectacular high-resolution images of the planet's surface. Colors used in this computer-generated picture of Magellan radar data are based on color images from the surface of Venus transmitted by the Soviet Venera 13 and 14 landers. The bright area running roughly across the middle represents the largest highland region of Venus known as Aphrodite Terra. CREDIT: MAGELLAN PROJECT, JPL, NASA

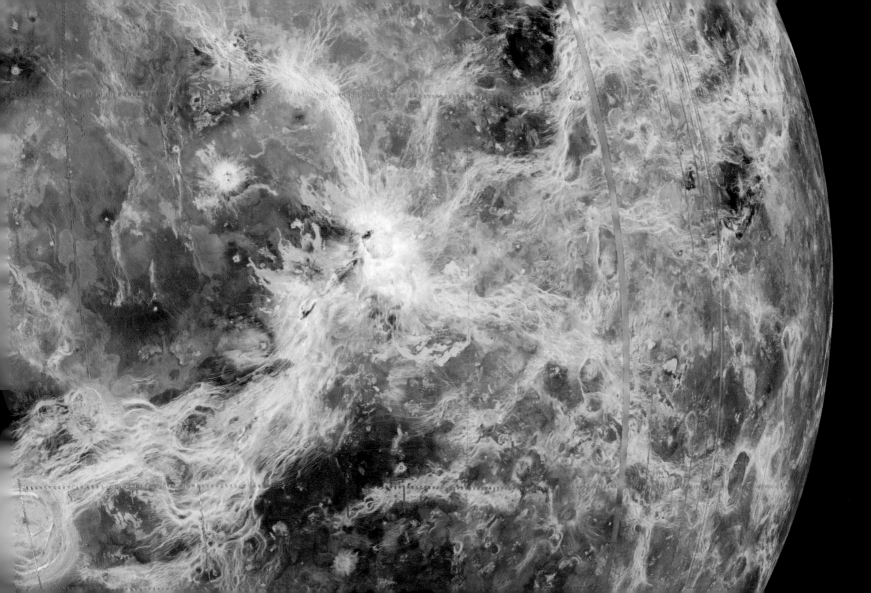

+ **GRO J1655-40: Evidence for a Spinning Black Hole**

IN THE CENTER OF A SWIRLING WHIRLPOOL OF HOT GAS IS LIKELY A BEAST THAT HAS NEVER BEEN SEEN DIRECTLY: A BLACK hole. Studies of the bright light emitted by the swirling gas frequently indicate not only that a black hole is present, but also its likely attributes. The gas surrounding GRO J1655-40, for example, has recently been found to display an unusual flickering at a rate of 450 times a second. Given a previous mass estimate for the central object of 7 times the mass of our sun, the rate of the fast flickering can be explained by a black hole that is rotating very rapidly. What physical mechanisms actually cause the flickering—and a slower quasiperiodic oscillation—in accretion disks surrounding black holes and neutron stars remains a topic of much research. DRAWING CREDIT: A. HOBART, CXC

+ **The M7 Open Star Cluster in Scorpius**

M7 IS ONE OF THE MOST PROMINENT OPEN CLUSTERS OF STARS ON THE SKY. THE CLUSTER, DOMINATED BY BRIGHT BLUE stars, can be seen with the naked eye in a dark sky in the tail of the constellation Scorpius. M7 contains approximately a hundred stars in total, is about 200 million years old and lies about 1,000 light-years away. This color picture was taken in 1995 at the Burrell-Schmidt Telescope at Kitt Peak National Observatory in Arizona. The M7 star cluster has been known since ancient times, being noted by Ptolemy in the year A.D. 130. Also visible are a dark dust cloud near the bottom of the frame and literally millions of unrelated stars toward the galactic center. CREDIT & COPYRIGHT: N. A. SHARP, REU PROGRAM, NOAO/AURA/NSF

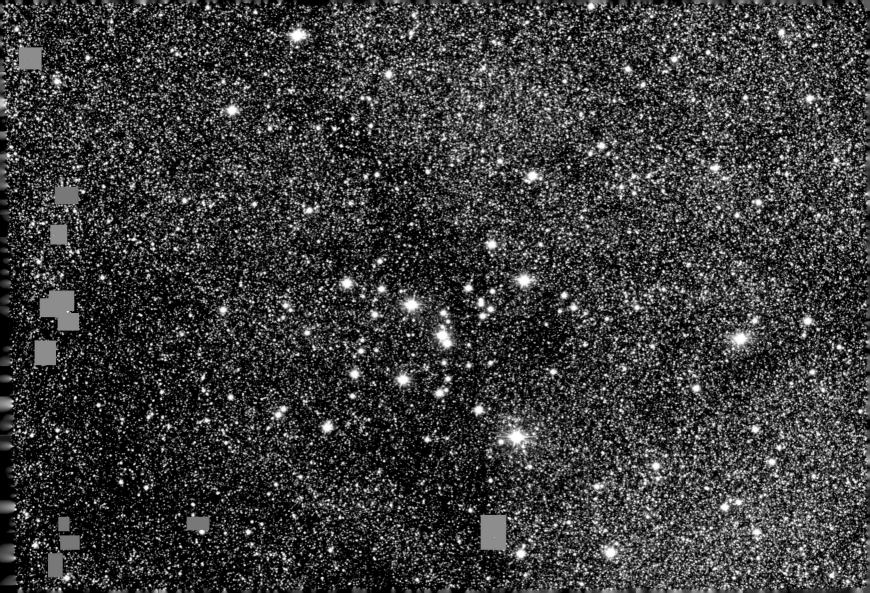

+ **Apollo 15's Home on the Moon**

COULD YOU EVER CALL THIS PLACE HOME? THE LUNAR MODULE SHOWN HERE, NAMED FALCON, SERVED AS HOME FOR APOLLO 15 astronauts David Scott and James Irwin during their stay on the Moon in July and August 1971. Meanwhile, astronaut Alfred Worden circled in the command module overhead. Harsh sunlight on the gray lunar surface lends the image an eerie quality, while the Lunar Apennine Mountains frame the background. Mount Hadley Delta is visible on the right. Visible in the foreground are tracks from the first Lunar Roving Vehicle, an electric car that enabled the astronauts to explore extended areas on the lunar surface. Apollo 15 confirmed that most lunar-surface features were created by impacts. Rocks returned by the Apollo 15 crew included green glass whose formation mechanism is still unclear. CREDIT: APOLLO 15 CREW, NASA

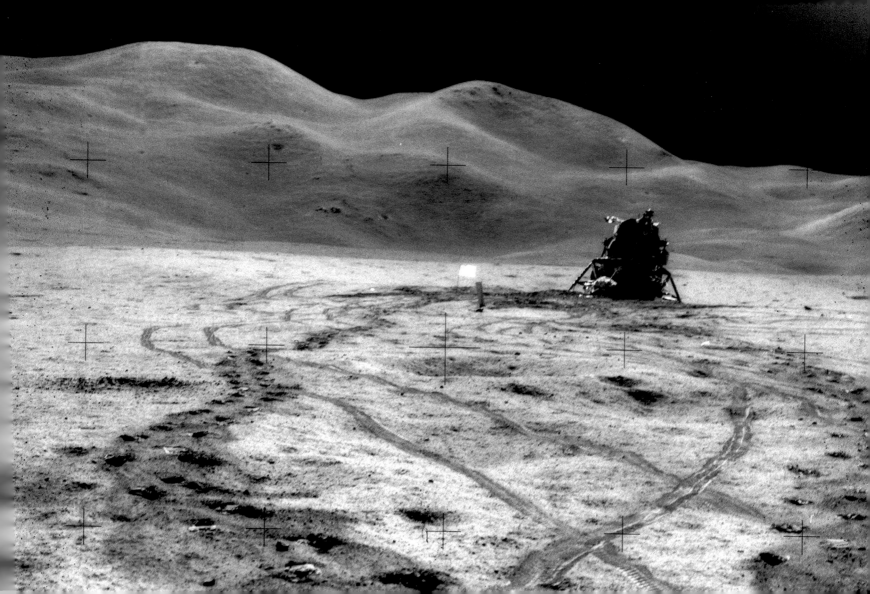

+ **Giant Cluster Bends, Breaks Images**

WHAT ARE THOSE STRANGE, BLUE OBJECTS? MANY ARE IMAGES OF A SINGLE, UNUSUAL, BEADED, BLUE, RINGLIKE GALAXY that just happens to line up behind a giant cluster of galaxies. Cluster galaxies here appear yellow and—together with the cluster's dark matter—act as a gravitational lens. A gravitational lens can create several images of background galaxies, analogous to the many points of light one would see while looking through a wine glass at a distant street light. The distinctive shape of this background galaxy, which is probably just forming, has allowed astronomers to deduce that it has separate images at 4, 8, 9, and 10 o'clock, from the center of the cluster. Possibly even the blue smudge just left of center is yet another image! This spectacular photograph from the Hubble Space Telescope was taken in October 1994. CREDIT: W. N. COLLEY & E. TURNER (PRINCETON), J.A. TYSON (LUCENT), HST, NASA

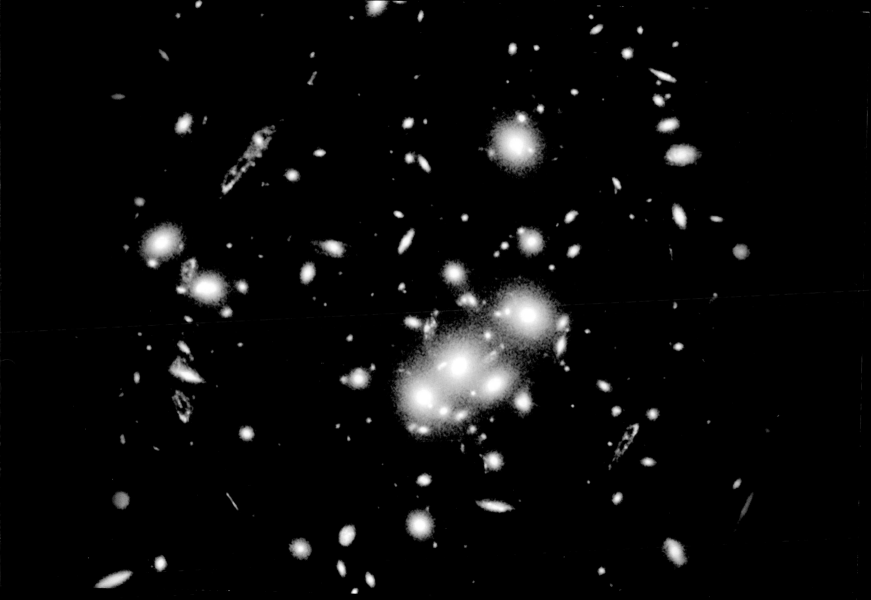

+ Warped Spiral Galaxy ESO 510-13

HOW DID SPIRAL GALAXY ESO 510-13 GET BENT OUT OF SHAPE? THE DISKS OF MANY SPIRALS ARE THIN AND FLAT, BUT NOT SOLID.

Spiral disks are loose conglomerations of billions of stars and diffuse gas, all gravitationally orbiting a galaxy center. A flat disk is thought to be created by sticky collisions of large, gas clouds early in the galaxy's formation. Warped disks are not uncommon, though, and even our own Milky Way galaxy is thought to have a small warp. The causes of spiral warps are still being investigated, but some warps are thought to result from interaction or even collisions between galaxies. ESO 510-13, pictured here, is approximately 150 million light-years away and measures about 100,000 light-years across. CREDIT: C. CONSELICE (U. WISCONSIN/STSCI) ET AL., HUBBLE HERITAGE TEAM (STSCI/AURA), NASA

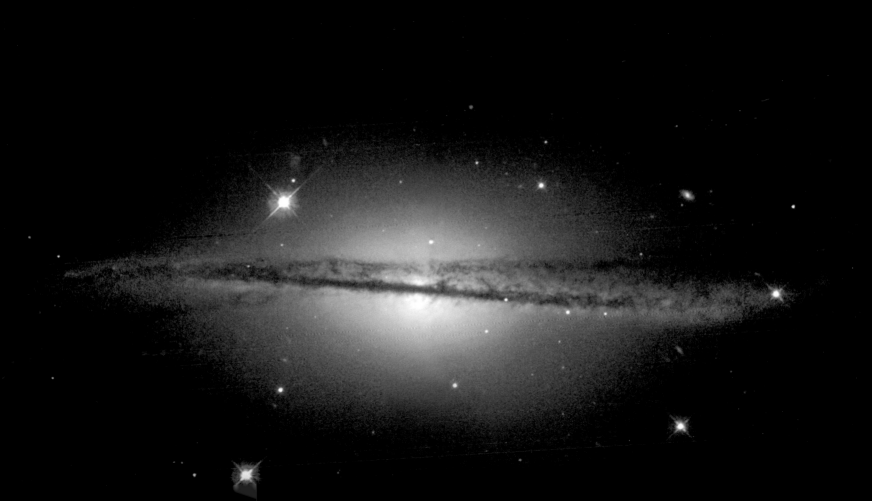

+ **All of Mars**

FROM POLE TO POLE AND EAST TO WEST, THIS IS ALL OF MARS. THIS PICTURE WAS DIGITALLY RECONSTRUCTED FROM OVER 200 million laser altimeter measurements taken by the Mars Global Surveyor spacecraft that orbited Mars in June 2001. The image strips Mars of its clouds and dust, and renders the whole surface visible simultaneously in its true daytime color. Particularly notable are the volcanoes of the Tharsis province, visible on the left, which are taller than any mountains on Earth. Just to the left of center is Valles Marineris, a canyon much longer and deeper than Earth's Grand Canyon. On the right, south of center, is the Hellas Planitia, a basin over 2,000 km wide that was likely created by a collision with an asteroid. Mars has many smooth lowlands in the north and many rough highlands in the south. CREDIT: NATIONAL GEOGRAPHIC SOCIETY, MOLA SCIENCE TEAM, MGS, JPL, NASA

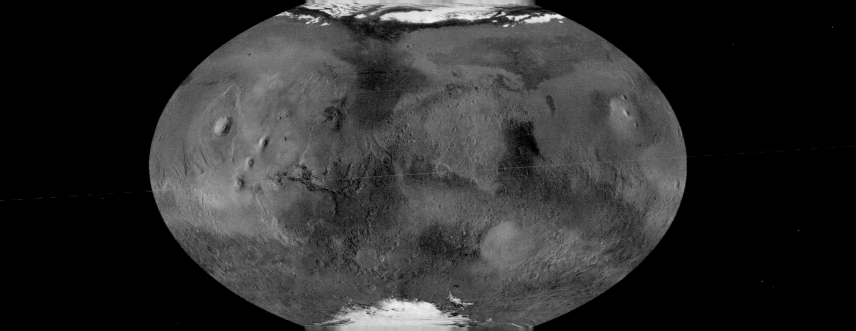

+ **A Cerro Tololo Sky**

HIGH ATOP A CHILEAN MOUNTAIN LIES ONE OF THE MAJOR OBSERVATORIES OF THE SOUTHERN SKY: CERRO TOLOLO. PICTURED here is the 4-meter Blanco Telescope, one of the premier telescopes of the Cerro Tololo Inter-American Observatory and of the past quarter-century. Far in the distance, beyond the telescope are thousands of individual stars and diffuse light from three galaxies: the Small Magellanic Cloud (upper left), the Large Magellanic Cloud (lower left), and our Milky Way galaxy (right). Visible just to Blanco's right is the famous chance superposition of four bright stars known as the Southern Cross. In this image, the observatory structures are lit solely by starlight. CREDIT & COPYRIGHT: ROGER SMITH, NOAO/AURA/NSF

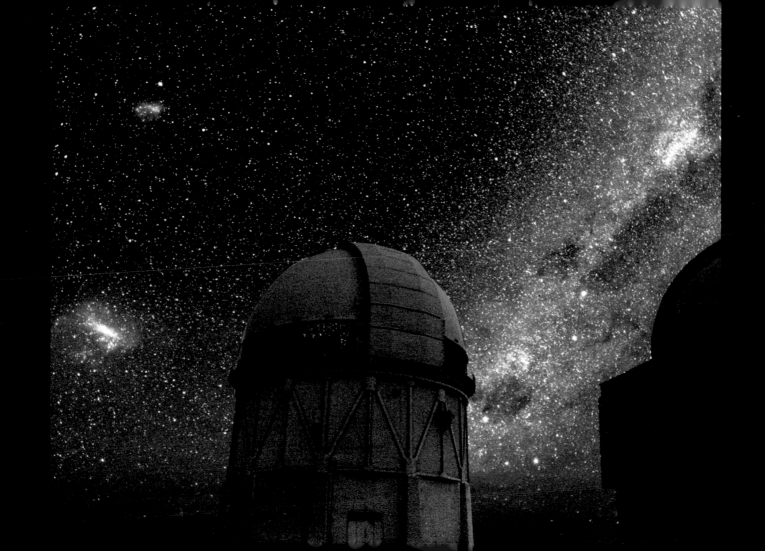

+ **A Halo around the Moon**

HAVE YOU EVER SEEN A HALO AROUND THE MOON? THIS FAIRLY COMMON SIGHT OCCURS WHEN HIGH, THIN CLOUDS containing millions of tiny ice crystals cover much of the sky. Each ice crystal acts like a miniature lens, although exactly how ice crystals form in clouds remains under investigation. Because most of the crystals have a similar elongated hexagonal shape, light entering one crystal face and exiting through the opposing face refracts 22 degrees, which corresponds to the radius of the Moon halo. A similar Sun halo may be visible during the day. The town in the foreground of this picture is San Sebastian, Spain. The distant planet Jupiter appears by chance on the halo's upper right. CREDIT & COPYRIGHT: JUAN CARLOS CASADO

+ **N44C: A Nebular Mystery**

WHY IS N44C GLOWING SO STRANGELY? THE STAR THAT APPEARS TO POWER THE NEBULA, ALTHOUGH YOUNG AND BRIGHT, does not seem hot enough to create some of the colors observed. A search for a hidden, hotter star in X rays has come up empty. One hypothesis is that the known central star has a neutron star companion in a very wide orbit. Hot X rays might only then be emitted during brief periods when the neutron star nears the known star and crashes through a disk of surrounding gas. Future observations could tell us the answer. N44C, pictured in this Hubble Space Telescope image, is an emission nebula in the Large Magellanic Cloud, a neighboring galaxy to our Milky Way galaxy. Flowing filaments of colorful gas and dark dust far from the brightest region are likely part of the greater N44c complex. It takes light approximately 125 light-years to cross N44C. CREDIT: DONALD GARNETT (U. ARIZONA) ET AL., HUBBLE HERITAGE TEAM, NASA

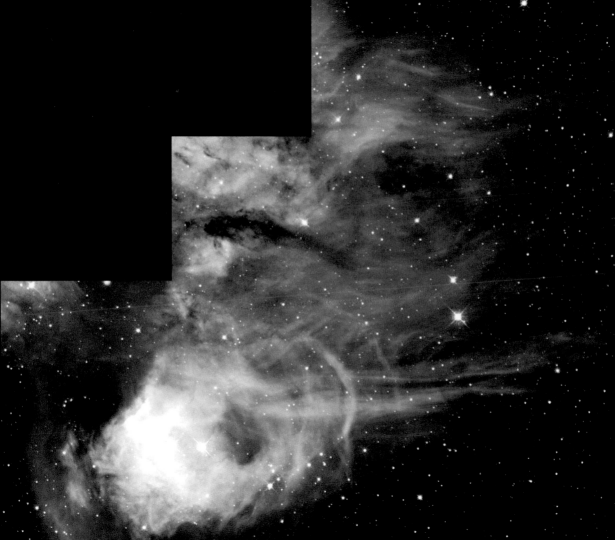

+ **The Far Infrared Sky**

THREE MAJOR SOURCES CONTRIBUTE TO THE FAR-INFRARED SKY: OUR SOLAR SYSTEM, OUR GALAXY, AND OUR UNIVERSE.

This image, released in 2000, in representative colors, is the highest resolution projection available of the entire far-infrared

sky created from years of observations by the now-defunct robot spacecraft COBE. Our solar system is evidenced most promi-

nently by the S-shaped blue sash called zodiacal light, consisting of small pieces of rock and dust orbiting between the Sun and

Jupiter. The disk of our galaxy is evidenced most prominently by the thin band of light-emitting dust that crosses the middle

of the image. Clouds and filaments of dust in our Milky Way also make intricate patterns, pervading most of the sky. Close

inspection of similar images reveals that the background is not completely dark, indicating that our universe itself provides a

diffuse glow, created by dust left over from star formation throughout the universe. CREDIT: E. L. WRIGHT (UCLA), COBE, DIRBE, NASA

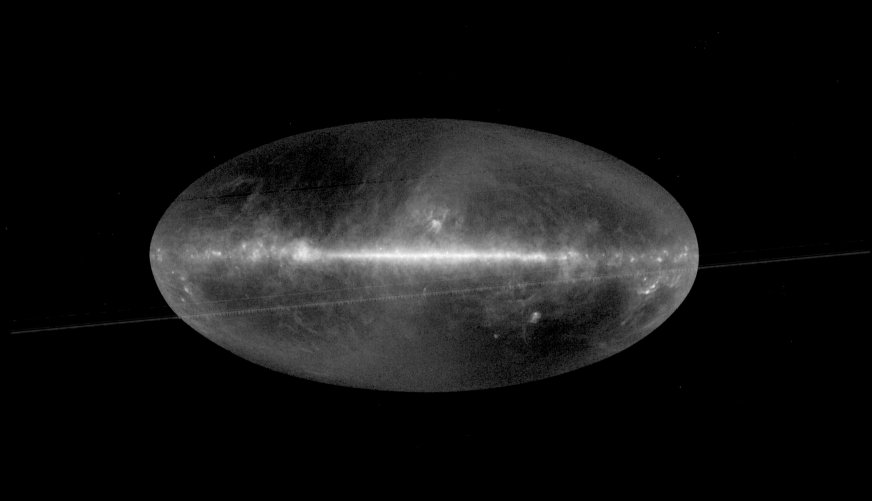

+ **The Near Infrared Sky**

WAS THIS PICTURE TAKEN FROM OUTSIDE OUR GALAXY? NO, IT IS A COMPOSITE TAKEN FROM EARTH'S ORBIT, WELL INSIDE our Milky Way galaxy. In light just a little too red for human eyes to see—"near-infrared" electromagnetic radiation—the disk and center of our galaxy stand out, giving an appearance likely similar to seeing our galaxy from the outside in visible light. This COBE image was reprocessed for higher resolution and shows red stars and dust in our galaxy superimposed against the faint glow of many dim stars in distant galaxies. Faintly visible as an S-shaped sash running through the image center is zodiacal light. Compared to the far-infrared sky, little galactic dust is visible. The two smudges on the lower right are the Large and Small Magellanic Clouds that are neighboring galaxies. CREDIT: E. L. WRIGHT (UCLA), COBE, DIRBE, NASA

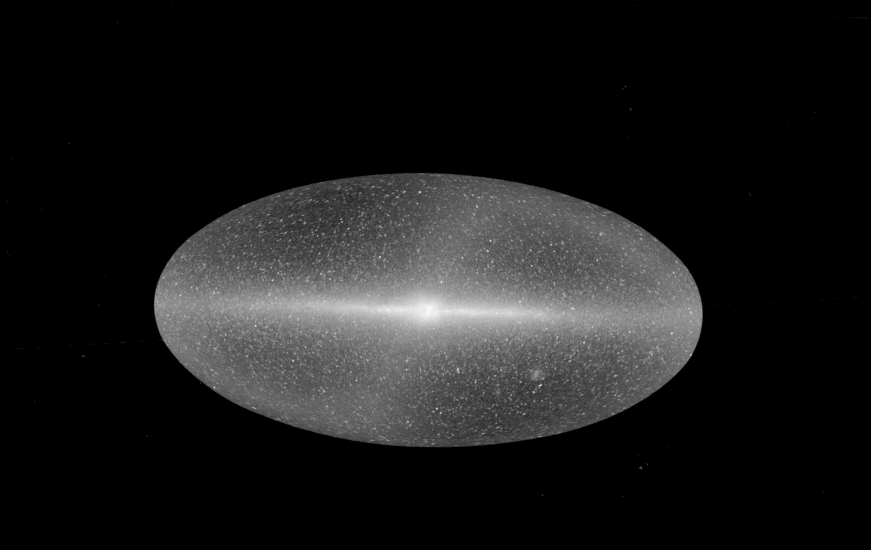

+ The Horsehead Nebula

ONE OF THE MOST IDENTIFIABLE NEBULAS IN THE SKY, THE HORSEHEAD NEBULA IN ORION IS PART OF A LARGE, DARK, molecular cloud. Also known as Barnard 33, the unusual shape was first discovered on a photographic plate in the late 1800s. The red glow originates from hydrogen gas predominantly behind the nebula, ionized by the nearby bright star Sigma Orionis. The darkness of the Horsehead is caused mostly by thick dust, although the lower part of the Horsehead's neck casts a shadow to the left. Streams of gas leaving the nebula are funneled by a strong magnetic field. Bright spots in the Horsehead Nebula's base are young stars just in the process of forming. Light takes approximately 1,500 years to reach us from the Horsehead Nebula. This image was taken with the 0.9-meter Telescope at Kitt Peak National Observatory. CREDIT: NIGEL SHARP, NOAO/AURA/NSF

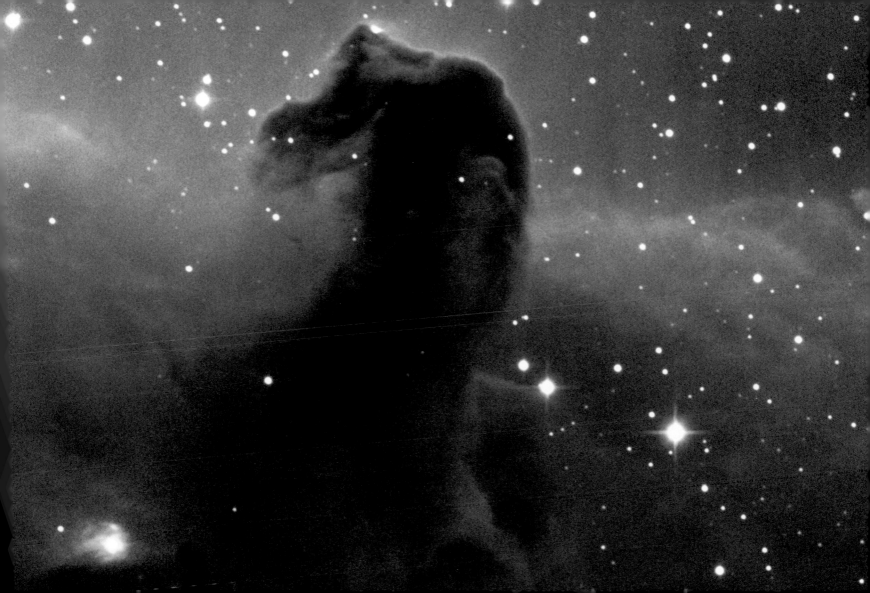

+ **Sagittarius Star Cloud**

STARS COME IN ALL DIFFERENT COLORS. THE COLOR OF A STAR INDICATES ITS SURFACE TEMPERATURE, AN IMPORTANT property used to assign each star a spectral type. Most stars in the Sagittarius Star Cloud are orange or red and relatively faint, as our Sun would appear if it were part of the cloud. The blue and greenish stars are hotter, many being relatively young and massive. The bright red stars are cool, red giants, bloated stars once similar to our sun that have entered a more advanced stage of evolution. Stars of the Sagittarius Cloud lie toward the center of our galaxy—tantalizing cosmic jewels viewed through a rift in the dark, pervasive, interstellar dust. This famous stellar grouping houses some of the oldest stars known. CREDIT: HUBBLE HERITAGE TEAM (AURA/ STSCI/ NASA)

+ **Sunspot Loops in Ultraviolet**

IT WAS A QUIET DAY ON THE SUN. THIS IMAGE SHOWS, HOWEVER, THAT EVEN DURING OFF DAYS THE SUN'S SURFACE IS A busy place. Shown in ultraviolet light, the relatively cool, dark regions have temperatures of thousands of degrees Celsius. Large sunspot group AR 9169 is visible as the bright area near the horizon. The bright, glowing gas flowing around the sunspots has a temperature of over 1 million degrees Celsius. The reason for the high temperatures is unknown but thought to be caused by the rapidly changing magnetic field loops that channel solar plasma. Sunspot group AR 9169 moved across the Sun during September 2000 and decayed in a few weeks. CREDIT: TRANSITION REGION AND CORONAL EXPLORER (TRACE)

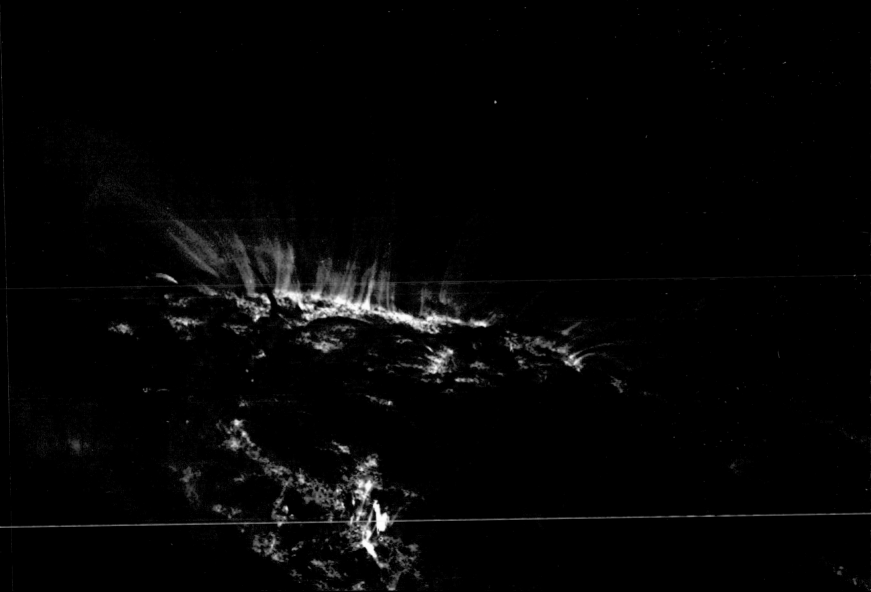

+ **Spiral Galaxy NGC 1232**

GALAXIES ARE FASCINATING NOT ONLY FOR WHAT IS NOT, BUT FOR WHAT IS INVISIBLE. GRAND SPIRAL GALAXY NGC 1232, captured in detail by one of the new Very Large Telescopes, is a good example. The visible is dominated by millions of bright stars and dark dust, caught up in a gravitational swirl of spiral arms rotating about the center. Open clusters containing bright blue stars can be seen sprinkled along these spiral arms, while dark lanes of dense, interstellar dust can be seen sprinkled between them. Less visible, but detectable, are billions of dim, normal stars and vast tracts of interstellar gas, together wielding such high mass that they dominate the dynamics of the inner galaxy. Invisible are even greater amounts of matter in a form we don't yet know. CREDIT: FORS1, 8.2-METER VLT ANTU, ESO

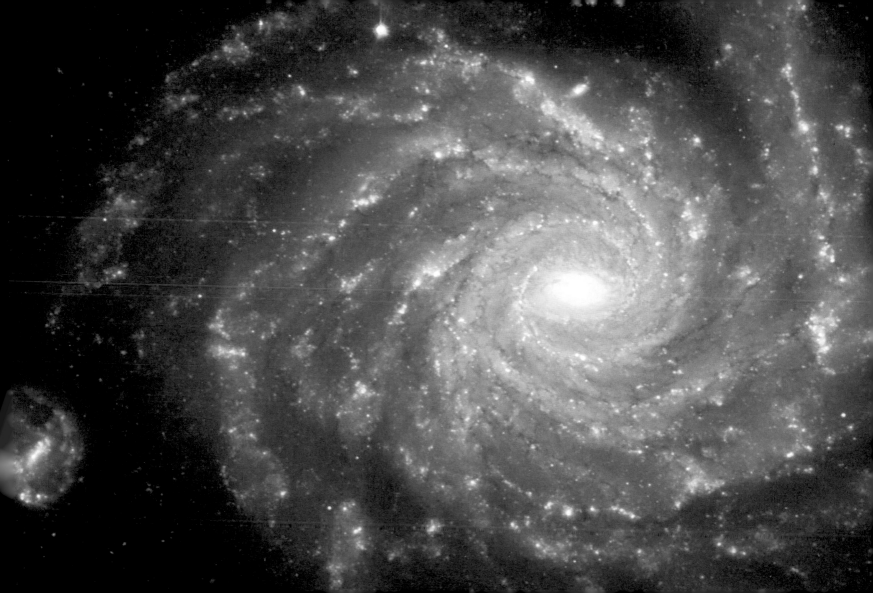

+ **IC 4406: A Seemingly Square Nebula**

HOW CAN A ROUND STAR MAKE A SQUARE NEBULA? THIS CONUNDRUM COMES TO LIGHT WHEN WE ARE STUDYING PLANETARY nebulas like IC 4406. Evidence indicates that IC 4406 is likely a hollow cylinder; its square appearance the result of our vantage point in viewing it from the side. Were IC 4406 viewed from the top, it would likely look similar to the Ring Nebula. This representative-color picture is a composite made by combining images taken by the Hubble Space Telescope in June 2001 and January 2002. Hot gas flows out of the ends of the cylinder, while filaments of dark dust and molecular gas lace the bounding walls. The star primarily responsible for this interstellar sculpture can be found in the planetary nebula's center. In a few million years, the only thing left visible in IC 4406 will be a fading white dwarf star. CREDIT: C. R. O'DELL (VANDERBILT U.) ET AL., HUBBLE HERITAGE TEAM, NASA

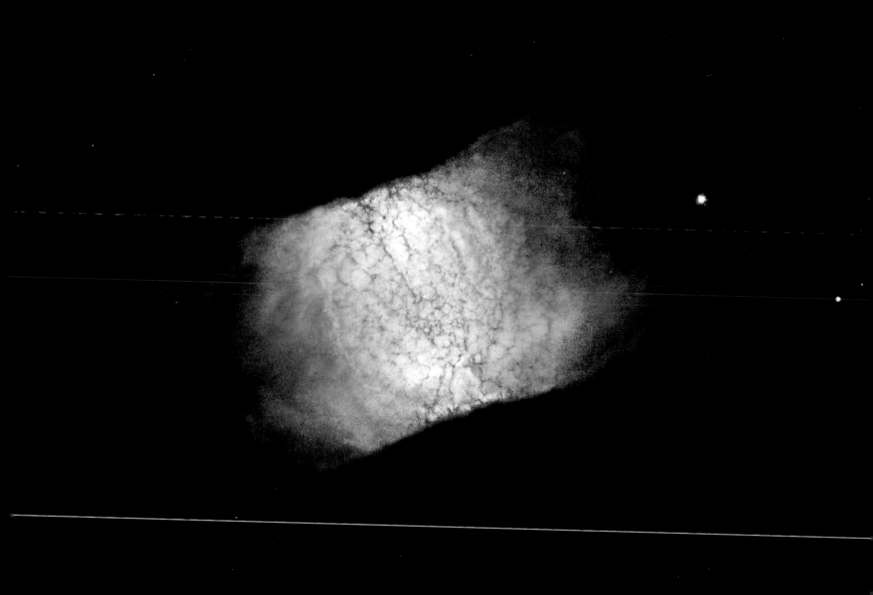

+ **Pleiades, Planets, and Hot Plasma**

BRIGHT STARS OF THE PLEIADES, FOUR PLANETS, AND ERUPTING SOLAR PLASMA ARE ALL CAPTURED IN THIS IMAGE FROM THE space-based SOlar and Heliospheric Observatory (SOHO). In the foreground of the 15-degree-wide field of view, a bubble of hot plasma, called a coronal mass ejection, is blasting away from the active Sun whose position and relative size is indicated by the central white circle. Beyond appear four of the five naked-eye planets—courtesy of the May 2000 planetary alignment that did not destroy the world! In the background are distant stars and the famous Pleiades star cluster, also easily visible to the unaided eye when it shines in the night sky. Distances for these familiar celestial objects are: the Sun, 150 million km away; Mercury, Venus, Jupiter, and Saturn, approximately 58, 110, 780, and 1,400 million km beyond the Sun respectively; and the Pleiades star cluster, a mere 3,800 trillion km away (400 light-years). SOHO itself orbits 1.5 million km sunward of planet Earth. The image was recorded by the Large Angle and Spectrometric COronagraph (LASCO) instrument onboard SOHO on Monday, May 15, 2000, at 10:42 Universal Time. CREDIT: SOHO - LASCO CONSORTIUM, ESA, NASA

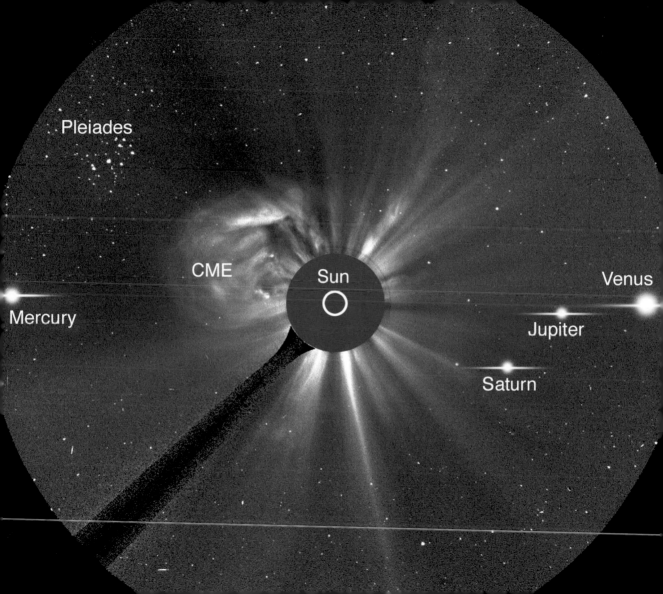

+ **A Piece of Interplanetary Dust**

THE DUST THAT PERVADES OUR SOLAR SYSTEM IS NOT THE DUST THAT PERVADES OUR HOMES. SOLAR-SYSTEM DUST COMES

from comets and asteroids, whereas house dust is most likely lint or dead cells. Pictured here is a piece of interplanetary dust

caught by a high-flying U2-type aircraft. It likely originates from the early days of our solar system, having been stored and later

ejected by a passing comet. The particle is composed of glass, carbon, and a conglomeration of silicate mineral grains. It measures

only 10 microns across, a tenth the width of a typical human hair. NASA's STARDUST mission, launched in 1999, is scheduled

to pass through the tail of comet Wild 2 in 2004 and return many more interstellar dust samples to Earth in 2006. CREDIT: NASA

+ **Alpha Centauri: The Closest Star System**

THE CLOSEST STAR SYSTEM TO THE SUN IS THE ALPHA CENTAURI SYSTEM. OF THE THREE STARS IN THE SYSTEM, THE dimmest—called Proxima Centauri—is actually the nearest star. The bright stars Alpha Centauri A and B form a close binary as they are separated by only 23 times the distance from Earth to the Sun——a distance slightly greater than the distance between Uranus and the Sun. In this picture, the brightness of the stars overwhelms the photograph, causing an illusion of great size, even though the stars are really just small points of light. The Alpha Centauri system is not visible in much of the Northern Hemisphere. Alpha Centauri A, also known as Rigil Kentaurus, is the brightest star in the constellation of Centaurus and is the fourth-brightest star in the night sky. Sirius is the brightest, even though it is more than twice as far away. By an exciting coincidence, Alpha Centauri A is the same type of star as our Sun, causing many to speculate that the Alpha Centauri system might contain planets that harbor life. CREDIT AND COPYRIGHT: STSCI DIGITIZED SKY SURVEY, ANGLO-AUSTRALIAN OBSERVATORY

+ **Cosmic Ripples Implicate Dark Universe**

WHAT MAY APPEAR FUZZY TO SOME MAKES THINGS CRYSTAL CLEAR TO OTHERS. THE COSMIC MICROWAVE BACKGROUND RADIATION emanating from the universe could only have this fuzzy pattern if the universe contained clear amounts of dark matter and dark energy. This conclusion, based on a detailed analysis of the temperature and spacing of the bumps in the cosmic pattern, was a surprise to those who felt that previous evidence for such a strange universe, based on observations of distant supernovas, was somehow inaccurate. The measurements were made with a novel group of microwave telescopes in Tenerife, Spain, called the Very Small Array. The bumps appearing here are some of the oldest objects ever seen. CREDIT: VERY SMALL ARRAY COLLABORATION

+ **White Rock Fingers on Mars**

WHAT CAUSED THIS UNUSUAL WHITE ROCK FORMATION ON MARS? INTRIGUED BY THE POSSIBILITY THAT THE FORMATION was the result of salt deposits left over as an ancient lakebed dried-up, detailed studies of these fingers now indicate a more mundane origin: volcanic ash. Studying the exact color of the formation indicated volcanic origin. The light material appears to have eroded away from surrounding area, indicating a very low-density substance consistent with the ash hypothesis. The stark contrast between the rocks and the surrounding sand is compounded by the unusual darkness of the sand. This picture was taken with the Thermal Emission Imaging System on the Mars Odyssey spacecraft. CREDIT: THEMIS, MARS ODYSSEY TEAM, ASU, JPL, NASA

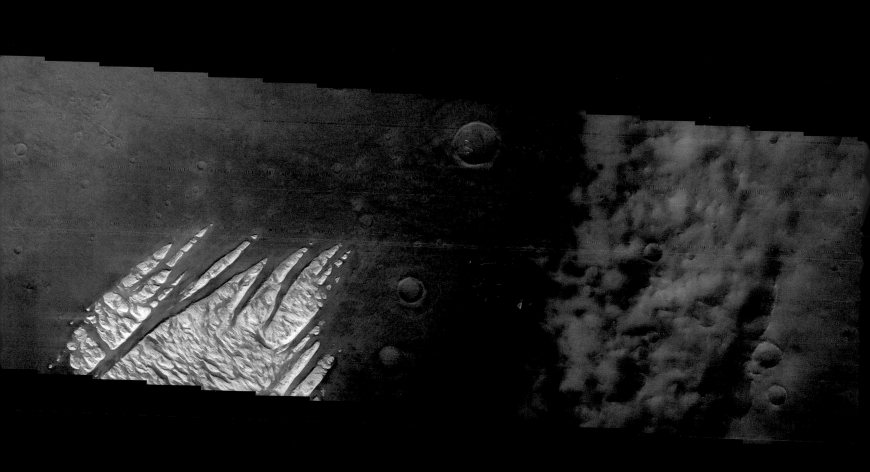

MAY

01
02
03
04
05
06
07
08
09
10
11
12
13
14
15
16
17
18
19
20
21
22
23
24
25
26
27
28
29
30
31

+ **Working in Space**

HIGH ABOVE PLANET EARTH, A HUMAN HELPS AN AILING MACHINE. THE MACHINE, IN THIS POTENTIALLY TOUCHING STORY,

is the Hubble Space Telescope, not pictured. The human is astronaut Steven L. Smith, and he is seen here retrieving a power tool

from the handrail of the Remote Manipulator System before resuming work on the HST in December 1999. Since many space mis-

sions involve costly equipment and complicated experiments, astronauts are usually people of considerable knowledge and training.

Although the hours may be long and the work may be taxing, one frequently reported perk of working in space is the spectacular

view. CREDIT: STS-103 CREW, NASA

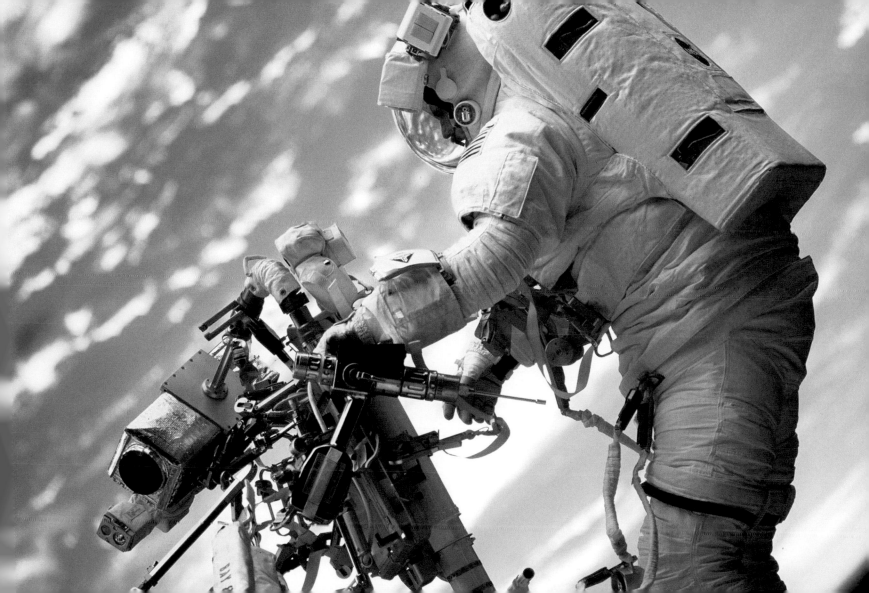

01
02
03
04
05
06
07
08
09
10
11
12
13
14
15
16
17
18
19
20
21
22
23
24
25
26
27
28
29
30
31

+ **The Very Large Array Turns Twenty**

THE MOST PHOTOGENIC ARRAY OF RADIO TELESCOPES IN THE WORLD HAS ALSO BEEN ONE OF THE MOST PRODUCTIVE. EACH of the twenty-seven radio telescopes in the Very Large Array (VLA) is the size of a house and can be moved on train tracks. The VLA, celebrating its twentieth year of operation, is pictured here in a compact formation in front of Tres Montosas, New Mexico. The VLA has been used to discover water on planet Mercury, radio-bright coronas around ordinary stars, micro-quasars in our galaxy, gravitationally induced Einstein rings around distant galaxies, and radio counterparts to cosmologically distant gamma-ray bursts. The vast size of the VLA has allowed astronomers to study the details of super-fast cosmic jets and even to map the center of our galaxy. CREDIT: BELOW: COURTESY NRAO/AUI. PHOTOGRAPHER DAVE FINLEY; OPPOSITE: CHRISTIAN DEICHERT

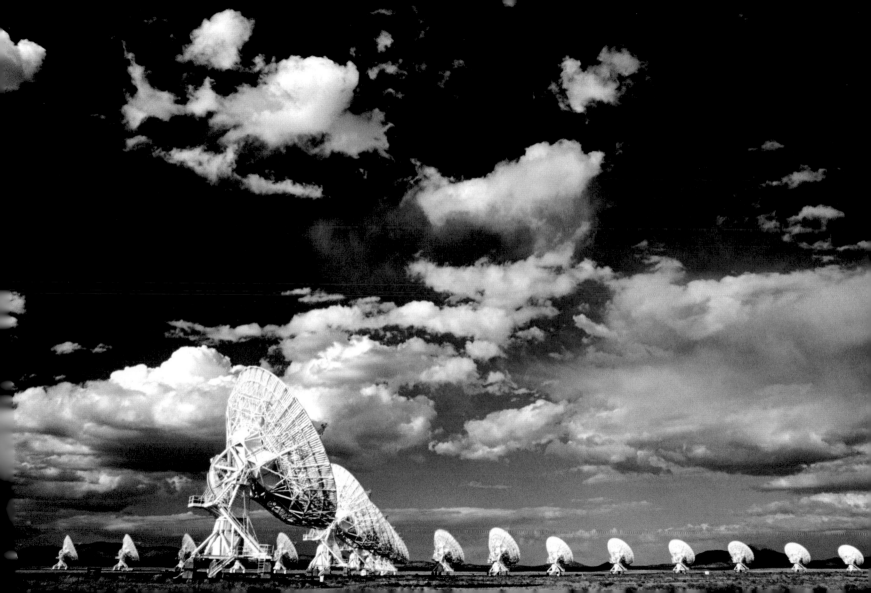

+ **Phobos: Doomed Moon of Mars**

MARS, THE RED PLANET NAMED FOR THE ROMAN GOD OF WAR, HAS TWO TINY MOONS, PHOBOS AND DEIMOS, WHOSE NAMES are derived from the Greek for "Fear" and "Panic." These martian moons may well be captured asteroids originating in the main asteroid belt between Mars and Jupiter or perhaps from even more distant reaches of the solar system. In this 1978 Viking 1 orbiter image, the large moon, Phobos, is indeed seen to be a heavily cratered asteroidlike object. Approximately 27 km across, Phobos really zips through the martian sky. Actually rising above Mars' western horizon and setting in the east, it completes an orbit in less than 8 hours. But Phobos is doomed. Phobos orbits so close to Mars (about 5,800 km above the surface; compare that to the Earth-to-Moon distance of 400,000 km) that gravitational tidal forces are dragging it down. In 100 million years or so it will likely crash into the surface of Mars or be shattered by stress caused by the relentless tidal forces, the debris forming a ring around Mars. CREDIT: VIKING PROJECT, JPL, NASA. IMAGE MOSAIC BY EDWIN V. BELL II (NSSDC/RAYTHEON ITSS)

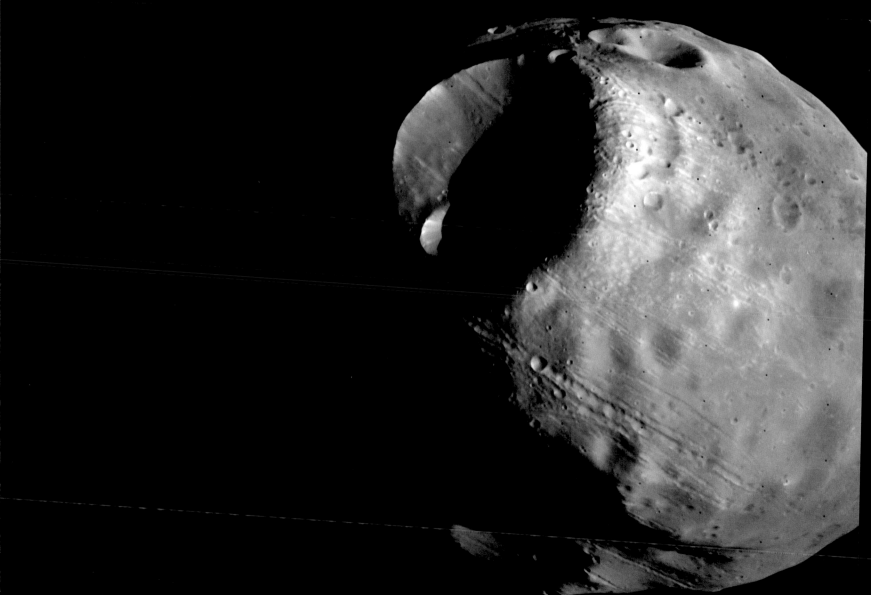

+ **Dust Hip Deep on Phobos**

LANDING ON THE MARTIAN MOON PHOBOS MIGHT BE HARDER THAN PREVIOUSLY THOUGHT. THE REASON: MOON DUST. RECENT photographs of Phobos have indicated that a layer of fine powder estimated to be a meter deep covers the entire surface. Evidence comes from infrared pictures that indicate the rapid speed with which Phobos's surface cools after sunset. This high-resolution image was taken from martian orbit by the Mars Global Surveyor spacecraft as it approached Phobos in 1998. The larger and innermost of two martian moons, Phobos measures approximately 20 km across and rotates once every 7 hours. The large 10-km diameter crater seen in sunlight at the bottom left is called Stickney. CREDIT: MARS GLOBAL SURVEYOR PROJECT, MSSS, JPL, NASA

+ An Unusual Globule in IC 1396

IS THERE A MONSTER IN IC 1396? KNOWN TO SOME AS THE ELEPHANT'S TRUNK NEBULA, PARTS OF GAS AND DUST CLOUDS OF THIS star-forming region may appear to take on foreboding forms, some nearly human. The only real monster here, however, is a bright young star too far from Earth to hurt us. Energetic light from this star is eating away the dust of the dark cometary globule near the top of this image. Jets and winds of particles emitted from this star are also pushing away ambient gas and dust. Nearly 3,000 light-years distant, the relatively faint IC 1396 complex covers a much larger region on the sky than shown here, with an apparent width of more than ten full moons. CREDIT & COPYRIGHT: CANADA–FRANCE–HAWAII TELESCOPE/JEAN-CHARLES CUILLANDRE/1999

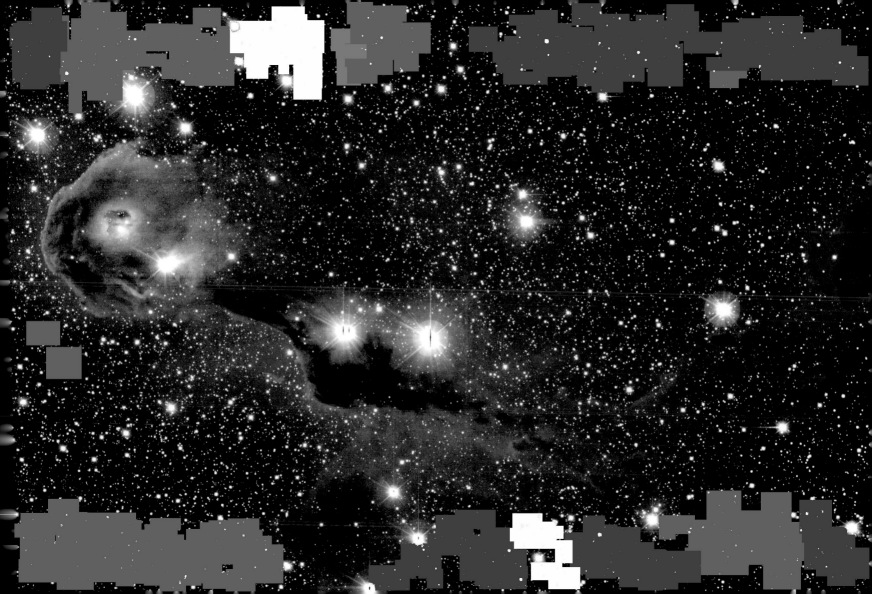

+

+ Galaxies Away

THIS STRIKING PAIR OF GALAXIES IS FAR, FAR AWAY . . . ABOUT 350 MILLION LIGHT-YEARS FROM EARTH. CATALOGUED AS AM 0500-620, the pair is located in the southern constellation Dorado. The background elliptical and foreground spiral galaxy are representative of two of the three major classes of galaxies that inhabit our universe. Within the disks of spiral galaxies, like our own Milky Way, gas, dust, and young blue star clusters trace out grand spiral arms. The dust lanes along the arms of this particular spiral stand out dramatically in this Hubble Space Telescope image, as they obligingly sweep in front of the background elliptical. Like the central bulges of spiral galaxies, elliptical galaxies tend toward spherical shapes resulting from the random motions of their stars. But while spirals produce new stars, star formation in ellipticals that lack gas and dust seems to have stopped. How do galaxies evolve with cosmic time? Evidence is growing that graceful galaxy shapes can hide a violent history. CREDIT: W. KEEL AND R. WHITE (U. ALABAMA), NASA

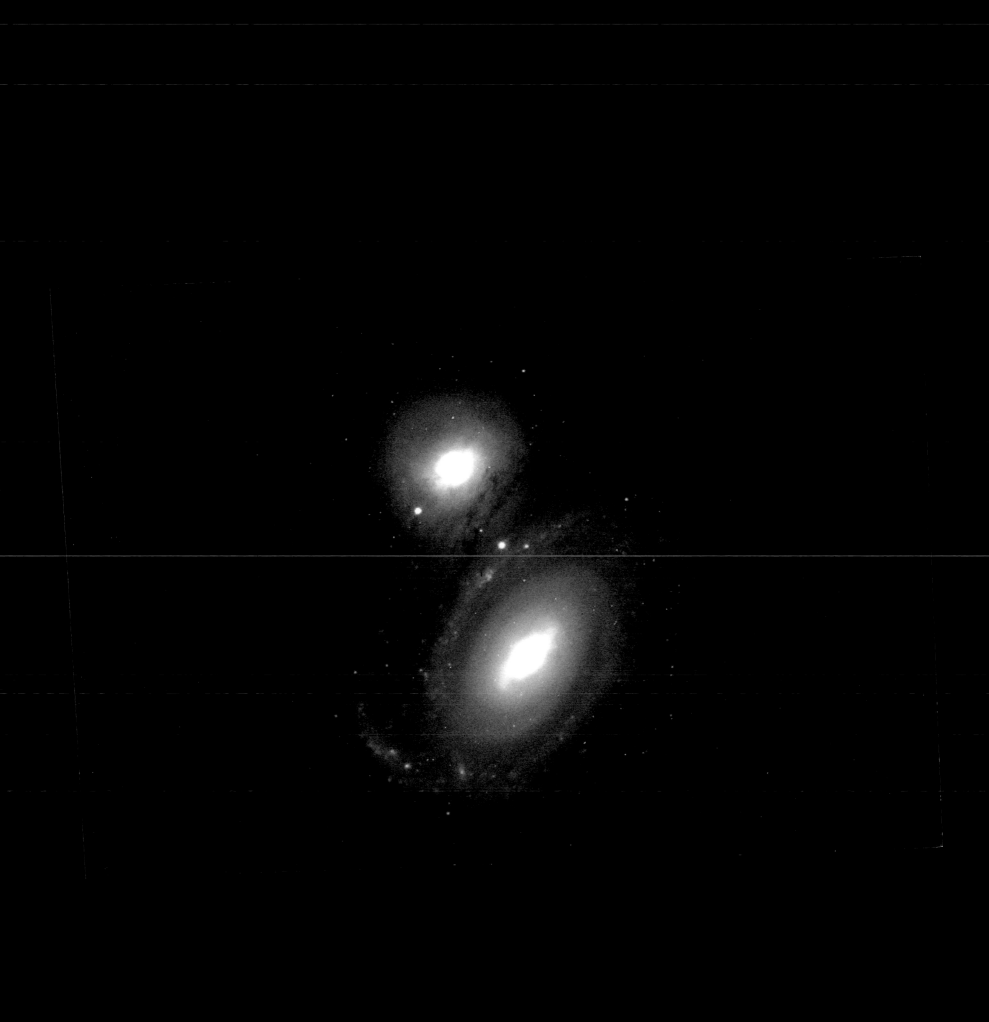

+ MyCn18: An Hourglass Nebula

THE SANDS OF TIME ARE RUNNING OUT FOR THE CENTRAL STAR OF THIS HOURGLASS-SHAPED PLANETARY NEBULA. WITH ITS nuclear fuel exhausted, this brief, spectacular, closing phase of a sun-like star's life occurs as its outer layers are ejected—its core becoming a cooling, fading white dwarf. In 1995, astronomers used the Hubble Space Telescope to make a series of images of planetary nebulas, including the one pictured. Here, delicate rings of colorful glowing gas (nitrogen: red, hydrogen: green, and oxygen: blue) outline the tenuous walls of the "hourglass." The unprecedented sharpness of the HST images has revealed surprising details of the nebula ejection process and may help resolve the outstanding mystery of the variety of complex shapes and symmetries of planetary nebulas. CREDIT: R. SAHAI AND J. TRAUGER (JPL), WFPC2, HST, NASA

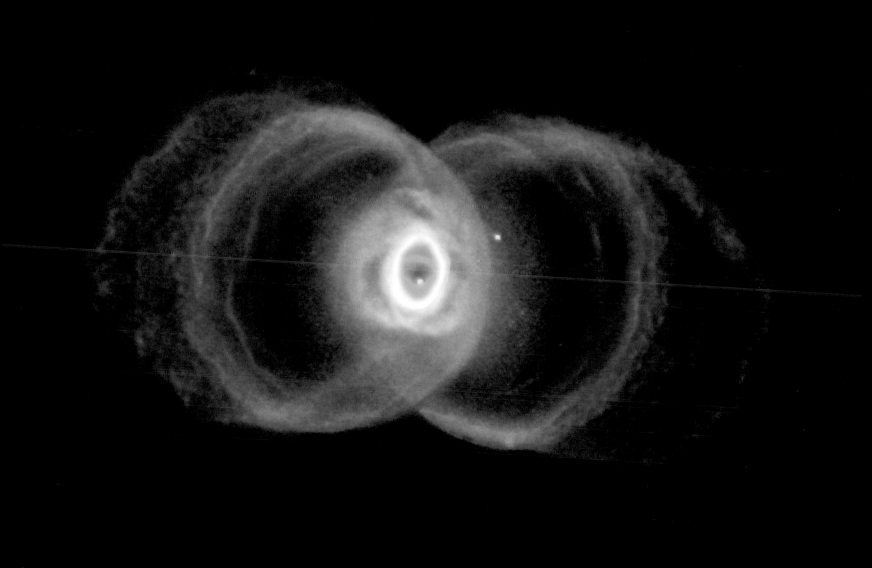

+ **In the Heart of the Crab**

THE SUPERNOVA EXPLOSION THAT FORMED THE CRAB NEBULA WAS FIRST SEEN IN THE YEAR A.D. 1054. IN JUNE 2000, ASTRONOMERS released a new image of the still-evolving center of the explosion. This representative-color photograph was taken in colors emitted by specific elements including hydrogen (orange), nitrogen (red), sulfur (pink), and oxygen (green), with the result appearing oddly similar to a Jackson Pollock painting. Visible is a complex array of gas filaments rushing out at over 5 million km per hour. Even at these tremendous speeds, though, it takes a filament over 600 years to cross the 3-light-year-wide frame. The rapidly spinning neutron star remnant of this ancient cataclysm is visible as the lower of the two bright stars just above the center of the photograph. The Crab Nebula (M1) is located 6,500 light-years away toward the constellation of Taurus. CREDIT: WILLIAM P. BLAIR (JHU) ET AL. HUBBLE HERITAGE TEAM (STSCI/AURA), NASA

+ **A Continuous Eruption on Jupiter's Moon Io**

A VOLCANO ON JUPITER'S MOON IO HAS BEEN PHOTOGRAPHED DURING AN ONGOING ERUPTION. HOT, GLOWING LAVA IS visible on the left of this representative-color image. A landscape of plateaus and valleys covered in sulfur and silicate rock surrounds the active volcano. Many of these features, including several of the dark spots, have been seen to change over a matter of months when compared with this and other flyby images recorded by the robot Galileo spacecraft. Io is slightly larger than Earth's moon and is the closest large moon to Jupiter. This image shows a region approximately 250 km across. How the internal structure of Io creates these active volcanoes remains under investigation. CREDIT: GALILEO PROJECT, JPL, NASA

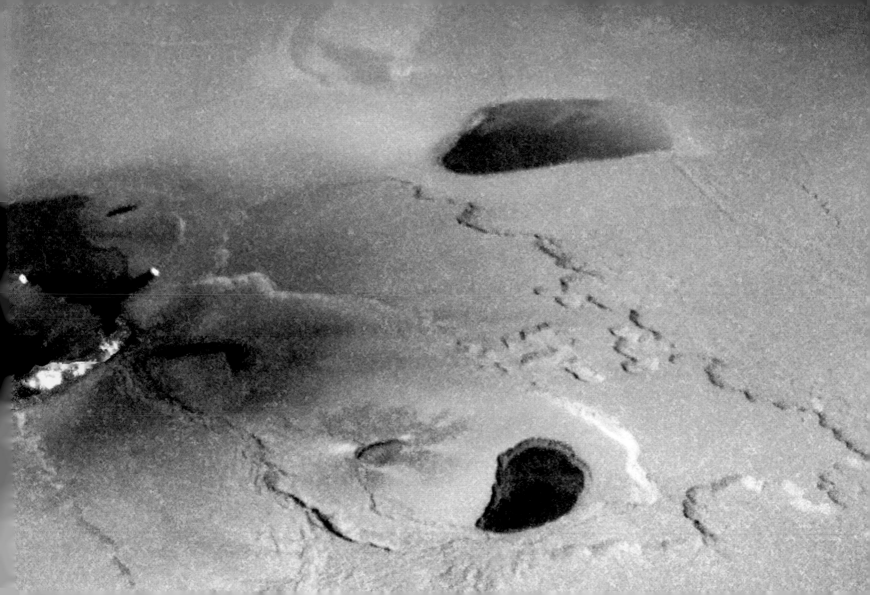

01
02
03
04
05
06
07
08
09
10
11
12
13
14
15
16
17
18
19
20
21
22
23
24
25
26
27
28
29
30

+ **Annular Eclipse: The Ring of Fire**

+

EVERY YEAR, A FEW LUCKY PEOPLE MAY HAVE THE OPPORTUNITY TO SEE A "RING OF FIRE." THAT'S THE NAME FOR A CENTRAL

view of an annular eclipse of the Sun by the Moon. At the peak of an annular eclipse, the middle of the Sun appears to be missing.

In fact, the dark silhouette of the Moon is seen surrounded by the Sun. An annular eclipse occurs instead of a total eclipse when

the Moon is on the more distant part of its elliptical orbit around Earth. This spectacular annular eclipse was photographed

behind palm trees in January 1992. In this case, the ring of fire was only visible from a path that crossed the Pacific Ocean.

From most of eastern Asia and western North America, the Moon only appeared to take a bite out of the sun. CREDIT & COPYRIGHT:

DENNIS MAMMANA (SKYSCAPES)

+ **Active Regions, CMEs, and X-Class Flares**

ON JUNE 8, 2000, SPACE WEATHER FORECASTERS PREDICTED MAJOR STORM CONDITIONS AS THE ACTIVE SUN HAD PRODUCED AT least three strong flares and a large coronal mass ejection (CME) since June 6. This false-color X-ray image of the Sun shows the active region generating the explosive events as the dominant bright area just above center. X-ray hot plasma suspended in looping magnetic fields arcs above this region, catalogued as AR 9026. AR 9026 appeared as a large group of sunspots in visible-light images. The three intense flares were all X-class events, the most severe class of solar flares based on X-ray flux measurements by the Earth-orbiting GOES satellites. Energetic particles from the CME, associated with the second X-class flare, were directed toward planet Earth. Their arrival a few days later was expected to trigger geomagnetic storms, with possible effects ranging from increased auroral displays to disruptions of satellites, communications systems, and electrical power grids. CREDIT: ISAS, YOHKOH PROJECT, SXT GROUP

+ **Apollo 17's Lunar Rover**

IN DECEMBER 1972, APOLLO 17 ASTRONAUTS EUGENE CERNAN AND HARRISON SCHMIDT SPENT ABOUT 75 HOURS EXPLORING THE Moon's Taurus-Littrow Valley while colleague Ronald Evans orbited overhead. Cernan and Schmidt were the last humans to walk or ride on the Moon—aided in their explorations by a Lunar Roving Vehicle. The skeletal-looking lunar rover was just over 3 meters long, 2 meters wide, and easily carried astronauts, equipment, and rock samples in the Moon's low gravity, which is approximately a sixth of Earth's. In this picture, Cernan tests the rover before they load its scientific equipment. Later, an umbrella-shaped high gain antenna and TV camera were mounted in the front. Powered by four 1/4-horsepower electric motors, one for each wheel, this rover was driven a total of about 29 km across the lunar surface. Its estimated top speed was a blazing 13 km per hour. CREDIT: APOLLO 17, NASA

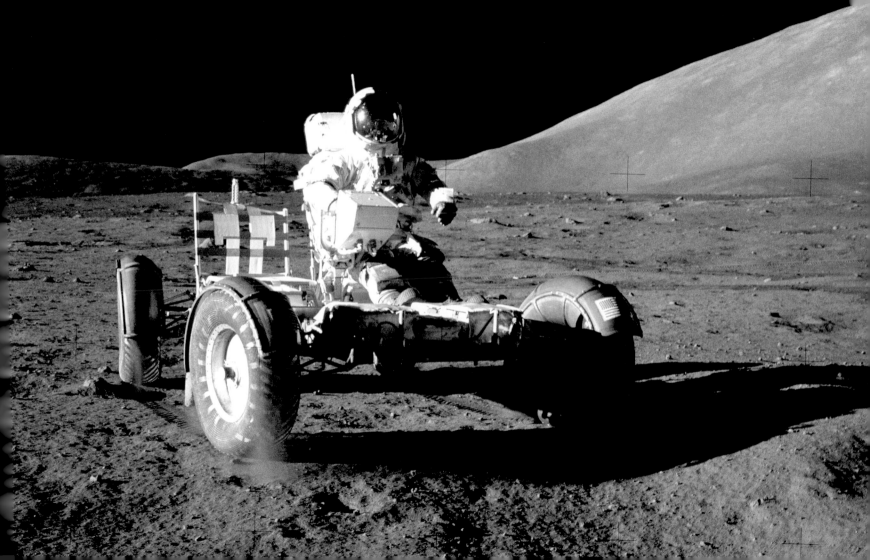

+ **Hydrogen, Helium, and the Stars of M10**

STARS LIKE THE SUN USE HYDROGEN FOR FUEL, "BURNING" HYDROGEN INTO HELIUM AT THEIR CORES THROUGH NUCLEAR FUSION.

But what happens when that hydrogen runs out? For a while, hydrogen burns in a shell surrounding the stellar core, and the star expands to become a red giant. The bright reddish orange stars in this beautiful two-color composite picture of the old globular star cluster M10 are examples of this phase of stellar evolution. Yet the bright blue stars apparent in M10 have evolved beyond the simple, hydrogen shell-burning stage. These stars have become "horizontal branch" giants with core temperatures hot enough to burn helium into carbon. In this image, only the barely visible, faint, gray-looking stars are likely to still be burning hydrogen at their cores.

CREDIT & COPYRIGHT: TILL CREDNER, SVEN KOHLE (BONN UNIVERSITY), HOHER LIST OBSERVATORY

+ **AB Aurigae: How to Make Planets**

THIS ENHANCED HUBBLE SPACE TELESCOPE IMAGE SHOWS IN REMARKABLE DETAIL THE INNER PORTION OF THE DISK OF dust and gas surrounding the star AB Aurigae. Knots of material, visible here for the first time, may well represent an early stage of a process resulting in the formation of planets over the next few million years. AB Aurigae is a young star (2 to 4 million years old), approximately 469 light-years distant. It is surrounded by a swirling disk about 30 times the size of our solar system. Astronomers believe planet making is just beginning in AB Aurigae's disk because known disks surrounding younger stars (less than 1 million years old) do not show such clumpy structure, while disks of slightly older stars (8 to 10 million years old) have gaps and features suggesting that planets have already been formed. Why the windowpane appearance? Wide black stripes in the picture are caused by opaque strips used to block out the overwhelming starlight and reveal the relatively faint disk. The distracting diagonal streaks are imaging artifacts. CREDIT: C.A. GRADY (NOAO, NASA/GSFC), ET AL., NASA

01
02
03
04
05
06
07
08
09
10
11
12
13
14
15
16
17
18
19
20
21
22
23
24
25
26
27
28
29
30

+

+ **A Bubbling Galaxy Center**

WHAT'S HAPPENING IN THE CENTER OF THIS GALAXY? CLOSE INSPECTION OF THE CENTER OF NGC 4438, AS VISIBLE IN THIS representative-color image by the Hubble Space Telescope, reveals an unusual bubble of hot gas (lower left). Astronomers speculate that this strange bubble was created by a massive central black hole that resides there. As gas swirls around the black hole, gravity and friction pull it in and heat it up. Some of the hot gas then falls into the black hole, but not all—some gas gets so hot it shoots out of the poles in fast jets. When these jets impact nearby material, the gas heats up, and this causes the detected glow. Galaxy NGC 4438 resides approximately 50 million light-years from Earth, and the pictured central bubble measures about 800 light-years across.

CREDIT: JEFFREY KENNEY (YALE) ET AL., WFPC2, HST NASA

+ **The Carina Nebula in Infrared**

+

APPROXIMATELY 3 MILLION YEARS AGO, THE STARS IN THE KEYHOLE NEBULA BEGAN TO FORM. THIS PICTURE OF THE KEYHOLE Nebula, also known as the Carina Nebula or NGC 3372, shows in infrared light many facets of this dramatic stellar nursery that lies only 9,000 light-years away. Fine dust reflects starlight while being heated and emitting light of its own. Open clusters Trumpler 14 and Trumpler 16 are visible on the upper left and center of the nebula. The bright star near Trumpler 14 is called Eta Carinae and is one of the most unusual stars known. A candidate for a supernova in the next few thousand years, Eta Carinae faded from being one of the brightest stars in the sky during the 1800s. Despite intensive study, astronomers remain unsure whether Eta Carinae is part of a binary star system. CREDIT: 2MASS COLLABORATION, U. MASS., IPAC

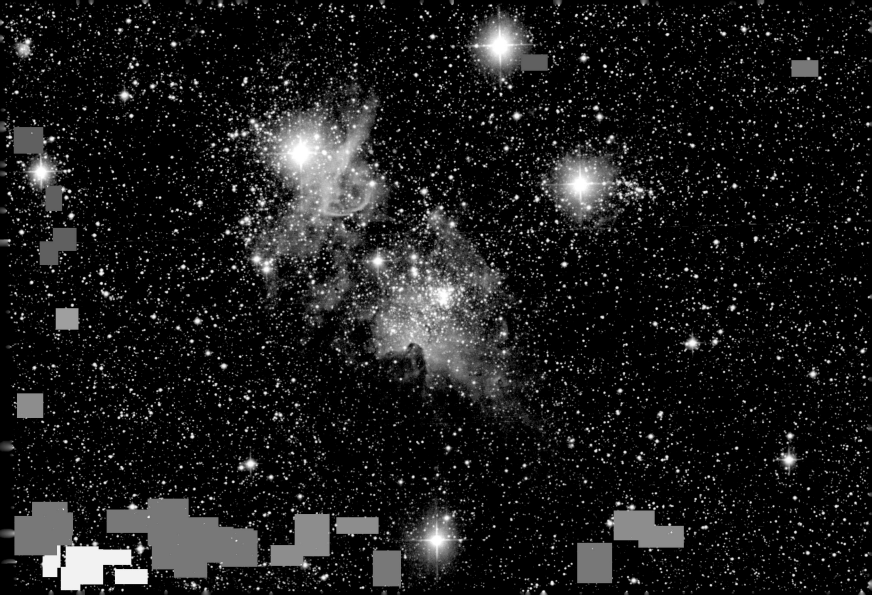

01
02
03
04
05
06
07
08
09
10
11
12
13
14
15
16
17
18
19
20
21
22
23
24
25
26
27
28
29
30

+ **Venus: Just Passing By**

+

VENUS, THE SECOND-CLOSEST PLANET TO THE SUN, IS A POPULAR DESTINATION FOR SPACECRAFT ULTIMATELY HEADED FOR THE

giant gas planets in the outer reaches of the solar system. Why visit Venus first? Using a "gravity-assist" maneuver, spacecraft can

swing by planets and gain energy during their brief encounter, saving fuel for use at the end of their long interplanetary voyage.

This colorized image of Venus was recorded by the Jupiter-bound Galileo spacecraft shortly after its gravity-assist flyby of Venus in

February 1990. Galileo's glimpse of the veiled planet shows structure in swirling sulfuric acid clouds. The bright area is sunlight

glinting off the upper cloud deck. The Saturn-bound Cassini spacecraft completed its own second flyby of Venus on June 24, 1999.

Launched in October 1997, Cassini should reach Saturn in July 2004. CREDIT: GALILEO PROJECT, JPL, NASA

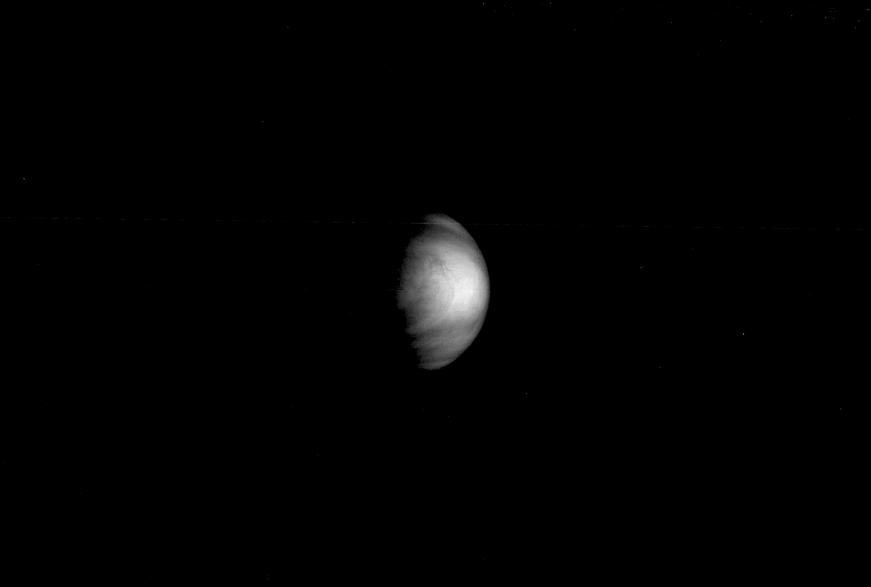

+ **Messiers and Mars**

A TELESCOPIC TOUR OF THE CONSTELLATION SAGITTARIUS OFFERS THE MANY BRIGHT CLUSTERS AND NEBULAS OF DIMEN-

sioned space in a starscape surrounding the galactic center. This gorgeous color deep-sky photograph visits two such lovely sights,

catalogued by the eighteenth century cosmic tourist Charles Messier as M8 and M20. M20 (upper left), the Trifid Nebula, presents

a striking contrast in red and blue colors and dark dust lanes. Just below and to the right is the expansive, alluring red glow of M8,

the Lagoon Nebula. Both nebulas are a few thousand light-years distant; at the far right, though, the dominant celestial beacon is a

"local" source, the planet Mars. Just passing through Sagittarius and strongly overexposed in this picture, the Red Planet is a short

4 light-minutes away. In May 2001, Mars was near its closest approach to planet Earth since 1988. The planet rose about sunset

and could be seen for most of the night shining brightly at about –2.3 magnitude. Urban imager Michael Cole recorded this

photograph at 3:00 A.M. on May 20, 2001, in clear skies over Camp Hancock, Oregon. CREDIT & COPYRIGHT: MICHAEL COLE

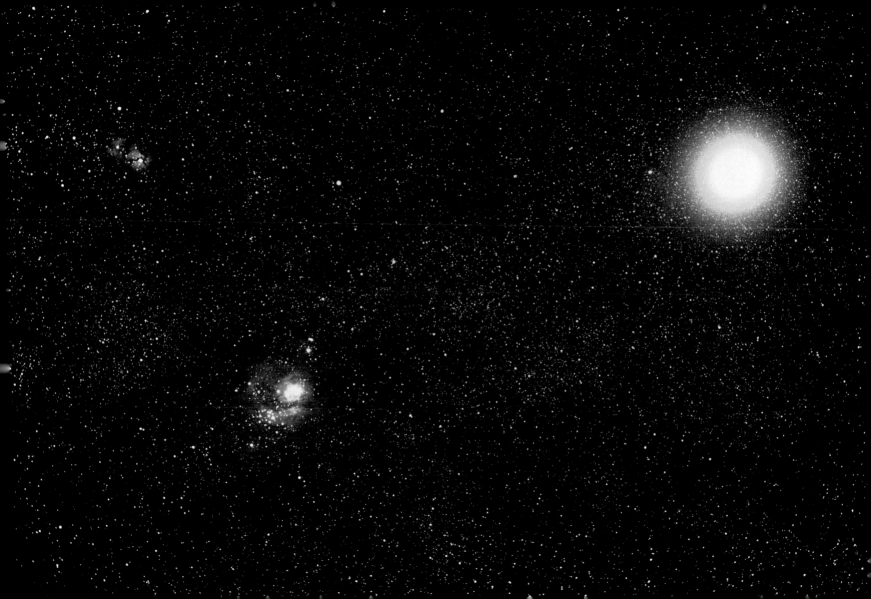

+ **Too Close to a Black Hole**

WHAT WOULD YOU SEE IF YOU WENT RIGHT UP TO A BLACK HOLE? HERE ARE TWO COMPUTER-GENERATED IMAGES HIGH-lighting how strange things would look. On the left is a normal star field containing the constellation Orion. Notice the three stars of nearly equal brightness that make up Orion's Belt. On the right is the same star field but this time with a black hole superimposed in the center of the frame. The black hole has such strong gravity that light is noticeably bent toward it—causing some very unusual visual distortions. In the distorted frame, every star in the normal frame has at least two bright images—one on each side of the black hole. In fact, near the black hole, you can see the whole sky—light from every direction is bent around and comes back to you. Black holes are thought to be the densest state of matter, and there is indirect evidence for their presence in stellar binary systems and the centers of globular clusters, galaxies, and quasars. CREDIT & COPYRIGHT: ROBERT NEMIROFF (MTU)

+ **A Sky Full of Hydrogen**

INTERSTELLAR SPACE IS FILLED WITH EXTREMELY TENUOUS CLOUDS OF GAS THAT ARE MOSTLY HYDROGEN. THE NEUTRAL hydrogen atom (HI in astronomer's shorthand) consists of one proton and one electron. The proton and electron spin like tops but can have only two orientations: spin axes parallel or antiparallel. It is a rare event for hydrogen atoms in the interstellar medium to switch from the parallel to the antiparallel configuration, but when they do, they emit radio waves with a wavelength of 21 centimeters (approximately 8 inches) and a corresponding frequency of exactly 1,420 MHz. Tuned to this frequency, radio telescopes have mapped the neutral hydrogen in the sky. This image represents such an all-sky HI survey with the plane of our Milky Way galaxy running horizontally through the center. In this false-color image no stars are visible, just diffuse clouds of gas tens to hundreds of light-years across which cluster near the plane. The gas clouds seem to form arcing, looping structures, stirred up by stellar activity in the galactic disk. CREDITS: J. DICKEY (UMN), F. LOCKMAN (NRAO), SKYVIEW

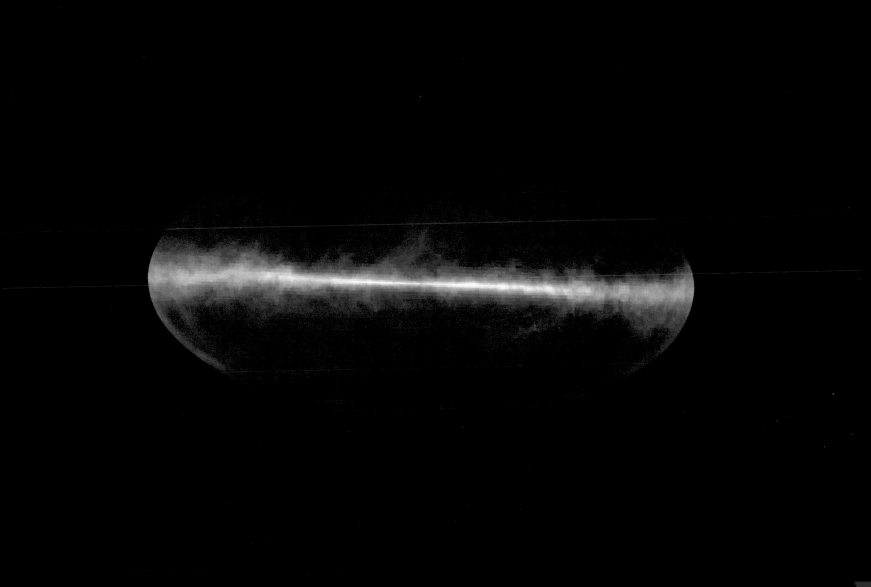

01
02
03
04
05
06
07
08
09
10
11
12
13
14
15
16
17
18
19
20
21
22
23
24
25
26
27
28
29
30

+ **NGC 4755: A Jewel Box of Stars**

THE GREAT VARIETY OF STAR COLORS IN THIS OPEN CLUSTER UNDERLIES ITS NAME: THE JEWEL BOX. ONE OF THE BRIGHT central stars is a red supergiant, in contrast to the many blue stars that surround it. The cluster, also known as Kappa Crucis, contains just over one hundred stars, and is approximately 10 million years old. Open clusters are younger, contain fewer stars, and contain a much higher fraction of blue stars than do globular clusters. This Jewel Box lies about 7,500 light-years away, so the light that we see today was emitted from the cluster before even the Great Pyramids in Egypt were built. The Jewel Box, pictured here, spans about 20 light-years, and can be seen with binoculars toward the southern constellation Crux.

CREDIT & COPYRIGHT: MICHAEL BESSELL (RSAA, ANU), MSO

+ **Crescent Neptune and Triton**

GLIDING SILENTLY THROUGH THE OUTER SOLAR SYSTEM, THE VOYAGER 2 SPACECRAFT CAMERA CAPTURED NEPTUNE AND

Triton together in crescent phase in 1989. This picture of the giant gas planet and its cloudy moon was taken from behind, just

after the spacecraft's closest approach. It could not have been taken from Earth because Neptune never shows a crescent phase

to sunward Earth. The unusual vantage point also robs Neptune of its familiar blue hue, as sunlight seen from here is scattered

forward, and so is reddened like the setting Sun. Neptune is smaller but more massive than Uranus, has several dark rings, and

emits more energy than it receives from the Sun. CREDIT: VOYAGER 2, NASA

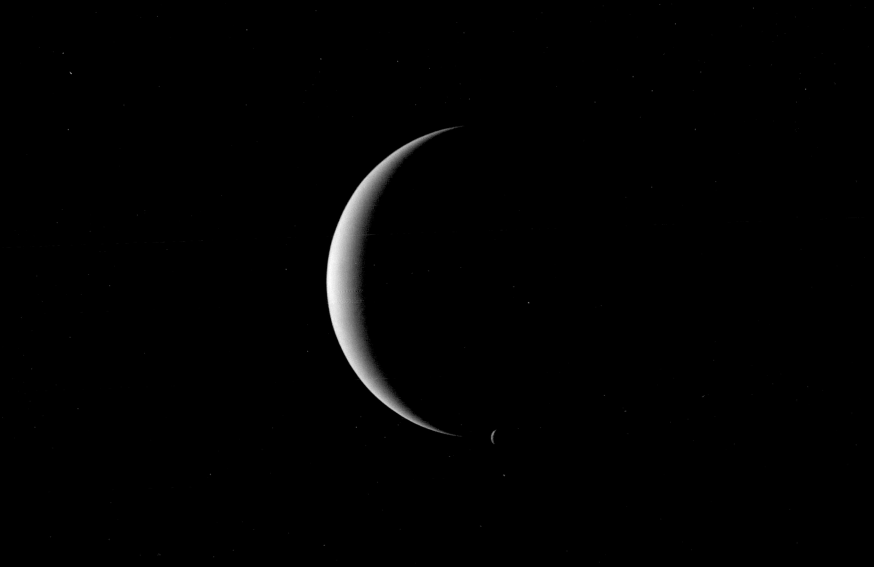

+ **Total Eclipse of the Active Sun**

A TOTAL ECLIPSE OF THE SUN IS THAT SPECIAL GEOCENTRIC CELESTIAL EVENT WHERE THE MOON PASSES EXACTLY IN FRONT of the solar disk. During a fleeting few minutes of totality, fortunate Earth dwellers located within the path of the Moon's dark shadow can witness the wondrous shimmering solar corona sharing the sky with stars and bright planets. For solar eclipses occurring near the maximum of the Sun's 11-year activity cycle, careful eclipse-watchers can also often see the spectacle of bright solar prominences lofted above active regions around the Sun's edge, as in this stunningly detailed image. The telescopic picture of the eclipsed Sun was taken in August 1999, only a year or so shy of the most recent solar maximum, and recorded at the beginning of totality from Kecel, Hungary. CREDIT & COPYRIGHT: MICHAEL KOBUSCH

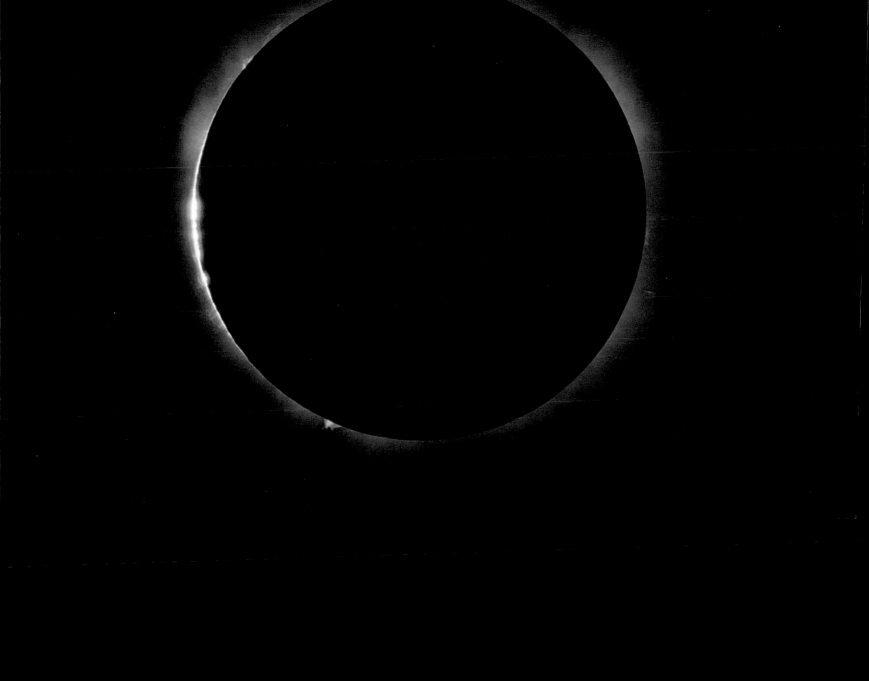

+ **Solstice Celebration**

SEASON'S GREETINGS! AT 01:48 UNIVERSAL TIME ON JUNE 21, 2000, THE SUN REACHED ITS NORTHERNMOST POINT IN PLANET Earth's sky, marking a season change and the first solstice of the year 2000. In celebration, consider this delightfully detailed, brightly colored image of the active Sun. From the EIT instrument onboard the space-based SOHO observatory, the tantalizing picture is a false-color composite of three images all made in extreme ultraviolet light. Each individual image highlights a different temperature regime in the upper solar atmosphere and was assigned a specific color; blue at 1 million, green at 1.5 million, and red at 2 million degrees Celsius. The combined image shows bright active regions strewn across the solar disk, which would otherwise appear as dark groups of sunspots in visible-light images, along with some magnificent plasma loops and an immense prominence at the right-hand solar limb. CREDIT: SOHO - EIT CONSORTIUM, ESA, NASA

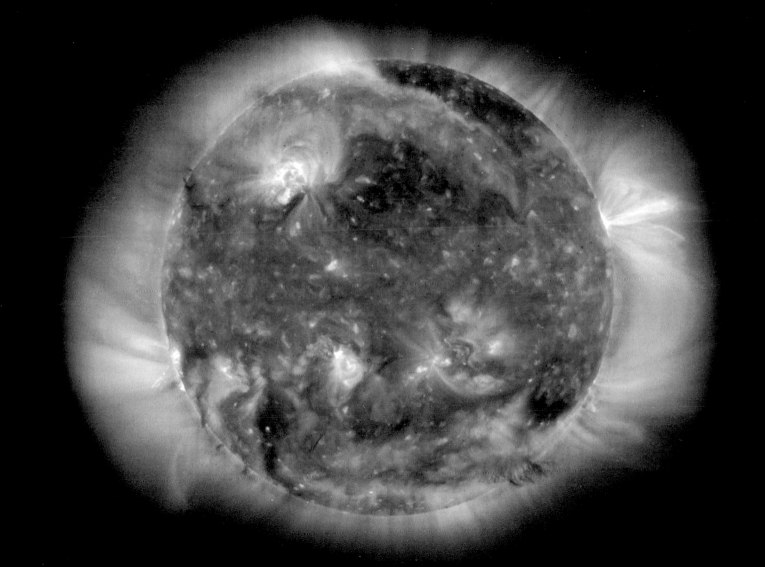

01
02
03
04
05
06
07
08
09
10
11
12
13
14
15
16
17
18
19
20
21
22
23
24
25
26
27
28
29
30

+ The Gullies of Mars

THE RECENTLY REVEALED GULLIES ON MARS ARE RARE. BUT THEY MAY PROVE to be sites of present-day, near-surface, liquid water, holding out the tantalizing possibility of martian life. Too small to have been seen by past Mars orbiters, these disconcerting landforms were found in only approximately 250 out of more than 20,000 high-resolution images from the Mars Global Surveyor space-craft. Gullies found so far are located away from the martian equatorial region, mostly at middle and southern high latitudes and on poleward-facing slopes. They are perplexing because researchers have evidence that the martian gullies are related to groundwater seepage and, like their terrestrial counterparts, liquid-water runoff—on a planet whose surface is thought to be too cold and atmosphere too thin for liquid water to exist. Alternatively, the gullies could be the result of a characteristically martian process. The gullies in the 3 km-wide area pictured here are in the south-facing wall of a crater in southern Noachis Terra. Unblemished by craters and overlaying young surface features, these and other gullies are inescapably young themselves. In fact, future monitoring of the martian gullies for changes could demonstrate whether the process that formed them is still active today. CREDIT: MALIN SPACE SCIENCE SYSTEMS, MGS, JPL, NASA

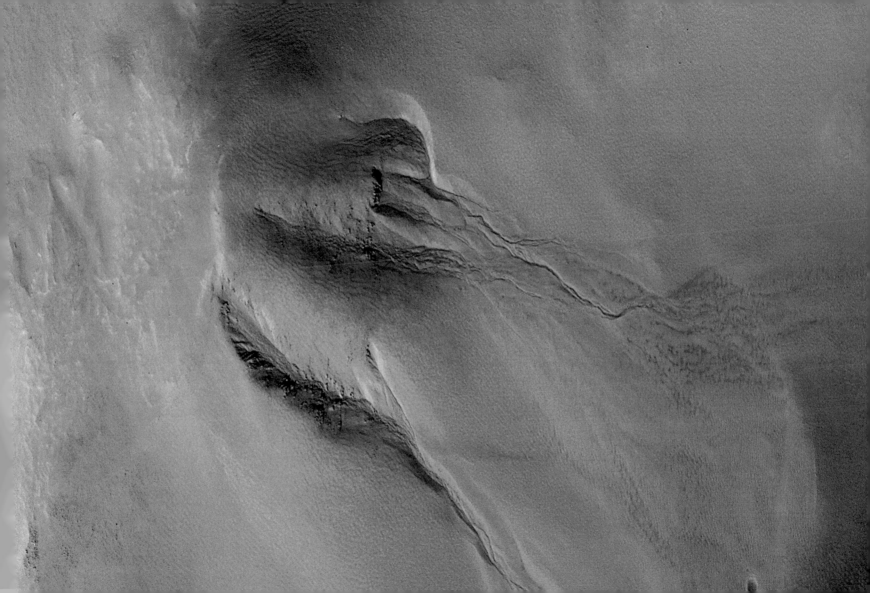

+ **The Cygnus Loop**

THE SHOCKWAVE FROM A 20,000-YEAR-OLD SUPERNOVA EXPLOSION IN THE CONSTELLATION CYGNUS IS STILL EXPANDING INTO interstellar space. The collision of this fast-moving wall of gas with a stationary cloud has heated it causing it to glow in visible as well as high-energy radiation, producing the nebula known as the Cygnus Loop (NGC 6960/95). The nebula is located a mere 1,400 light-years away. The color code used here indicates emission from different kinds of atoms excited by the shock: oxygen: blue, sulfur: red, and hydrogen: green. This picture was taken with the Wide Field and Planetary Camera 2 onboard the Hubble Space Telescope. CREDIT: J. HESTER (ASU), NASA

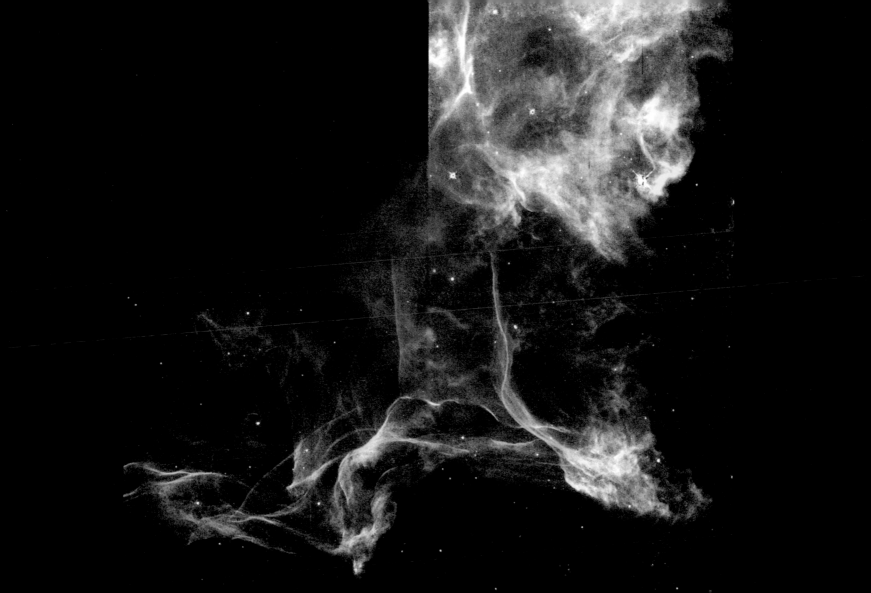

+ **NGC 3132: The Eight-Burst Nebula**

IT'S THE DIM STAR, NOT THE BRIGHT ONE, NEAR THE CENTER OF NGC 3132 THAT CREATED THIS ODD BUT BEAUTIFUL planetary nebula. Nicknamed both the Eight-Burst Nebula and the Southern Ring Nebula, the glowing gas nebula originated in the outer layers of a star like our Sun. In this representative-color picture, the blue pool of light seen surrounding this binary system is energized by the hot surface of the faint star. Although photographed to explore unusual symmetries, it's actually the asymmetries that help make this planetary nebula so intriguing. Neither the unusual shape of the surrounding cooler shell nor the structure and placements of the cool filamentary dust lanes running across NGC 3132 are well understood. CREDIT: HUBBLE HERITAGE TEAM (AURA/STSCI /NASA)

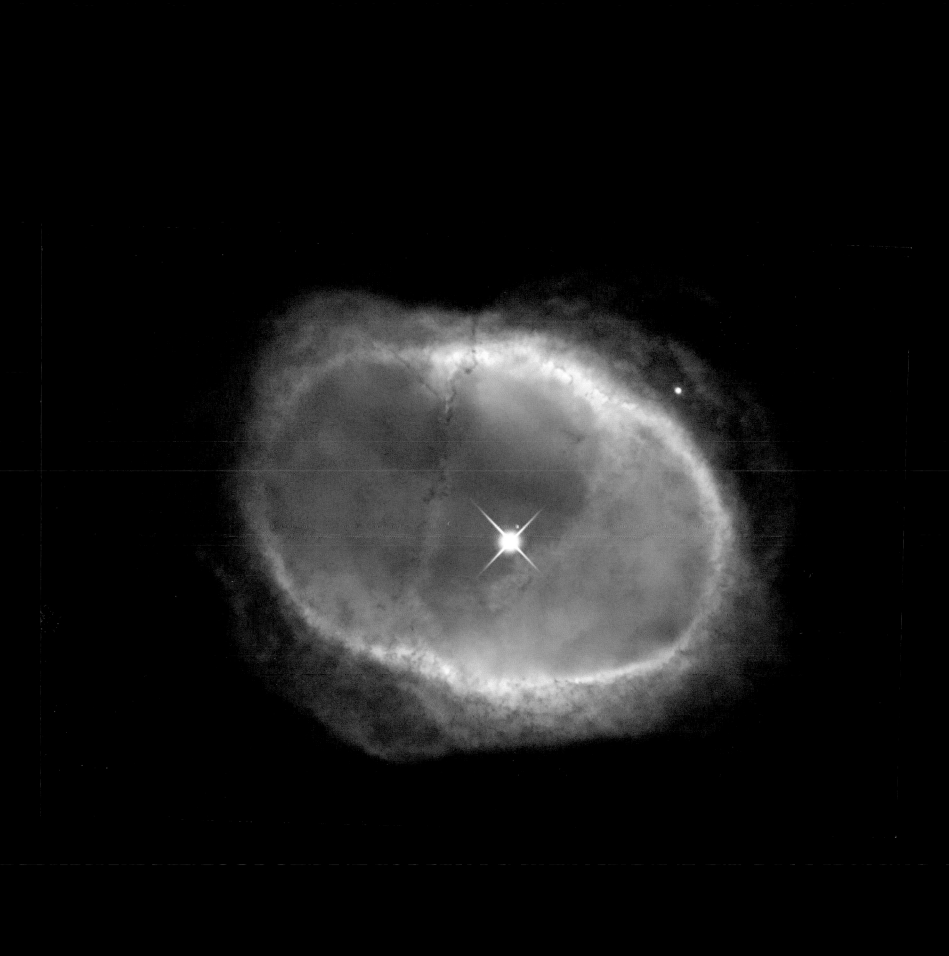

+ **NGC 7635: The Bubble Nebula**

WHAT CREATED THIS HUGE SPACE BUBBLE? A MASSIVE STAR THAT IS NOT ONLY BRIGHT AND BLUE, BUT IS ALSO EMITTING A fast stellar wind of ionized gas. The Bubble Nebula, which appears at the bottom of this Hubble Space Telescope image, is actually the smallest of three bubbles surrounding massive star BD+602522, and part of the gigantic bubble network S162 created with the help of other massive stars. As fast moving gas expands off BD+602522, it pushes surrounding sparse gas into a shell. The energetic starlight then ionizes the shell, causing it to glow. This picture shows many details of the Bubble Nebula never seen before and many still not understood. The nebula, also known as NGC 7635, is approximately 6 light-years across and visible with a small telescope towards the constellation Cassiopeia. CREDIT: DONALD WALTER (SCSU) ET AL., WFPC2, HST, NASA

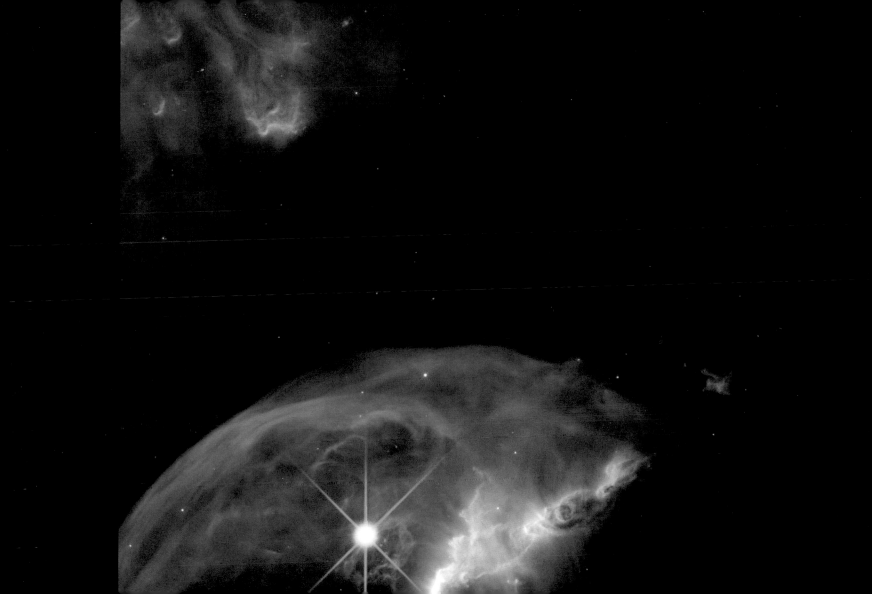

+ **Happy Birthday Charles Messier**

FRENCH ASTRONOMER CHARLES MESSIER WAS BORN ON JUNE 26, 1730. INSPIRED BY CHILDHOOD SIGHTINGS OF COMETS AND A solar eclipse visible from his hometown of Badonvillier, France, he became an astronomer and comet hunter who kept careful records of his observations. While hunting for comets he made a now-famous list of fuzzy, diffuse-looking objects that appeared at fixed positions in the sky. Although these objects looked like comets, Messier knew that since they did not move with respect to the background stars they could not be the comets he was searching for. The 110 objects on Messier's revised list, individually depicted in this grid of digital images, are now well known to modern astronomers to be among the brightest and most striking nebulas, star clusters, and galaxies. Objects on Messier's list are still referred to by their "Messier number," and this grid is numerically ordered beginning with M1 in the upper left corner and ending with M110 at the lower right. The first object in his catalogue, M1 is also known as the Crab Nebula. It was recorded during his search for the return of comet Halley in 1758. Messier died in his home in Paris in 1817. CREDIT: PAUL GITTO, ARCTURUS OBSERVATORY, HTTP://COMETMAN.COM

+ **M63: The Sunflower Galaxy**

ONE OF THE BRIGHT SPIRAL GALAXIES VISIBLE IN THE NORTHERN SKY IS M63, THE SUNFLOWER GALAXY. M63, ALSO CATALOGUED as NGC 5055, can be found with a small telescope in the constellation Canes Venaciti. Visible in this picture are long winding spiral arms glowing blue from a few bright young stars, emission nebulas glowing red from hot ionized hydrogen gas, and dark dust in numerous filaments. M63 interacts gravitationally with M51 (the Whirlpool galaxy) and several smaller galaxies. Light takes approximately 35 million years to reach us from M63, and about 60,000 years to cross the Sb-type spiral galaxy. Stars in the outer regions of the Sunflower galaxy rotate around the center at a speed so high they should fly off into space, indicating that some sort of invisible, gravitationally binding, dark matter is present. CREDIT & COPYRIGHT: SATOSHI MIYAZAKI (NAOJ), SUPRIME-CAM, SUBARU TELESCOPE, NOAJ

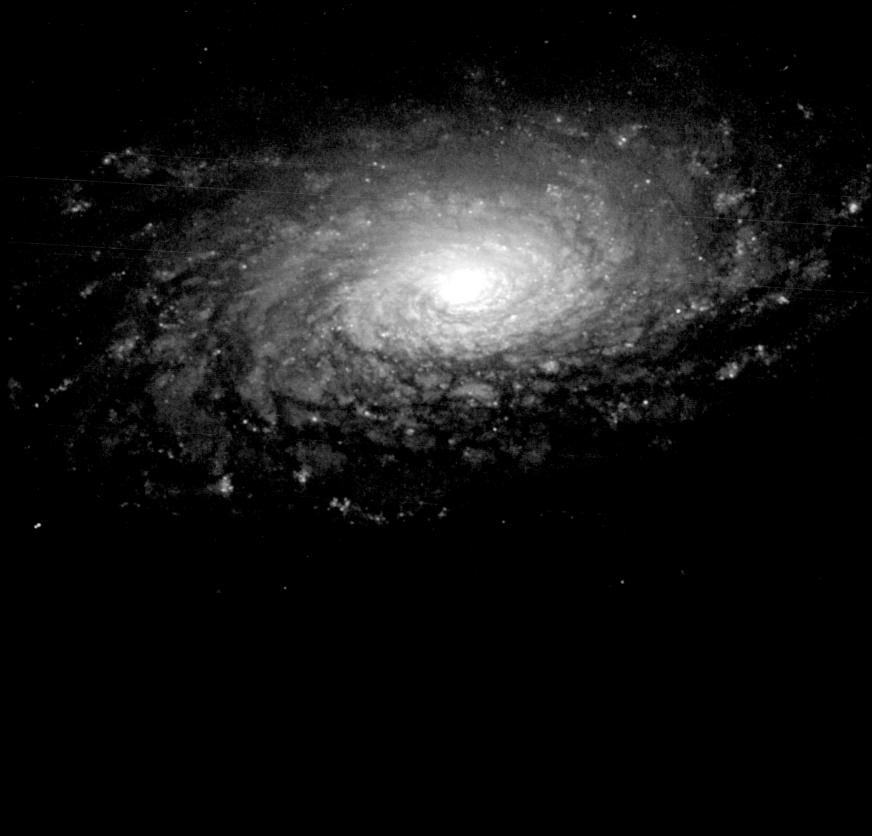

01
02
03
04
05
06
07
08
09
10
11
12
13
14
15
16
17
18
19
20
21
22
23
24
25
26
27
28
29
30

+ **Inside the Eagle Nebula**

FROM AFAR, THE WHOLE AREA LOOKS LIKE AN EAGLE. A CLOSER LOOK AT THE EAGLE NEBULA, HOWEVER, REVEALS THE BRIGHT region is actually a window into the center of a larger dark shell of dust. Through this window, a brightly lit workshop appears where a whole open cluster of stars is being formed. In this cavity, tall pillars and round globules of dark dust and cold molecular gas remain where stars are still forming. Already visible are several young, bright blue stars whose light and winds are burning away and pushing back the remaining filaments and walls of gas and dust. The Eagle Nebula, tagged M16, lies approximately 6,500 light-years away, spans about 20 light-years, and is visible with binoculars toward the constellation Serpens. This picture combines three specific emitted colors and was taken with the 0.9-meter Telescope on Kitt Peak Observatory in Arizona. CREDIT & COPYRIGHT: T. A. RECTOR & B. A. WOLPA, NOAO/AURA/NSF

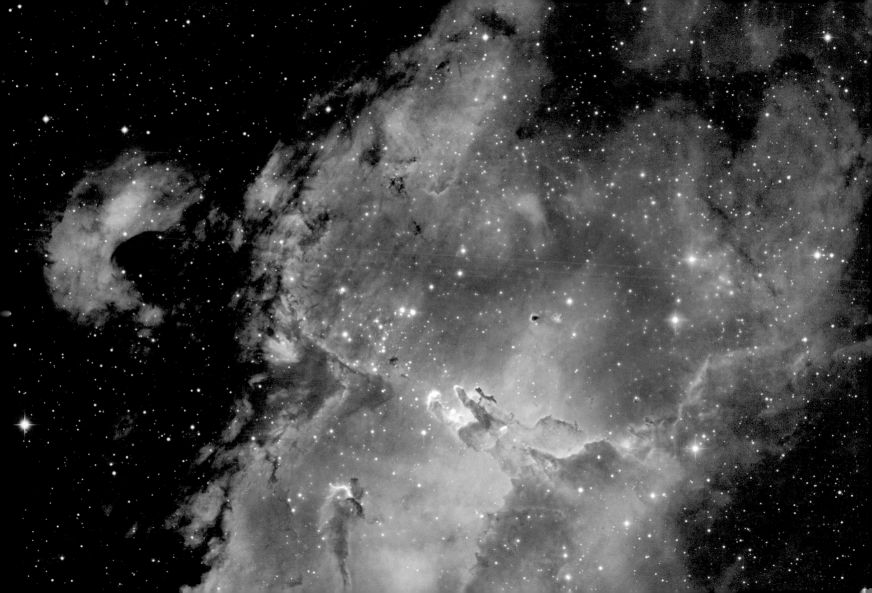

+ Ida and Dactyl: Asteroid and Moon

THIS ASTEROID HAS A MOON! THE ROBOT SPACECRAFT GALILEO DESTINED TO EXPLORE THE JOVIAN SYSTEM ENCOUNTERED

and photographed two asteroids during its long journey to Jupiter. Ida, the second asteroid it photographed, was discovered to

have a moon that appears as a small dot to its right in this picture. The tiny moon, named Dactyl, is approximately one mile

across, while the potato-shaped Ida measures about 58 km long and 23 km wide. Dactyl is the first moon of an asteroid to ever

be discovered. The names Ida and Dactyl are based on characters in Greek mythology. Do other asteroids have moons?

CREDIT: GALILEO PROJECT, JPL, NASA

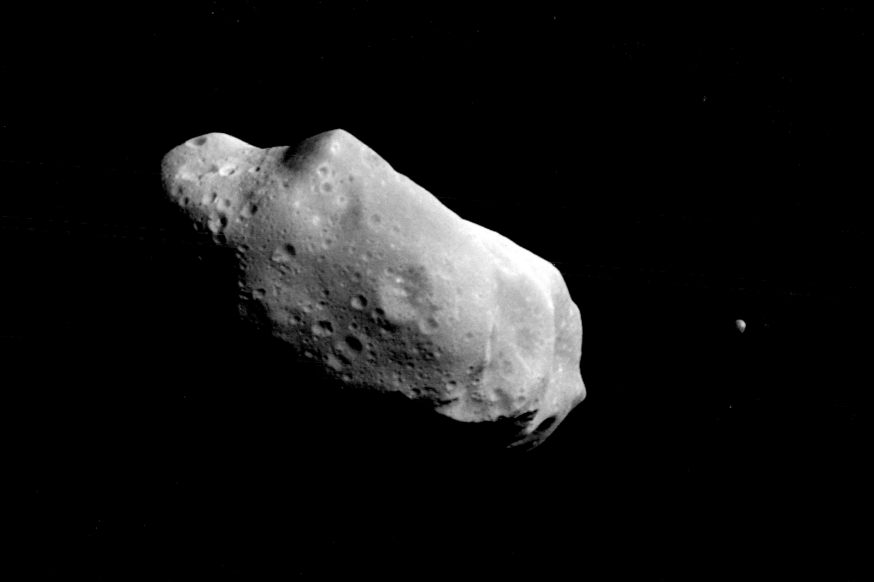

+ **Vintage Gamma Rays**

GAMMA RAYS ARE THE MOST ENERGETIC FORM OF ELECTROMAGNETIC RADIATION. SINCE THESE HIGH-ENERGY PHOTONS penetrate and interact in normal materials, they cannot be focused by lenses and mirrors such as those in optical telescopes. So how do you make an image in gamma-ray light? One way is to use a patterned mask of material that can cast gamma-ray shadows on a digital detector array. The mask is called a coded aperture, and the resulting shadow patterns can be used to construct a gamma-ray image of the source. For example, consider the picture here. In place of a coded mask, familiar objects were positioned in front of a detector array and illuminated with gamma rays in a laboratory test. The familiar objects used to make the shadow image are shown to the left. The detector array is part of the imaging gamma-ray telescope for the International Gamma-Ray Astrophysics Laboratory satellite. CREDIT: ESA / IAS / CEA-SACLAY

+ **Spiral Galaxy NGC 7742**

THIS MIGHT RESEMBLE THE FRIED EGG YOU HAD FOR BREAKFAST, BUT IT'S ACTUALLY MUCH LARGER. IN FACT, RINGED BY BLUE-tinted, star-forming regions and faintly visible spiral arms, the yolk yellow center of this face-on spiral galaxy, NGC 7742, is approximately 3,000 light-years across. About 72 million light-years away in the constellation Pegasus, NGC 7742 is known to be a Seyfert galaxy—a type of active spiral galaxy with a center or nucleus that is very bright at visible wavelengths. Across the spectrum, the tremendous brightness of a Seyfert galaxy can change over periods of just days to months, and galaxies like NGC 7742 are suspected of harboring massive black holes at their cores. This beautiful color picture is courtesy of the Hubble Space Telescope Heritage Project.

CREDIT: HUBBLE HERITAGE TEAM (AURA/ STSCI/ NASA)

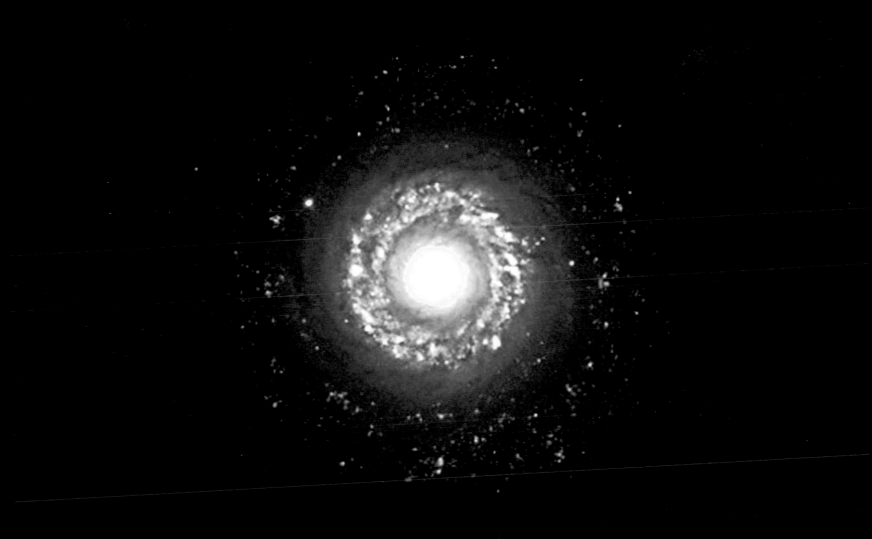

+ **Aurora at Midnight**

WHAT'S HAPPENING BEHIND THOSE TREES? AURORA. THIS PICTURE WAS taken at midnight near Fairbanks, Alaska, and captures familiar trees, common clouds, and a glowing sky markedly different than a sunset. Particularly strange is the green auroral ring caused by energetic particles interacting with oxygen high in Earth's atmosphere. The small water droplets that compose clouds reflect and absorb auroral light, giving clouds a reddish tinge. This picture was taken on November 6, 2000.

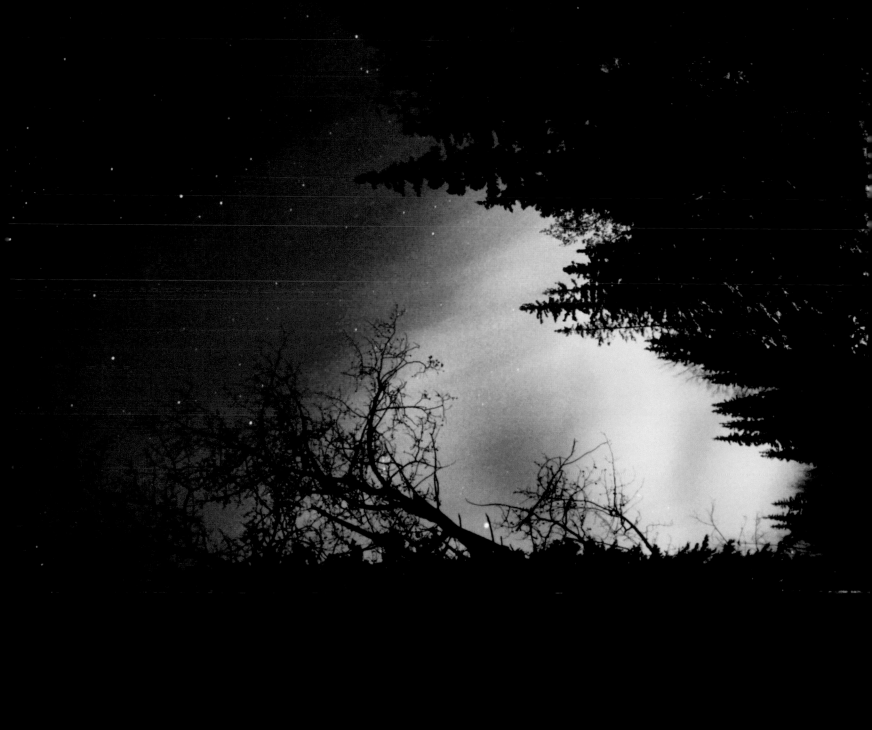

+ The Local Interstellar Cloud

THE STARS ARE NOT ALONE. IN THE DISK OF OUR MILKY WAY GALAXY APPROXIMATELY 10 PERCENT OF VISIBLE MATTER IS IN the form of gas, called the interstellar medium (ISM). The ISM is not uniform and shows patchiness near our sun. It can be quite difficult to detect the ISM that surrounds the Sun because it is so tenuous and emits so little light. The ISM is mostly hydrogen gas, however, absorbs some very specific colors that can be detected against the background of light from the nearest stars. A working map of the local ISM within 10 light-years, based on recent observations, is shown here. These observations show that our Sun is moving through a Local Interstellar Cloud as this cloud flows outward from the Scorpius-Centaurus Association star-forming region. Our Sun may exit the Local Interstellar Cloud during the next 10,000 years. Much remains unknown about the local ISM, including details of its distribution, its origin, and how it affects the Sun and planet Earth.

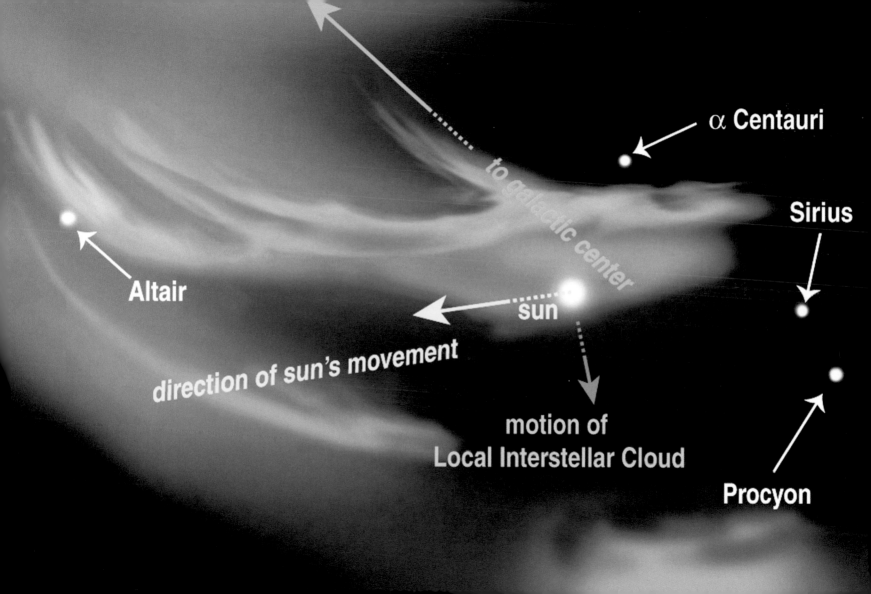

+ + The Local Bubble and the Galactic Neighborhood

WHAT SURROUNDS THE SUN IN THIS NECK OF THE MILKY WAY GALAXY? OUR CURRENT BEST GUESS IS DEPICTED IN THIS MAP of the surrounding 1,500 light-years. Currently, the Sun is passing through a Local Interstellar Cloud (LIC), shown in violet, which is flowing away from the Scorpius-Centaurus Association of young stars. The LIC resides in a low-density hole in the interstellar medium called the Local Bubble, shown in black. Nearby, high-density molecular clouds, including the Aquila Rift, surround star-forming regions, each shown in orange. The Gum Nebula, shown in green, is a region of hot ionized hydrogen gas. Inside the Gum Nebula is the Vela Supernova Remnant, shown in pink, which is expanding to create fragmented shells of material like the LIC. Future observations should help astronomers discern more about the local galactic neighborhood and how it might have affected Earth's climate in the past. CREDIT & COPYRIGHT: ARTIST: LINDA HUFF (AMERICAN SCIENTIST), REPRODUCED BY PERMISSION OF SIGMA XI, THE SCIENTIFIC RESEARCH SOCIETY. CITATION: FRISCH, PRISCILLA, "THE GALACTIC ENVIRONMENT OF THE SUN," AMERICAN SCIENTIST VOL. 88, NO. 1, JANUARY–FEBRUARY 2000

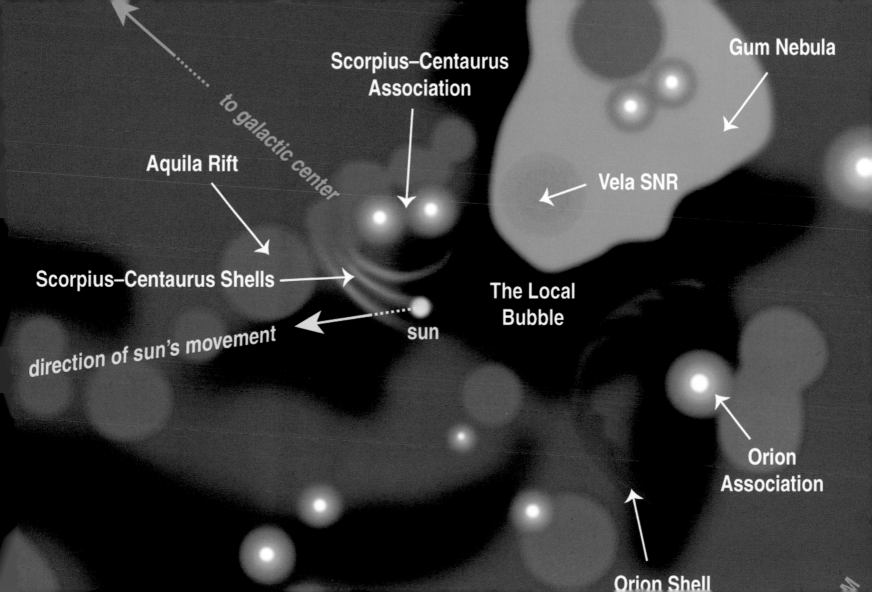

Gum Nebula

Scorpius–Centaurus Association

Aquila Rift

Vela SNR

Scorpius–Centaurus Shells

The Local Bubble

sun

direction of sun's movement

to galactic center

Orion Association

Orion Shell

+ **A Step toward Gravitational Wave Detection**

ACCELERATE A CHARGE AND YOU'LL GET ELECTROMAGNETIC RADIATION: LIGHT. BUT ACCELERATE ANY MASS AND YOU'LL GET gravitational radiation. Light is seen all the time, but, so far, a confirmed direct detection of gravitational radiation has yet to be made. When absorbed, gravitational waves (GWs) create a tiny symmetric jiggle similar to squashing a rubber ball and letting go quickly. Two or more detectors separated by a large distance can be used to discern GWs from everyday bumps. Powerful astronomical GW sources would coincidentally jiggle detectors, even on opposite ends of planet Earth. Pictured here are the 2-km-long arms of one such detector: the LIGO Hanford Observatory in Washington, which in 2000 achieved a phase-lock milestone to future GW detection. When it and its sister interferometer in Louisiana become fully operational, they may see a GW sky so strange it won't be immediately understood. CREDIT: LIGO, CALTECH, NSF

+ **Strange Orange Soil on the Moon**

HOW DID ORANGE SOIL APPEAR ON THE MOON? THIS MYSTERY BEGAN WHEN ASTRONAUT HARRISON SCHMIDT NOTICED THE off-color patch near Apollo 17's Taurus-Littrow landing site in 1972. Schmidt and fellow astronaut Eugene Cernan scooped up some of the unusual orange soil for detailed inspection back on Earth. Pictured here is a return sample shown greatly magnified, with its discovery location shown in the inset. The orange soil contains particles less than a tenth millimeter across, some of the smallest particles yet found on the Moon. Lunar geologists now think that the orange soil was created during an ancient fire-fountain. Detailed chemical and dating analyses indicate that during an explosive volcanic eruption 3.64 billion years ago, small drops of molten rock cooled rapidly into the nearly spherical, colored grains. The origin of some of the unusual elements found in the soil, however, remains unknown. CREDIT: APOLLO 17 CREW, NASA

01
02
03
04
05
06
07
08
09
10
11
12
13
14
15
16
17
18
19
20
21
22
23
24
25
26
27
28
29
30
31

+ **The Galactic Center in Infrared, Part 1**

THE CENTER OF OUR GALAXY IS A BUSY PLACE. IN VISIBLE LIGHT, MUCH OF THE GALACTIC CENTER IS OBSCURED BY OPAQUE

dust. In infrared light, however, dust glows more and obscures less, allowing nearly one million stars to be recorded in this

photograph. The galactic center itself appears on the right and is located about 30,000 light-years away toward the constellation

Sagittarius. The galactic plane of our Milky Way galaxy, the plane in which the Sun orbits, is identifiable by the dark, diagonal

dust lane. The absorbing dust grains are created in the atmospheres of cool red-giant stars and grow in molecular clouds. The

region directly surrounding the galactic center also glows in radio and X rays, and is thought to house a large black hole.

CREDIT: 2MASS PROJECT, UMASS, IPAC/CALTECH, NSF, NASA

+ **The Galactic Center in Infrared, Part 2**

THE CENTER OF OUR GALAXY IS OBSCURED IN VISIBLE LIGHT BY DARK DUST THAT ROTATES WITH THE STARS IN THE GALACTIC plane. In this century, however, sensors have been developed that can detect light more red than humans can see—light called infrared. The picture results from a digital combination of data taken by the 2MASS and MSX galactic surveys. In near-infrared light (shown in blue) the dust is less opaque, and many previously shrouded red giant stars become visible. In the mid-infrared (shown in red) the dust itself glows brightly, but the view penetrates very close to our tumultuous and mysterious galactic center.

CREDIT: 2MASS PROJECT, UMASS, IPAC/CALTECH, NSF, NASA

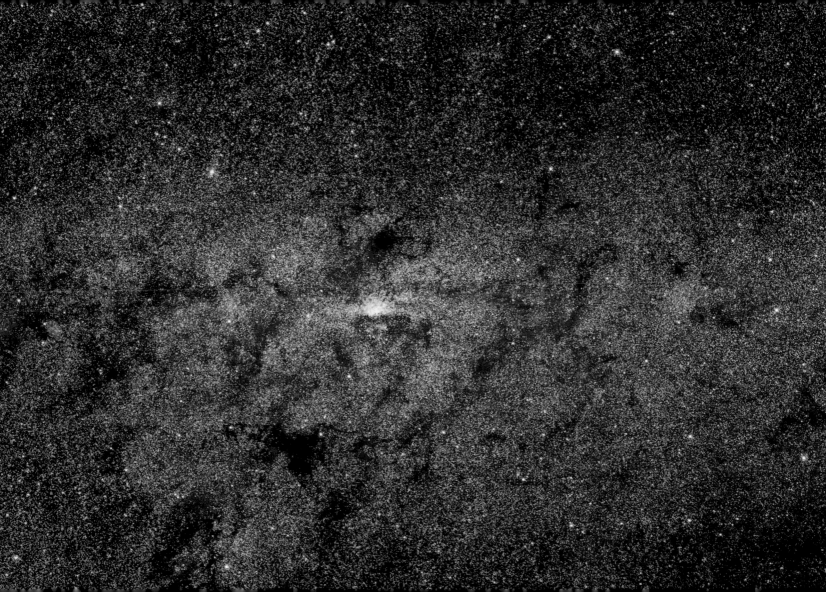

01
02
03
04
05
06
07
08
09
10
11
12
13
14
15
16
17
18
19
20
21
22
23
24
25
26
27
28
29
30
31

+ **Shapley 1: An Annular Planetary Nebula**

WHAT HAPPENS WHEN A STAR RUNS OUT OF NUCLEAR FUEL? THE CENTER CONDENSES INTO A WHITE DWARF AND THE

outer atmospheric layers are expelled into space and appear as a planetary nebula. This particular planetary nebula, designated

Shapley 1 after the famous astronomer Harlow Shapley, has a structure very similar to a large, thin ring. Although some of

these nebulas look like planets in the sky (hence their name), they actually surround stars far outside our solar system.

CREDIT & COPYRIGHT: D. MALIN (AAO), AATB

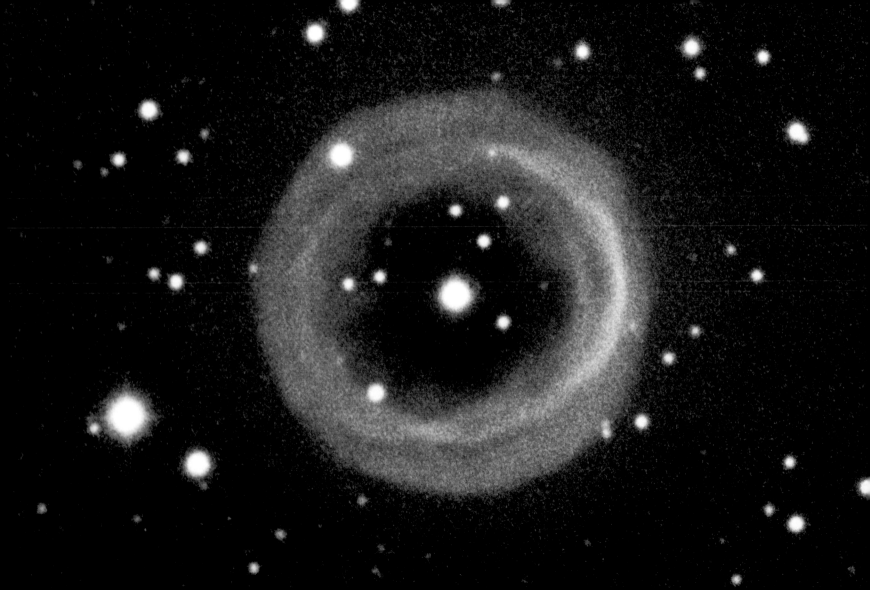

01
02
03
04
05
06
07
08
09
10
11
12
13
14
15
16
17
18
19
20
21
22
23
24
25
26
27
28
29
30
31

+ **The Sudbury Neutrino Detector**

TWO THOUSAND METERS BELOW THE GROUND, A GIANT SPHERE HAS BEGUN to detect nearly invisible particles. These particles, neutrinos, are extremely abundant in the universe but usually go right through just about everything. By stocking this 12-meter sphere with an unusual type of heavy water and surrounding it with light detectors, astrophysicists hope to catch the occasional neutrino collision. Since the Sudbury Neutrino Observatory is sensitive to all types of neutrinos, future results might hold clues to how much neutrinos change type on the fly, how our own Sun emits neutrinos, and even how important neutrinos are to the composition of the entire universe.

CREDIT: A. B. MCDONALD (QUEEN'S UNIVERSITY) ET AL., THE SUDBURY NEUTRINO OBSERVATORY INSTITUTE

01
02
03
04
05
06
07
08
09
10
11
12
13
14
15
16
17
18
19
20
21
22
23
24
25
26
27
28
29
30
31

+ **A Total Eclipse over Africa**

WHAT'S THAT DARK SPOT ON THE SUN? IT'S THE MOON. ON JUNE 21, 2001, a total solar eclipse was visible in parts of Africa. In a series of multiple exposures from Malambanyama, Zambia, Cees Bassa captured the setting sun being eclipsed—one of the most spectacular records of the eclipse. All of the images were taken 20 minutes apart, and all but the central image were taken though a dark solar filter. Without the filter, the central image features the enormous flowing corona that surrounds the Sun. The planet Jupiter can be seen superimposed just to the left of the next image after totality. CREDIT & COPYRIGHT: CEES BASSA (STERREKUNDIG INSTITUUT UTRECHT)

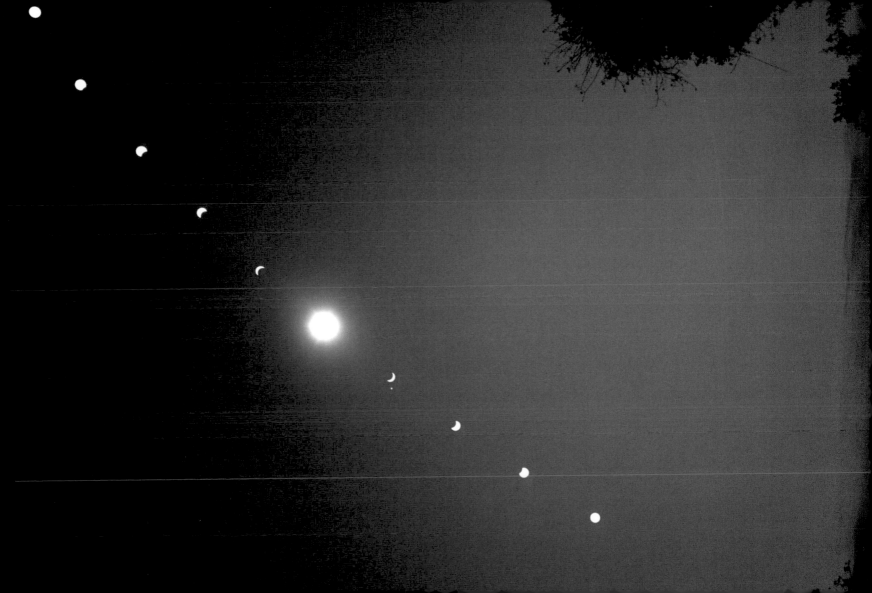

01
02
03
04
05
06
07
08
09
10
11
12
13
14
15
16
17
18
19
20
21
22
23
24
25
26
27
28
29
30
31

+ **Asteroid Gaspra's Best Face**

ASTEROID 951, GASPRA, IS A HUGE ROCK TUMBLING IN SPACE. GASPRA BECAME ONE OF THE BEST-STUDIED ASTEROIDS IN 1991, when the spacecraft Galileo flew by, giving astronomers the opportunity to examine it more closely. In this photograph, subtle color variations have been exaggerated to highlight changes in how reflective the surface is, surface structure, and composition. Gaspra is approximately 20 km long and orbits the Sun in the main asteroid belt between Mars and Jupiter. CREDIT: THE GALILEO PROJECT, NASA

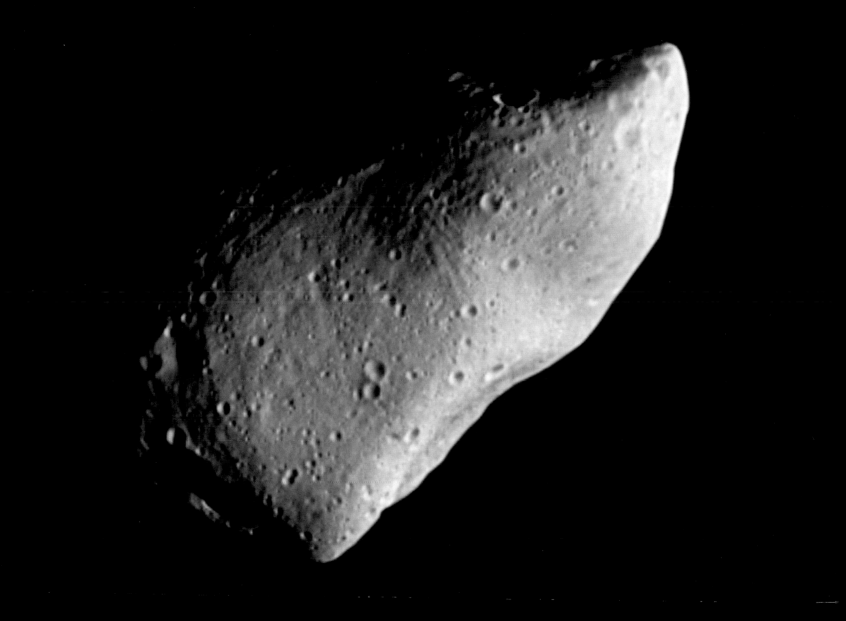

+ **Vela Supernova Remnant in Optical**

APPROXIMATELY 11,000 YEARS AGO, A STAR IN THE CONSTELLATION VELA EXPLODED. THIS BRIGHT SUPERNOVA MAY HAVE been visible to the first human farmers. Today the Vela Supernova Remnant marks the position of this relatively close and recent explosion in our galaxy. A roughly spherical, expanding shock wave is visible in X rays. In this optical photograph, a portion of the spherical blast wave is shown in detail. As gas flies away from the detonated star, it reacts with the interstellar medium, knocking away closely held electrons from even heavy elements. When the electrons recombine with these atoms, this produces light in many different colors and energy bands. CREDIT: PHOTOGRAPH MADE FROM PLATES TAKEN WITH THE UK SCHMIDT TELESCOPE. COLOR PHOTOGRAPHY BY DAVID MALIN. COPYRIGHT: ANGLO-AUSTRALIAN TELESCOPE BOARD

+ **White Dwarf Stars Cool**

DIMINUTIVE BY STELLAR STANDARDS, WHITE DWARF STARS ARE INTENSELY HOT . . . BUT THEY ARE COOLING. WHEN THEIR interior nuclear fires cease burning, they continue to cool until they fade away. This Hubble Space Telescope image (right) covers a small region near the center of a globular cluster known as M4, seen on the left in a ground-based telescopic view. Here, researchers have discovered a large concentration of white dwarf stars (circled). This was expected—low-mass stars, including the Sun, are believed to evolve to the white dwarf stage. Studying how these stars cool could lead to a better understanding of their ages, of the age of their parent globular cluster, even the age of our universe. CREDIT: H. RICHER (UBC) ET AL., WFPC2, HST, NASA

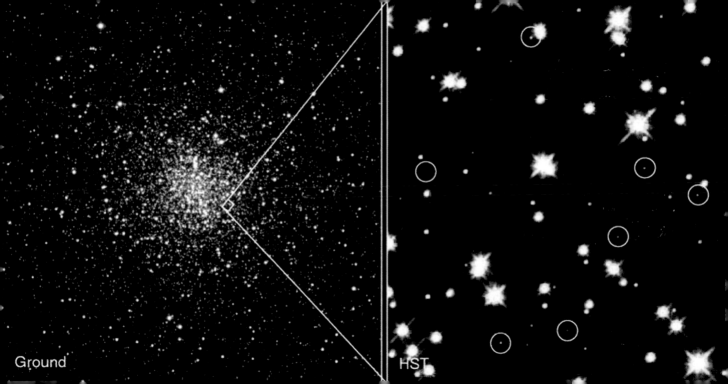

Ground

HST

+ **Io in True Color**

THE STRANGEST MOON IN THE SOLAR SYSTEM IS BRIGHT YELLOW. THIS PICTURE, SHOWING IO'S TRUE COLORS, WAS TAKEN IN July 1999 by the Galileo spacecraft currently orbiting Jupiter. Io's colors derive from sulfur and molten silicate rock. The unusual surface of Io is kept very fresh by its system of active volcanoes. The intense tidal gravity of Jupiter stretches Io and damps rotation wobble caused by Jupiter's other galilean moons. The resulting friction greatly heats Io's interior, causing molten rock to explode through the surface. Io's volcanoes are so active that they are effectively turning the whole moon inside out. Some of Io's volcanic lava is so hot it glows in the dark. CREDIT: GALILEO PROJECT, JPL, NASA

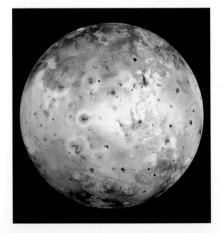

+ **Pelican Nebula Ionization Front**

THE PELICAN NEBULA IS SLOWLY BEING TRANSFORMED. IC 5070, THE NEBULA'S OFFICIAL DESIGNATION, IS DIVIDED FROM THE larger North America Nebula by a molecular cloud filled with dark dust. The Pelican, however, receives much study because it is a particularly active mix of star formation and evolving gas clouds. This area within the Pelican Nebula was produced in two specific colors to better understand these interactions. Here, hot hydrogen gas glows in red, while cooler sulfur glows blue-green. The light from young energetic stars is slowly transforming the cold gas to hot gas, with the advancing boundary between the two known as an ionization front. Particularly dense filaments of cold gas remain. Millions of years from now this nebula might no longer be known as the Pelican, as the balance and placement of stars and gas will leave something that appears completely different.

CREDIT: JOHN BALLY (U. COLORADO), KPNO 0.9-M TELESCOPE, NOAO/AURA/NSF

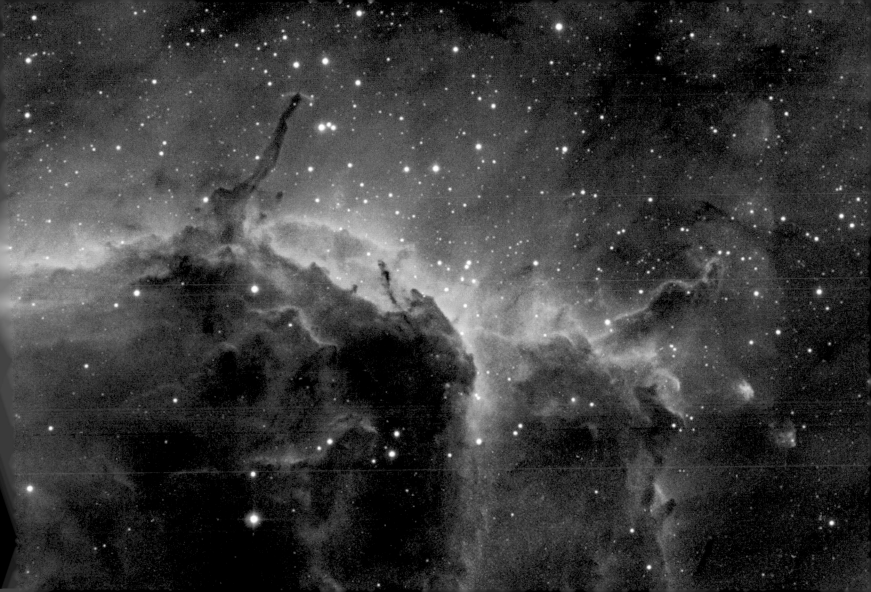

+ **The Carina Nebula in Three Colors**

STARS, LIKE PEOPLE, DO NOT ALWAYS GO GENTLE INTO THAT GOOD NIGHT. THE CARINA NEBULA, ALSO KNOWN AS THE KEYHOLE Nebula and NGC 3372, results from dying star Eta Carinae's violently casting off dust and gas during its final centuries. Eta Carinae, one of the most luminous stars known, is visible as the bright star near the center of the nebula. This picture was taken in three distinct colors of light: blue light as emitted from hot oxygen, green light as emitted by warm hydrogen, and red light as emitted by cool sulfur. Eta Carinae faded from being one of the brightest stars in the sky during the 1800s, but is still visible with binoculars in southern skies towards the constellation Carina. CREDIT & COPYRIGHT: NATHAN SMITH (UNIVERSITY OF MINNESOTA), NOAO, AURA, NSF

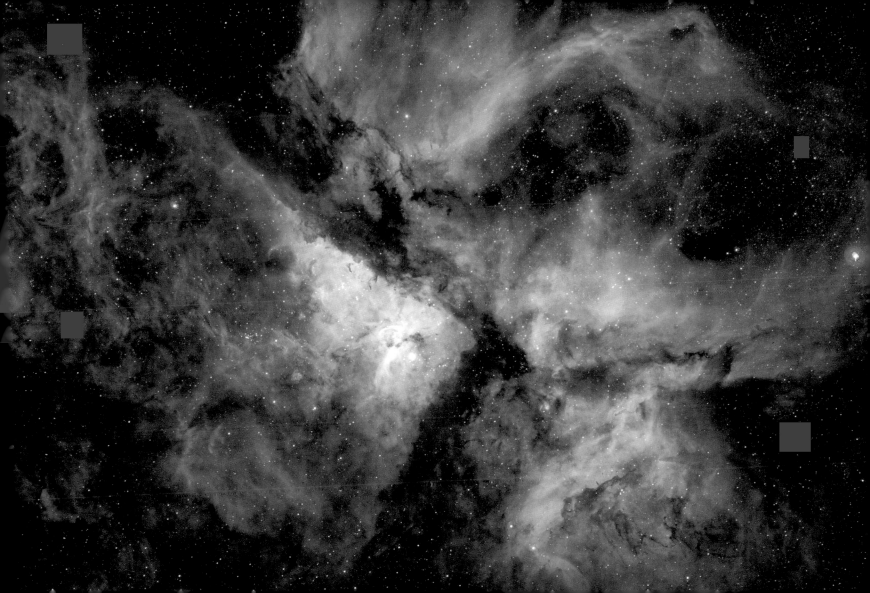

+ Dwarf Elliptical Galaxy NGC 205 in the Local Group

OUR MILKY WAY GALAXY IS NOT ALONE. IT IS PART OF A GATHERING OF APPROXIMATELY TWENTY-FIVE GALAXIES KNOWN AS THE local group. Members include the Great Andromeda galaxy (M31), M32, M33, the Large Magellanic Cloud, the Small Magellanic Cloud, Dwingeloo 1, several small irregular galaxies, and many dwarf elliptical and dwarf spheroidal galaxies. Pictured on the lower left is one of the dwarf ellipticals: NGC 205. Like M32, NGC 205 is a companion to the large M31, and can sometimes be seen to the south of M31's center (upper right) in photographs. This image shows NGC 205 to be unusual for an elliptical galaxy in that it contains at least two dust clouds (at 1 and 4 o'clock—they are visible, but hard to spot) and signs of recent star formation. This galaxy is sometimes known as M110, although it was actually not part of Messier's original catalogue.

CREDIT: CANADA-FRANCE-HAWAII TELESCOPE/JEAN-CHARLES CUILLANDRE/1999

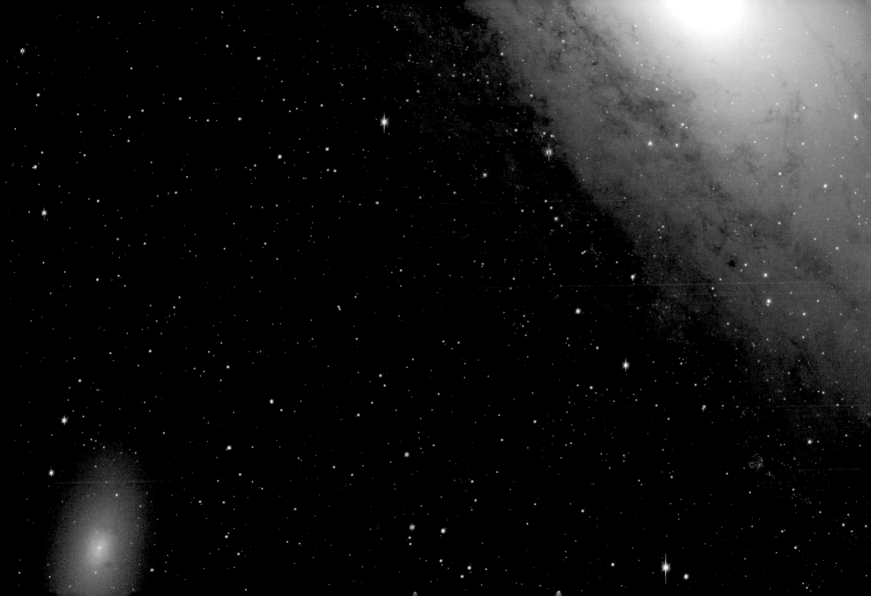

+ **The Tarantula Zone**

THE TARANTULA NEBULA IS MORE THAN 1,000 LIGHT-YEARS ACROSS—A GIANT EMISSION NEBULA WITHIN OUR NEIGHBORING galaxy, the Large Magellanic Cloud. Inside this cosmic arachnid lies a central young cluster of massive stars, catalogued as R136, whose intense radiation and strong winds have helped energize the nebular glow and shape the spidery filaments. In this impressive color mosaic of images from the Wide-Field Imager camera on European Southern Observatory's 2.2-meter telescope at La Silla Observatory, Chile, other young star clusters can be seen still within the nebula's grasp. Also notable among the denizens of the Tarantula zone are several dark clouds invading the nebula's outer limits. The small but expanding remnant of Supernova 1987a, the closest supernova in modern history, lies just off the lower right corner of the field of the image. The rich mosaic's field of view covers an area on the sky about the size of the full moon in the southern constellation Dorado. CREDIT : M. SCHIRMER, T. ERBEN, M. LOMBARDI (IAEF BONN), EUROPEAN SOUTHERN OBSERVATORY

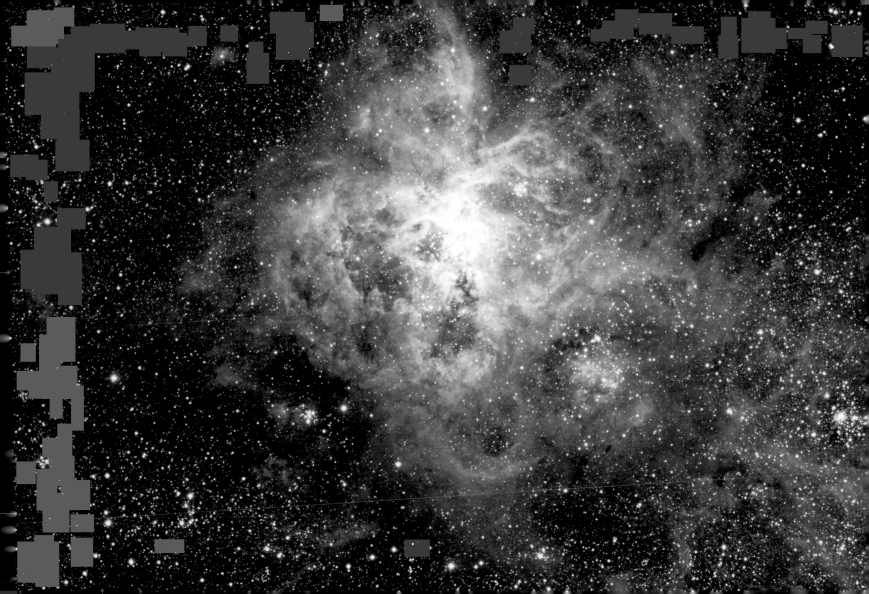

+ **Apollo 12: Self-Portrait**

IS IT ART? IN NOVEMBER 1969, APOLLO 12 ASTRONAUT-PHOTOGRAPHER CHARLES "PETE" CONRAD RECORDED THIS masterpiece while documenting colleague Alan Bean's lunar soil-collecting activities on the Oceanus Procellarum. The image is dramatic and stark. Bean is faceless. The harsh environment of the Moon's Ocean of Storms is echoed in his helmet's perfectly composed reflection of Conrad and the lunar horizon. The works of photojournalists originally intent on recording the human condition on planet Earth, such as Lewis W. Hine's images from New York City in the early twentieth century or Margaret Bourke-White's magazine photography, are widely regarded as art. Similarly, many documentary astronomy and space images can be appreciated for their artistic and aesthetic appeal. CREDIT: C. CONRAD, APOLLO 12, NASA

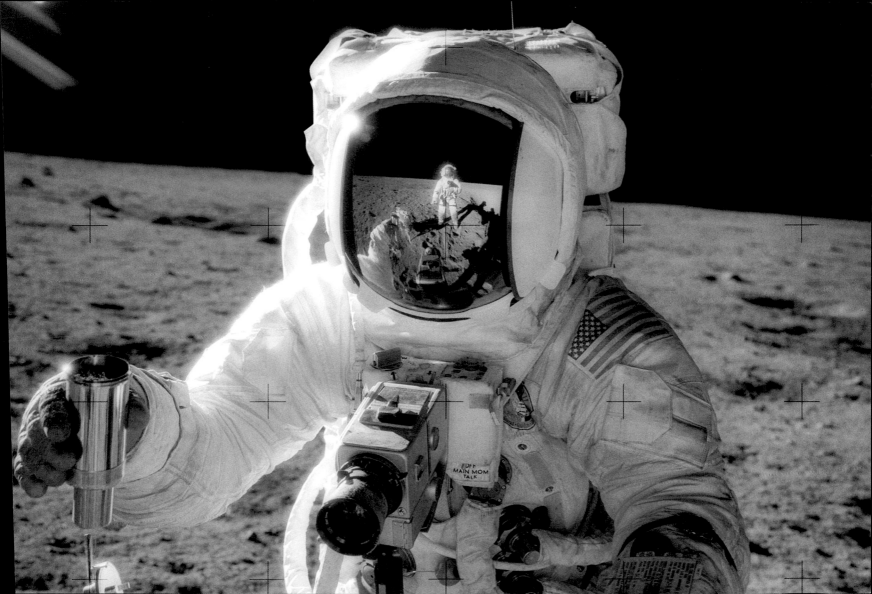

01
02
03
04
05
06
07
08
09
10
11
12
13
14
15
16
17
18
19
20
21
22
23
24
25
26
27
28
29
30
31

+ **Nearby Spiral M33**

M33 IS A PROMINENT NEARBY SPIRAL GALAXY. NICKNAMED THE TRIANGULUM, M33 IS ONE OF THE LARGER MEMBERS OF THE local group of galaxies. Two massive spiral galaxies dominate the local group: M31 and our Milky Way galaxy. M33 is the only other spiral galaxy known in the local group. At 3 million light-years, M33 is the second-closest spiral galaxy to our Milky Way galaxy, and is close enough to appear twice the angular size of the full Moon. M33 is thought by some to be a satellite galaxy to massive M31. Globular clusters in M33's halo appear unusual and might be much younger than globular clusters in our galaxy's halo. CREDIT & COPYRIGHT: D. MALIN (AAO), IAC, RGO, ISAAC NEWTON TELESCOPE

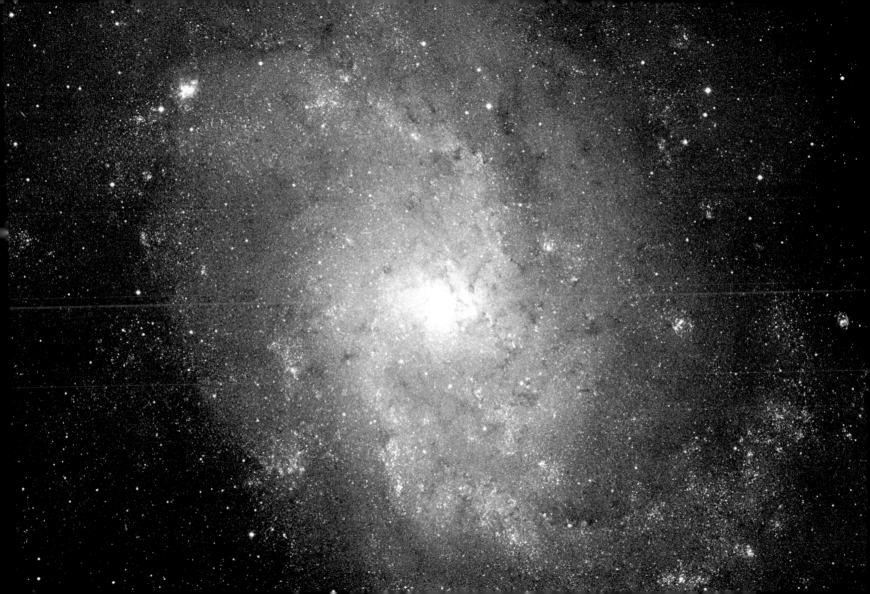

+ Slightly above Mars Pathfinder

IF YOU COULD HAVE HOVERED ABOVE THE PATHFINDER MISSION TO MARS IN 1997, THIS IS WHAT YOU MIGHT HAVE SEEN.

Directly below you is the control tower of Sagan Memorial Station. Three dark solar arrays extend out to collect valuable energy, surrounded by light-colored deflated airbags that protected Pathfinder's instruments from directly colliding with the rocky martian surface. The left solar panel has ramps that Pathfinder's rolling robot Sojourner started down to its adventure to nearby rocks. Sojourner itself is visible inspecting a rock nicknamed Yogi at 11 o'clock. Rocks cover the martian surface, with Twin Peaks visible on the horizon at 9 o'clock. The distant sky is mostly orange. This image is a digital combination of panoramic pictures taken by Pathfinder on Mars and a picture of a Lander scale model back on Earth. The Pathfinder Mission to Mars was able to collect data for 3 months, sending back information that has indicated a wet distant past for the planet. CREDIT: IMP TEAM, JPL, NASA

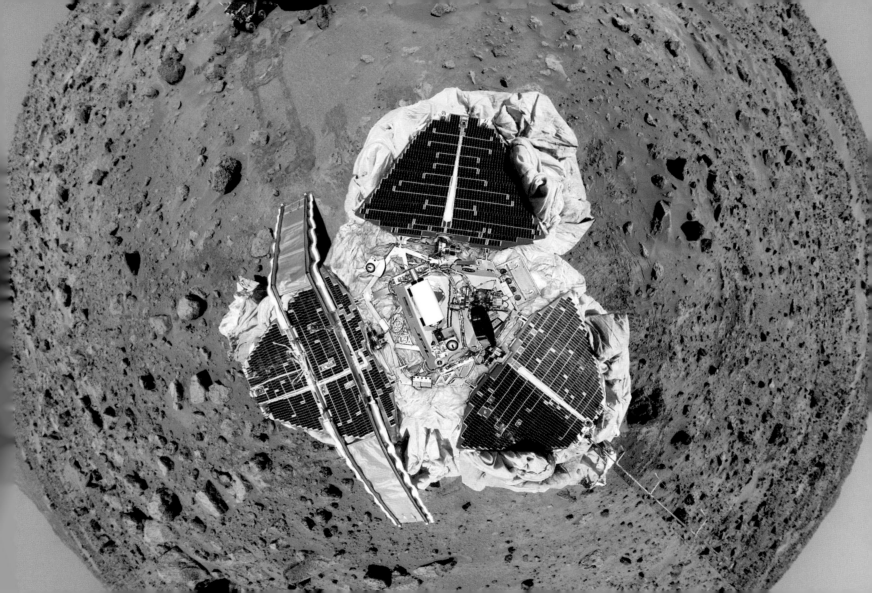

+ **A Presidential Panorama of Mars**

THIS IMAGE, DUBBED A PRESIDENTIAL PANORAMA BY THE MARS PATHFINDER TEAM, IS ONE OF THE GREATEST PANORAMAS EVER taken on the surface of Mars. It shows in colorful detail the surroundings of the Sagan Memorial Station. Now look closely at the big rock midway in the picture. That rock is called Yogi and just to its left is the robot rover Sojourner taking measurements of it. Other now-famous rocks are also visible, including Barnacle Bill and Flat Top. After this picture was taken, Sojourner went on to analyze a rock named Scooby Doo. The Mars Pathfinder mission landed on July 4, 1997, and collected data for approximately 3 months. Analysis indicates that the Pathfinder site was likely awash in water in the distant past, but has been dry for the last 2 billion years. CREDIT: IMP TEAM, JPL, NASA

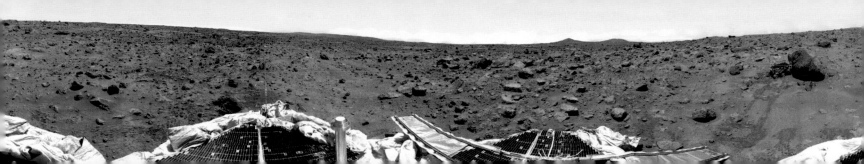

01
02
03
04
05
06
07
08
09
10
11
12
13
14
15
16
17
18
19
20
21
22
23
24
25
26
27
28
29
30
31

+ **Discovery to Orbit**

BIRDS DON'T FLY THIS HIGH. AIRPLANES DON'T GO THIS FAST. THE STATUE OF Liberty weighs less. No species other than human can even comprehend what is going on, nor could any human just a millennium ago. The launch of a rocket bound for space is an event that inspires awe and challenges description. Pictured here, the space shuttle Discovery lifted off during the early morning hours of September 9, 1994. From a standing start, the 2-million-kilogram rocketship left to circle Earth where the outside air is too thin to breathe and where there is little noticeable onboard gravity. On average, rockets bound for space are now launched from somewhere on Earth once a week. CREDIT: NASA

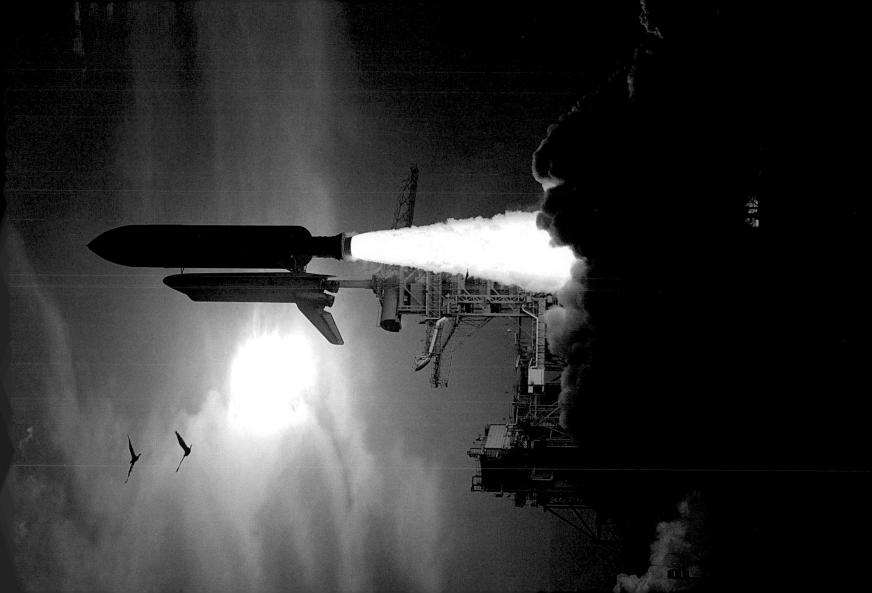

+ **Why Stars Twinkle**

THIS IS WHAT A STAR REALLY LOOKS LIKE FROM THE SURFACE OF EARTH. TO THE BEST THAT THE HUMAN EYE CAN SEE, STARS are so far away they appear the same as would infinitesimal points of light. Earth's atmosphere, however, is clumpy, so that different air pockets produce different images of a single pointlike star. Because the atmosphere is always turbulent, the number and position of the image is always changing, with the result that stars appear to twinkle. Close inspection will reveal a single, small image of the star that is repeated over and over. This image of Betelgeuse is called a speckle and its size is again not really infinitesimal, but determined by strange quantum effects that involve the finite size of the telescope. Recent work in adaptive optics ("rubber mirrors") has made spectacular advances in reducing atmospheric blurring. CREDIT: APPLIED OPTICS GROUP (IMPERIAL COLLEGE).

HERSCHEL 4.2-M TELESCOPE

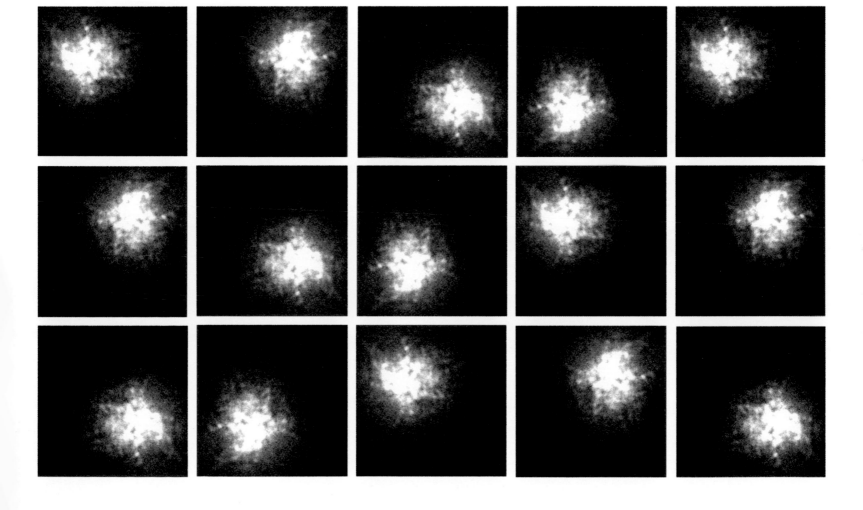

01
02
03
04
05
06
07
08
09
10
11
12
13
14
15
16
17
18
19
20
21
22
23
24
25
26
27
28
29
30
31

+ **Noctilucent Clouds**

SOMETIMES IT'S NIGHT ON THE GROUND BUT DAY IN THE AIR. AS EARTH ROTATES, THE HORIZON BLOCKS THE SUN. WHEN IT'S dark on the ground, sunlight still shines on clouds above. Under usual circumstances, a pretty sunset might be visible, but unusual noctilucent clouds float so high up they can be seen well after dark. Although noctilucent clouds are thought to be composed of small ice-coated particles, much remains unknown about them. Pictured here, a network of noctilucent clouds casts a colorful but eerie glow visible above the dark. CREDIT & COPYRIGHT: PEKKA PARVIAINEN (NCWG/U. COLORADO)

+ **Ancient Volcanoes of Mars**

FINDINGS OF ANCIENT MARTIAN MICROBIAL FOSSILS IN METEORITES AND LIQUID WATER-RELATED FEATURES ON MARS'S SURFACE are currently controversial issues. But one thing long established by space-based observations of the Red Planet is the presence of volcanoes, as Mars supports some of the largest volcanoes in the solar system. This synthetic color picture recorded by the Mars Global Surveyor spacecraft shows two of them, Ceraunius Tholus (left) and Uranius Tholus. Found north of the Tharsis region of truly large martian volcanoes, these are actually two relatively small volcanoes. The summit crater of Ceraunius Tholus is approximately 25 km across. Impact craters that overlay the volcanic martian terrain indicate that these volcanoes are themselves ancient and inactive.

CREDIT: MALIN SPACE SCIENCE SYSTEMS, MOC, MGS, JPL, NASA

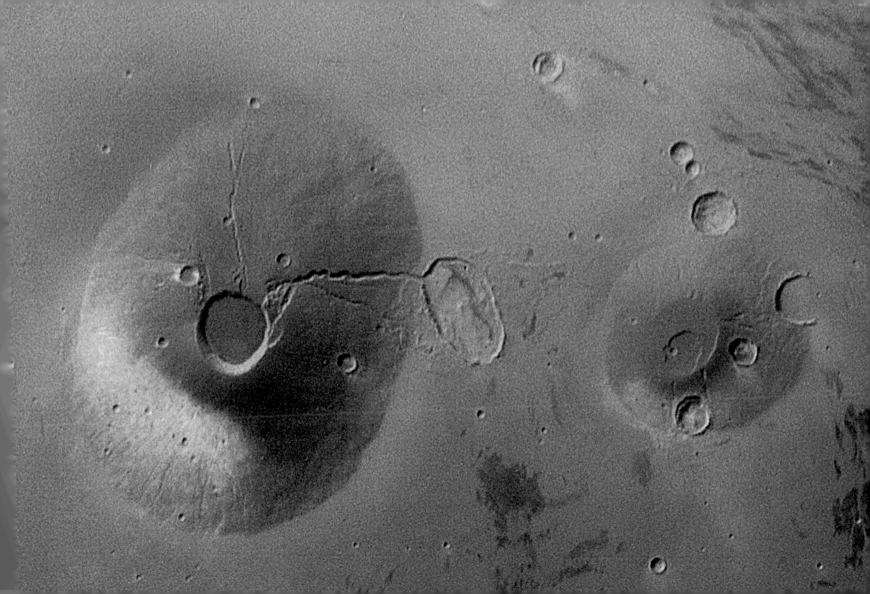

01
02
03
04
05
06
07
08
09
10
11
12
13
14
15
16
17
18
19
20
21
22
23
24
25
26
27
28
29
30
31

+ **Comet LINEAR Disperses**

WHAT'S HAPPENED TO THE NUCLEUS OF COMET LINEAR? THIS BRIGHT COMET UNEXPECTEDLY BROKE UP INTO MANY SMALLER

pieces. The breakup occurred on or about July 25, 2000, and was noted by many astronomers around the world, with particularly

pioneering work by Mark Kidger. Since then astronomers have been searching in vain to find any fragments left of the nucleus,

and watching to see how fast the remaining debris fades. In August 2000 the Hubble Space Telescope was maneuvered to

photograph the region and recovered some of the disintegrating fragments that used to compose comet LINEAR's nucleus.

This image covers only the very tip of an elongated diffuse train of slowly dispersing gas, dust, ice fragments, and gravel. The

largest bits remaining of the badly fractured nucleus appear to be less than 30 meters across. This debris train will not collide

with the Earth and so will not cause a meteor shower. Interested astronomers are now theorizing why comet LINEAR's nucleus

disintegrated into such small pieces. CREDIT: H. WEAVER (JHU) ET AL., WFPC2, HST, NASA

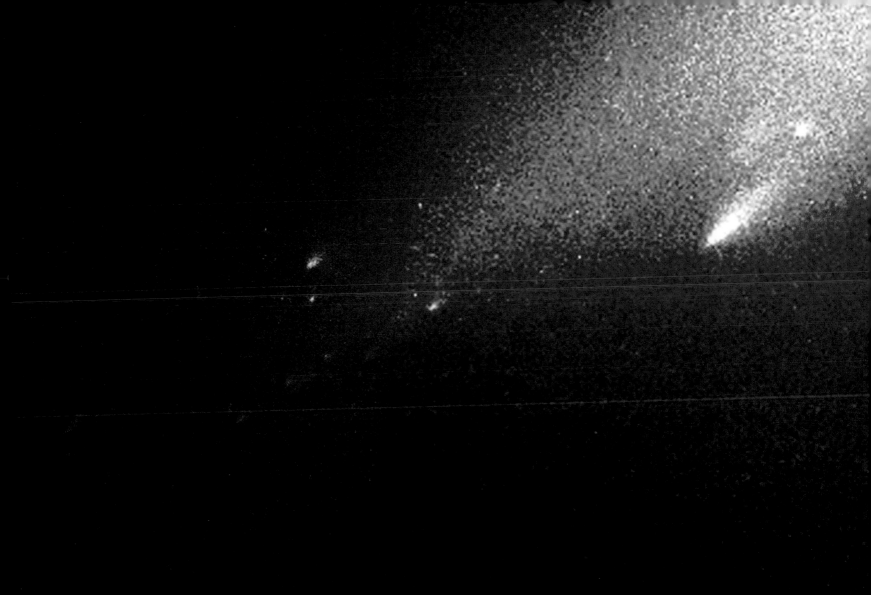

01
02
03
04
05
06
07
08
09
10
11
12
13
14
15
16
17
18
19
20
21
22
23
24
25
26
27
28
29
30
31

+ **The Closest Galaxy: The Sagittarius Dwarf**

WHAT'S THE CLOSEST GALAXY TO OUR MILKY WAY? FOR MANY YEARS ASTRONOMERS THOUGHT IT WAS THE LARGE MAGELLANIC Cloud. But the seemingly insignificant fuzzy patch shown here turned out to be part of a galaxy that is even closer. Named the Sagittarius Dwarf, this small galaxy went unnoticed until its discovery in 1994 by R. Ibata, G. Gilmore, and M. Irwin. The reason the Sagittarius Dwarf hadn't been discovered earlier is because it is so dim, it is so spread out over the sky, and there are so many Milky Way stars in front of it. The distance to the Sagittarius Dwarf was measured to be approximately one-third of the distance to the LMC. Astronomers now believe that this galaxy is slowly being torn apart by the vast gravitational forces of our galaxy.

CREDIT & COPYRIGHT: A. OKSANEN, 2.6 METER NORDIC OPTICAL TELESCOPE

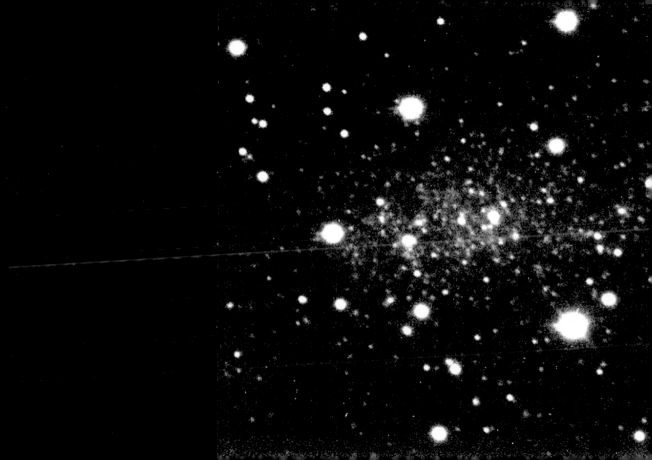

01
02
03
04
05
06
07
08
09
10
11
12
13
14
15
16
17
18
19
20
21
22
23
24
25
26
27
28
29
30
31

+ **Once in a Blue Moon**

HOW OFTEN DOES A FULL MOON OCCUR TWICE IN A SINGLE MONTH? EXACTLY ONCE IN A BLUE MOON. WHILE THE TERM blue moon is thought to originate from common language expressions used hundreds of years ago, the modern usage of blue moon refers to the second full moon in a single month. A blue moon typically occurs every few years; the reason for its rarity is that the 29.53 days between full moons is only slightly shorter than the number of days in the average month. Don't expect a blue moon to look blue. But it is possible for the Moon to sometimes appear tinged blue due to fine dust circulating in Earth's atmosphere, possibly from a volcanic explosion. This dramatically sharp picture of a full moon was recorded on December 22, 1999. It was the last full moon of 1999, a year which also boasted two blue moons. CREDIT AND COPYRIGHT: ROBERT GENDLER

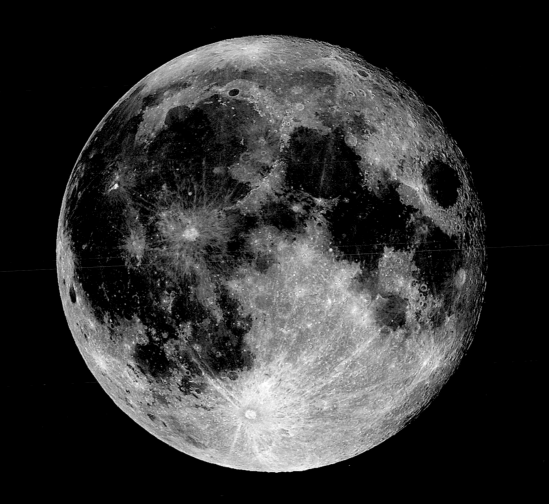

+ **Behind CL1358+62: A New Farthest Object**

WHAT IF WE COULD SEE BACK TO THE BEGINNING OF THE UNIVERSE? AT ONE-TENTH THE UNIVERSE'S PRESENT AGE, WE might see galaxies forming. But what did galaxies look like when they were forming? These questions took a step toward being answered with the analysis of this 1997 Hubble Space Telescope photograph of the most distant object yet discovered. Pictured in the box, this galaxy, a faint red smudge, appears to us as it looked billions of years ago. In technical terms, this galaxy lies at the then record redshift of z=4.92. Practically all of the yellow-white objects in the photograph are galaxies in a nearby cluster that together act as a lens, amplifying the light from the ancient galaxy. A follow-up observation by the ground-based Keck Telescope actually measured the distant redshift. CREDIT: M. FRANX (U. GRONINGEN) & G. ILLINGWORTH (UCSC), WFPC2, HST, NASA

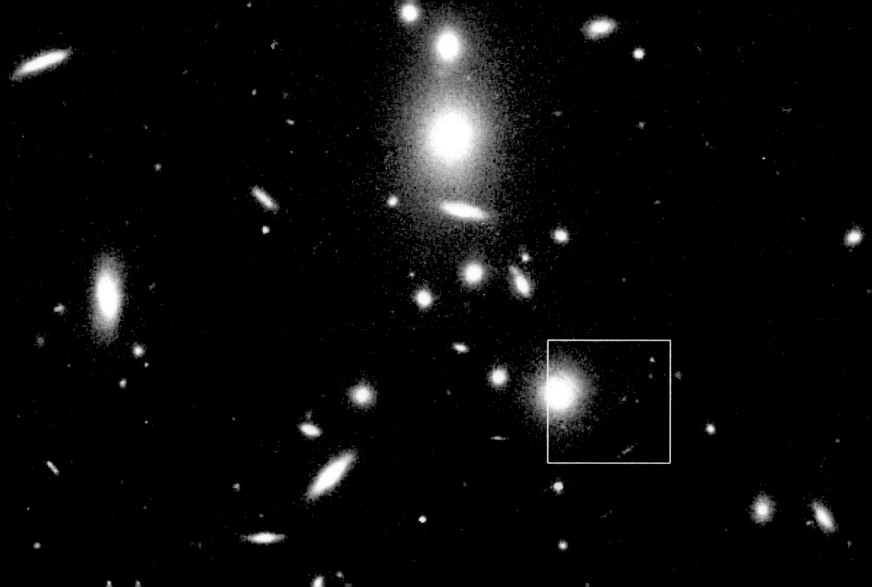

01
+
02
03
04
05
06
07
08
09
10
11
12
13
14
15
16
17
18
19
20
21
22
23
24
25
26
27
28
29
30
31

+ **A String of Pearls**

COMET SHOEMAKER-LEVY 9, NAMED AFTER ITS CODISCOVERERS, WAS OFTEN REFERRED TO AS THE "STRING OF PEARLS" COMET.

It was famous for its remarkable appearance as well as its collision with the planet Jupiter. The comet's original single nucleus was

torn to pieces by Jupiter's strong gravity during a close encounter with the solar system's largest planet in 1992. In this composite of

Hubble Space Telescope images, the pieces are seen to be "pearls" strung out along the comet's orbital path. In July 1994 these pieces

collided with Jupiter in a rare and spectacular series of events. CREDIT: H. WEAVER (JHU), T. SMITH (STSCI), NASA

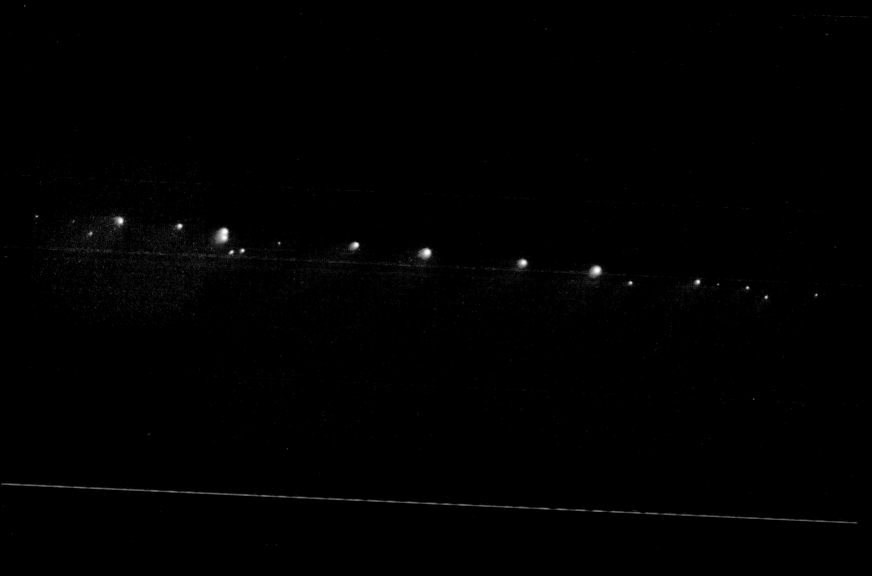

+ Jupiter Swallows Comet Shoemaker-Levy 9

WHAT HAPPENS WHEN A COMET ENCOUNTERS A PLANET? IF THE PLANET HAS A ROCKY SURFACE, A HUGE IMPACT FEATURE WILL form. A giant planet like Jupiter, however, is mostly gas. When comet Shoemaker-Levy 9 struck Jupiter in 1994, each piece was swallowed into the vast jovian atmosphere. Pictured here is a time-lapse sequence of the result of two fragments striking Jupiter. As the comet plunged in, it created large, dark marks that gradually faded (left to right). The high temperature of gas under Jupiter's cloud tops surely caused the comet fragment to melt before it plunged very far. Because Jupiter is much more massive than any comet, the orbit of Jupiter around the Sun did not change noticeably as a result of the impact. CREDIT: H. HAMMEL (SSI), WFPC2, HST, NASA

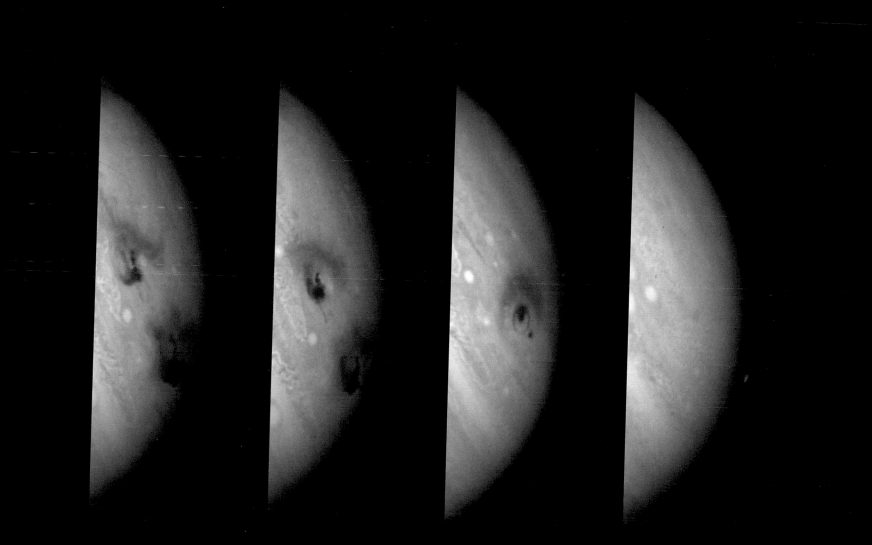

+ Jets from Radio Galaxy 3C296

JETS OF STREAMING PLASMA EXPELLED BY THE CENTRAL BLACK HOLE OF A MASSIVE ELLIPTICAL GALAXY LIKELY LIGHT UP this composite image of 3C296. The jets emanating from NGC 5532 are nearly a million light-years long. Exactly how the central black hole expels some of the stellar debris and material that falls into it is still unknown. After clearing the galaxy, however, the jets inflate large bubbles of energized particles that could glow at radio wavelengths for millions of years. If excited by a passing shock front, inactive radio bubbles can even light up again after a billion years. Visible light is depicted in this image in blue, while radio waves are shown in red. The radio map was created with the Very Large Array of radio telescopes. CREDIT & COPYRIGHT: NATIONAL RADIO ASTRONOMY OBSERVATORY/AUI

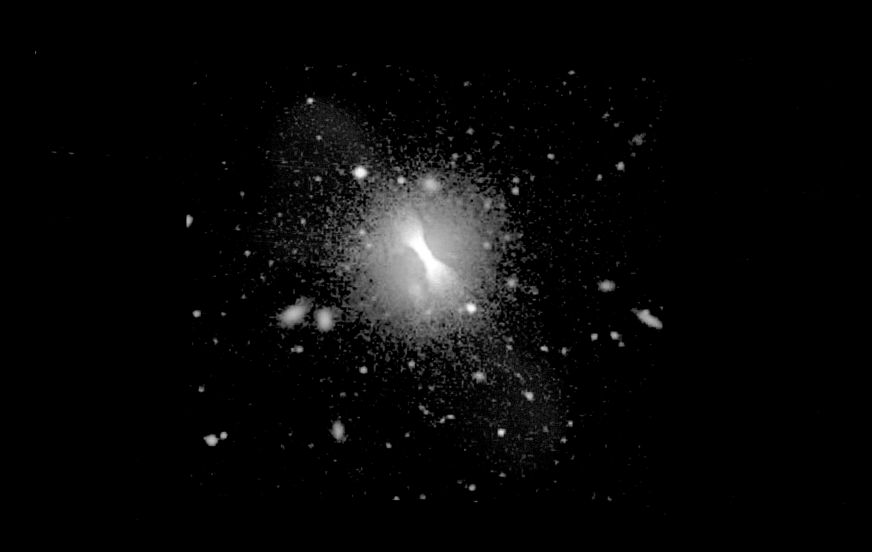

+ Anticrepuscular Rays over Colorado

WHAT'S HAPPENING OVER THE HORIZON? ALTHOUGH THE SCENE MAY APPEAR SOMEHOW SUPERNATURAL, NOTHING MORE unusual is occurring than a setting Sun and some well-placed clouds. Pictured here are anticrepuscular rays. To understand them, start by picturing common crepuscular rays that are seen any time that sunlight pours though scattered clouds. Now, although sunlight indeed travels along straight lines, the projections of these lines onto the spherical sky are great circles. Therefore, the crepuscular rays from a setting (or rising) sun will appear to reconverge on the other side of the sky. At the antisolar point 180 degrees around from the Sun, they are referred to as "anticrepuscular rays." Pictured here is a particularly striking set of anticrepuscular rays photographed in 2001 from a moving car just outside Boulder, Colorado. CREDIT & COPYRIGHT: JOHN BRITTON

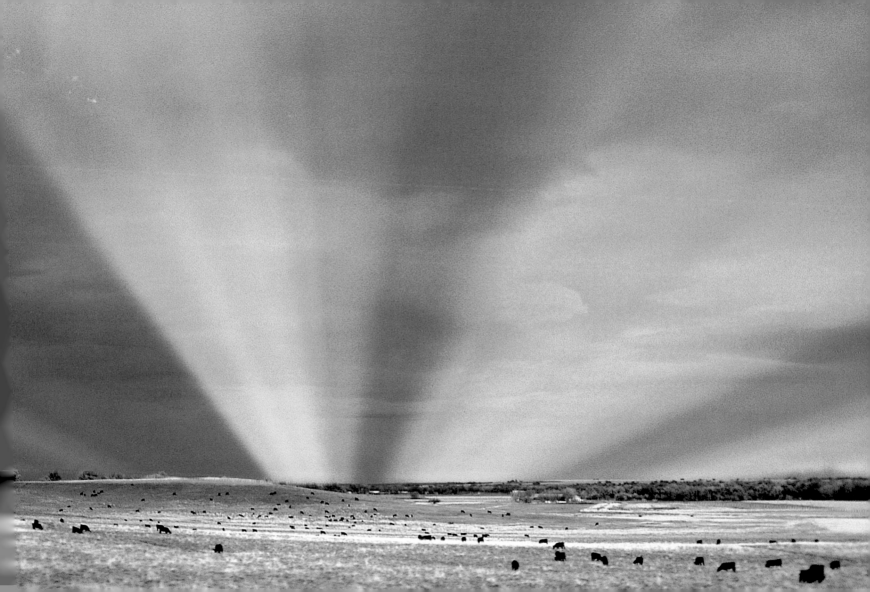

+ Halley's Nucleus: An Orbiting Iceberg

WHAT DOES A COMET NUCLEUS LOOK LIKE? FORMED FROM THE PRIMORDIAL STUFF OF THE SOLAR SYSTEM, IT IS THOUGHT TO resemble a very dirty iceberg. But for active comets, telescopic images only reveal the surrounding cloud of gas and dust, the comet's coma, and the characteristic cometary tails. In 1986, the European spacecraft Giotto encountered the nucleus of Halley's comet as it approached the Sun. Data from Giotto's camera was used to generate this enhanced image of the potato-shaped nucleus that measures roughly 15 km across. It shows surface features on the dark nucleus against the bright background of the coma as the icy material is vaporized by the Sun's heat. Every 76 years comet Halley returns to the inner solar system, and each time the nucleus sheds about a 6-meter-deep layer of its ice and rock into space. This debris composes Halley's tails and leaves an orbiting trail responsible for the Orionids meteor shower. CREDIT: HALLEY MULTICOLOR CAMERA TEAM, GIOTTO PROJECT, ESA. COPYRIGHT: MPAE

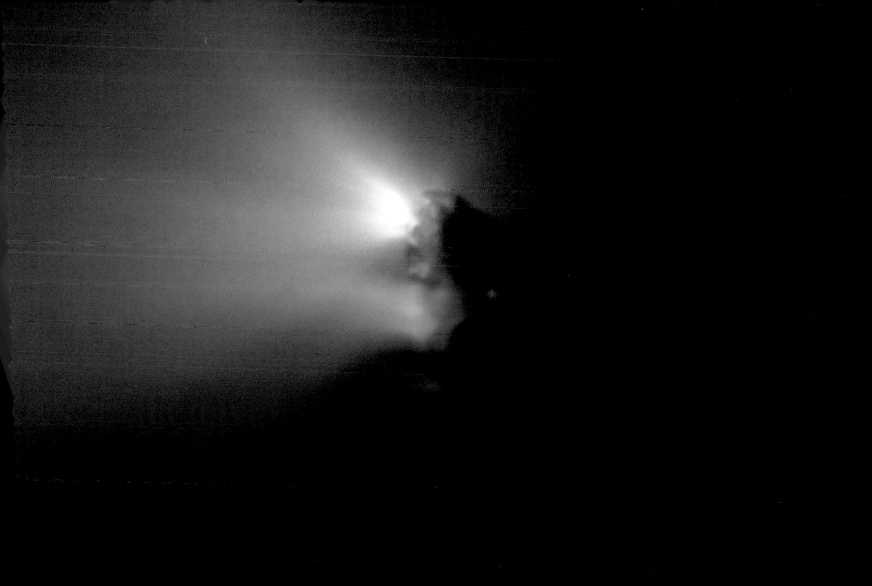

+ Hale-Bopp from Indian Cove

GOOD CAMERAS WERE ABLE TO OBTAIN IMPRESSIVE PHOTOGRAPHS OF COMET HALE-BOPP WHEN IT WAS AT ITS BRIGHTEST IN 1997.

In this photograph taken April 5, 1997, comet Hale-Bopp was imaged from Indian Cove Campground in the Joshua Tree National Forest, California. In this 30-second exposure, a flashlight was used to illuminate foreground rocks momentarily. At its brightest in March and April of 1997, comet Hale-Bopp was easily visible to the unaided eye, even in light-polluted skies above major metropolitan areas. Known as the Great Comet of 1997, Hale-Bopp may have been the most-viewed comet in history. CREDIT & COPYRIGHT: WALLY PACHOLKA/ASTROPICS.COM

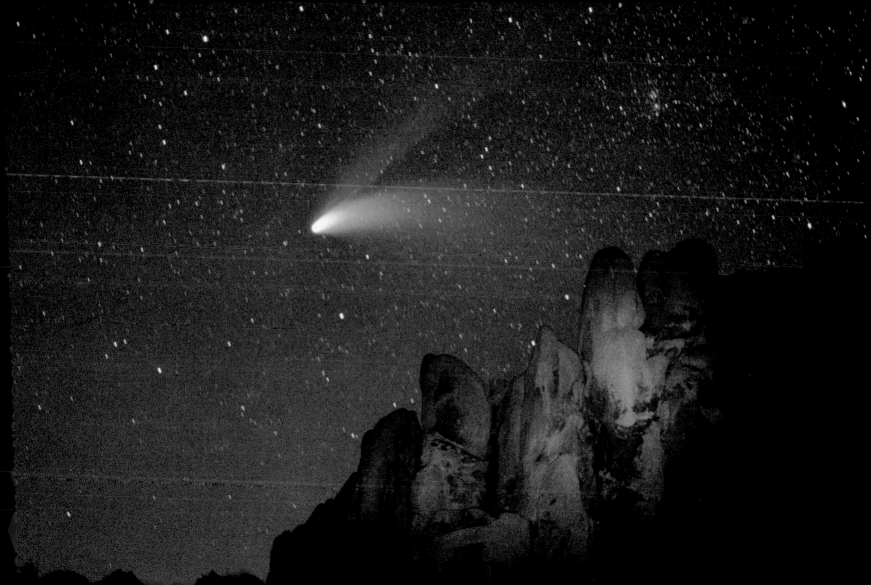

+ **Bright Galaxy M81**

BIG AND BEAUTIFUL SPIRAL GALAXY M81, IN THE NORTHERN CONSTELLATION URSA MAJOR, IS ONE OF THE BRIGHTEST GALAXIES visible on the skies of planet Earth. This superbly detailed view reveals its bright nucleus, grand spiral arms, and sweeping cosmic dust lanes on a scale comparable to the Milky Way. Hinting at a disorderly past, a remarkable dust lane runs straight through the disk, below and to the right of the galactic center, contrary to M81's other prominent spiral features. The errant dust lane may be the lingering result of a close encounter between M81 and its smaller companion galaxy, M82. Scrutiny of variable stars in M81 (aka NGC 3031) has yielded one of the best-determined distances for an external galaxy—11.8 million light-years. CREDIT & COPYRIGHT: ROBERT GENDLER

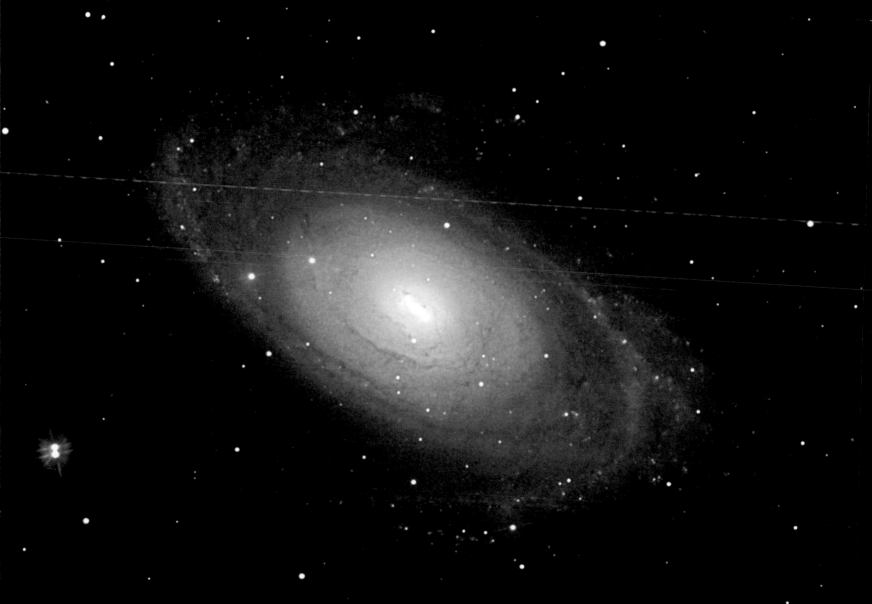

+ NGC 1365: A Nearby Barred Spiral Galaxy

MANY SPIRAL GALAXIES HAVE BARS ACROSS THEIR CENTERS. EVEN OUR OWN MILKY WAY GALAXY IS THOUGHT TO HAVE A BAR, but one that is perhaps not so prominent as the one in NGC 1365, shown here. The persistence and motion of the bar imply relatively massive spiral arms. The placement of bright young blue stars and dark dust lanes also indicates a strong rotating density wave of star formation. NGC 1365 is a member of the Fornax Cluster of galaxies. Because NGC 1365 is relatively nearby, simultaneous measurements of its speed and distance are possible, which helps astronomers estimate how fast our universe is expanding.

CREDIT: FORS TEAM, 8.2-METER VLT ANTU, ESO

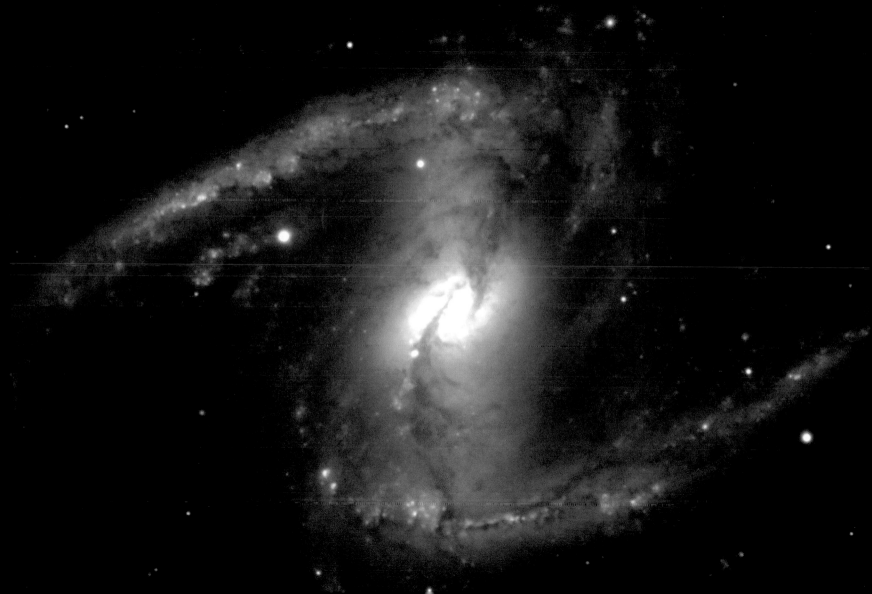

+ A Solar Filament Lifts Off

+

HOT GAS FREQUENTLY ERUPTS FROM THE SUN. ONE SUCH ERUPTION PRODUCED THE GLOWING FILAMENT PICTURED HERE, captured on July 19, 2000, by the Earth-orbiting TRACE satellite. Composed of relatively cool, dense gas, the filament, although small compared to the overall size of the Sun, measures over 100,000 km in height, so that the entire Earth could easily fit into its outstretched arms. Gas in the filament is funneled by the complex and changing magnetic field of the Sun. After lifting off from the Sun's surface, most of the filamentary gas will eventually fall back. More powerful solar eruptions emit particles that reach the Earth and can disrupt man-made satellites. The cause and nature of solar eruptions is the topic of much research.

CREDIT: TRANSITION REGION AND CORONAL EXPLORER (TRACE)

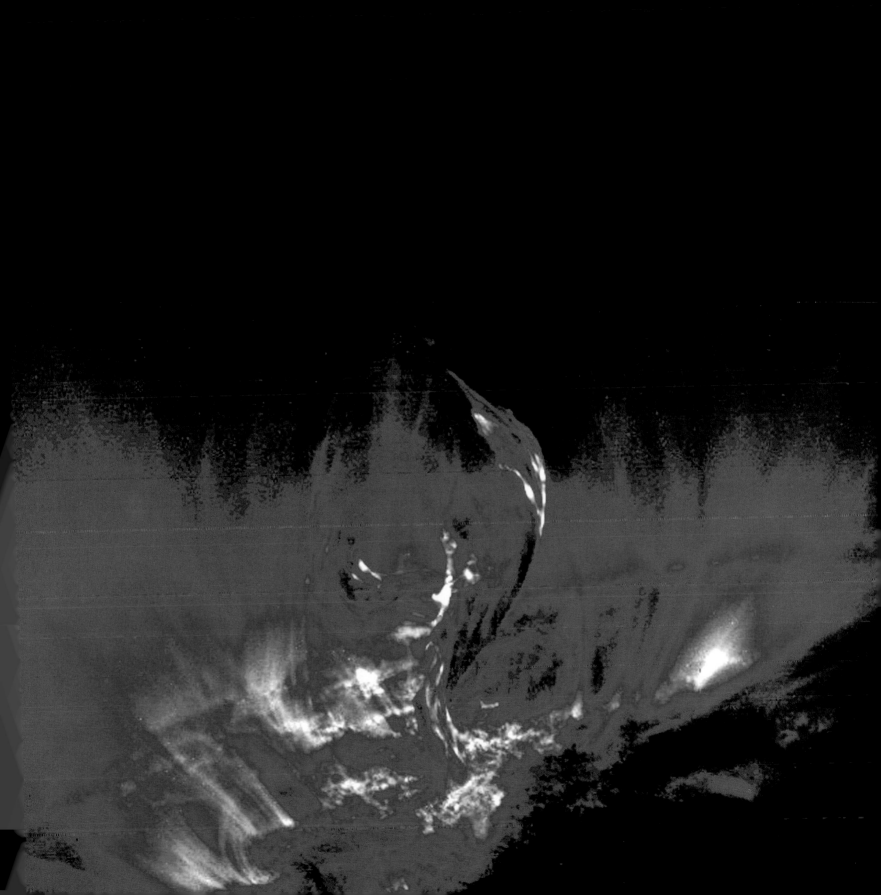

+ **Voyager Views Titan's Haze**

+

LAUNCHED IN 1977, THE VOYAGER I SPACECRAFT'S HISTORIC TOUR OF THE OUTER SOLAR SYSTEM TOOK IT PAST SATURN IN LATE

1980. On November 12, 1980, Voyager 1 recorded this view looking across the edge of Titan, Saturn's largest moon, from a distance of

approximately 22,000 km. Seen here in false color, the moon's hazy atmosphere appears orange with further layers of blue haze sus-

pended above. Titan's mostly nitrogen atmosphere, denser than Earth's, also contains methane and is thought to be laced with more

complex hydrogen and carbon compounds. The composition is likened to Earth's atmosphere before life began. Spotted by Voyager,

the detached layers of haze hundreds of kilometers above the surface, along with details of Titan's atmospheric chemistry, have

intrigued earthbound researchers who have recently proposed a model that links seasonal variations in the haze, winds, and sunlight.

Their model accounts for the early Voyager observations as well as subsequent studies. Further tests of the model are anticipated when

the Huygens probe, carried by the saturn-bound Cassini spacecraft, enters Titan's atmosphere in 2005. CREDIT: VOYAGER PROJECT, JPL, NASA

+ **A Mystery in Gamma Rays**

GAMMA RAYS ARE THE MOST ENERGETIC FORM OF LIGHT, PACKING A MILLION OR MORE TIMES THE ENERGY OF VISIBLE LIGHT photons. If you could see gamma rays, the familiar skyscape of steady stars would be replaced by some of the most bizarre objects known to modern astrophysics—and some that are unknown. When the EGRET instrument on the orbiting Compton Gamma-ray Observatory surveyed the sky in the 1990s, it catalogued 271 celestial sources of high-energy gamma rays. Researchers identified some with exotic black holes, neutron stars, and distant flaring galaxies. But 170 of the catalogued sources, shown in this all-sky map, remain unidentified. Many sources in this gamma-ray mystery map likely belong to already-known classes of gamma-ray emitters and are simply obscured or too faint to be otherwise positively identified. However, astronomers have called attention to the ribbon of sources winding through the plane of the galaxy, projected here along the middle of the map, which may represent a large unknown class of galactic gamma-ray emitters. In any event, the unidentified sources could remain a mystery until the planned launch of the more sensitive Gamma-ray Large Area Space Telescope in 2006. CREDIT: N. GEHRELS, D. MACOMB, D. BERTSCH, D. THOMPSON, R. HARTMAN (GSFC), EGRET, NASA

01
02
03
04
05
06
07
08
09
10
11
12
13
14
15
16
17
18
19
20
21
22
23
24
25
26
27
28
29
30
31

+

+ **A Perseid Meteor**

EVERY YEAR, AROUND THE NIGHTS OF AUGUST 11 OR 12, THE PERSEID METEOR SHOWER REACHES ITS MAXIMUM. GRAINS OF COSMIC sand and gravel shed from comet Swift-Tuttle streak across the sky as they vaporize during entry into Earth's atmosphere. The annual Perseids result from the yearly crossing of Earth through comet Swift-Tuttle's orbit. The Perseids are typically the most active meteor showers of the year. On a clear, dark sky, an observer might see a meteor a minute near peak times, but if a bright moon haunts the night it will overwhelm the glow from many of the fainter Perseid meteors. Pictured here is a Perseid meteor from 1993. The colors are representative, but enhanced digitally. As the meteor streaked across the night sky, different excited atoms emitted different colors of light. The origin of the green tinge visible at the right is currently unknown, however, and might result from oxygen in Earth's atmosphere. Perseid meteors can best be seen from a reclining position, away from lights, just before the dawn twilight.

CREDIT & COPYRIGHT: S. KOHLE & B. KOCH (ASTRON. I., U. BONN)

+ **Doomed Star Eta Carinae**

ETA CARINAE MAY BE ABOUT TO EXPLODE. BUT NO ONE KNOWS WHEN—IT COULD BE 1 MILLION YEARS FROM NOW, OR IT COULD be sooner! Eta Carinae's mass—approximately 100 times greater than our Sun—makes it an excellent candidate for a full-blown supernova. Historical records do show that about 150 years ago Eta Carinae, a star in the Keyhole Nebula, underwent an unusual outburst that made it one of the brightest stars in the southern sky. This image, taken in 1996, resulted from sophisticated image-processing procedures designed to bring out new details in the unusual nebula that surrounds this rogue star. Now clearly visible are two distinct lobes, a hot central region, and strange radial streaks. The lobes are filled with lanes of gas and dust that absorb the blue and ultraviolet light emitted near the center. The streaks remain unexplained. Will these clues tell us how the nebula was formed? Will they better indicate when Eta Carinae will explode? CREDIT: J. MORSE (U. COLORADO), K. DAVIDSON (U. MINNESOTA) ET AL., WFPC2, HST, NASA

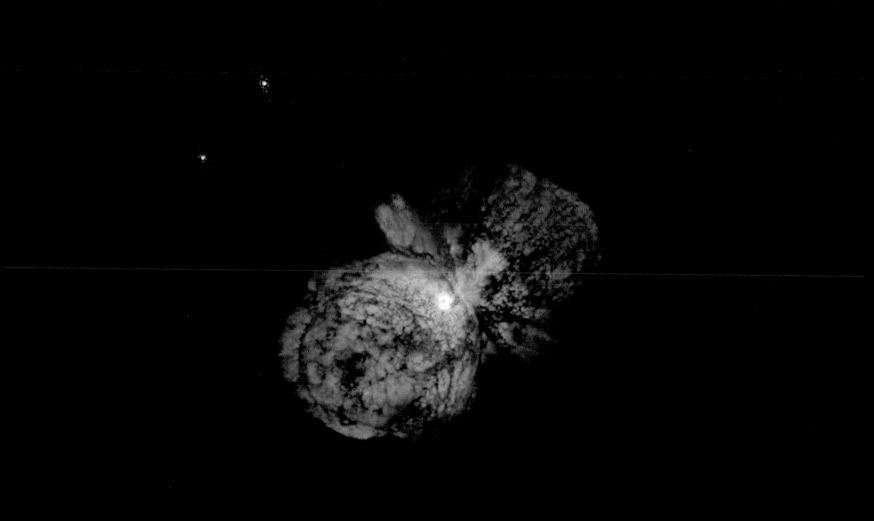

+ Mars Rocks, Sojourner Rolls

THIS COLOR IMAGE, FEATURING A ROCK DUBBED YOGI AND THE ROLLING SOJOURNER ROBOT, WAS TAKEN ON THE SURFACE OF Mars by the Mars Pathfinder spacecraft camera. Friendly-looking Yogi appears to be leaning into the prevailing winds, causing some to suggest that the rock's two-tone surface may be due to the accumulation of rust-colored dust on its windward face. Also seen is the six-wheeled Sojourner robot that rode to Mars onboard Pathfinder. About the size of a house cat, Sojourner roamed over 50 meters across the martian surface investigating Yogi and other rocks up close. As suggested in a student essay, the roving Sojourner was named for Sojourner Truth, an African American reformist who lived during the Civil War era. After landing on Mars on July 4, 1997, the Mars Pathfinder spacecraft was renamed the Sagan Memorial Station in honor of American astronomer Carl Sagan. CREDIT: IMP TEAM, JPL, NASA

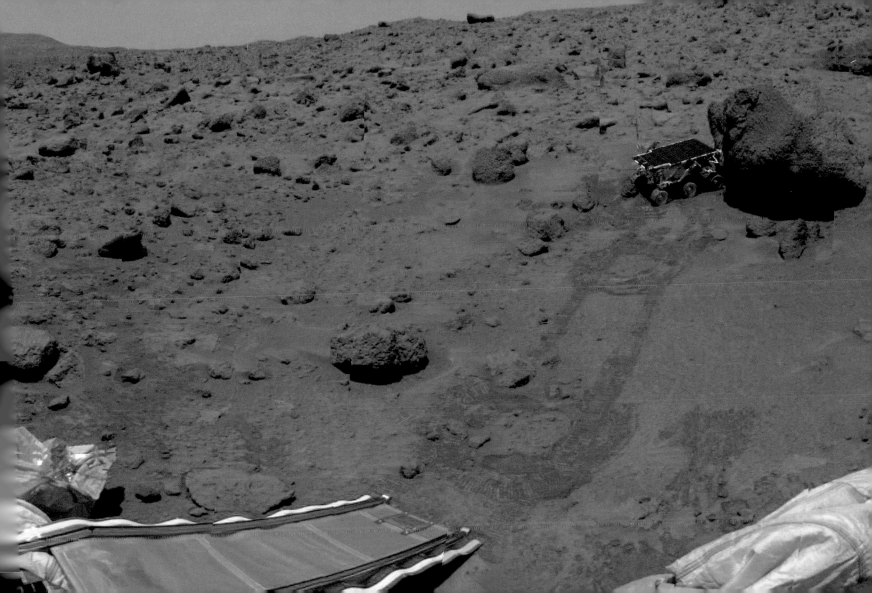

+ **The Solar Spectrum**

IT IS STILL NOT KNOWN WHY THE SUN'S LIGHT IS MISSING SOME COLORS. SHOWN HERE ARE ALL THE VISIBLE COLORS OF the Sun, produced by passing the Sun's light through a prismlike device. This spectrum was created at the McMath-Pierce Solar Observatory and shows, first off, that although our yellow-appearing Sun emits light of nearly every color, it does indeed appear brightest in yellow-green light. The dark patches in the spectrum arise from gas at or above the Sun's surface, absorbing sunlight emitted below. Since different types of gas absorb different colors of light, it is possible to determine what gases compose the Sun. Helium, for example, was first discovered in 1870 from a solar spectrum and only later found here on Earth. Today, the majority of spectral absorption lines have been identified—but not all. CREDIT & COPYRIGHT: NIGEL SHARP (NOAO), FTS, NSO, KPNO, AURA, NSF

+ **Where is Upsilon Andromedae?**

IN 1999, A TEAM OF ASTRONOMERS LED BY PAUL BUTLER AND GEOFFREY MARCY ANNOUNCED THE DETECTION OF THREE LARGE planets orbiting the star Upsilon Andromedae—the first planetary system known to orbit a normal star other than our sun. These planets were not directly photographed but found through a Doppler technique developed to use large telescopes to search nearby stars for wobbling planetary signatures. However, Upsilon Andromedae itself is visible to the unaided eye, shining in Earth's sky in the northern constellation Andromeda at about 4th magnitude. This deep photographic image shows Upsilon Andromedae along with fainter stars and "deep-sky" objects including the famous Andromeda spiral galaxy (M31) (above), the Triangulum galaxy (M33) (right), and the star cluster NGC 752 (below right). Approximately 44 light-years distant, Upsilon Andromedae is a star only a little more massive and just slightly hotter than the Sun. CREDIT AND COPYRIGHT: TILL CREDNER & SVEN KOHLE

+ **The 47 Ursae Majoris System**

BY WATCHING AND WAITING, ASTRONOMERS HAVE UNCOVERED THE PRESENCE OF MORE THAN SEVENTY PLANETS ORBITING STARS other than the Sun. So far almost all these extrasolar planets have crazy, elongated orbits, lie uncomfortably close to their parent stars, or are found in bizarre, inhospitable systems. A known exception is the nearby sun-like star, 47 Ursae Majoris (47 UMa), discovered to have at least two planets in nearly circular orbits reminiscent of Jupiter and Saturn in our own familiar solar system. The planets are too distant and faint to be photographed directly. Still, 13 years of spectroscopic observations of 47 UMa begun by Paul Butler and Geoffrey Marcy revealed the wobbling signature of a second planet intertwined with one previously known. In this artist's illustration, the worlds of 47 UMa hang over the rugged volcanic landscape of a hypothetical moon. The moon orbits the newly discovered planet, imagined here with Saturn-like rings, while the previously known planet is visible as a tiny crescent, close to the yellowish star. Closer still to 47 UMa is another tiny dot, a hypothetical Earth-like water world. About 51 light-years distant, 47 UMa can be found on planet Earth's sky near the Big Dipper. CREDIT: COPYRIGHT 2001 LYNETTE COOK

+ On the Origin of Gold

WHERE DID THE GOLD IN YOUR JEWELRY ORIGINATE? NO ONE IS COMPLETELY SURE. THE RELATIVE AVERAGE ABUNDANCE OF gold in our solar system appears higher than can be found in the early universe, in stars, and even in typical supernova explosions. Some astronomers now suggest that neutron-rich heavy elements such as gold might be most easily made in rare neutron-rich explosions such as the collision of neutron stars. Pictured here is a computer-animated frame depicting two neutron stars spiraling in toward each other, just before they collide. Since neutron-star collisions are also suggested as the origin of gamma-ray bursts, it is possible that you already own a souvenir from one of the most powerful explosions in the universe.

CREDIT: STEPHAN ROSSWOG (UNIVERSITY OF LEICESTER) ET AL., UKAFF

Temperature [millions of degrees]

100 3000 10000 30000 60000 100000

01
02
03
04
05
06
07
08
09
10
11
12
13
14
15
16
17
18
19
20
21
22
23
24
25
26
27
28
29
30
31

+ **M16: Stars from Eagle's EGGs**

NEWBORN STARS ARE FORMING IN THE EAGLE NEBULA. THIS IMAGE, TAKEN WITH THE HUBBLE SPACE TELESCOPE IN 1995, shows evaporating gaseous globules (EGGs) emerging from pillars of molecular hydrogen gas and dust. The giant pillars are light-years in length and are so dense that interior gas contracts gravitationally to form stars. At each pillar's end, the intense radiation of bright, young stars causes low-density material to boil away, leaving exposed stellar nurseries of dense EGGs. The Eagle Nebula, associated with the open star cluster M16, lies approximately 7,000 light-years away. This is probably the most well-known image taken by the Hubble Space Telescope. CREDIT: J. HESTER, P. SCOWEN (ASU), HST, NASA

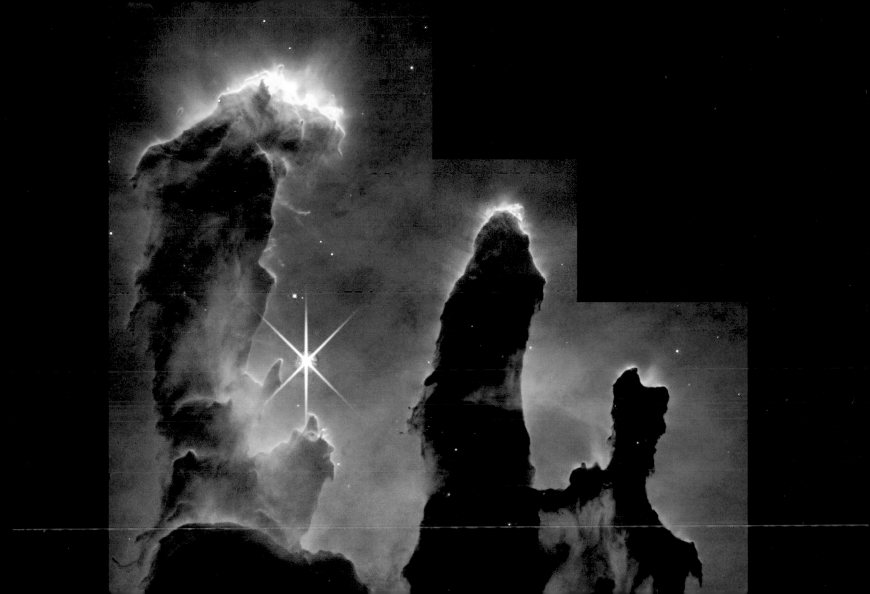

+ **The Lagoon Nebula in Three Colors**

THE BRIGHT LAGOON NEBULA IS HOME TO A DIVERSE ARRAY OF ASTRONOMICAL OBJECTS. PARTICULARLY INTERESTING ARE the bright, open cluster of stars and several energetic star-forming regions. Some pictures show the Lagoon Nebula dominated by an overall red glow that is caused by luminous hydrogen gas, with dark filaments that are caused by absorption by dense lanes of dust. This picture, from the Curtis-Schmidt Telescope, however, shows the nebula's emission in three exact colors specifically emitted by hydrogen, oxygen, and sulfur. The Lagoon Nebula, also known as M8 and NGC 6523, lies approximately 5,000 light-years away. The Lagoon Nebula can be located with binoculars in the constellation Sagittarius, spanning a region over 3 times the diameter of a full Moon. CREDIT & COPYRIGHT: R. BARBA, N. MORRELL ET AL. (UNLP), CTIO, NOAO/AURA/NSF

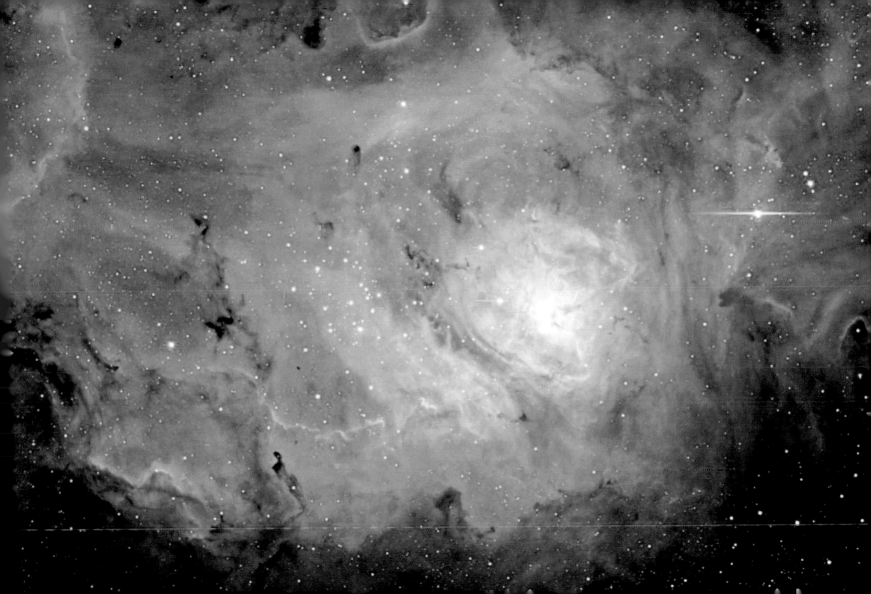

+ Twistin' by the Lagoon

+

THE AWESOME SPECTACLE OF STARBIRTH PRODUCES EXTREME STELLAR WINDS AND INTENSE ENERGETIC STARLIGHT—

bombarding dusty molecular clouds inside the Lagoon Nebula. At least two long, funnel-shaped clouds, each roughly a half

light-year long, have apparently been formed by this activity. They extend from the upper left of this close-up of the bright area

of the Lagoon known as the Hourglass. Are these interstellar funnel clouds actually swirling, twisting analogs to Earthly torna-

does? It's possible. As energy from nearby young, hot stars, like the one at lower right, pours into the cool dust and gas, large

temperature differences in adjoining regions can be created, generating shearing winds. This picture is a reprocessed HST

image made in 1995 as researchers explored this nearby (5,000 light-years-distant) star-forming region that lies in the direction

of Sagittarius. CREDIT: A. CAULET (ST-ECF, ESA), NASA

+ **East of the Lagoon Nebula**

LOCATED TO THE EAST OF THE LAGOON NEBULA, THE STAR FIELD PICTURED HERE IS RICH IN DIVERSITY. ON THE LOWER RIGHT of the image are clouds rich in dark dust that hides background stars and young star systems still forming. On the upper left are clouds filled with hot, glowing gas, including part of the emission nebula catalogued as NGC 6559. Between the two regions is a dust nebula reflecting light from a group of massive blue stars. The region pictured spans about 3 light-years and likely has a common history with the Lagoon Nebula itself. These nebulas lie about 5,000 light-years away toward the constellation Sagittarius.

CREDIT & COPYRIGHT: CANADA–FRANCE–HAWAII TELESCOPE/JEAN-CHARLES CUILLANDRE/2000

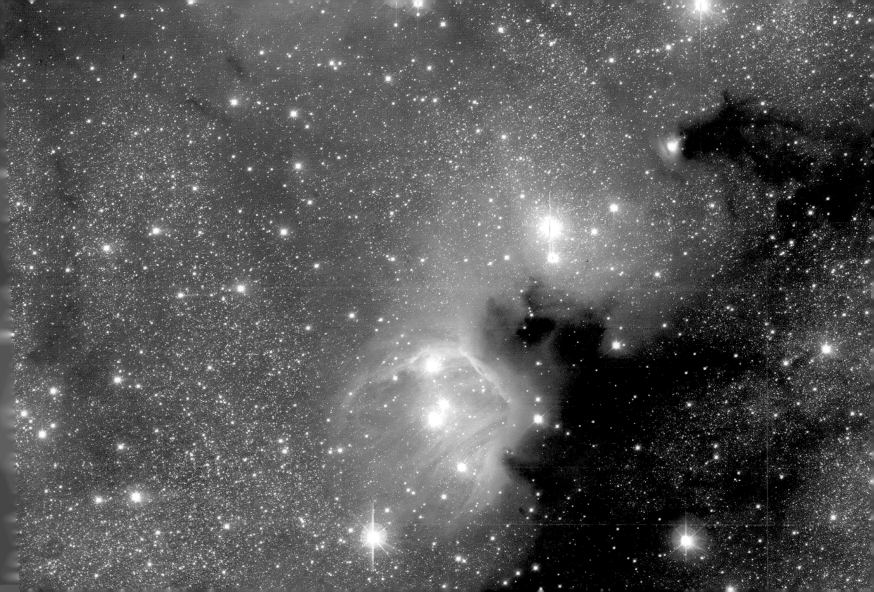

+ **Dark Spots on Neptune**

NEPTUNE HAS SPOTS. THE SOLAR SYSTEM'S OUTERMOST GAS GIANT SHOWS A NEARLY UNIFORM BLUE HUE CREATED BY SMALL amounts of methane drifting in a thick atmosphere of nearly colorless hydrogen and helium. Dark spots do appear, however, that are anticyclones: large, high-pressure systems that swirl in Neptune's cold cloud tops. Two dark spots are visible in this picture taken by the robot Voyager 2 spacecraft in 1989: an Earth-size Great Dark Spot located on the far left, and Dark Spot 2 located near the bottom. A bright companion cloud dubbed Scooter accompanies the Great Dark Spot. Computer simulations indicate that bright cloud features are methane clouds that might commonly be found near dark spots. Subsequent images of Neptune by the Hubble Space Telescope in 1994 indicated that although both of these dark spots had dissipated, another had been created since.

CREDIT: VOYAGER 2 TEAM, NASA

+ **In the Center of the Trapezium**

START WITH THE CONSTELLATION ORION. BELOW ORION'S BELT IS A FUZZY AREA KNOWN AS THE GREAT NEBULA OF ORION, OR M42. In this nebula is a bright star cluster known as the Trapezium, shown here. New stellar systems are forming there in gigantic globs of gas and dust known as proplyds. Looking closely at this picture also reveals that gas and dust surrounding some of the dimmer stars appear to form structures that point away from the brighter stars. The combination of several exposures from the Hubble Space Telescope made this false-color image. CREDIT: J. BALLY, D. DEVINE, & R. SUTHERLAND, D. JOHNSON (CITA), HST, NASA

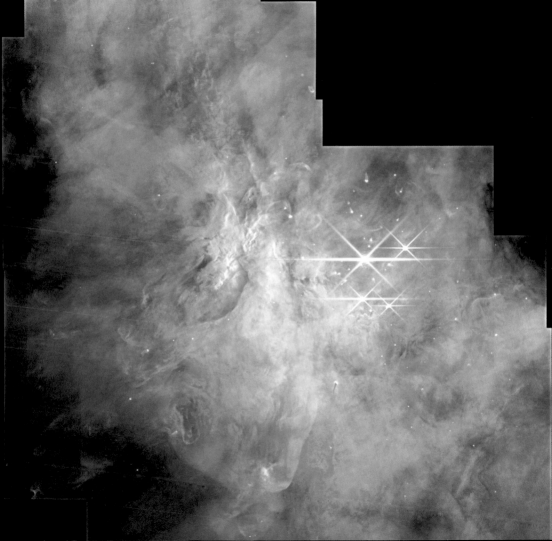

+ The Brown Dwarfs of Orion's Trapezium

THE BRIGHT STARS PICTURED HERE ARE WELL KNOWN AS THE TRAPEZIUM, AN OPEN CLUSTER OF STARS IN THE CENTER OF

the Orion Nebula. The many dim objects, however, are not well known and have come to attention only on images made in

infrared light. These dim objects are thought to be brown dwarfs and possibly large, free-floating planets. Brown dwarfs are stars

too puny to create energy in their core by fusing hydrogen into helium. Although many more brown dwarfs than hot stars have

now been found in Orion, their very low masses make them inadequate to compose much of the dark matter expected in galaxies

and the universe. This false-color mosaic combines infrared and visible light images of the Trapezium from the Hubble Space

Telescope. Faint brown dwarfs with masses as small as approximately 1 percent of the mass of the Sun are seen in the infrared

data. Also visible are complex lanes of hot gas (appearing in blue) and cooler, fine dust that blocks and reflects nearby starlight.

CREDIT: G. SCHNEIDER (UOFA), K. L. LUHMAN (CFA), ET AL., NICMOS IDT, NASA. WFPC2 DATA: C. O'DELL AND S. WONG (RICE)

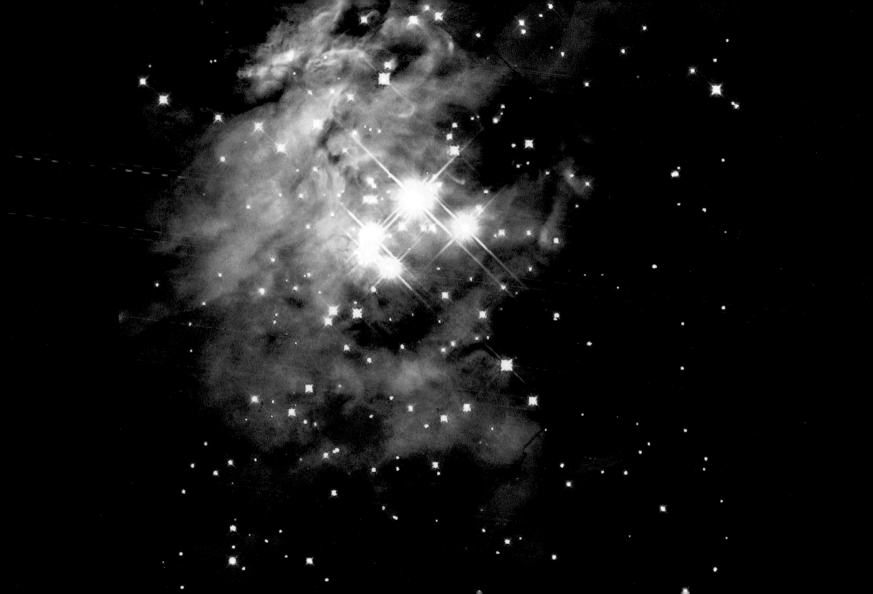

+ **Trapezium: Teardrops in My Skies**

SOMETIMES THE UNEXPECTED COMES IN A FAMILIAR SHAPE. IN THIS PICTURE, THE SEEMINGLY FAMILIAR TEARDROP-SHAPED object just right of center is actually an unusually situated disk of gas and dust. In fact, the teardrop is about the size of our own solar system and is racing against time to condense and form planets. This disk, however, is unfortunate enough to lie in the Trapezium, which is also home to several immense, bright stars. These bright stars emit light so powerful that it erodes away the gas and dust in planet-forming disks. Large Jupiter-like planets will probably never form in this hostile environment, but it is currently unknown whether Earth-like planets could form and survive. CREDIT: D. JOHNSTONE (CITA), J. BALLY (U. COLORADO) ET AL., WFPC2, HST, NASA

01
02
03
04
05
06
07
08
09
10
11
12
13
14
15
16
17
18
19
20
21
22
23
24
25
26
27
28
29
30
31

+ **The Helix Nebula from CFHT**

ONE DAY OUR SUN MAY LOOK LIKE THIS. THE HELIX NEBULA IS THE CLOSEST EXAMPLE OF A PLANETARY NEBULA CREATED at the end of the life of a Sun-like star. The outer gases of the star, expelled into space, appear from our vantage point as if we are looking down a helix. The remnant central stellar core, destined to become a white dwarf star, glows in light so energetic it causes the previously expelled gas to fluoresce. The Helix Nebula, given a technical designation of NGC 7293, lies 450 light-years away toward the constellation Aquarius and spans 1.5 light-years. This image was taken with the Canada-France-Hawaii Telescope (CFHT) located atop a dormant volcano in Hawaii. A close-up of the inner edge of the Helix Nebula shows unusual gas knots of unknown origin. CREDIT & COPYRIGHT: CANADA-FRANCE-HAWAII TELESCOPE/JEAN-CHARLES CUILLANDRE/1999

+ The Eclipse Tree

IF YOU LOOK CLOSELY AT THE SHADOW OF THIS TREE, YOU WILL SEE SOMETHING QUITE UNUSUAL: IT IS COMPOSED OF HUNDREDS of images of a solar eclipse in progress. Small gaps between the tree's leaves are acting like simple pinhole cameras, projecting a discernible image of the crescent Sun onto the shaded sidewalk below. This tree's height and multitude of leaves combine dramatically to produce the large size and number of images. Watching an eclipse this way is relatively safe, but looking directly at the Sun, even during an eclipse, is dangerous, and proper precautions should be taken. This picture was taken in 1994 on the campus of Northwestern University, Evanston, Illinois. CREDIT & COPYRIGHT: ELISA J. ISRAEL

+ **Looking Back on an Eclipsed Earth**

HERE IS WHAT THE EARTH LOOKS LIKE DURING A SOLAR ECLIPSE. THE SHADOW OF THE MOON CAN BE SEEN DARKENING PART of Earth. This shadow moves across the Earth at nearly 2,000 km per hour. Only observers near the center of the dark circle see a total solar eclipse—others see a partial eclipse where only part of the Sun appears blocked by the Moon. This spectacular picture of the August 11, 1999, solar eclipse was one of the last ever taken from the Mir Space Station. CREDIT: MIR 27 CREW; COPYRIGHT: CNES

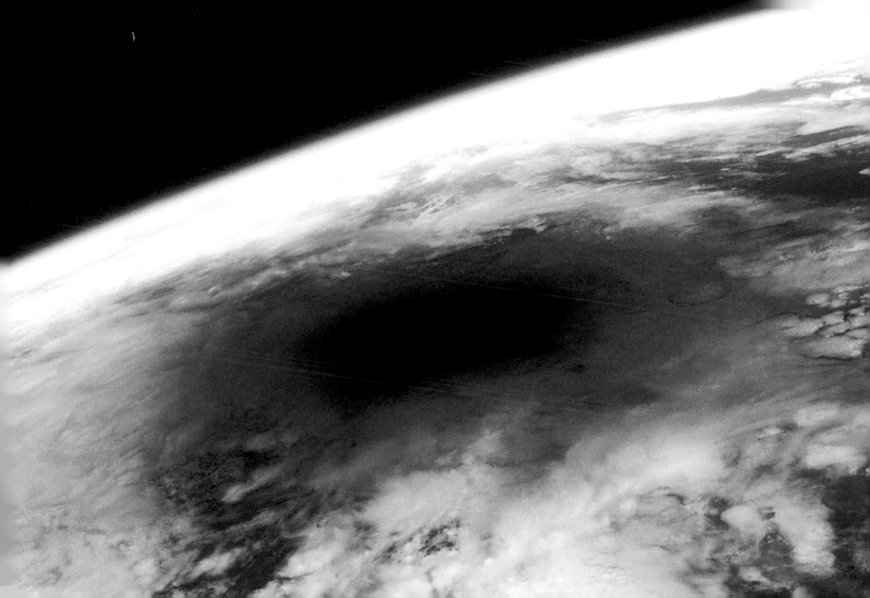

01
02
03
04
05
06
07
08
09
10
11
12
13
14
15
16
17
18
19
20
21
22
23
24
25
26
27
28
29
30
31

+ Full Throttle for Deep Space 1

AT FULL THROTTLE, THE DEEP SPACE 1 SPACECRAFT'S INNOVATIVE ION drive produces approximately one-fiftieth of a pound of thrust . . . a force so great that it would just about hold up a piece of paper on planet Earth! Still, powered by solar arrays, ion propulsion systems can run continuously. For long-duration space missions they ultimately win out over the powerful but brief blasts of less efficient chemical rockets. Deep Space 1 is seen here suspended in an assembly room, a folded solar array resting above the circular ion propulsion module. Already a successful technology demonstrator with experimental autonomous software, the spacecraft flew by asteroid 9969 Braille in July of 1999. In November that year, the robot probe was nearly lost due to the failure of its wide-field star tracker camera. But engineers were able to reprogram the navigation system to utilize another onboard camera and on June 28, 2000, the ion drive was throttled up. Again steering by the stars, Deep Space 1 rendezvoused with periodic comet Borrelly in

September 2001. CREDIT: DEEP SPACE 1 PROJECT, JPL, NASA

+ **1999 JM8: A Rock Too Close**

NEARLY 4 KM ACROSS, THE HUGE ROCK KNOWN AS 1999 JM8 SILENTLY PASSED ONLY 8.5 MILLION KM FROM EARTH IN EARLY August 1999. The small asteroid was completely unknown before May of that same year. Every few million years, a rock like this impacts Earth, with potentially devastating effects. Radar from two of the largest radio telescopes, Arecibo and Goldstone, tracked and imaged this Apollo asteroid as it crossed inside Earth's orbit, only 22 times the distance to the Moon. Although 1999 JM8 missed Earth, thousands of similar but unknown asteroids likely exist that cross Earth's orbit. In fact, a few asteroids pass inside the orbit of the Moon every decade. Possibly of larger concern to humanity are the more numerous rocks nearly 100 meters across. Were one of these to strike an ocean, a dangerous tidal wave might occur. CREDIT: L. BENNER (JPL) ET AL., NAIC, NASA

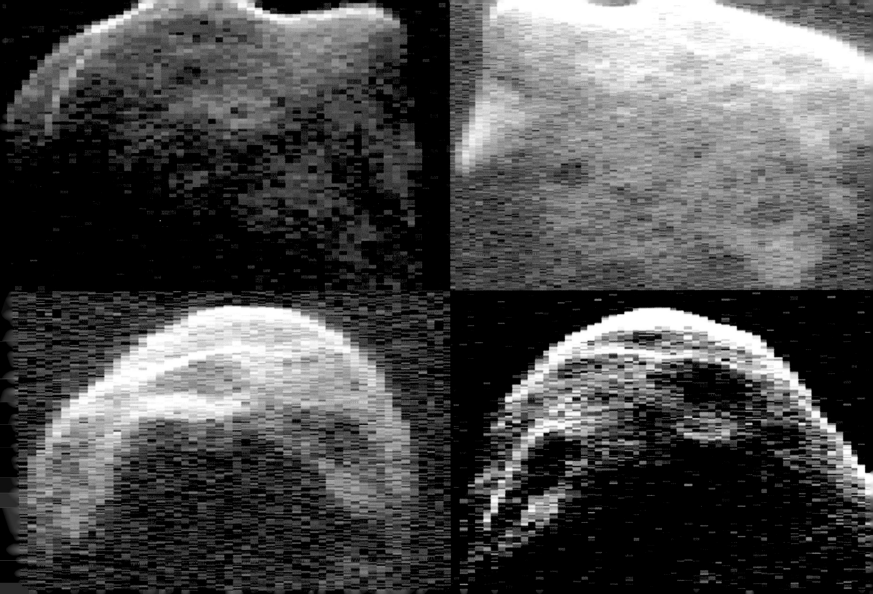

01
02
+
03
04
+ **Hot Gas and Dark Matter**
05
06
07
08
IS THE GRAVITY OF THE GALAXIES SEEN IN THIS IMAGE STRONG ENOUGH TO CONTAIN THE GLOWING HOT GAS? SUPERIMPOSED ON
09
10
an optical picture of a group of galaxies is an image taken in X-ray light. This picture, taken by ROSAT satellite, shows confined hot
11
12
gas highlighted in false red color, and provides clear evidence that the gravity exerted in groups and clusters of galaxies exceeds the
13
14
gravity of all the individual component galaxies combined. The extra gravity is attributed to dark matter, the nature and abundance of
15
16
which is one of the biggest mysteries in astronomy today. CREDIT: RICHARD MUSHOTZKY (GSFC/NASA), ROSAT, ESA, NASA
17
18
19
20
21
22
23
24
25
26
27
28
29
30

+ **Star Cluster R136 Bursts Out**

IN THE CENTER OF STAR-FORMING REGION 30 DORADUS LIES A HUGE CLUSTER OF THE LARGEST, HOTTEST, MOST MASSIVE stars known. Catalogued as R136, the cluster contains energetic stars that are breaking out of the cocoon of gas and dust from which they formed. This disintegrating cocoon, which fills the rest of this picture taken by the Hubble Space Telescope, is predominantly ionized hydrogen from 30 Doradus. R136 is composed of thousands of hot, blue stars, some approximately 50 times more massive than our sun. R136, also known as NGC 2070, lies in the Large Magellanic Clouds, a satellite galaxy to our own Milky Way galaxy. Although the young ages of stars in R136 make it similar to a Milky Way open cluster, its high density of stars will likely turn it into a low-mass globular cluster in a few billion years. CREDIT: N. WALBORN (STSCI) ET AL., WFPC2, HST, NASA

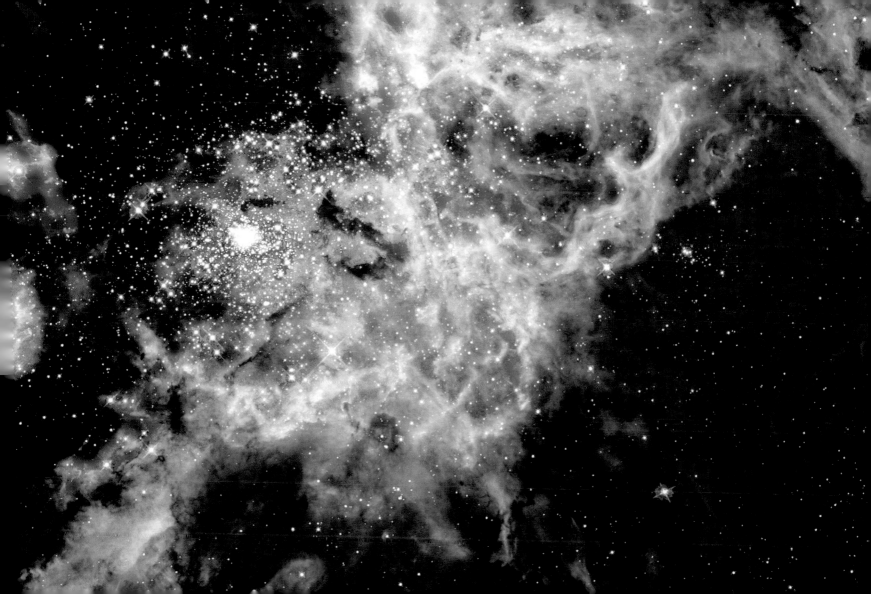

+ + 2dF Sees Waves of Galaxies

HOW ARE GALAXIES DISTRIBUTED IN THE UNIVERSE? THIS QUESTION IS OF MORE THAN AESTHETIC INTEREST BECAUSE THE answer likely holds clues to the composition of the universe itself. This map shows the distribution of over two hundred thousand galaxies and was generated by one of the most complex astronomical instruments yet created: the Two-Degree Field (2dF) system. The 2dF system measures galaxy redshifts, allowing astronomers to estimate distances to some of the millions of galaxies visible, and hence to make a three-dimensional map of the local universe. Although the distribution of galaxies appears nearly uniform on the largest scale, waves of galaxies are discernible extending up to 100 million light-years. Detailed analyses of the incoming data indicate that to create such a network of waves, normal baryonic matter must make up only 15 percent of all matter, while all matter must make up only about 30 percent of that needed to make the universe geometrically flat. Is the remaining 70 percent dark energy?

CREDIT: MATTHEW COLLESS (ANU) ET AL., 2DF GALAXY REDSHIFT SURVEY

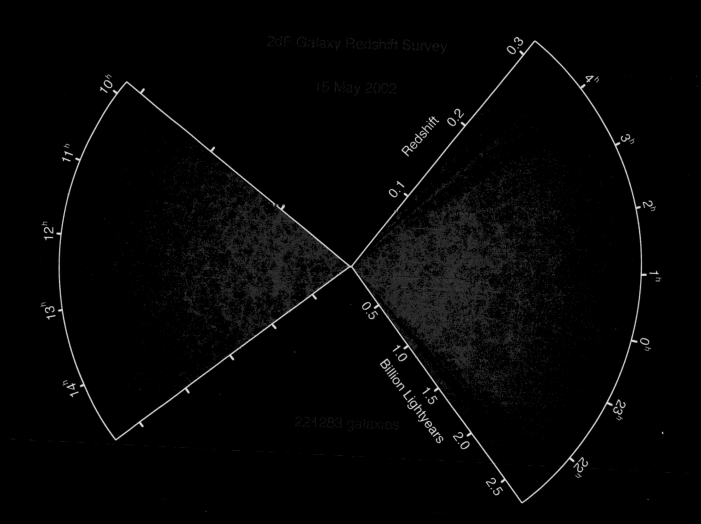

+ CFHT Star Trails

HIGH ATOP A DORMANT VOLCANO IN HAWAII, AN EYE 3.6 METERS WIDE STARES AT A FAINT LIGHT ON THE NIGHT SKY. UNLIKE a human eye, which collects light for only a fraction of a second at a time, a telescope such as the Canada-France-Hawaii Telescope can collect light for hours. Faint sources become visible that were previously beyond human imagination. These meticulous observations usually take so long, though, that the Earth's spin causes the telescope to move under the sky. This motion is visible in this photograph as star trails in the background. The CFHT itself must counterspin to keep on target. The enormous size of the CFHT dome can be gauged by the car in the foreground. The CFHT is one of the smaller telescopes atop Mauna Kea.

CREDIT: CANADA-FRANCE-HAWAII TELESCOPE/JEAN-CHARLES CUILLANDRE/1999

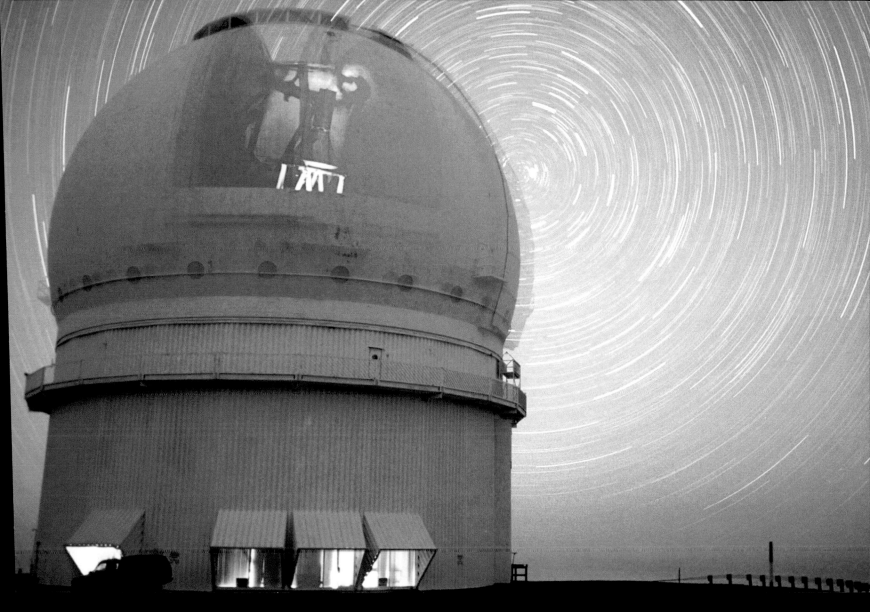

+ HCG 87: A Small Group of Galaxies

+

SOMETIMES GALAXIES FORM GROUPS. FOR EXAMPLE, OUR OWN MILKY WAY GALAXY IS PART OF THE LOCAL GROUP OF GALAXIES.

Small, compact groups, like Hickson Compact Group 87 (HCG 87) shown here, are interesting partly because they slowly self-destruct. Indeed, the galaxies of HCG 87 are gravitationally stretching each other during their 100-million-year orbits around a common center. The pulling creates colliding gas that causes bright bursts of star formation and feeds matter into their active galaxy centers. HCG 87 is composed of a large edge-on spiral galaxy visible on the lower left, an elliptical galaxy visible on the lower right, and a spiral galaxy visible near the top. The small spiral near the center might be far in the distance. Several stars from our galaxy are also visible in the foreground. The Hubble Space Telescope's Wide Field Planetary Camera 2 took this picture in July 1999. Studying groups like HCG 87 allows insight into how all galaxies form and evolve. CREDIT: SALLY HUNSBERGER (LOWELL OBS.), JANE

CHARLTON (PENN STATE), ET AL. & THE HUBBLE HERITAGE TEAM (AURA/ STSCI/ NASA)

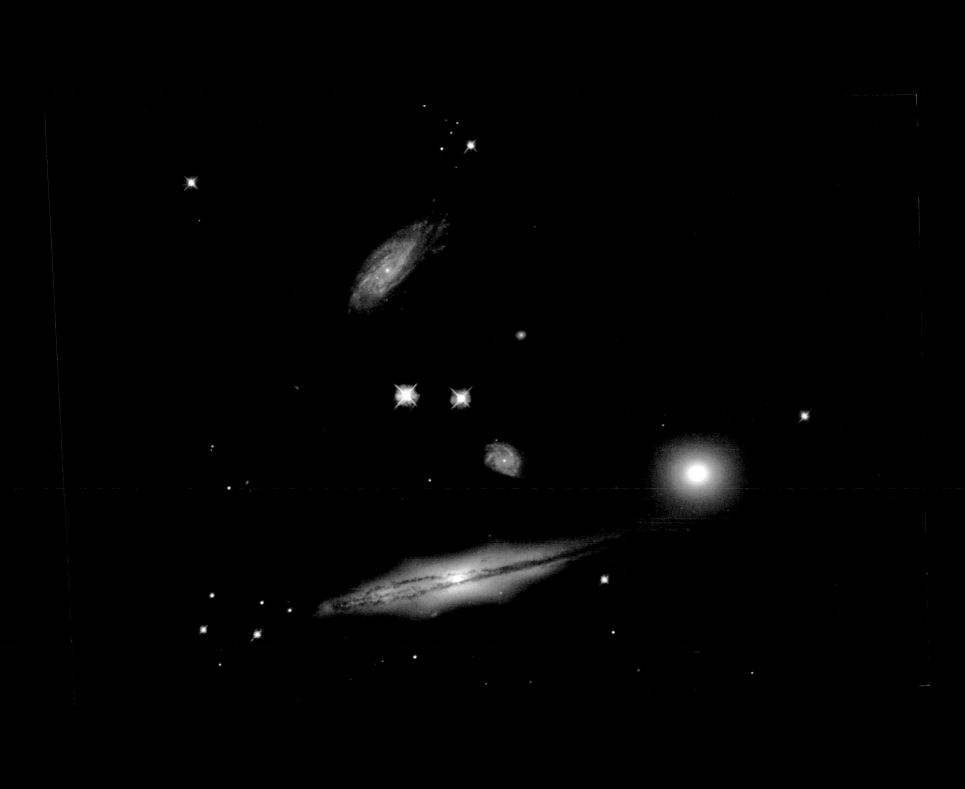

+ **The North America Nebula**

HERE'S A FAMILIAR SHAPE IN AN UNFAMILIAR LOCATION! THIS EMISSION NEBULA IS FAMOUS PARTLY BECAUSE IT RESEMBLES Earth's continent of North America. To the right of the North America Nebula, catalogued as NGC 7000, is the less luminous Pelican Nebula. The two emission nebulas measure approximately 50 light-years across, are located about 1,500 light-years away, and are separated by a dark absorption cloud. The nebulas can be seen with binoculars from a dark location. Look for a small nebular patch northeast of bright star Deneb in the constellation Cygnus. CREDIT & COPYRIGHT: JASON WARE

+ IC 418: The Spirograph Nebula

+

WHAT IS CREATING THE STRANGE TEXTURE OF IC 418? DUBBED THE SPIROGRAPH NEBULA FOR ITS RESEMBLANCE TO DRAWINGS

from a cyclical drawing tool, planetary nebula IC 418 shows patterns that are not well understood. Perhaps they are related to

chaotic winds from the variable central star, which changes brightness unpredictably in just a few hours. By contrast, evidence

indicates that only a few million years ago IC 418 was probably a well-understood star similar to our sun. Only a few thousand

years ago, IC 418 was probably a common red giant star. Since running out of nuclear fuel, though, the outer envelope has begun

expanding outward, leaving a hot remnant core destined to become a white dwarf star, visible in the center of the image. The

light from the central core excites surrounding atoms in the nebula, causing them to glow. IC 418 lies about 2,000 light-years

away and spans 0.3 light-year. This false-color image taken from the Hubble Space Telescope reveals the unusual details.

CREDIT: R. SAHAI (JPL) ET AL., HUBBLE HERITAGE TEAM (STSCI/AURA), NASA

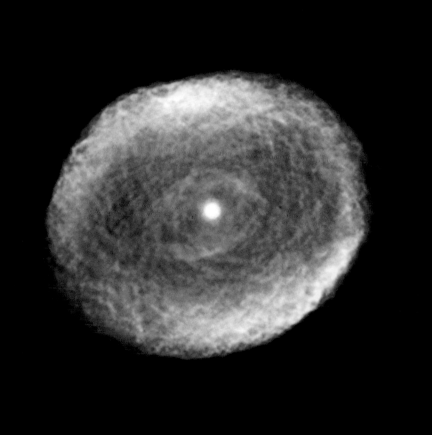

+ Solar Magnetic Bananas

+

IS THAT OUR SUN? THE UNUSUAL BANANA-SHAPED LOOPS SHOWN HERE ARE ACTUALLY PART OF A COMPUTER-GENERATED

snapshot of our sun's magnetic field. This animated frame was constructed using data from the ground-based U.S. Solar Vector

Magnetograph and the space-based Japanese X-ray Telescope Yohkoh. Surfaces of constant magnetic-field strength loop through

the Sun's corona, break through the Sun's surface, and connect regions of magnetic activity such as sunspots. CREDIT: A. GARY ET AL.

(NASA/MSFC), NASA

01
02
03
04
05
06
07
08
09
10
11
12
13
14
15
16
17
18
19
20
21
22
23
24
25
26
27
28
29
30

+ Galactic Center Flicker Indicates Black Hole

WHY WOULD THE CENTER OF OUR GALAXY FLICKER? MANY ASTRONOMERS BELIEVE THE ONLY CREDIBLE ANSWER INVOLVES A BLACK hole. During observations of Sagittarius A* with the orbiting Chandra X-ray Observatory, the bright X-ray source at the very center of our Milky Way brightened dramatically for a few minutes. Sagittarius A* is visible as the bright dot near the center of this image. Since large objects cannot vary quickly, a small source is implicated in the variation. Evidence including the motions of central stars indicates that the center of our galaxy is a massive place, however, estimated to be over a million times the mass of our sun. Only one known type of object can fit so much mass in so small a volume: a black hole. This short flicker therefore provides additional evidence that a black hole does indeed reside at our galaxy's center. If this is true, the flicker might have been caused by an object torn apart as it fell toward the disruptive monster. CREDIT: F. BAGANOFF (MIT) ET AL., CXO, NASA

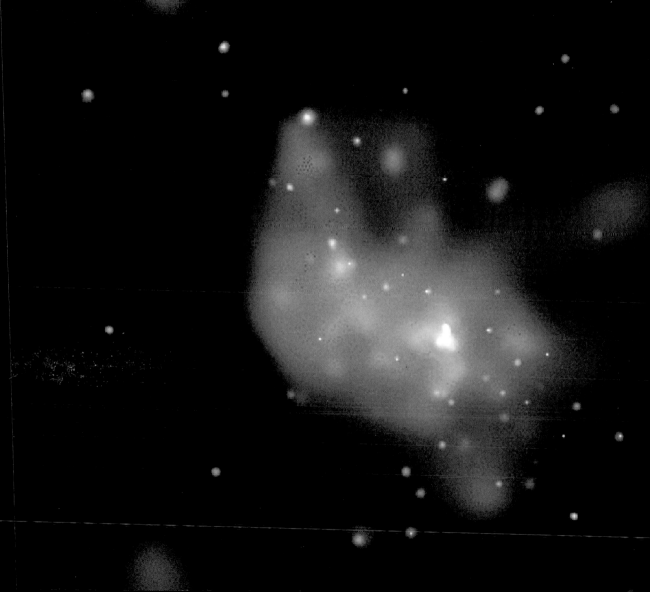

+ Spiral Galaxy NGC 3310 across the Visible

THE PARTY IS STILL GOING ON IN SPIRAL GALAXY NGC 3310. ROUGHLY 100 MILLION YEARS AGO, NGC 3310 LIKELY COLLIDED with a smaller galaxy, causing the large spiral galaxy to light up with a tremendous burst of star formation. The changing gravity during the collision created density waves that compressed existing clouds of gas and triggered the star-forming party. This composite image by the Hubble Space Telescope was used to find the ages of many of the resulting clusters of stars. To the surprise of many, some of the clusters are quite young, indicating that starburst galaxies may remain in starburst mode for quite some time. NGC 3310 spans about 50,000 light-years, lies about 50 million light-years away, and is visible with a small telescope toward the constellation Ursa Major. CREDIT: G. R. MEURER (JHU) ET AL., HUBBLE HERITAGE TEAM (STSCI/AURA), NASA

01
02
03
04
05
06
07
08
09
10
11
12
13
14
15
16
17
18
19
20
21
22
23
24
25
26
27
28
29
30

+ **The Red Spider Planetary Nebula**

OH, WHAT A TANGLED WEB A PLANETARY NEBULA CAN WEAVE. THE RED SPIDER PLANETARY NEBULA SHOWS THE COMPLEX STRUCTURE that can result when a normal star ejects its outer gases and becomes a white dwarf star. Officially tagged NGC 6537, this two-lobed symmetric planetary nebula houses one of the hottest white dwarfs ever observed, probably as part of a binary star system. Internal winds emanating from the central stars have been measured in excess of 1,000 km per second. These winds expand the nebula, flow along the nebula's walls, and cause waves of hot gas and dust to collide. Atoms caught in these colliding shocks radiate light shown in this representative-color picture. The Red Spider Nebula lies toward the constellation Sagittarius. Its distance is not well known, but is estimated by some to be approximately 4,000 light-years away. CREDIT: GARRELT MELLEMA (LEIDEN UNIVERSITY) ET AL., HST, ESA, NASA

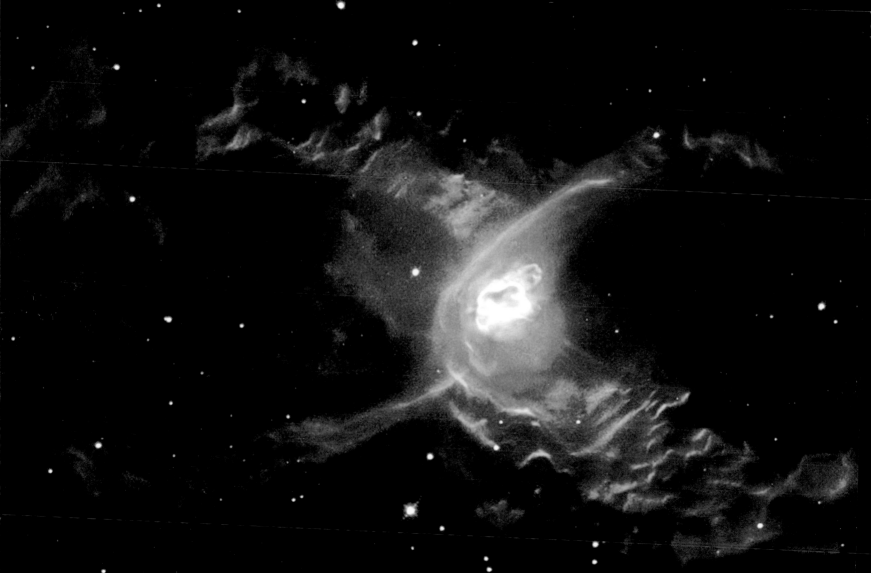

01
02
03
04
05
06
07
08
09
10
11
12
13
14
15
16
17
18
19
20
21
22
23
24
25
26
27
28
29
30

+ **Southwest Mercury**

THE PLANET MERCURY RESEMBLES A MOON. MERCURY'S OLD SURFACE IS HEAVILY CRATERED, LIKE THAT OF MANY MOONS. ALTHOUGH Mercury is larger than most moons, it is smaller than Jupiter's moon Ganymede and Saturn's moon Titan. Dominated by an iron core, Mercury is much denser and more massive than any moon. In fact, Earth is the only planet that is denser. A visitor to Mercury's surface would see some strange sights. Because Mercury rotates exactly 3 times every 2 orbits around the Sun, and because Mercury's orbit is so elliptical, a visitor to Mercury might see the Sun rise, stop in the sky, go back toward the rising horizon, stop again, then set quickly over the other horizon. From Earth, Mercury's proximity to the Sun causes it to be visible only for a short time just after sunset or just before sunrise. CREDIT: MARINER 10, NASA

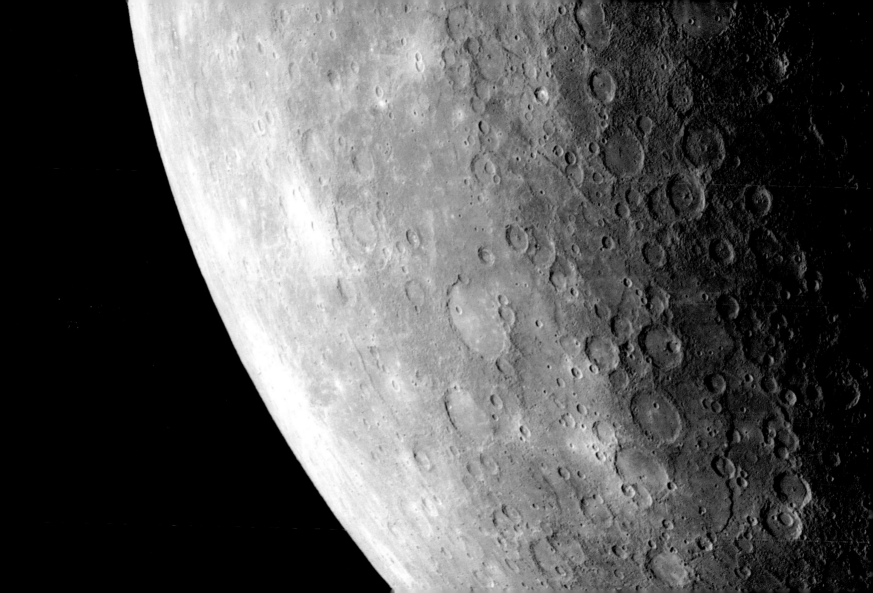

01
02
03
04
05
06
07
08
09
10
11
12
13
14
15
16
17
18
19
20
21
22
23
24
25
26
27
28
29
30

+ **The Space Shuttle Docked with Mir**

BEFORE THERE WAS THE INTERNATIONAL SPACE STATION, THE REIGNING ORBITING SPACEPORT WAS RUSSIA'S MIR. PICTURED here in 1995, the United States space shuttle Atlantis docked with the segmented Mir. During shuttle mission STS-71, astronauts answered questions from school students over amateur radio and performed science experiments aboard Spacelab. The Spacelab experiments helped to increase understanding of the effects of long-duration space flights on the human body. In 2001, after 15 years of successful service, the decaying Mir Space Station broke up as it entered Earth's atmosphere. CREDIT: NIKOLAI BUDARIN, RUSSIAN SPACE RESEARCH INSTITUTE, NASA

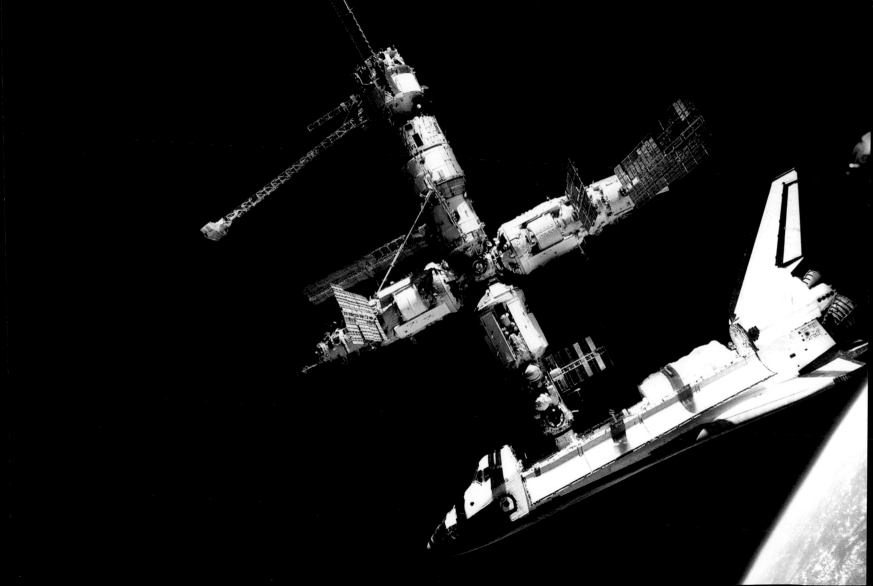

+ The Big Corona

MOST PHOTOGRAPHS DON'T ADEQUATELY PORTRAY THE MAGNIFICENCE OF THE SUN'S CORONA. SEEING THE CORONA FIRST-hand during a total solar eclipse is best. The human eye can adapt to see features that photographic film usually cannot. Welcome, however, to the digital age. This picture is a combination of twenty-two photographs that were digitally processed to highlight faint features of a total eclipse that occurred in August 1999. The outer pictures of the Sun's corona were digitally altered to enhance dim, outlying waves and filaments. The inner pictures of the usually dark Moon were enhanced to bring out its faint glow from doubly reflected sunlight. Shadow seekers need not fret, though, since as yet there is no way that digital-image processing can mimic the fun involved in experiencing a total solar eclipse. CREDIT & COPYRIGHT: FRED ESPENAK (NASA/GSFC)

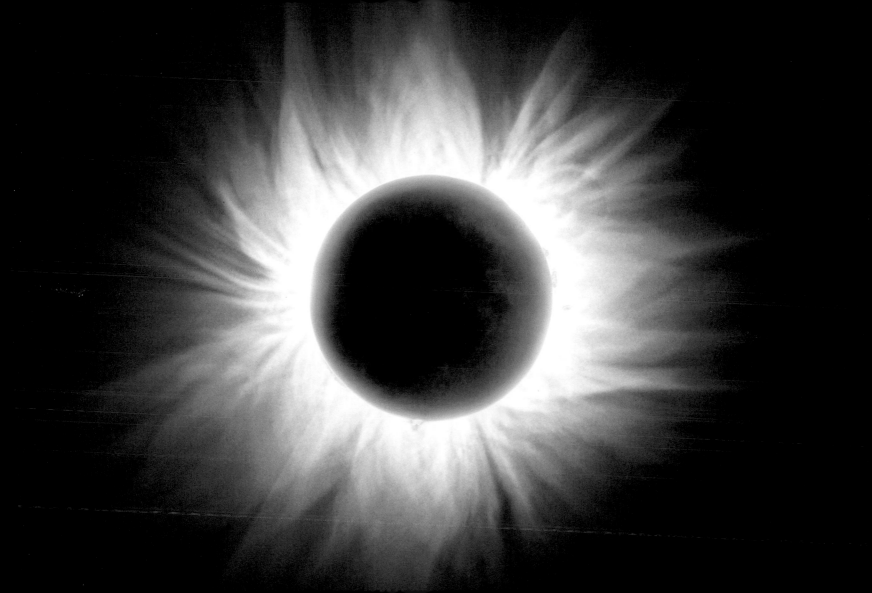

+ **Jupiter's Rings Revealed**

WHY DOES JUPITER HAVE RINGS? JUPITER'S RINGS WERE DISCOVERED IN 1979 BY THE PASSING VOYAGER I SPACECRAFT, BUT their origin has always been a mystery. Data from the Galileo spacecraft that orbited Jupiter in 1998 confirmed that these rings were created by meteoroid impacts on small nearby moons. As a small meteoroid strikes tiny Adrastea, for example, it will bore into the moon, vaporize, and explode dirt and dust off into a jovian orbit. Pictured here is an eclipse of the Sun by Jupiter, as viewed from Galileo. Small dust particles high in Jupiter's atmosphere, as well as the dust particles that compose the rings, can be seen by reflected sunlight. CREDIT: M. BELTON (NOAO), J. BURNS (CORNELL) ET AL., GALILEO PROJECT, JPL, NASA

01
02
03
04
05
06
07
08
09
10
11
12
13
14
15
16
17
18
19
20
21
22
23
24
25
26
27
28
29
30

+ **Southwest Andromeda**

+

THIS NEW COMPOSITE IMAGE OF THE SOUTHWEST REGION OF M31 FROM THE SUBARU TELESCOPE SHOWS MANY STARS, NEBULAS, and star clusters never before resolved. An older population of stars near Andromeda's center causes the yellow hue visible on the upper right. Young, blue stars stand out in the spiral arms on the lower left. Red emission nebulas, blue open clusters of stars, and sweeping lanes of dark dust punctuate the swirling giant. Andromeda, at about 2.5 million light-years distant, and our Milky Way are the largest galaxies in the local group of galaxies. Understanding M31 helps astronomers to understand our own Milky Way galaxy, since the two are so similar. CREDIT & COPYRIGHT: SATOSHI MIYAZAKI (NAOJ) ET AL., SUPRIME-CAM, SUBARU TELESCOPE, NOAJ

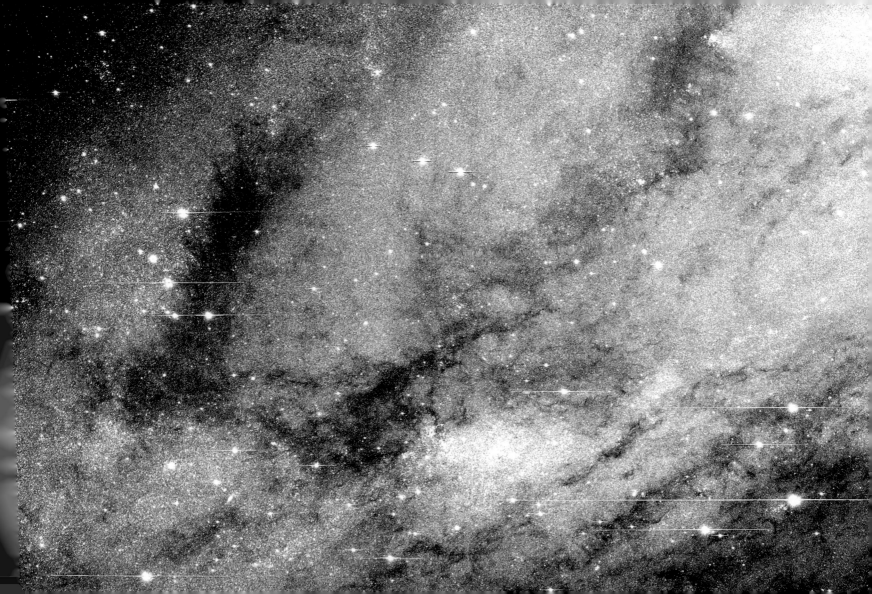

01
02
03
04
05
06
07
08
09
10
11
12
13
14
15
16
17
18
19
20
21
22
23
24
25
26
27
28
29
30

+ Zodiacal Light and the False Dawn

AN UNUSUAL TRIANGLE OF LIGHT WILL BE PARTICULARLY BRIGHT NEAR THE EASTERN HORIZON BEFORE SUNRISE DURING

the next 2 months for observers in Earth's Northern Hemisphere. Once considered a false dawn, this triangle of light is actually

zodiacal light, light reflected from interplanetary dust particles. The triangle is clearly visible on the left of this image taken

from Mauna Kea, Hawaii on August 30, 2001, by one of the developing global networks of fish-eye nighttime web cameras called

CONCAMs. Zodiacal dust orbits the Sun predominantly in the same plane as the planets: the ecliptic. Indeed, the triangle

points to bright spots Jupiter and Saturn, with Saturn nearer the center. Zodiacal light is so bright this time of year because the

dust band is oriented nearly vertical at sunrise, so that the thick air near the horizon does not block out relatively bright reflect-

ing dust. Zodiacal light is also bright for people in Earth's Northern Hemisphere in March and April just after sunset.

CREDIT: THE NIGHT SKY LIVE PROJEC, NSF

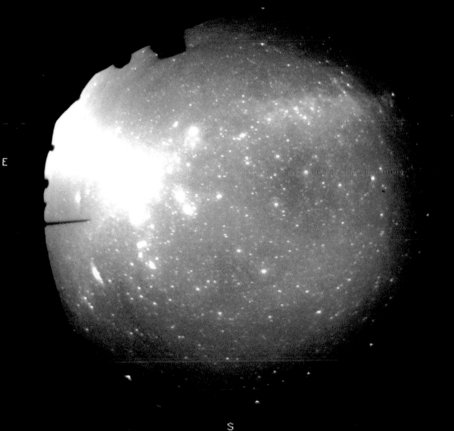

+ Tycho's Supernova Remnant in X ray

HOW OFTEN DO STARS EXPLODE? BY LOOKING AT EXTERNAL GALAXIES, ASTRONOMERS CAN GUESS THAT THESE EVENTS, KNOWN as a supernovas, should occur about once every 30 years in a typical spiral galaxy like our Milky Way. However, the obscuring gas and dust in the disk of our galaxy probably prevents us from seeing many galactic supernovas—making observations of these events in our own galaxy relatively rare. In fact, in 1572, the revered Danish astronomer, Tycho Brahe, witnessed one of the last to be seen. The remnant of this explosion is still visible today, as the shockwave it generated continues to expand into the gas and dust among the stars. Here is a false-color image of the X rays emitted by this shockwave, made by the orbiting Chandra Observatory. The nebula is known as Tycho's Supernova Remnant. CREDIT: NASA/CXC/SAO

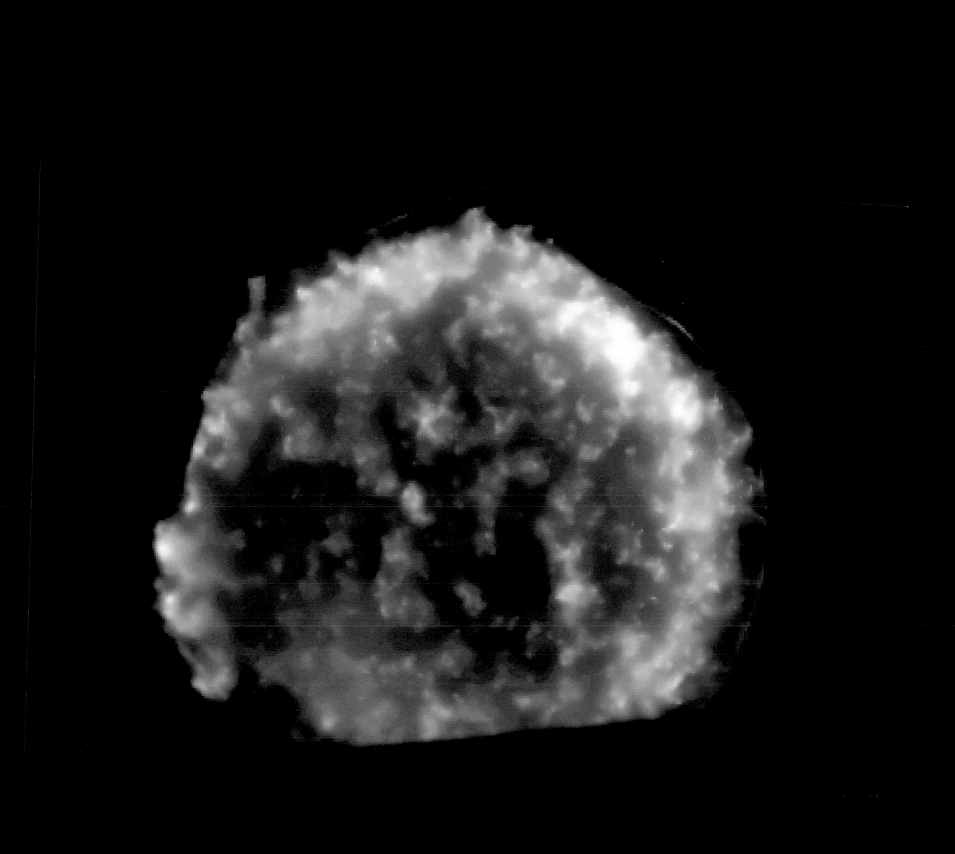

01
02
03
04
05
06
07
08
09
10
11
12
13
14
15
16
17
18
19
20
21
22
23
24
25
26
27
28
29
30

+ **Star-Forming Region RCW38 from 2MASS**

THE STAR CLUSTER IN RCW38 WAS HIDING. LOOKING AT THE STAR-FORMING REGION RCW38 WILL NOT NORMALLY REVEAL most of the stars in this cluster. The reason is that the open cluster is so young that it is still shrouded in thick dust that absorbs visible light. This dust typically accompanies the gas that condenses to form young stars. When viewed in infrared light, however, many stars in RCW38 are revealed, because dust is less effective at absorbing infrared light. This representative-color image mosaic of RCW38, taken by the Two Micron All-Sky Survey (2MASS) in infrared light, shows not only many bright blue stars from the star cluster but also clouds of brightly emitting gas and dramatic lanes of dark dust. RCW38 spans approximately 10 light-years and is located about 5,500 light-years away toward the constellation Vela. CREDIT: R. HURT, 2MASS PROJECT, UMASS, IPAC/CALTECH, NSF, NASA

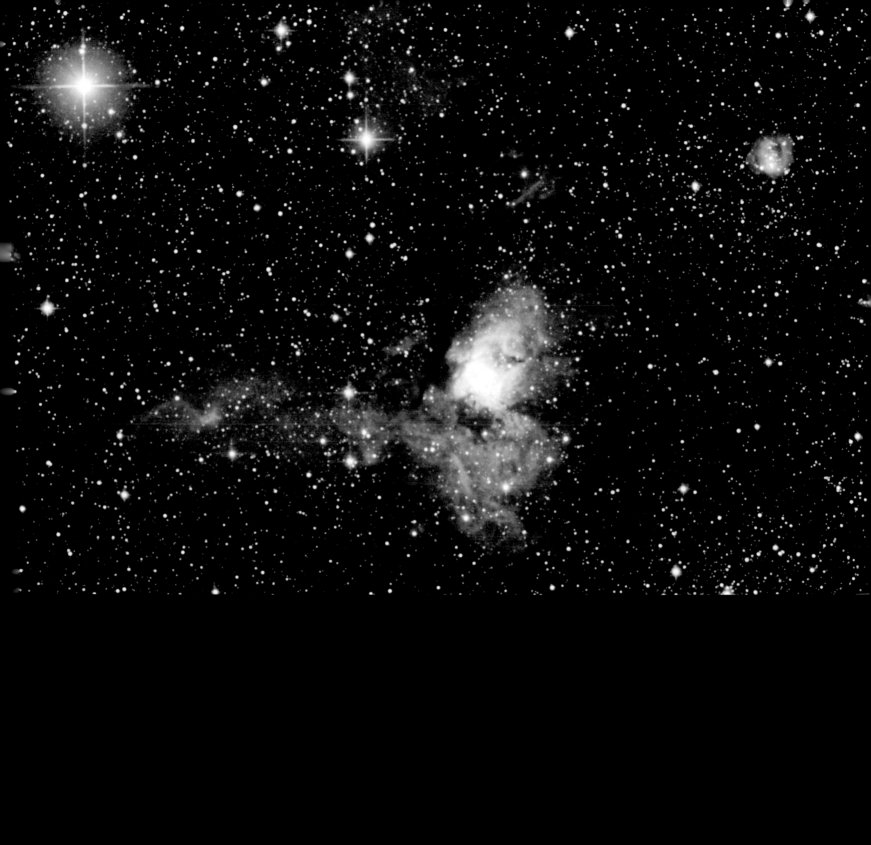

01
02
03
04
05
06
07
08
09
10
11
12
13
14
15
16
17
18
19
20
21
22
23
24
25
26
27
28
29
30

+ **The Quintuplet Star Cluster**

BRIGHT CLUSTERS OF STARS FORM AND DISPERSE NEAR THE CENTER OF OUR GALAXY. FOUR MILLION YEARS AGO THE QUINTUPLET Cluster, pictured here, formed and is now slowly dispersing. The Quintuplet Cluster is located within 100 light-years of the galactic center and is home to the brightest star yet catalogued in our galaxy: the Pistol Star. Objects near our galactic center are usually hidden from view by opaque dust. This picture was able to capture the cluster in infrared light, though, with the NICMOS camera onboard the orbiting Hubble Space Telescope. The young Quintuplet Cluster is one of the most massive open clusters yet discovered, but is still much less massive than the ancient globular clusters that orbit in the distant halo. Some of the bright white stars visible may be on the verge of blowing themselves up in a spectacular supernova. CREDIT: DON FIGER (STSCI) ET AL., NASA

01
02
03
04
05
06
07
08
09
10
11
12
13
14
15
16
17
18
19
20
21
22
23
24
25
26
27
28
29
30

+ **At the Edge of the Helix Nebula**

WHILE EXPLORING THE INNER EDGE OF THE HELIX NEBULA WITH THE HUBBLE SPACE TELESCOPE'S WIDE FIELD PLANETARY Camera 2, astronomers were able to produce this striking image—rich in details of an exotic environment. This planetary nebula, created near the final phase of a sun-like star's life, is composed of tenuous shells of gas ejected by the hot central star. The atoms of gas, stripped of electrons by ultraviolet radiation from the central star, radiate light at characteristic energies, allowing specific chemical elements to be identified. In this image, emission from nitrogen is represented as red, hydrogen emission as green, and oxygen as blue. The inner edge of the Helix Nebula, also known as NGC 7293, is in the direction of the nebula's central star, which is toward the upper right. Clearly visible near the inner edge are finger-shaped cometary knots. CREDIT: R. O'DELL AND K. HANDRON (RICE UNIVERSITY), NASA

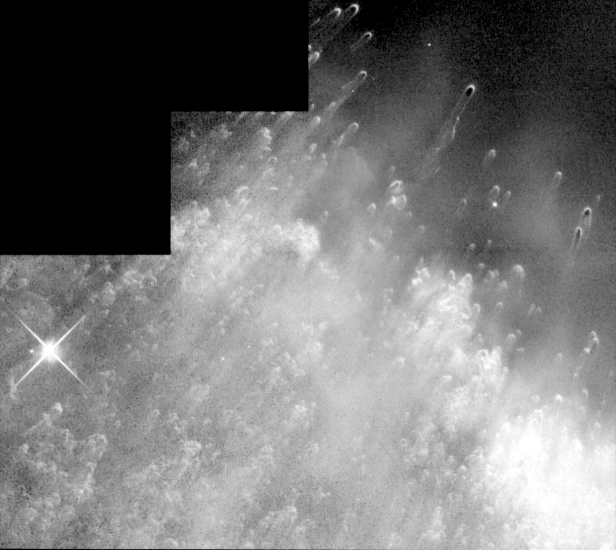

01
02
03
04
05
06
07
08
09
10
11
12
13
14
15
16
17
18
19
20
21
22
23
24
25
26
27
28
29
30

+ **Equinox and Eruptive Prominence**

YEARLY, ON SEPTEMBER 22ND OR 23RD, THE SUN MOVES SOUTH ACROSS THE CELESTIAL EQUATOR, CAUSING SEASONS TO CHANGE from summer to fall in the Northern Hemisphere, and from winter to spring in the Southern Hemisphere. Defined by the Sun's position in sky, the event is known as an equinox—meaning the length of daylight is equal to the length of night. In September 1999, the active Sun produced the dramatic eruptive prominence seen in this extreme ultraviolet picture from the space-based SOHO observatory. The hot plasma is lofted above the solar surface by twisting magnetic fields. How big is the prominence? By comparison, planet Earth would appear smaller than your fingernail. CREDIT: SOHO - EIT CONSORTIUM, ESA, NASA

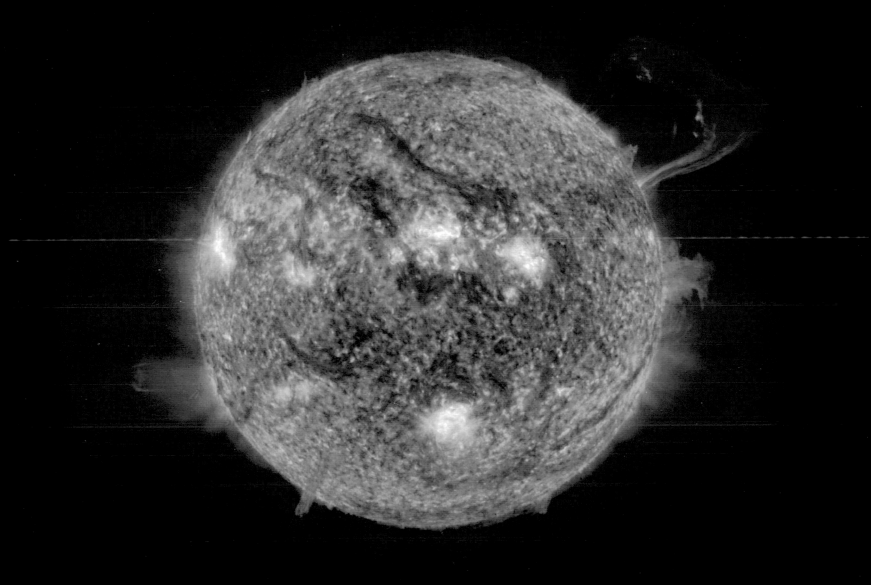

+ **Molecular Cloud Barnard 68**

WHERE DID ALL THE STARS GO? WHAT USED TO BE CONSIDERED A HOLE IN THE SKY IS NOW KNOWN TO ASTRONOMERS AS A dark molecular cloud. Here, a high concentration of dust and molecular gas absorb practically all the visible light emitted from background stars. The eerily dark surroundings help make the interiors of molecular clouds some of the coldest and most isolated places in the universe. One of the most notable of these dark absorption nebulas is a cloud toward the constellation Ophiuchus known as Barnard 68, pictured here. That no stars are visible in the center indicates that Barnard 68 is relatively nearby, with measurements placing it approximately 500 light-years away and a half light-year across. It is not known exactly how molecular clouds like Barnard 68 form, but it is known that these clouds themselves are likely places for new stars to form.

CREDIT: FORS TEAM, 8.2-METER VLT ANTU, ESO

+

+ **Love and War by Moonlight**

VENUS, NAMED FOR THE ROMAN GODDESS OF LOVE, AND MARS, THE GOD OF WAR, APPROACH EACH OTHER BY MOONLIGHT IN this lovely sky view recorded on May 14, 2002, from Dunkirk, Maryland. The 4-second time exposure made in twilight with a digital camera also records earthshine illuminating the otherwise dark surface of the young crescent Moon. Venus shines as the third-brightest object in Earth's sky, after the Sun and the Moon, and had been appearing as the brilliant evening star in the pantheon of planets arrayed in the West during April and May 2002. Here, Venus's light is so intense that it produces a noticeable spike in the sensitive camera's image. Much fainter Mars is lower in the picture, caught between tree limbs swaying in a gentle evening breeze. By early June, Mars became harder to spot as it wandered toward the horizon, but Venus and father Jupiter drew closer together, presenting a spectacular pair of bright planets in the West. CREDIT & COPYRIGHT: FRED ESPENAK (COURTESY OF WWW.MRECLIPSE.COM)

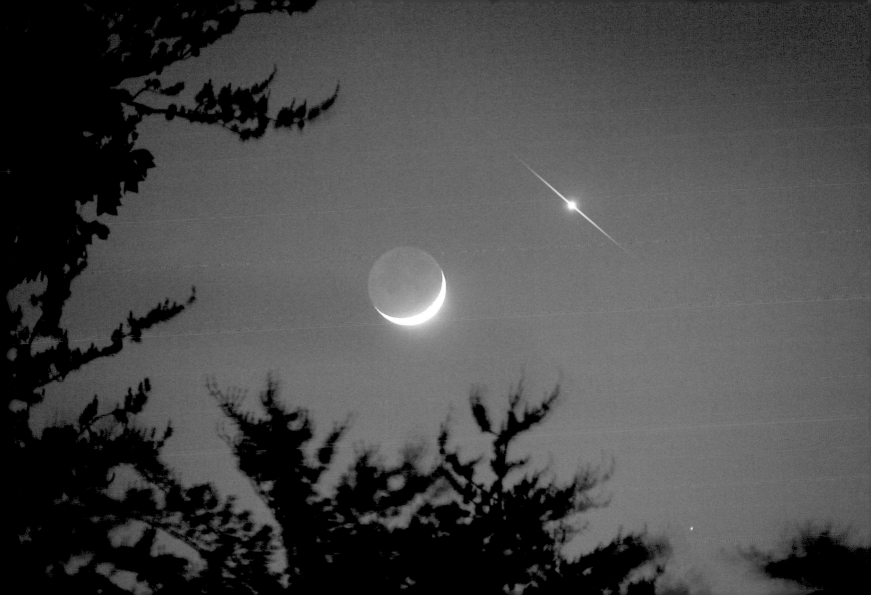

01
02
03
04
05
06
07
08
09
10
11
12
13
14
15
16
17
18
19
20
21
22
23
24
25
26
27
28
29
30

+ **Comet Borrelly's Nucleus**

WHAT DOES A COMET NUCLEUS LOOK LIKE, PART TWO? TO ANSWER THIS QUESTION, NASA CONTROLLERS DROVE AN AGING probe through the hostile environs of a distant comet, expecting that even if comet fragments disabled the spacecraft, it would be worth the risk. Contrary to expectations, the probe, Deep Space 1, survived. Pictured here is the most detailed image ever taken of a comet nucleus, obtained by Deep Space 1 and released by NASA. Comet Borrelly's nucleus is seen to be approximately 8 km long with mountains, faults, grooves; smooth, rolling plains, and materials of vastly different reflectance. Light-colored regions are present near the center and seem to give rise to dust jets seen in Borrelly's coma, visible in distant images of the comet. Previously, the best image of a comet nucleus came from the Giotto mission to comet Halley in 1986. Deep Space 1 images of Borrelly add welcome bedrock to understanding solar-system history and to the accurate prediction of future brightness changes of notoriously fickle comets. CREDIT & COPYRIGHT: DEEP SPACE 1 TEAM, JPL, NASA

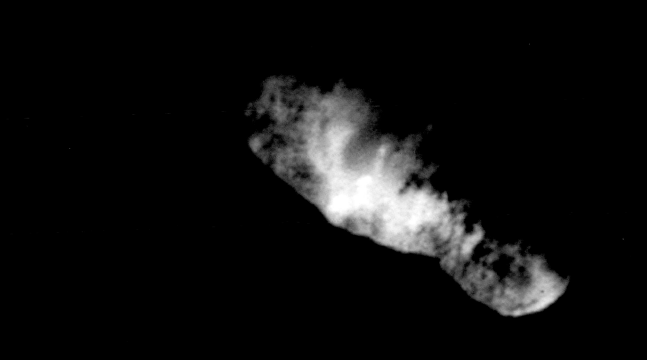

+ **A Venus Landing**

THIS IMAGE REPRESENTS THE FIRST COLOR PANORAMIC VIEW FROM VENUS. IT WAS TRANSMITTED TO EARTH BY A TV CAMERA ON the Soviet Venera 13 lander that parachuted to the surface on March 1, 1982. Venus's clouds are composed of sulfuric acid droplets, while its surface temperature is about 900 degrees Fahrenheit (482 degrees Celsius) at an atmospheric pressure of 92 times that of sea level on Earth. Despite these harsh conditions, the Venera 13 lander survived long enough to send back a series of images and perform an analysis of the venusian soil. Part of the lander itself is visible in the lower portion of the image. An earlier Soviet Venus lander, Venera 7 (1970), was the first spacecraft to return data from the surface of another planet. CREDIT: SOVIET PLANETARY EXPLORATION PROGRAM

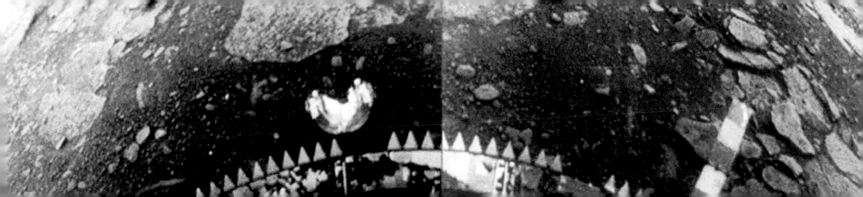

+ **Our Galaxy in Stars, Gas, and Dust**

THE DISK OF OUR MILKY WAY GALAXY IS HOME TO HOT NEBULAS, COLD DUST, AND BILLIONS OF STARS. THE RED NEBULAS visible in this contrast-enhanced picture are primarily emission nebulas, glowing clouds of hydrogen gas heated by nearby, bright, young stars. The blue nebulas are primarily reflection nebulas, clouds of gas and fine dust reflecting the light of nearby, bright stars. Perhaps the most striking, though, are the areas of darkness, including the Pipe Nebula visible on the image, bottom left. These are lanes of thick dust, often containing relatively cold molecular clouds of gas. Dust is so plentiful that it obscures the galactic center in visible light, hiding its true direction until discovered early in the twentieth century. The diffuse glow comes from billions of older, fainter stars like our sun, which are typically much older than any of the nebulas. Most of the mass of our galaxy remains in a form currently unknown. CREDIT & COPYRIGHT: JOHN GLEASON WITH STEVE MANDEL, CELESTIAL IMAGES

+ **A Lonely Neutron Star**

HOW MASSIVE CAN A STAR GET WITHOUT IMPLODING INTO A BLACK HOLE? THESE LIMITS ARE BEING TESTED BY THE DISCOVERY of a lone neutron star in space. Observations by the Hubble Space Telescope have been combined with previous observations by the X-ray ROSAT observatory and ultraviolet EUVE observatory for the isolated star in this image at the location of the arrow. Astronomers are able to infer directly the star's size from measurements of its brightness, temperature, and the farthest distance that it could possibly be from Earth. Assuming that the object is a neutron star of typical mass, some previous theories of neutron-star structure would have predicted an implosion that would have created a black hole. That this neutron star even exists therefore allows a window to the extreme conditions in the interiors of neutron stars. CREDIT: F. WALTER (SUNY STONY BROOK), WFPC2, HST, NASA

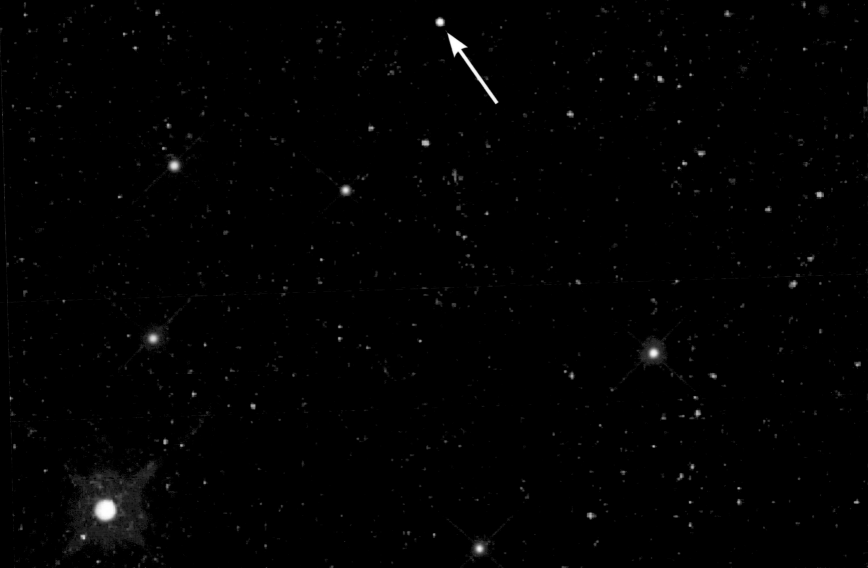

+ **Dusk of the Planets**

A GREAT GROUPING OF PLANETS WAS VISIBLE TO THE WEST JUST AFTER sunset in april 2002. for the rest of April and into May, Mercury, Venus, Earth, Mars, Jupiter, and Saturn—the innermost six planets of our solar system—could be seen in a single educated glance. The image on the left captured them all in one frame. Connecting the planetary dots serves to delineate the edge-on ecliptic, the plane in which the planets orbit the Sun. The shot was taken on April 23, 2002, near Chatsworth, New Jersey, and even includes scattered light from the Sun and the Moon. Aside from the planets, the Pleiades and Hyades open clusters of stars are visible.

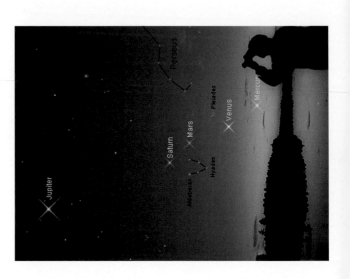

+ **Volcano and Aurora in Iceland**

SOMETIMES BOTH HEAVEN AND EARTH ERUPT. IN ICELAND IN 1991, THE VOLCANO HEKLA ERUPTED AT THE SAME TIME THAT auroras were visible overhead. Pictured here, the green auroral band hovers about 100 km above the erupting lava. Hekla, one of the most famous volcanoes in the world, has erupted at least 20 times over the past millennium, sometimes causing great destruction. An eruption that occurred in 2000 caused only minor damage. Is Earth the solar system's only planet with both auroras and volcanoes? CREDIT & COPYRIGHT: SIGURDUR HRAFN STEFNISSON

01
02
03
04
05
06
07
08
09
10
11
12
13
14
15
16
17
18
19
20
21
22
23
24
25
26
27
28
29
30
31

+ **The Moons of Earth**

WHILE ORBITING THE PLANET DURING THEIR JUNE 1998 MISSION, THE CREW OF THE SPACE SHUTTLE DISCOVERY PHOTOGRAPHED this view of two moons of Earth. Thick storm clouds are visible in the lovely blue planet's nurturing atmosphere and the spindly Russian Mir Space Station, which was then Earth's largest artificial moon, can be seen above the planet's limb. The bright spot to the right of Mir is Earth's very large natural satellite, the Moon. Mir orbited planet Earth once every 90 minutes about 300 km above the planet's surface, or about 6,500 km from Earth's center. The Moon orbits once every 28 days at a distance of about 400,000 km from the center of Earth. CREDIT: STS-91 CREW, NASA

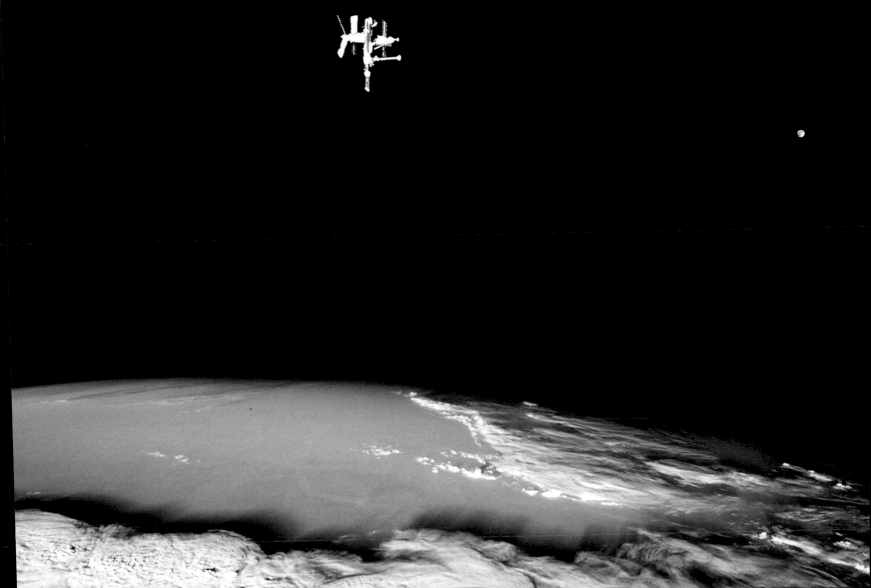

+ **The Einstein Cross Gravitational Lens**

MOST GALAXIES HAVE A SINGLE NUCLEUS—DOES THIS GALAXY HAVE FOUR? THE STRANGE ANSWER LEADS ASTRONOMERS TO conclude that the nucleus of the surrounding galaxy is not even visible in this image. Rather, the central cloverleaf is light emitted from a background quasar. The gravitational field of the visible foreground galaxy breaks light from this distant quasar into four distinct images. The quasar must be properly aligned behind the center of a massive galaxy for a mirage like this to be evident. The general effect is known as gravitational lensing, and this specific case is known as the Einstein Cross. Stranger still, the images of the Einstein Cross vary in relative brightness, enhanced occasionally by the additional gravitational microlensing effect of specific stars in the foreground galaxy. CREDIT & COPYRIGHT: J. RHOADS (STSCI) ET AL., WIYN,NOAO/AURA/NSF

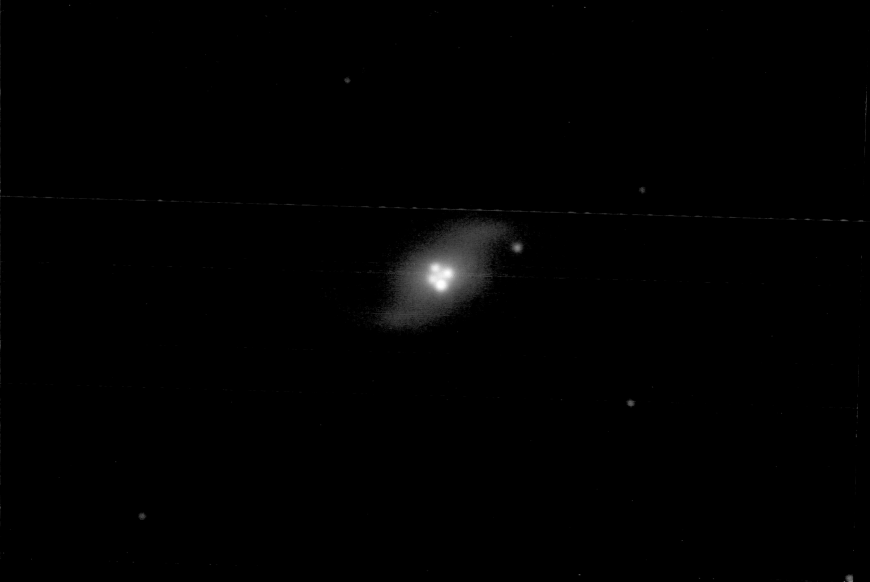

+ **M74: The Perfect Spiral**

IF NOT PERFECT, THEN THIS SPIRAL GALAXY IS AT LEAST ONE OF THE MOST PHOTOGENIC. AN ISLAND UNIVERSE OF ABOUT ONE hundred billion stars, 30 million light-years away toward the constellation Pisces, NGC 628, or M74, presents a gorgeous face-on view to Earthbound astronomers. The grand design of M74's graceful spiral arms traced by bright blue star clusters and dark cosmic dust lanes is similar in many respects to our own home galaxy, the Milky Way. Recorded with a 28 million-pixel detector array, this impressive image celebrates first light for the Gemini Multi-Object Spectrograph (GMOS), a state-of-the-art instrument at the 8-meter Gemini North Telescope. The Gemini North Observatory gazes into the skies above Mauna Kea, Hawaii, while its twin observatory, Gemini South, operates at the summit of Cerro Pachón in central Chile. CREDIT: GEMINI OBSERVATORY, GMOS TEAM

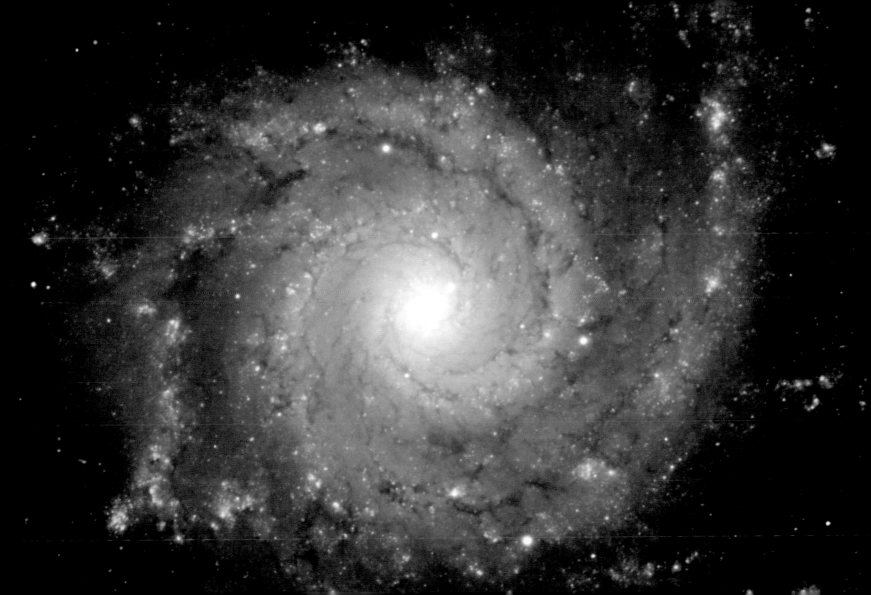

+ **A Sunspot Up Close**

SOMETIMES SMALL REGIONS OF THE SUN APPEAR UNUSUALLY DARK. VISIBLE HERE IS A CLOSE-UP PICTURE OF A SUNSPOT, A depression on the Sun's face that is slightly cooler and less luminous than the rest of the Sun. The Sun's complex magnetic field creates this cool region by inhibiting hot material from entering the spot. Sunspots can be larger than Earth and typically last for only a few days. This high-resolution picture also shows clearly that the Sun's face is a bubbling sea of separate cells of hot gas. These cells are known as granules. A solar granule is about 1,000 km across and lasts about 10 minutes. After that, many granules explode. CREDIT: VACUUM TOWER TELESCOPE, NSO, NOAO/AURA/NSF

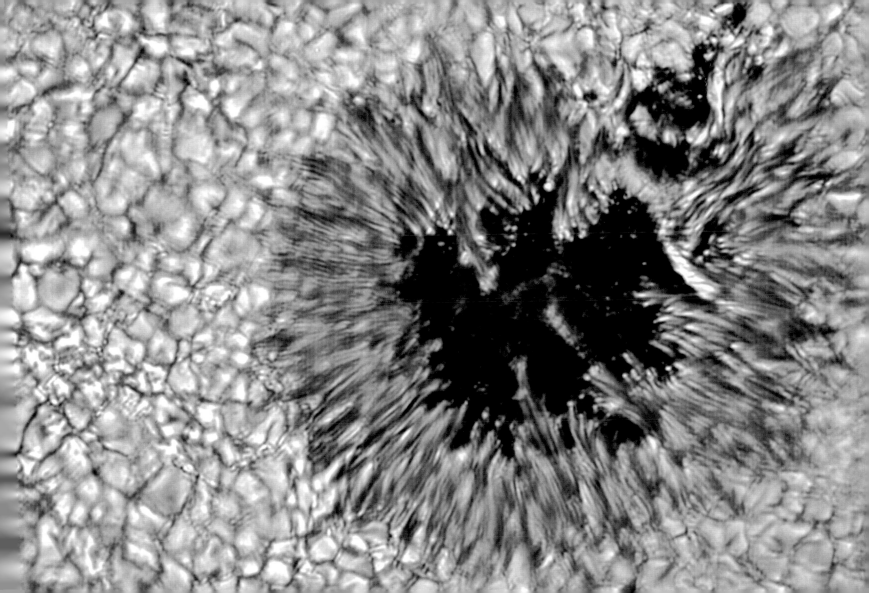

+ **Hen 1357: Newborn Nebula**

THIS HUBBLE SPACE TELESCOPE SNAPSHOT SHOWS HEN 1357, THE YOUNGEST KNOWN PLANETARY NEBULA. GRACEFUL, GENTLE curves and symmetry suggest its popular name—The Stingray Nebula. Observations in the 1970s detected no nebular material, but this image from March 1996 clearly shows the Stingray's emerging bubbles and rings of shocked and ionized gas. Energizing the gas, the hot, central star is nearing the end of its life, evolving toward a final white-dwarf phase. The image also shows a companion star (at about 10 o'clock) within the nebula. Astronomers suspect that such companions account for the complex shapes and rings of this and many other planetary nebulas. This cosmic infant is approximately 130 times the size of our own solar system and growing. It is 18,000 light-years distant, in the southern constellation Ara. CREDIT: M. BOBROWSKY, NASA

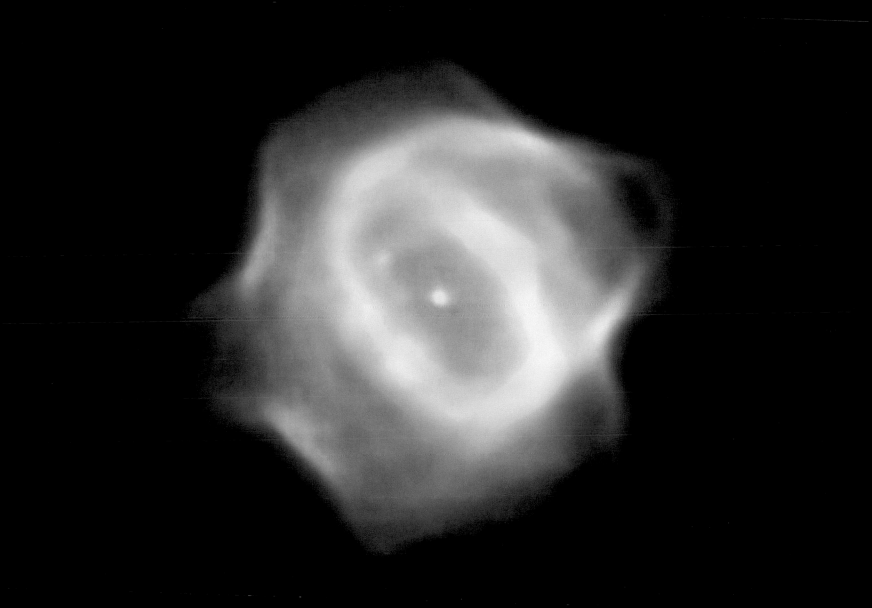

+ **The First Rocket Launch from Cape Canaveral**

A NEW CHAPTER IN SPACE FLIGHT BEGAN IN JULY 1950 WITH THE LAUNCH OF THE FIRST ROCKET FROM CAPE CANAVERAL, Florida: the Bumper 2. Shown here, the Bumper 2 was an ambitious two-stage rocket program that topped a V-2 missile base with a WAC Corporal rocket. The upper stage was able to reach then-record altitudes of almost 400 km, higher than even modern space shuttles fly today. Launched under the direction of the General Electric Company, the Bumper 2 was used primarily for testing rocket systems and for research on the upper atmosphere. Bumper 2 rockets carried small payloads that allowed them to measure attributes of the upper atmosphere, including air temperature and cosmic-ray impacts. Seven years later, the Soviet Union launched Sputnik I and Sputnik II, the first artificial satellites to orbit Earth. In response, in 1958, the United States created NASA.

CREDIT: NASA

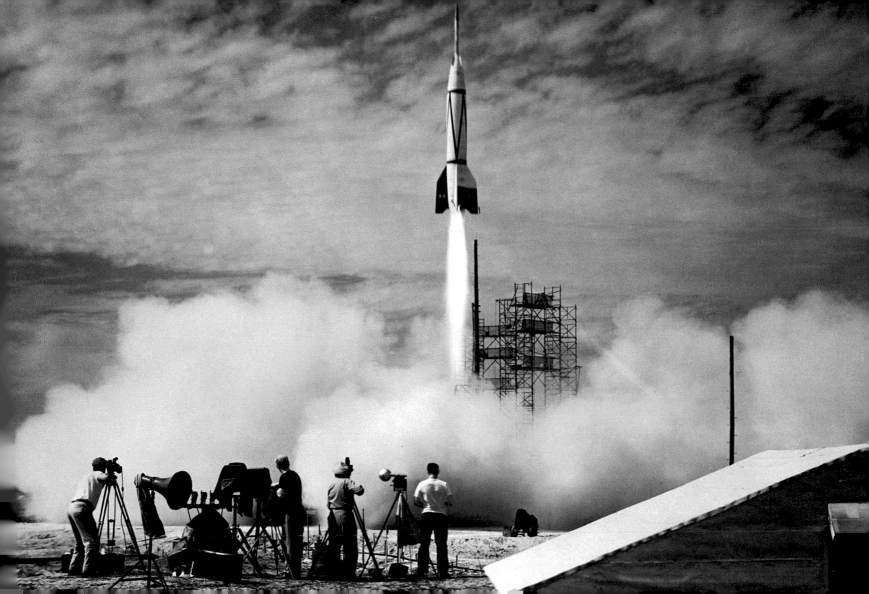

+ **Redshift 5.8: A New Farthest Quasar**

THE DISTANCE RECORD FOR A QUASAR KEEPS GETTING BROKEN. AT THE TIME OF ITS DISCOVERY, NO OTHER OBJECT IN THE universe was known to be more distant than this tiny speck. Don't close the record book yet, though. Discovered in 2000, this quasar was clocked at redshift 5.82. The exact relation between redshift and distance remains unknown, although surely higher redshifts do mean greater distance. This quasar is likely billions of light-years away and so is seen when the universe was younger than 1 billion years, less than a tenth of its present age. Like all quasars, this object is probably a large black hole in the center of a distant galaxy. CREDIT: STEPHEN KENT (FNAL), SDSS COLLABORATION

+ **APM 08279+5255: The Brightest Object Yet Known**

IT SHINES WITH THE BRIGHTNESS OF A HUNDRED BILLION SUNS. IS IT A MIRAGE? IN 1998 THE QUASAR LABELED APM 08279+5255 was reported to set a new record as the brightest continuously emitting object yet known. APM 08279+5255's great distance, though, makes it appear only as bright as magnitude 15.2, an object that can be seen with a moderate-size telescope. It is the quasar's extreme redshift of 3.87 that places it far across our universe and implies a truly impressive energy output. One possible explanation of APM 08279+5255's record luminosity is that it is partly a mirage: its light is highly magnified by an intervening galaxy that acts as a gravitational lens. Alternatively, APM 08279+5255 might be the most active known center of an intriguing class of colliding galaxies rich in gas and dust. The quasar is indicated by the arrow in this negative picture. CREDIT: M.J. IRWIN (RGO), R.A. IBATA (ESO), G.F. LEWIS (U. WASHINGTON, U. VICTORIA), AND E.J. TOTTEN (KEELE U.), ISAAC NEWTON 2.5-M TELESCOPE

APM08279+5255

+ **Triton: Neptune's Largest Moon**

ON OCTOBER 10, 1846, WILLIAM LASSELL WAS OBSERVING THE NEWLY DISCOVERED PLANET NEPTUNE. HE WAS ATTEMPTING TO confirm his observation, made just the previous week, that Neptune had a ring. But this time he discovered that Neptune had a satellite as well. Lassell soon proved that the ring was a product of his new telescope's distortion, but the satellite Triton remained. This enhanced color picture was taken in 1989 by Voyager 2, the only spacecraft ever to pass Triton. Voyager 2 found fascinating terrain, a thin atmosphere, even evidence for ice volcanoes on this world of peculiar orbit and spin. Ironically, Voyager 2 also confirmed the existence of complete thin rings around Neptune—but these would have been quite invisible to Lassell. CREDIT: VOYAGER 2, NASA

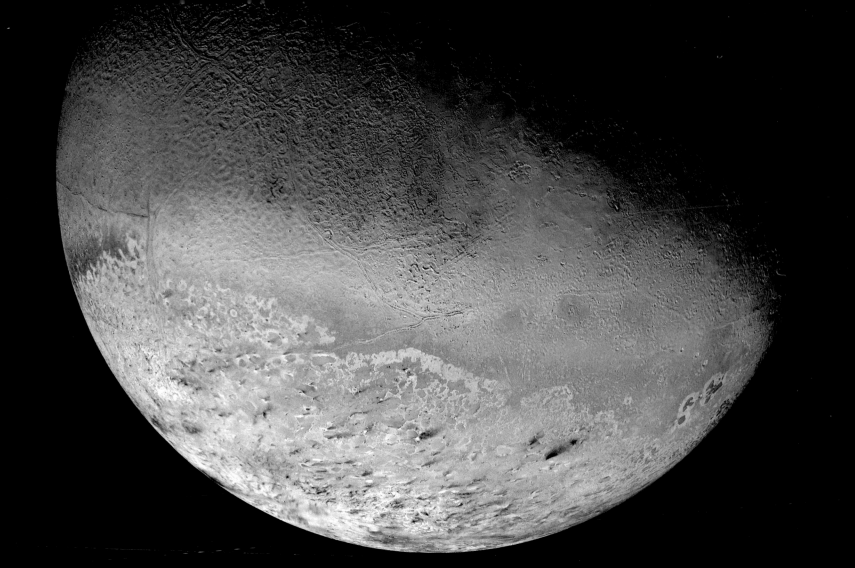

+ **3C175: Quasar Cannon**

NOT ONLY IS 3C175 A QUASAR; IT IS A GALAXY-FUELED PARTICLE CANNON. VISIBLE AS THE CENTRAL DOT IS QUASAR 3C175, the active center of a galaxy so distant that the light we see from it was emitted when Earth was just forming. This image was recorded in radio waves by an array of house-size telescopes called the Very Large Array. Shooting out from 3C175 is believed to be a relatively narrow jet of protons and electrons traveling near the speed of light that is over 1 million light-years long. The jet acts like a particle cannon and bores through gas clouds in its path. How this jet forms and why it is so narrow remain topics of current research. CREDIT & COPYRIGHT: ALAN BRIDLE (NRAO CHARLOTTESVILLE) VLA, NRAO, NSF

OCTOBER

01
02
03
04
05
06
07
08
09
10
11
12
13
14
15
16
17
18
19
20
21
22
23
24
25
26
27
28
29
30
31

+ The Water Vapor Channel

WHAT ALIEN PLANET'S BIZARRE LANDSCAPE LURKS BELOW THESE FIERY-LOOKING CLOUDS? IT'S ONLY PLANET EARTH, OF COURSE . . .

as seen on the Water Vapor Channel. Hourly, images like this one (an infrared image shown in false color) are brought to you by the

orbiting Geostationary Operational Environmental Satellites' multichannel imagers. These instruments can produce images at the

infrared wavelength of 6.7 microns, or about 10 times the wavelength of visible light, recording radiation absorbed by water vapor in the

upper troposphere. In this picture, the planet's dark regions correspond to high concentrations of water vapor over storms and high

cloud tops, while bright areas are relatively dry. The dominant bright feature seen here is a persistent region of dry, descending air

extending west into the Pacific off the Peruvian coast. Atmospheric water vapor is otherwise invisible to the eye and is produced by

evaporation from the oceans. CREDIT: F. HASLER, D. CHESTERS, ET AL., GOES PROJECT, NASA/GSFC

+ **Astronaut at Work**

DID YOU EVER HAVE A DAY WHERE EVERYTHING GOT TURNED AROUND AND YOU JUST COULDN'T TELL WHICH WAY WAS UP?

Fortunately, this didn't happen on May 21, 2000, to astronaut James S. Voss, who spent 6 hours preparing to fix and upgrade the International Space Station. Voss is shown here anchored in the clutches of space shuttle Atlantis's mechanical arm, maneuvering outside the shuttle's cargo bay high above planet Earth. This space walk was the eighty-fifth in United States history and the fifth dedicated to the construction of the International Space Station. The STS-101 mission returned after successfully replacing the station's batteries, lifting the station into a higher orbit, and replenishing needed supplies. In several years, when the International Space Station is complete, a crew of astronauts will live and work in a volume similar to a 747 jumbo jet.

CREDIT: STS-101 CREW, NASA

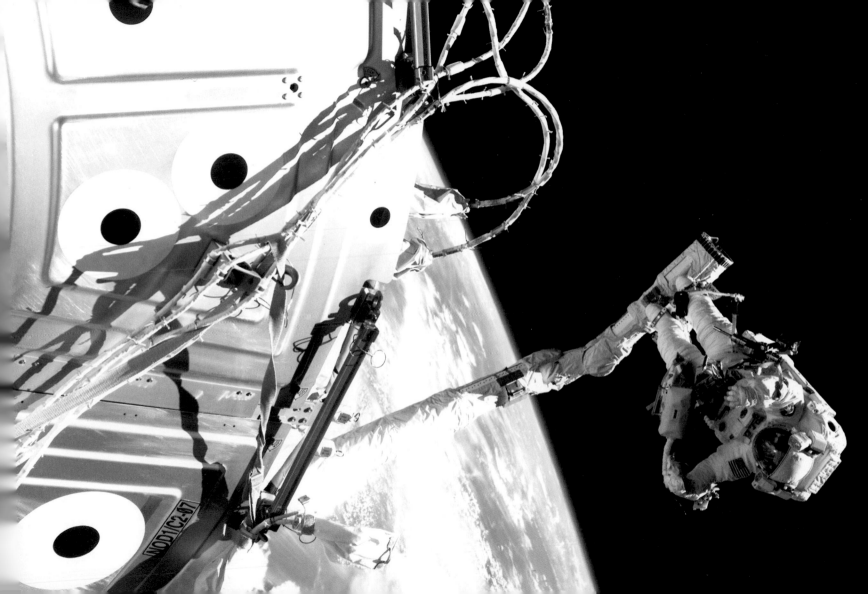

+ **Far Side of the Moon**

LOCKED IN SYNCHRONOUS ROTATION, THE MOON ALWAYS PRESENTS ITS WELL-KNOWN NEAR SIDE TO EARTH. BUT FROM LUNAR orbit, Apollo astronauts also grew to know the Moon's far side. This sharp picture from Apollo 16's mapping camera shows the eastern edge of the familiar near side (left) and the strange and heavily cratered far side of the Moon. Surprisingly, the rough and battered surface of the far side looks very different from the near side that is covered with the smooth, dark lava flows known as lunar maria. The likely explanation is that the far-side crust is thicker, making it harder for molten material from the interior to flow to the surface and form the smooth maria. CREDIT: APOLLO 16, NASA

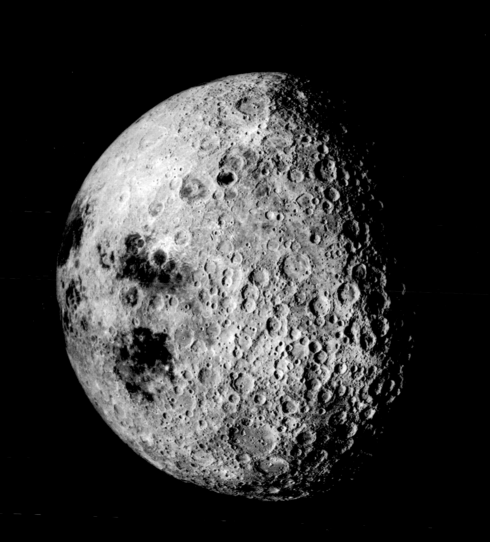

+ **Orion Nebula: The 2MASS View**

FEW ASTRONOMICAL SIGHTS EXCITE THE IMAGINATION LIKE THE NEARBY STELLAR NURSERY KNOWN AS THE ORION NEBULA.

The nebula's glowing gas surrounds hot young stars at the edge of an immense interstellar molecular cloud only 1,500 light-years away. This distinctively detailed image of the Orion Nebula was constructed using data from the Two Micron All-Sky Survey or 2MASS. Using telescopes in the Northern and Southern Hemispheres of planet Earth, the 2MASS project has mapped the entire sky in infrared light. The wavelength of infrared light is longer than visible light but more easily penetrates obscuring dust clouds. 2MASS cameras were sensitive to near-infrared wavelengths around 2 microns, or about 0.00008 inch. Visible light has a wavelength of about 0.00002 inch. Survey observations in three infrared bands were translated to blue, green, and red colors to produce this composite image. CREDIT: 2MASS COLLABORATION, U. MASS., IPAC. MOSAIC BY E. KOPAN

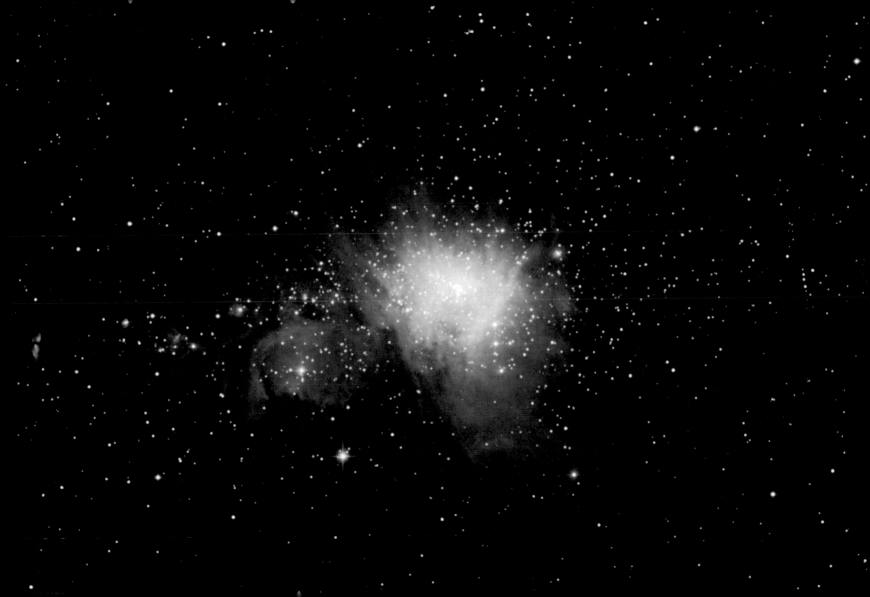

+ **Dust and Gas Surrounding Star R Coronae Australis**

YOUNG STAR R CORONAE AUSTRALIS HAS A DUSTY HOME. THE DUST IS SO THICK ON THE UPPER LEFT OF THIS PHOTOGRAPH that little light from background stars comes through. Thinner dust near the stars reflects light from R Coronae Australis (upper right) and neighbor TY Coronae Australis, giving their surroundings a flowing appearance. Were these stars more massive they would emit light energetic enough to ionize much of the nearly invisible surrounding hydrogen gas, causing it to appear bright red. The unusual structure above the center is a Herbig-Haro Object, a knot of gas ejected from the star that has impacted surrounding gas. R Coronae Australis is approximately 500 light-years away, while the region shown is about 4 light-years across.

CREDIT: F. COMERON, WFI, MPG, LA SILLA OBSERVATORY, ESO

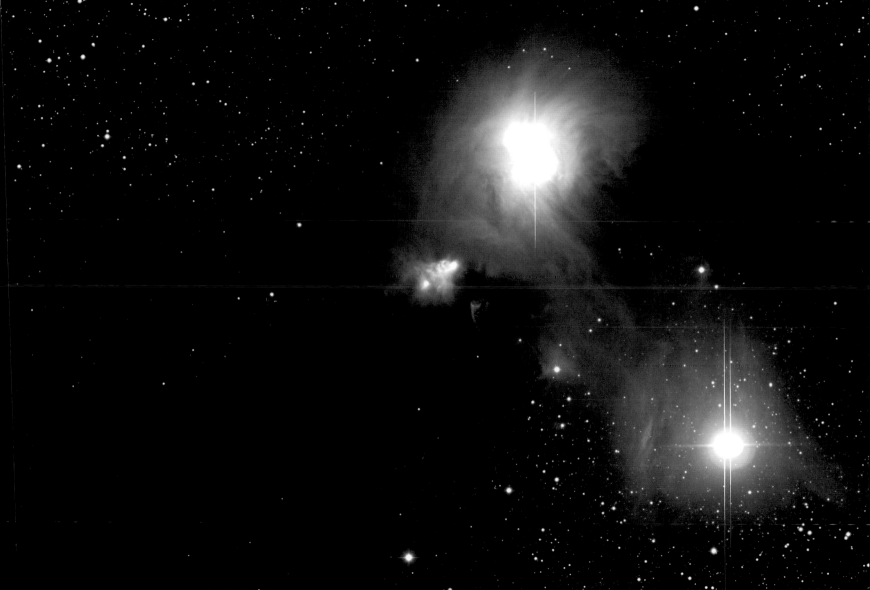

+ Mars: A Mist In Mariner Valley

AN ICY MIST AND LATE AFTERNOON CLOUDS COVER MUCH OF THIS SECTION OF VALLES MARINERIS ON MARS. THE VALLES

Marineris, or Mariner Valley, is a huge canyon system about 4,000 km long and up to 8 km deep. This early test image was pro-

duced using data from Mars Global Surveyor's wide-angle cameras that viewed the canyon from a distance of 580 to 1,000 km.

Color was synthesized using images recorded through blue and red filters. CREDIT: MGS PROJECT, JPL, NASA

+ **NGC 3603: An Active Star Cluster**

NCG 3603 IS HOME TO A MASSIVE STAR CLUSTER, THICK DUST PILLARS, AND A STAR ABOUT TO EXPLODE. THE CENTRAL, OPEN cluster contains about two thousand bright stars, each of which is much brighter and more massive than our sun. Together, radiations from these stars are energizing and pushing away surrounding material, making NGC 3603 one of the most interesting star-forming regions known. NGC 3603 is approximately 20,000 light-years away. The section shown is about 20 light-years across. What is possibly most interesting about this representative-color picture is the large number of dim stars visible. These stars are less massive than our sun, demonstrating that great numbers of low-mass stars also form in active starburst regions.

CREDIT: B. BRANDL (CORNELL) ET AL., ISAAC, VLT, ESO

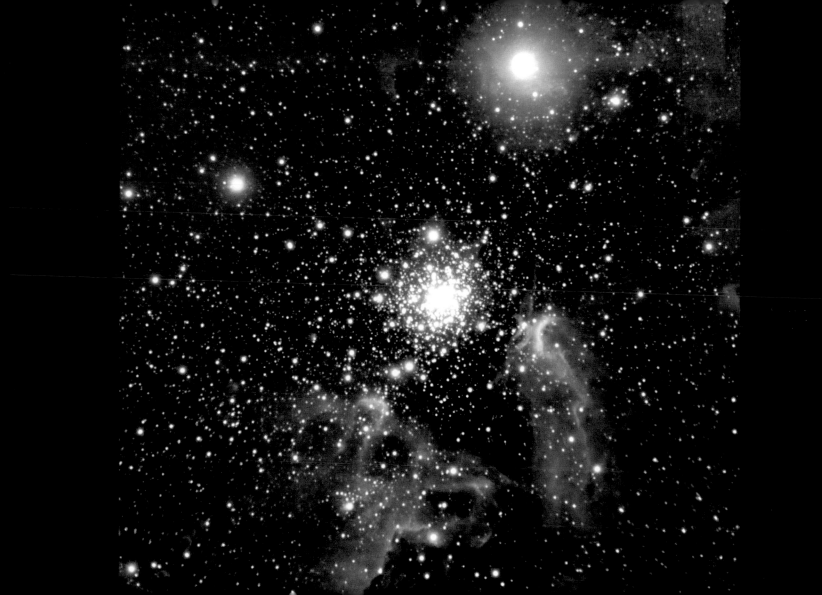

+ X-ray Stars and Winds in the Rosette Nebula

THIS MOSAIC OF X-RAY IMAGES CUTS A SWATH ACROSS THE PHOTOGENIC ROSETTE NEBULA, A STELLAR NURSERY 5,000 LIGHT-years from Earth toward the constellation Monoceros, the Unicorn. Constructed from data recorded by the orbiting Chandra X-ray Observatory, the mosaic spans less than 100 light-years and is color-coded to show low energies in red and high-energy X rays in blue. At the upper right is the young star cluster NGC 2244, central to the Rosette Nebula itself. The hot outer layers of the massive stars are seen to be copious sources of X rays, but a diffuse X-ray glow also pervades this cluster of newborn stars. Since these stars are so young (less than a few million years old), the diffuse X-ray emission is thought to be powered by energetic, colliding stellar winds rather than remnants of supernovas explosions, a final act in the life cycle of massive stars. Moving away from the center, south and east across the nebula (upper right to lower left), the hot, blustery environment gives way to dense molecular gas, absorbing low-energy X rays while revealing the penetrating high-energy X rays from embedded stars.

CREDIT: L. TOWNSLEY (PENN STATE), ET AL., NASA

+ **Infrared Uranus**

THE SUN'S THIRD-LARGEST PLANET USUALLY LOOKS QUITE DULL. URANUS TYPICALLY APPEARS AS A FEATURELESS SMALL SPOT in a small telescope or a featureless, large orb in a large telescope. In August 1998, however, the Hubble Space Telescope was able to photograph Uranus in infrared light, where the distant planet better shows its unusual clouds, rings, and moons. Recent analysis indicates that clouds seen here in orange appear to circle Uranus at speeds in excess of 500 km per hour. Comparisons to earlier photographs show a slight precession shift in the brightest of Uranus's rings. Several of Uranus's numerous small moons are visible. CREDIT: E. KARKOSCHKA ET AL. (UNIVERSITY OF ARIZONA), NICMOS, HST, NASA

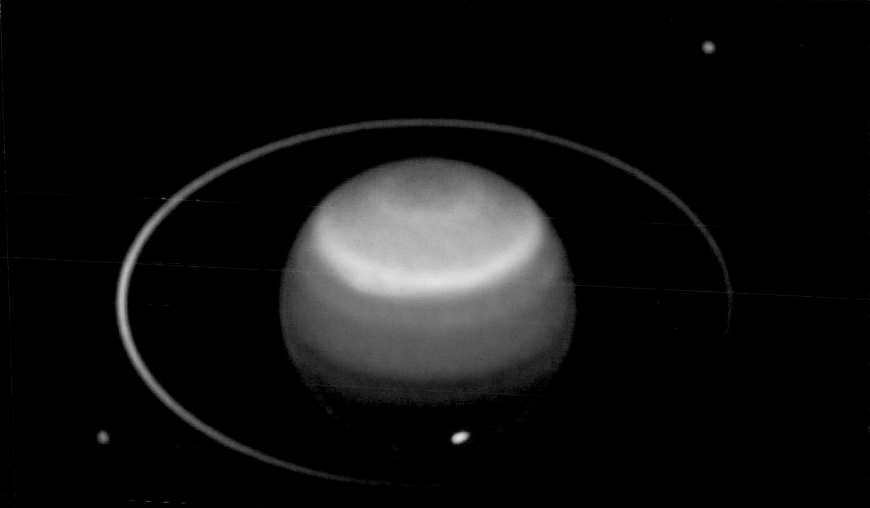

+ **The Sombrero Galaxy from VLT**

WHY DOES THE SOMBRERO GALAXY LOOK LIKE A HAT? REASONS INCLUDE THE SOMBRERO'S UNUSUALLY LARGE AND EXTENDED central bulge of stars and dark, prominent dust lanes that appear in a disk that we see nearly edge-on. Billions of old stars cause the diffuse glow of the extended central bulge. Close inspection of the bulge in this photograph shows many points of light that are actually globular clusters. Also known as M104, the Sombrero galaxy's spectacular dust rings harbor many younger and brighter stars and show intricate details astronomers do not yet fully understand. The very center of the Sombrero glows across the electromagnetic spectrum, and is thought to house a large black hole. Fifty-million-year-old light from the Sombrero galaxy can be seen with a small telescope toward the constellation Virgo. CREDIT: PETER BARTHEL (KAPTEYN INST.) ET AL., FORS1, VLT ANTU, ESO

+ Iridium 52: Not a Meteor

WHILE HUNTING FOR METEORS IN THE NIGHT SKY ABOVE THE WHITE MOUNTAINS NEAR BISHOP, CALIFORNIA, ASTRONOMER James Young instead captured this brilliant celestial apparition. Recorded near twilight on August 13, 1999, the bright streak is not the flash of a meteor trail but sunlight glinting off a satellite. The satellite, Iridium 52, is one of a constellation of Iridium digital communication satellites orbiting Earth known for producing stunning, predictable "flares" as they momentarily reflect sunlight from shiny antenna surfaces. For well-placed observers, the peak brightness of this Iridium satellite flare reached about –6 magnitude, not quite as bright as the half-illuminated Moon. At magnitude 2.5, the bright star at the bottom is Alpha Pegasi, a star in the constellation Pegasus. CREDIT: J. W. YOUNG (TMO, JPL, NASA), USED WITH PERMISSION

+ **Millions of Stars in Omega Centauri**

PICTURED HERE IS THE LARGEST BALL OF STARS IN OUR GALAXY. APPROXIMATELY TEN MILLION STARS ORBIT THE CENTER OF THIS globular cluster—named Omega Centauri—as this giant, globular cluster orbits our galactic center. Evidence indicates that Omega Centauri is by far the most massive of the approximately 150 known globular clusters in the Milky Way. Omega Centauri, catalogued as NGC 5139, spans about 150 light-years, lies about 15,000 light-years away, and can be seen without visual aid toward the constellation Centaurus. The stars in globular clusters are generally older, redder, and less massive than our Sun. Studying globular clusters not only tells us about the history of our galaxy but also limits the age of the universe. CREDIT & COPYRIGHT: LOKE KUN TAN (STARRYSCAPES)

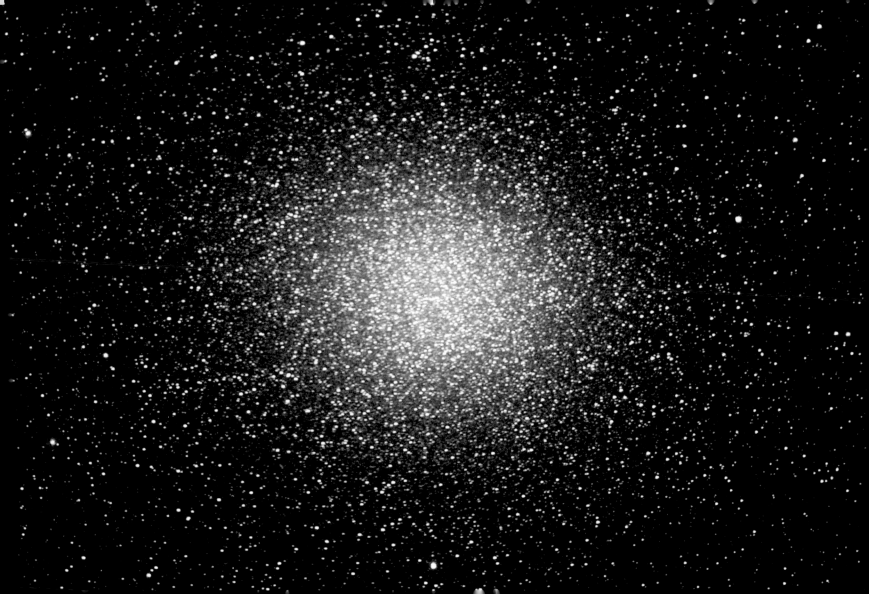

01
02
03
04
05
06
07
08
09
10
11
12
13
14
15
16
17
18
19
20
21
22
23
24
25
26
27
28
29
30
31

+ **N132D and the Color of X rays**

SUPERNOVA REMNANT N132D SHOWS OFF COMPLEX STRUCTURES IN THIS SHARP, COLOR X-RAY IMAGE. STILL, OVERALL, THIS cosmic debris from a massive star's explosive death has a strikingly simple horseshoe shape. While N132D lies 180,000 light-years distant in the Large Magellanic Cloud, the expanding remnant appears here about 80 light-years across. Light from the supernova blast that created it would have reached planet Earth approximately 3,000 years ago. Observed by the orbiting Chandra X-ray Observatory, N132D glows in X rays, its shocked gas heated to millions of degrees Celsius. Since X rays are invisible to humans, the Chandra X-ray image data are represented in this picture by assigning visible colors to X rays with different energies. Low-energy X rays are shown as red, medium-energy as green, and high-energy as blue. These color choices make a pleasing picture and they also show the X rays in the same energy order as visible-light photons, which range from low to high energies as red, green, and blue. CREDIT: SAO, CXC, NASA

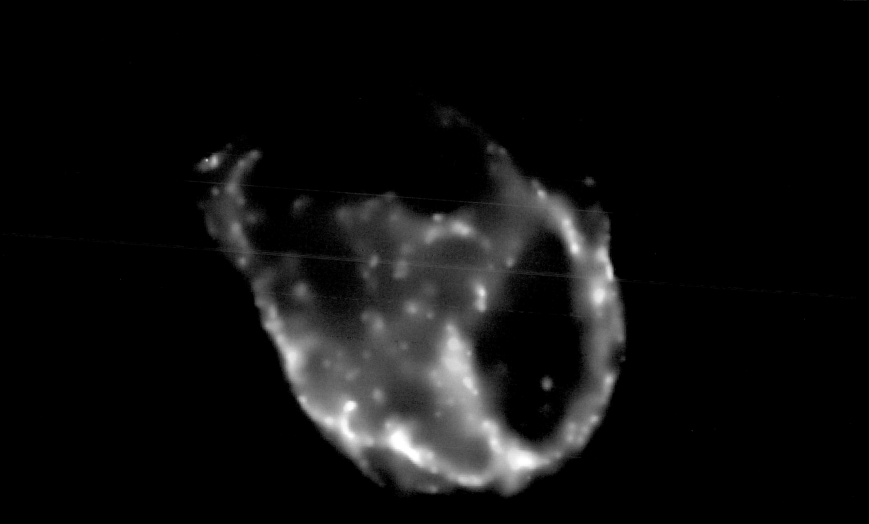

+ **NGC 2261: Hubble's Variable Nebula**

WHAT CAUSES HUBBLE'S VARIABLE NEBULA TO VARY? THE UNUSUAL NEBULA PICTURED HERE CHANGES ITS APPEARANCE noticeably in just a few weeks. Discovered over 200 years ago and subsequently cataloged as NGC 2261, this remarkable nebula is named for Edwin Hubble, who studied it in the early 1900s. Hubble's Variable Nebula is a reflection nebula made of gas and fine dust fanning out from the star R Monocerotis. The faint nebula is about 1 light-year across and lies about 2,500 light-years away toward the constellation Monoceros, the Unicorn. A leading explanation for Hubble's Variable Nebula holds that dense knots of opaque dust pass close to R Monocerotis and cast moving shadows onto the reflecting dust seen in the rest of the nebula.

CREDIT: WILLIAM SPARKS (STSCI), SYLVIA BAGGETT (STSCI) ET AL., & THE HUBBLE HERITAGE TEAM (AURA/ STSCI/ NASA)

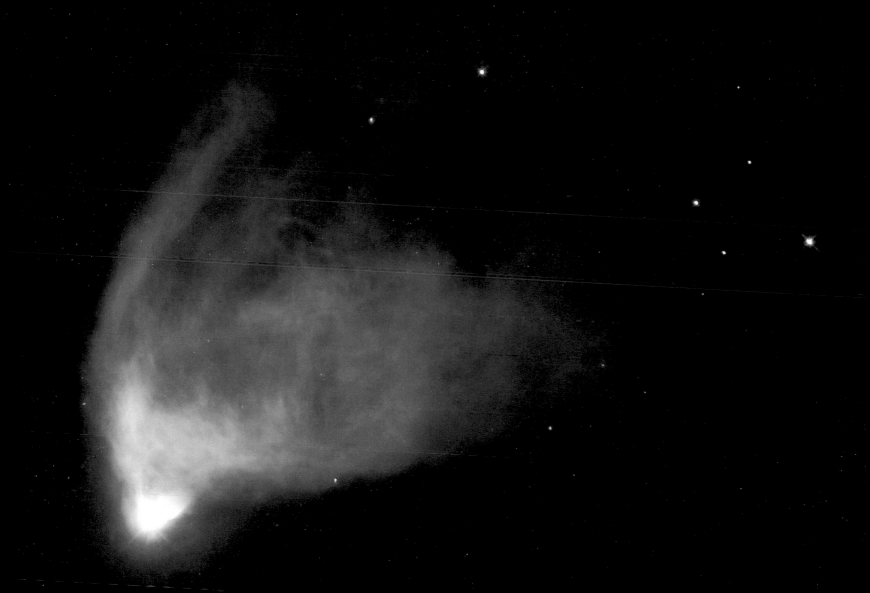

+ **The Map of Eros**

+

THIS MAP OF EROS WAS CONSTRUCTED FROM A MOSAIC OF IMAGES RECORDED BY THE NEAR-SHOEMAKER SPACECRAFT, WHICH orbited the 40 × 14 × 14-km asteroid from February 2000 to February 2001. A simple cylindrical projection of an irregularly shaped world, the map's individual images don't always match up at the edges. Shown here, place names have been proposed to describe the geography of Eros with a fitting theme, though. They are based on romantic figures in the history and literature of the cultures of planet Earth. The largest feature, Himeros, is a depression about 10 km wide. In Greek mythology, Himeros was an attendant of Eros and the personification of the longing of love. In February 2001, the NEAR-Shoemaker spacecraft gently touched down on Eros, making the first-ever landing on an asteroid. CREDIT: NEAR PROJECT, JHU APL, NASA

+ **Elements in the Aftermath**

MASSIVE STARS SPEND THEIR BRIEF LIVES FURIOUSLY BURNING NUCLEAR FUEL. THROUGH FUSION AT EXTREME TEMPERATURES and densities surrounding the stellar core, nuclei of light elements such as hydrogen and helium are combined with heavier elements like carbon, oxygen, and so on, in a progression that ends with iron. As a result, a supernova explosion, a massive star's inevitable and spectacular demise, blasts back into space debris enriched with heavier elements to be incorporated into other stars and planets. This detailed false-color X-ray image from the orbiting Chandra X-ray Observatory shows a hot, expanding stellar debris cloud about 36 light-years across. Catalogued as G292.0+1.8, this young supernova remnant in the southern constellation Centaurus resulted from a massive star that exploded an estimated 1,600 years ago. Bluish colors highlight filaments of the multimillion-degree gas that are exceptionally rich in oxygen, neon, and magnesium. Just below and left of center, a pointlike object in the Chandra image suggests that the enriching supernova also produced a pulsar in its aftermath, a rotating neutron star remnant of the collapsed stellar core.

CREDIT: J.HUGHES (RUTGERS) ET AL., CXC, NASA

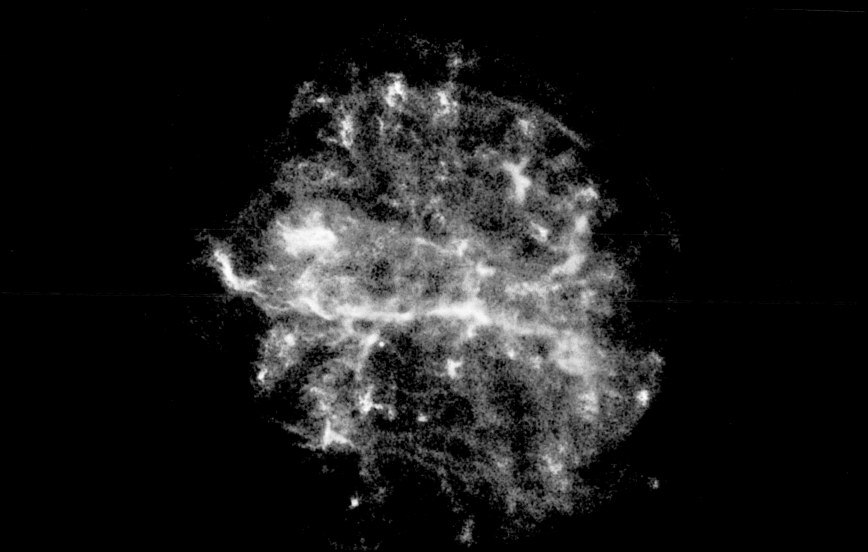

01
02
03
04
05
06
07
08
09
10
11
12
13
14
15
16
17
18
19
20
21
22
23
24
25
26
27
+ 28
29
30
31

+ **Rafting for Solar Neutrinos**

WHERE HAVE ALL THE NEUTRINOS GONE? A LONG TIME PASSING SINCE THIS question was first asked (decades ago). As increasingly larger and more sensitive detectors were built, fewer neutrinos from our Sun were found than expected. But why? Here, scientists check the equipment surrounding a huge tank of extremely pure water from the Super-Kamiokande experiment that began operation in 1996 in Japan to detect colliding neutrinos. Large detectors are needed because the neutrino is an elementary particle that goes right through practically everything. More recent experimental results suggest that neutrinos can change quantum properties when they interact with tangled solar magnetic fields, becoming related particles that some neutrino experiments were not designed to detect. CREDIT: SUPER-KAMIOKANDE COLLABORATION, JAPAN

+ **NGC 6791: An Old, Large Open Cluster**

NGC 6791 IS ONE OF THE OLDEST AND LARGEST OPEN CLUSTERS OF STARS KNOWN. BUT HOW DID IT GET SO DIRTY? OPEN STAR clusters usually each contain a few hundred stars that are less than a billion years old. Open star cluster NGC 6791, however, contains thousands of stars recently measured to be about 8 billion years old. What's really confusing, though, is that the stars of NGC 6791 are relatively dirty—the minuscule amounts of heavy elements they contain (generically called metals) are high relative to most other star clusters. Old stars are supposed to be metal poor, since metals have only been slowly accumulating in our Milky Way galaxy. This enigma makes NGC 6791, pictured here, one of the most-studied open clusters and a possible example of how stars might evolve in the centers of galaxies. CREDIT: BARBARA J. MOCHEJSKA (CAMK) ET AL., 2.1-M TELESCOPE, KPNO, NOAO/AURA/NSF

+ **The Witch Head Nebula**

DOUBLE, DOUBLE, TOIL AND TROUBLE,/FIRE BURN, AND CAULDRON BUBBLE— maybe Macbeth should have consulted the Witch Head Nebula. This suggestively shaped reflection nebula is associated with the bright star Rigel in the constellation Orion. More formally known as IC 2118, the Witch Head Nebula glows primarily by light reflected from Rigel, located just outside the top right corner of this image. Fine dust in the nebula reflects the light. The blue color is caused not only by Rigel's blue color but also because the interstellar dust grains reflect and scatter blue light more efficiently than red. The same physical process causes Earth's daytime sky to appear blue, although the particles scattering light in Earth's atmosphere are molecules of nitrogen and oxygen. The nebula lies approximately 1,000 light-years away. CREDIT: GARY STEVENS

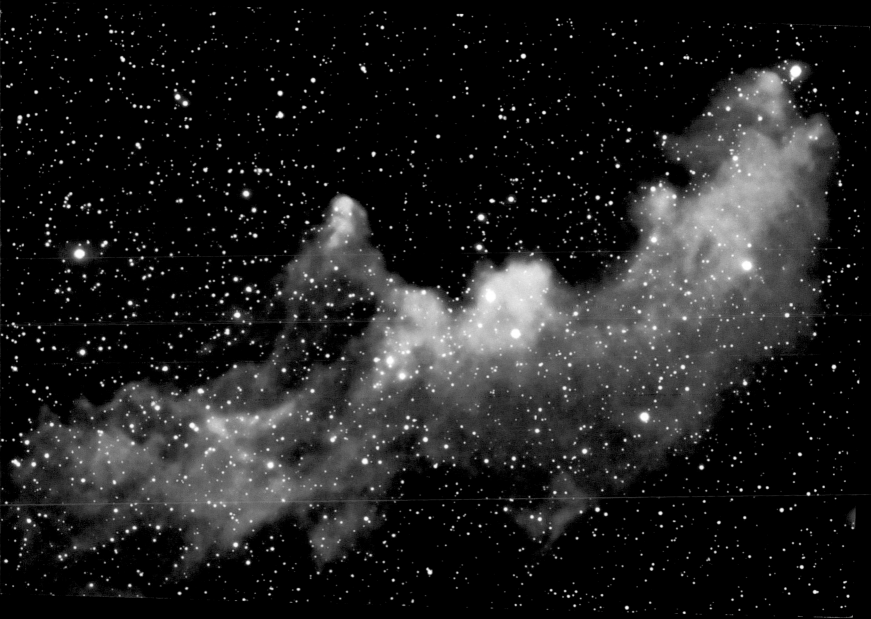

+ Halloween and the Ghost Head Nebula

HALLOWEEN'S ORIGIN IS ANCIENT AND ASTRONOMICAL. SINCE THE FIFTH CENTURY B.C., HALLOWEEN HAS BEEN CELEBRATED as a cross-quarter day, a day halfway between an equinox (equal day/equal night) and a solstice (minimum day/maximum night in the Northern Hemisphere). Another cross-quarter day is Groundhog Day. Halloween's modern celebration retains historical roots in dressing to scare away the spirits of the dead. A perhaps-fitting modern tribute to this ancient holiday is this picture of the Ghost Head Nebula taken with the Hubble Space Telescope. Appearing similar to the icon of a fictional ghost, NGC 2080 is actually a star-forming region in the Large Magellanic Cloud, a satellite galaxy of our own Milky Way galaxy. The Ghost Head Nebula spans approximately 50 light-years and is shown here in representative colors. CREDIT: MOHAMMAD HEYDARI-MALAYERI (OBSERVATOIRE DE PARIS) ET AL., ESA, NASA

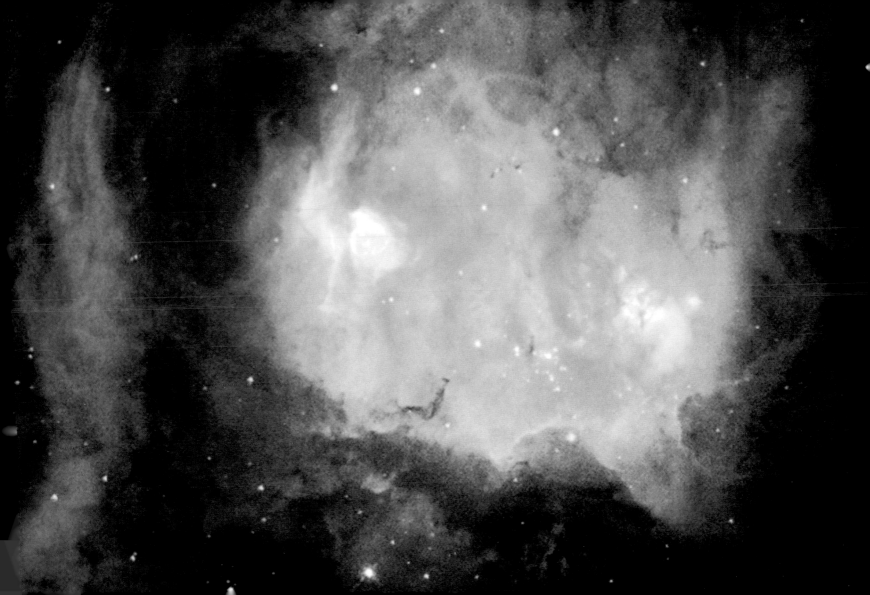

+ **Fireball, Smoke Trail, Meteor Storm**

RETURNING FROM ORBIT, SPACE SHUTTLES ENTER THE ATMOSPHERE AT APPROXIMATELY 8 KM PER SECOND AS FRICTION HEATS their protective ceramic tiles to over 1,400 degrees Celsius. By contrast, the bits of comet dust that became the Leonid meteors seen on November 18, 2001, were moving at 70 km per second, completely vaporizing at altitudes of around 100 km. In this single 5-minute time exposure, three Leonid meteors can be seen shooting through skies above Spruce Knob, West Virginia. Background stars are near the constellation Orion. The brightest meteor, a fireball, dramatically changes colors along its path and leaves a smoky, persistent trail drifting in high-altitude winds. From that extremely dark site, at an elevation of 1,200 meters, astrophotographer Jerry Lodriguss reports, "We observed a [zenithal hourly rate] of about 3,600 at 10:30 Universal Time and very high rates from 9:30 UT until well into the start of astronomical twilight at 10:50 UT. It was quite a spectacular storm, with bolides going off like flashbulbs, green and red fireballs, and other fainter Leonids in all parts of the sky." CREDIT & COPYRIGHT: JERRY LODRIGUSS

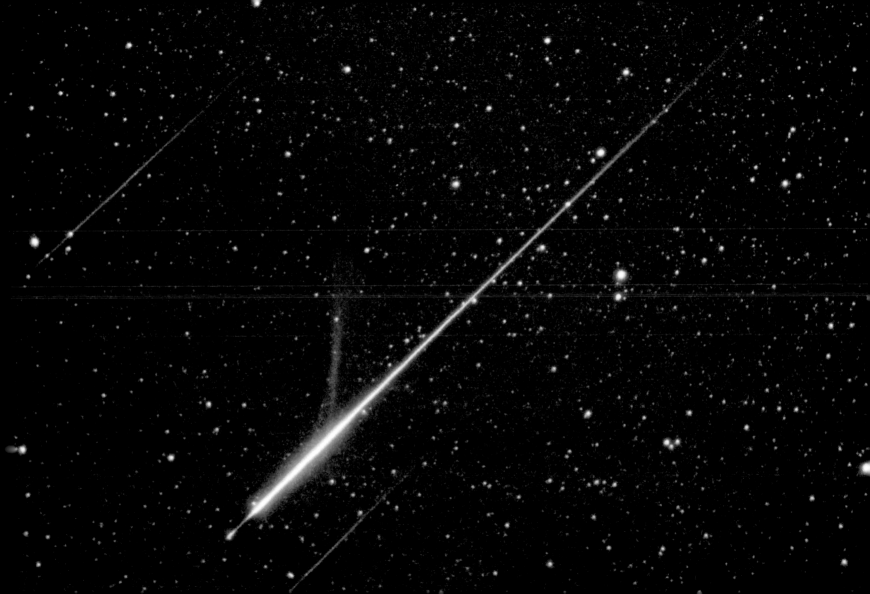

+ **PG 1115+080: A Ghost of Lensing Past**

IN THIS TANGLE OF QUASARS AND GALAXIES LIES A CLUE TO THE EXPANSION RATE OF THE UNIVERSE. A DIFFUSE GLOW EVIDENT IN the picture on the left reveals a normal elliptical galaxy. Directly behind this galaxy lies a normal quasar. Because the quasar is directly behind the galaxy, however, the gravity of the galaxy deflects quasar light like a lens, creating four bright images of the same distant quasar. When these images are all digitally subtracted, a distorted image of the background galaxy that hosts the quasar appears—here shown on the right in ghostly white. Each quasar image traces how the quasar looked at different times in the past, with the time between images influenced by the expansion rate of the universe itself. Assuming dark matter in the elliptical lens galaxy traces the visible matter, this expansion rate is a value close to that determined by other methods. Analysis of this image by itself sheds little light on whether the global geometry of the universe is affected by a cosmological constant. CREDIT: C. IMPEY (U. ARIZONA) ET AL., CASTLES SURVEY, NICMOS, HST, NASA

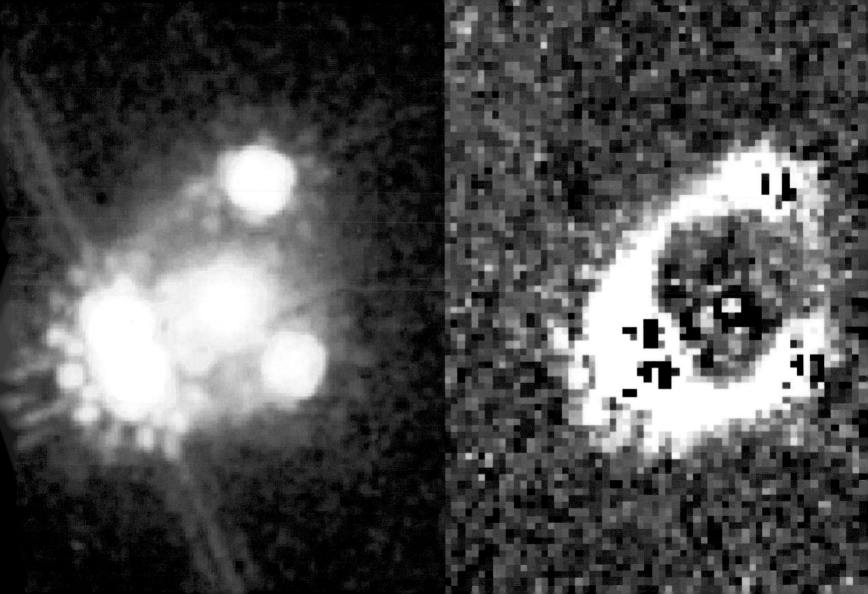

+ **A Galaxy Collision in NGC 6745**

GALAXIES DON'T NORMALLY LOOK LIKE THIS. NGC 6745 ACTUALLY SHOWS THE RESULTS OF TWO GALAXIES THAT HAVE BEEN colliding for hundreds of millions of years. Just off the photograph, to the lower right, is the smaller galaxy, moving away. The larger galaxy, pictured here, used to be a spiral galaxy but now is damaged and appears peculiar. Gravity has distorted the shapes of the galaxies. Although it is likely that no stars in the two galaxies directly collided, the gas, dust, and ambient magnetic fields do interact directly. In fact, a knot of gas pulled off the larger galaxy on the lower right has now begun to form stars. NGC 6745 has a span of approximately 80 thousand light-years and is located about 200 million light-years away. CREDIT: ROGER LYNDS

(KPNO/NOAO) ET AL., HUBBLE HERITAGE TEAM, NASA

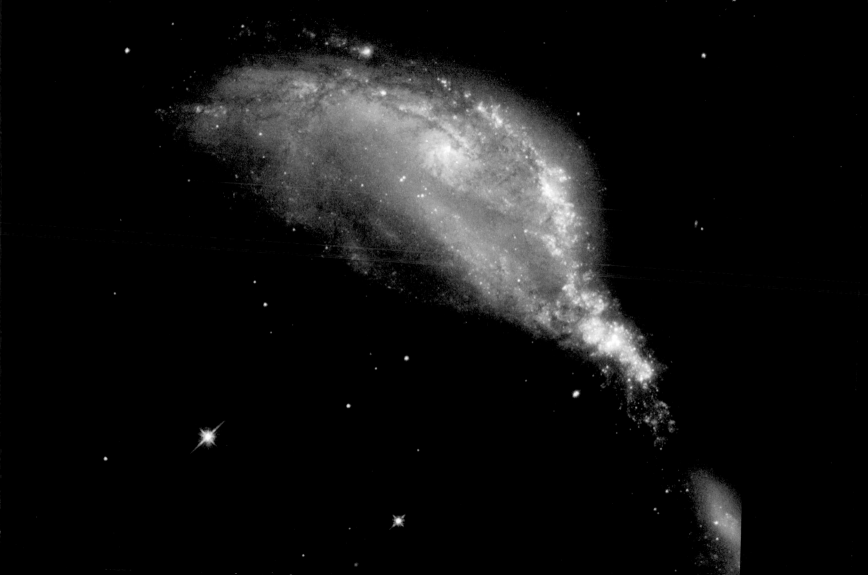

01
02
03
+ 04
05
06
07
08
09
10
11
12
13
14
15
16
17
18
19
20
21
22
23
24
25
26
27
28
29
30

+ Leonids from Leo

IS LEO LEAKING? LEO, THE FAMOUS SKY CONSTELLATION VISIBLE ON THE LEFT OF THIS ALL-SKY PHOTOGRAPH, APPEARS TO BE the source of all the meteors seen in 1998's Leonid meteor shower. That the name Leonid points back to Leo is not a surprise: sand-sized debris expelled from comet Tempel-Tuttle follows a well-defined orbit about our sun, and the part of the orbit that approaches Earth is superimposed in front of the constellation Leo. Therefore, when Earth crosses this orbit, the radiant point of falling debris appears in Leo. Over 150 meteors can be seen in this 4-hour intermittent exposure. CREDIT: JURAJ TOTH (COMENIUS U. BRATISLAVA), MODRA OBSERVATORY

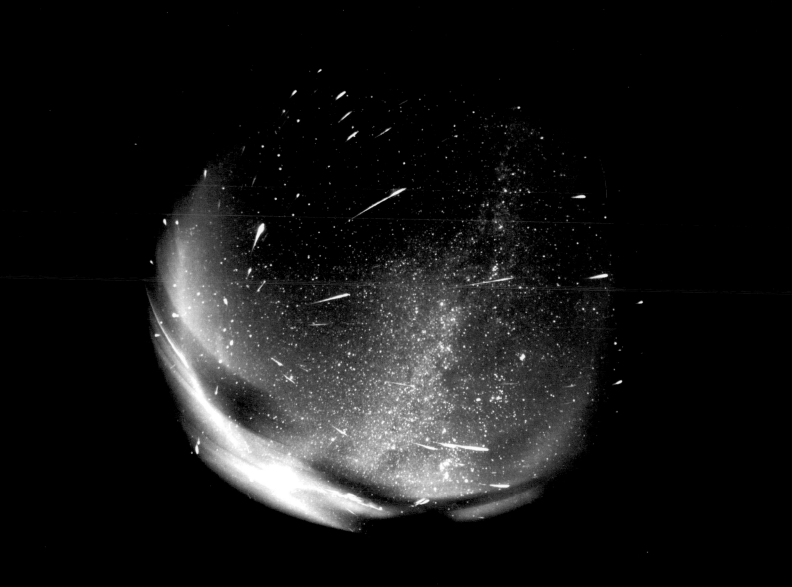

NOVEMBER

01
02
03
04
05
06
07
08
09
10
11
12
13
14
15
16
17
18
19
20
21
22
23
24
25
26
27
28
29
30

+ **Natural Saturn on the Cassini Cruise**

WHAT WOULD YOU SEE APPROACHING SATURN ABOARD AN INTERPLANETARY CRUISE SHIP? YOUR VIEW WOULD LIKELY RESEMBLE

this subtly shaded image of the gorgeous, ringed gas giant. Processed by the Hubble Heritage project, the picture intentionally

avoids overemphasizing color contrasts and presents a natural-looking Saturn with cloud bands, storms, nearly edge-on rings, and

the small, round shadow of the moon Enceladus near the center of the planet's disk. Of course, seats were not available on the

Cassini spacecraft, the ship en route in 2002. Cassini flew by Jupiter at the turn of the millennium and is scheduled to arrive at

Saturn in the year 2004. After an extended cruise to a world 1,400 million km from the Sun, Cassini will tour the saturnian system,

conducting a remote, robotic exploration with software and instruments designed by denizens of planet Earth. CREDIT: HUBBLE HERITAGE

TEAM (AURA/ STSCI/ NASA)

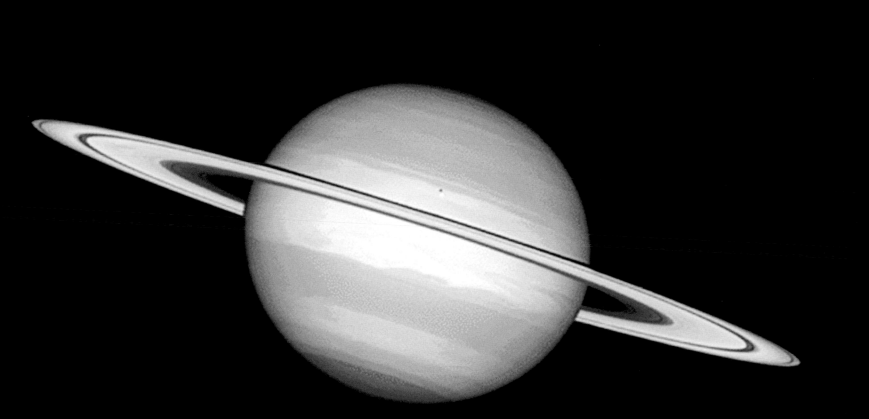

01
02
03
04
05
06
07
08
09
10
11
12
13
14
15
16
17
18
19
20
21
22
23
24
25
26
27
28
29
30

+ **Heaven on Earth**

IF SOMETIMES IT APPEARS THAT THE ENTIRE MILKY WAY GALAXY IS RAINING down on your head, do not despair. It happens twice a day. As the Sun rises in the East, wonders of the night sky become less bright than the sunlight scattered by our own Earth's atmosphere, and so fade from view. They will only rotate back into view when the Earth again eclipses our bright Sun at dusk. This battle between heaven and Earth was captured dramatically during the last few minutes of daylight on August 10, 1999, in Koumi, Japan. Dark dust, millions of stars, and bright, glowing, red gas highlight the plane of our Milky Way galaxy, which lies on average thousands of light-years behind Earth's clouds, which appear yellow and green. CREDIT & COPYRIGHT: NAOYUKI KURITA

+ **A Sun Pillar in Red and Violet**

SOMETIMES THE UNKNOWN IS BEAUTIFUL. IN FEBRUARY 2000, NEAR LAKE TAHOE, NEVADA, TWO AMATEUR PHOTOGRAPHERS noticed an unusual red column of light rise mysteriously from a setting sun. During the next few minutes, they were able to capture on film the pillar and a photogenic sunset. In the resulting image shown here, the red column is seen above a serene Lake Tahoe and snow-capped mountains across from Lake Tahoe-Nevada State Park. The mysterious column, they learned later, is a Sun Pillar, a phenomenon where sunlight reflects off distant, falling ice crystals. CREDIT & COPYRIGHT: JIM KIRKPATRICK & BRIGITTE KIRKPATRICK

+ **The Gum Nebula Supernova Remnant**

BECAUSE THE GUM NEBULA IS THE CLOSEST SUPERNOVA REMNANT, IT IS ACTUALLY HARD TO SEE. SPANNING 40 DEGREES OF THE

sky, the nebula is so large and faint, it is easily lost in the din of a bright and complex background. The Gum Nebula, highlighted

nicely in this wide-angle photograph, is so close that we are much nearer the front edge than the back edge, at distances of 450

and 1,500 light-years respectively. The complex nebula lies in the direction of the constellations Puppis and Vela. Oddly, much

remains unknown about the Gum Nebula, including the timing and even number of supernova explosions that formed it.

CREDIT & COPYRIGHT: JOHN GLEASON (CELESTIAL IMAGES)

+ **Spiral Galaxies in Collision**

BILLIONS OF YEARS FROM NOW, ONLY ONE OF THESE TWO GALAXIES WILL REMAIN. UNTIL THEN, SPIRAL GALAXIES NGC 2207 and IC 2163 will pull each other apart slowly, creating tides of matter, sheets of shocked gas, lanes of dark dust, bursts of star formation, and streams of cast-away stars. Astronomers predict that NGC 2207, the larger galaxy on the left, will eventually incorporate IC 2163, the smaller galaxy on the right. In the most recent encounter that peaked 40 million years ago, the smaller galaxy is swinging around counterclockwise and is now slightly behind the larger galaxy. The space between stars is so vast that when galaxies collide, the stars in them usually do not. CREDIT: DEBRA MELOY ELMEGREEN (VASSAR COLLEGE) ET AL., & THE HUBBLE HERITAGE TEAM (AURA/ STSCI/ NASA)

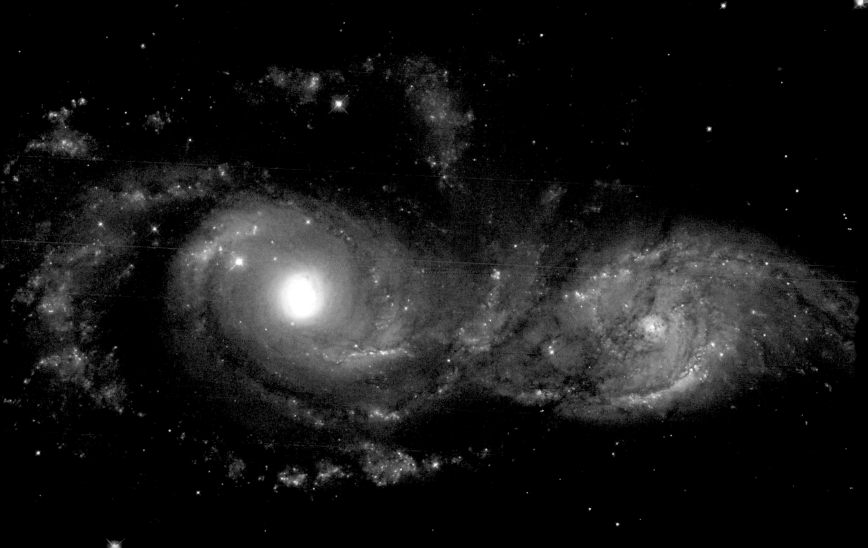

01
02
03
04
05
06
07
08
09
10
11
12
13
14
15
16
17
18
19
20
21
22
23
24
25
26
27
28
29
30

+ Ultraviolet Earth from the Moon

HERE'S A SWITCH: THIS PICTURE IS OF EARTH TAKEN FROM A LUNAR observatory! This false-color picture shows how Earth glows in ultraviolet light. UV light is so blue humans can't see it. Although very little UV light is transmitted through Earth's atmosphere, what sunlight does make it through can cause sunburn. The Far UV Camera/Spectrograph deployed and left on the Moon by the crew of Apollo 16 took this picture. The part of Earth facing the Sun reflects much UV light, but perhaps more interesting is the side facing away from the Sun. Here bands of UV emission are also apparent. These bands are the result of auroras and are caused by charged particles expelled by the Sun. CREDIT: G. CARRUTHERS [NRL] ET AL., FAR UV CAMERA, APOLLO 16, NASA

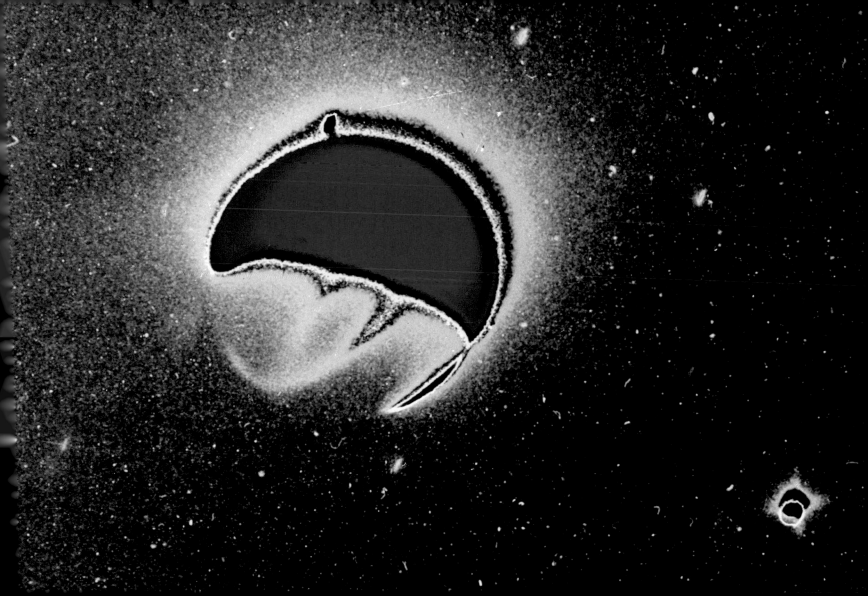

+ **The First Lunar Observatory**

THE APOLLO 16 CREW DEPLOYED THE FIRST, AND SO FAR ONLY, LUNAR ASTRONOMICAL OBSERVATORY IN 1972. THE FAR Ultraviolet Camera/Spectrograph used a 3-inch diameter Schmidt Telescope to photograph Earth, nebulas, star clusters, and the Large Magellanic Cloud. The tripod-mounted astronomical equipment is seen here, just behind a jumping John W. Young, placed in the shadow of the Lunar Module so it would not overheat. The Far Ultraviolet Camera Spectograph took pictures in ultraviolet light that would normally be blocked by Earth's atmosphere. The camera was created by George Carruthers, had a field of view of 20 degrees, and could detect stars having visual magnitude brighter than 11. One hundred seventy-eight images were recorded in a film cartridge that the astronauts returned to Earth. The observatory still stands on the Moon today.

CREDIT: APOLLO 16, NASA

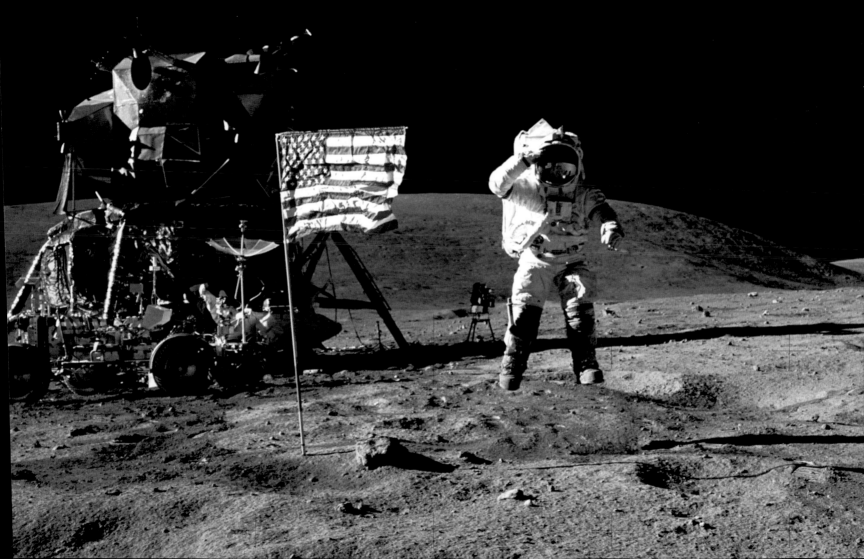

+ Pangea Ultima: Earth in 250 Million Years?

IS THIS WHAT WILL BECOME OF EARTH'S SURFACE? THE SURFACE OF EARTH IS BROKEN UP INTO SEVERAL LARGE PLATES THAT ARE slowly shifting. Approximately 250 million years ago, the plates on which the present-day continents rest were positioned quite differently, so that all the landmasses were clustered together in one supercontinent now dubbed Pangea. About 250 million years from now, extrapolating from current positions and movements, the plates are again projected to reposition themselves so that a single landmass dominates. This simulation from the PALEOMAP Project shows this giant landmass: Pangea Ultima. At that time, the Atlantic Ocean will be just a distant memory, and whatever beings inhabit Earth will be able to walk from North America to Africa. CREDIT & COPYRIGHT: C. R. SCOTESE (U. TEXAS AT ARLINGTON), PALEOMAP

250 Million Years in Future

Africa

Pangea Ultima

Eurasia

North
America

PACIFIC
OCEAN

South
America

Australia

Antarctica

Ancient Landmass

Modern Landmass

Subduction Zone (triangles point in the
direction of subduction)

Sea Floor Spreading Ridge

© 2000 C. R. Scotese, PALEOMAP Project

+ **Disorder in Stephan's Quintet**

WHAT ARE FOUR CLOSELY GROUPED GALAXIES DOING IN THIS IMAGE? THE GROUPING COMPOSES A MAJORITY OF THE LARGE galaxies in Stephan's Quintet, with the fifth prominent galaxy located off this image to the lower right. Three of these four galaxies show nearly the same redshift, indicating that they reside at the same distance from us. These three galaxies are in the midst of a titanic collision, each ripping the others apart with gravitational tidal forces. The large, bluish spiral at the bottom edge is a foreground galaxy much closer than the others and hence not involved in the cosmic battle. Most of Stephan's Quintet lies approximately 300 million light-years away toward the constellation Pegasus. CREDIT: JANE C. CHARLTON (PENN STATE) ET AL., HST, ESA, NASA

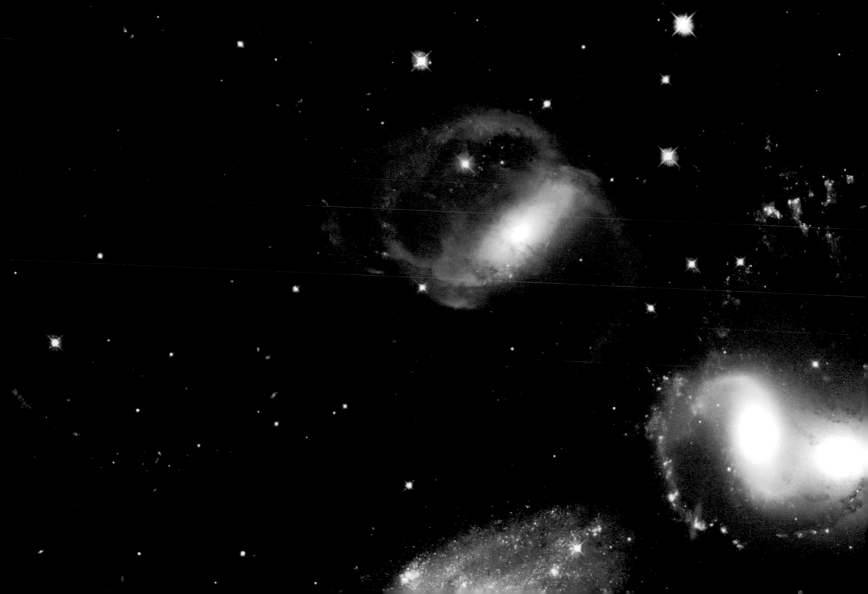

+ **M31: The Andromeda Galaxy**

ANDROMEDA IS THE NEAREST MAJOR GALAXY TO OUR OWN MILKY WAY GALAXY. TOGETHER THESE TWO GALAXIES DOMINATE THE local group of galaxies. The diffuse light from Andromeda is caused by the hundreds of billions of stars that compose it. The several distinct stars that surround Andromeda's image are actually stars in our galaxy that are well in front of the background object. Andromeda is frequently referred to as M31, since it is the 31st object on Messier's list of diffuse sky objects. M31 is so distant it takes about 2 million years for light to reach us from there. Much about M31 remains unknown, including why the center contains two nuclei. CREDIT & COPYRIGHT: JASON WARE

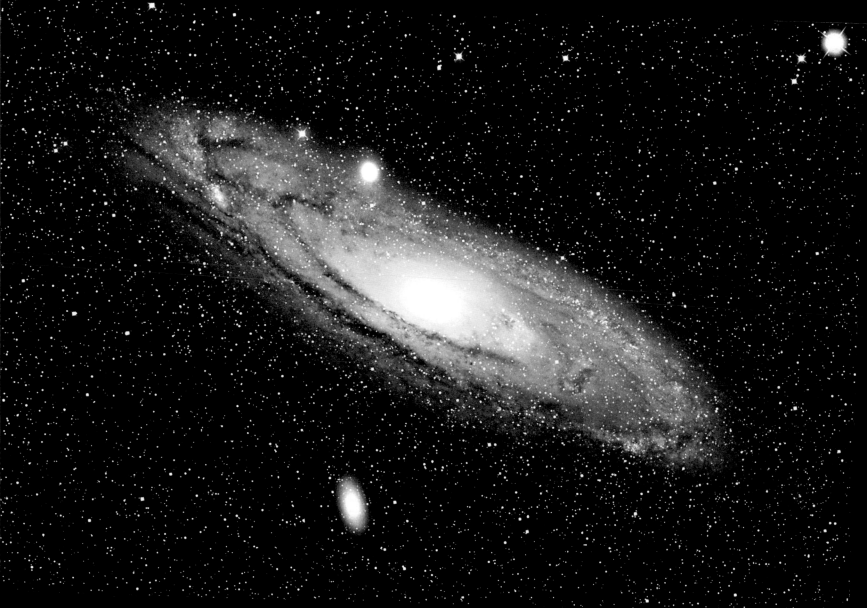

+ **Recycling Columbia**

ON NOVEMBER 12, 1981, THE SPACE SHUTTLE COLUMBIA BECAME THE FIRST REUSABLE SPACESHIP. ITS SECOND TRIP TO LOW

Earth orbit and back again followed its maiden voyage by only 7 months. Seen here Columbia, 56 meters long with a 24-meter

wingspan, is launched, mated to an external fuel tank and two solid rocket boosters producing dramatic exhaust plumes. The

solid rocket boosters, one on each side of the external tank, provide most of the thrust in the first 2 minutes after launch, then

are jettisoned for later recovery. Supplying the main shuttle engines during liftoff, the external fuel tank separates after about

8 minutes. The largest shuttle element not recycled for a future flight, the external tank falls back toward Earth, breaking up and

descending into a remote ocean area. Still the oldest operating shuttle, Columbia is pictured here in June 1992 rocketing toward

a cloudbank on its twelfth flight. Officially designated OV-102, Columbia is fittingly named after the eighteenth-century sailing

vessel that became the first American ship to circumnavigate planet Earth. CREDIT: STS-50, NASA

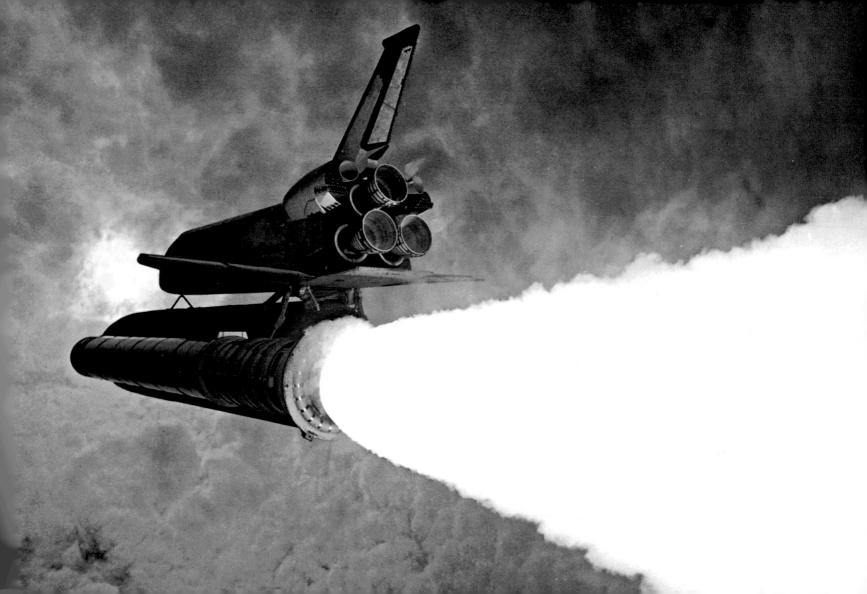

+ **Counting Stars in the Infrared Sky**

THE BULGING CENTER OF OUR MILKY WAY GALAXY, DARK COSMIC CLOUDS, THE THIN GALACTIC PLANE, AND EVEN NEARBY galaxies are easy to spot in this sky view. But each pixel in this digital image is actually based on star counts alone—as derived from the Two Micron All-Sky Survey (2MASS) database. In 2001, the 2MASS project completed a ground-based survey of the entire sky and cataloged upwards of 250 million stars. Their full, all-sky picture assigns a brightness and color to individual pixels based on corresponding star counts in each of the survey's three near-infrared bands. The star-packed galactic center appears with the bright plane of our galaxy running horizontally through it. Dense regions of interstellar dust clouds, still opaque to penetrating near-infrared light, appear dark by reducing the 2MASS star counts. Our fuzzy neighboring galaxies, the Large and Small Magellanic Clouds, are at the lower right, while scattered single bright spots correspond to the intense concentrations of stars in the Milky Way's large globular star clusters. CREDIT: J. CARPENTER, M. SKRUTSKIE, R. HURT, 2MASS PROJECT, NSF, NASA

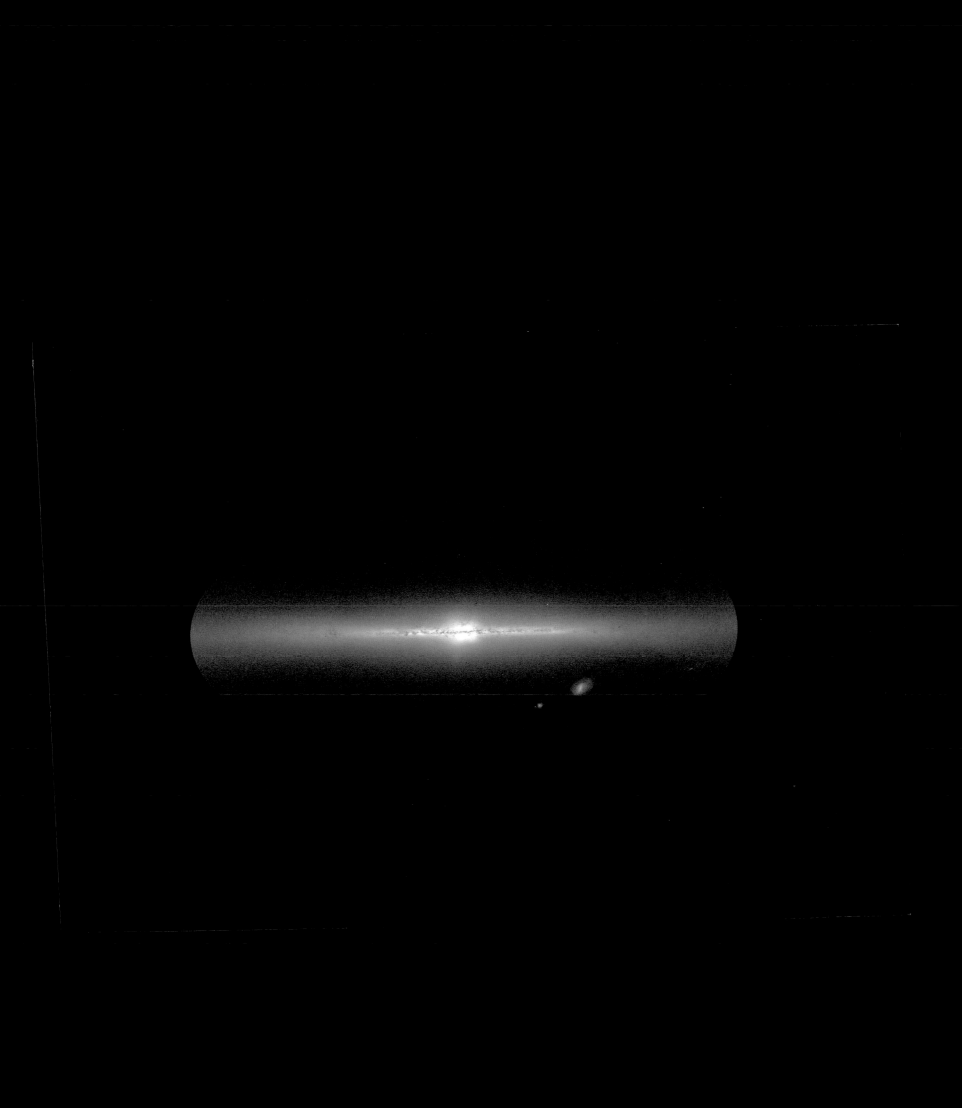

+ **Catching Falling Stardust**

THIS CARROT-SHAPED TRACK IS ACTUALLY LITTLE MORE THAN FIVE HUNDREDTHS OF AN INCH LONG. IT IS THE TRAIL OF A

meteoroid through an unusual high-tech, low-density substance called aerogel, exposed to space by the shuttle-launched European

Recoverable Carrier spacecraft. This meteoroid is about a thousandth of an inch in diameter. It is visible where it came to rest, just

beyond the tip of the carrot at the far left. Chemical analyses of interplanetary dust particles similar to this one suggest that some

of them may be bits of comets and thus represent samples of material from the early stages of the formation of the solar system.

CREDIT: ESA, NASA

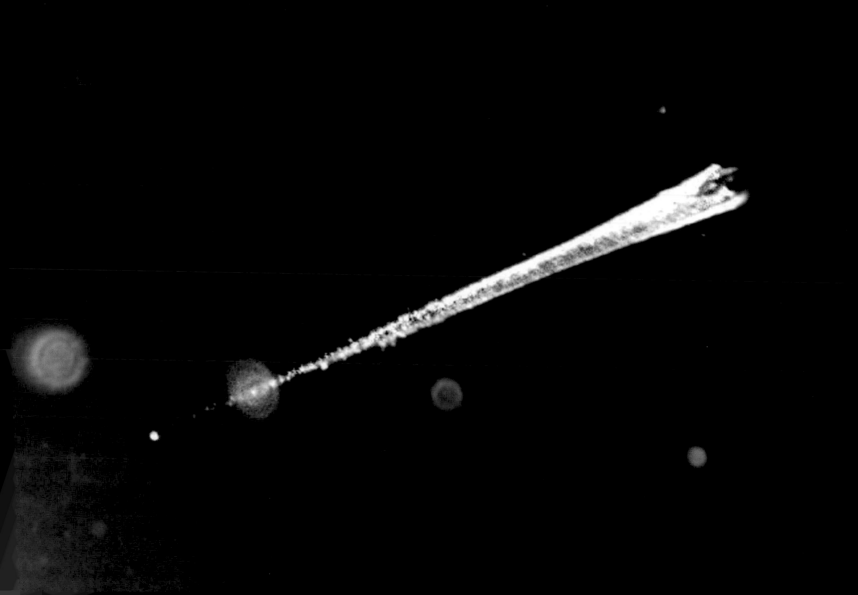

01
02
03
04
05
06
07
08
09
10
11
12
13
14
15
16
17
18
19
20
21
22
23
24
25
26
27
28
29
30

+ Io: The Prometheus Plume

+

TWO SULFUROUS ERUPTIONS ARE VISIBLE ON JUPITER'S VOLCANIC MOON Io in this color composite galileo image. On the left, over Io's limb, a new bluish plume rises about 86 miles above the surface of a volcanic caldera known as Pillan Patera. In the middle of the image, near the night/day shadow line, the ring-shaped Prometheus plume is seen rising 45 miles above Io, casting a shadow to the right of the volcanic vent. Named for the Greek god who gave mortals fire, the Prometheus plume is visible in every image ever made of the region, dating back to the Voyager flybys of 1979—presenting the possibility that this plume has been continuously active for at least 18 years. This image was recorded on June 28, 1997, at a distance of 372,000 miles. CREDIT: GALILEO PROJECT, JPL, NASA

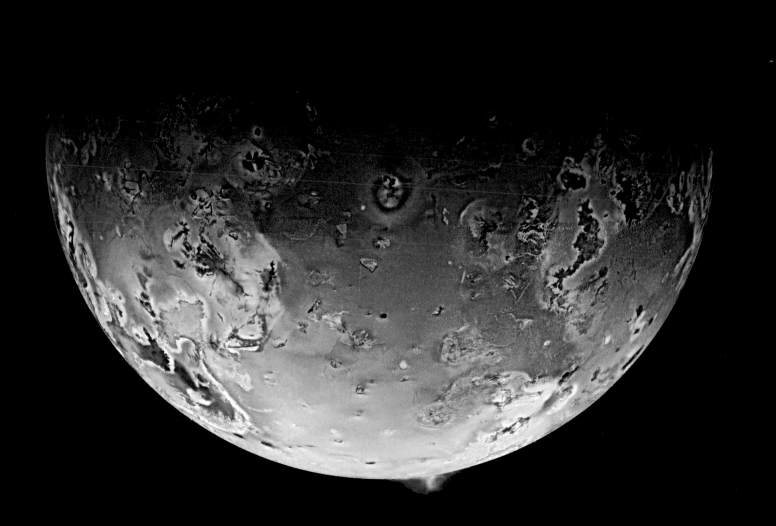

+ Henize 3-401: An Elongated Planetary Nebula

HOW DO DYING STARS EJECT THEIR OUTER LAYERS? STARS THAT CREATE ELEGANT PLANETARY NEBULAS LIKE HENIZE 3-401, pictured here, are not unusual, causing speculation that, one day, our own sun may look like this. Henize 3-401 is one of the most elongated planetary nebulas yet discovered, a particularly odd feat for a seemingly round star. Perhaps, some astronomers hypothesize, the elongated shape gives us a clue to the expulsion mechanism. Genesis hypotheses include that the outer layers of gas are funneled out by the star's own magnetic field, and that a second unseen star is somehow involved. After the gas disperses in a few thousand years, only a white dwarf star will remain. Henize 3-401 lies approximately 10,000 light-years away toward the constellation of Carina. CREDIT: R. SAHAI (JPL/NASA) ET AL., HST, NASA, ESA

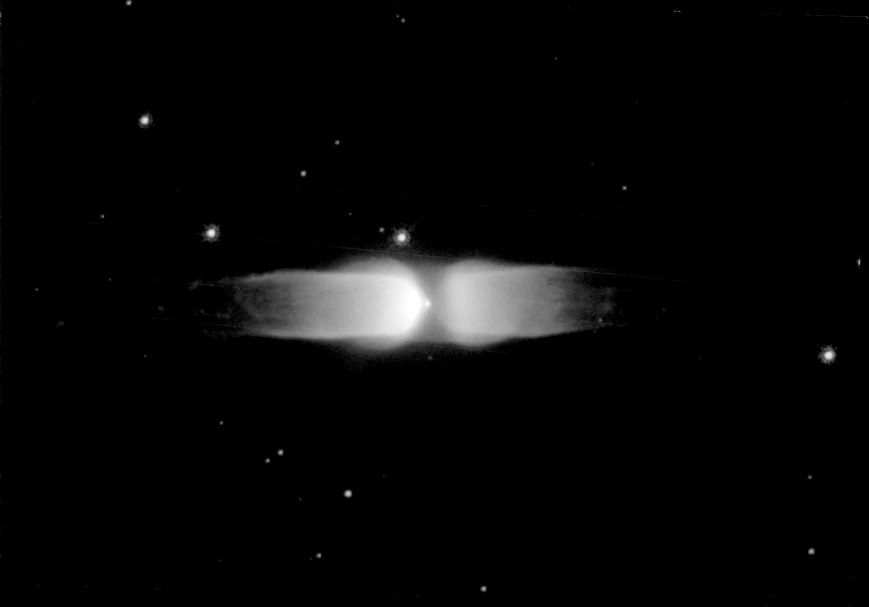

01
02
03
04
05
06
07
08
09
10
11
12
13
14
15
16
17
18
19
20
21
22
23
24
25
26
27
28
29
30

+ **Muon Wobble Possible Door to Supersymmetric Universe**

HOW FAST DO FUNDAMENTAL PARTICLES WOBBLE? A SURPRISING ANSWER TO THIS SEEMINGLY INCONSEQUENTIAL QUESTION is coming out of Brookhaven National Laboratory in New York, and may not only indicate that the Standard Model of Particle Physics is incomplete but also that our universe is filled with a previously undetected type of fundamental particle. Specifically, the muon, a particle with similarities to a heavy electron, has had its relatively large wobble under scrutiny since 1999 in an experiment known as g-2 (gee-minus-two), pictured here. The result galvanizes other experimental groups around the world to confirm it, and pressures theorists to better understand it. The rate of wobble is sensitive to a strange sea of virtual particles that pop into and out of existence everywhere. The unexpected wobble rate may indicate that this sea houses virtual particles that include nearly invisible supersymmetric counterparts to known particles. If so, a nearly invisible universe of real supersymmetric particles might exist all around us. CREDIT: R. BOWMAN, G-2 COLLABORATION, BNL, DOE

+ Gomez's Hamburger: A Protoplanetary Nebula

WHAT, IN HEAVEN, IS THAT? SOMETIMES ASTRONOMERS SEE THINGS ON THE SKY THEY DON'T IMMEDIATELY UNDERSTAND.

In 1985 this happened to Arturo Gomez, and the object became known as Gomez's Hamburger for its distinctive yet familiar shape.

After some investigation, the object was identified as a protoplanetary nebula, a gas cloud emitted by a sun-like star just after its

central hydrogen fuel has all been fused to helium. Gomez's Hamburger is on its way to becoming a full-fledged planetary nebula in

a few thousand years. The light seen (the bun) is reflected by dust from the central star, although the star itself is obscured by a thick

dust disk that runs across the middle (the patty). Gomez's Hamburger, pictured here in an image from the Hubble Space Telescope,

is only a fraction of a light-year across but located approximately 10,000 light-years away toward the constellation Sagittarius.

CREDIT: ARTURO GOMEZ (CTIO/ NOAO), HUBBLE HERITAGE TEAM, NASA

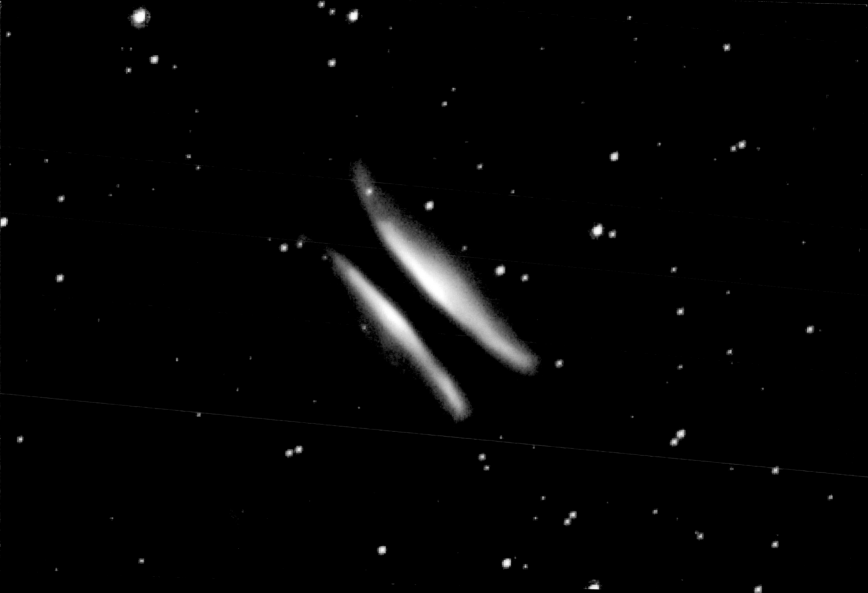

+ **The Orion Nebula in Hydrogen**

THE GREAT NEBULA IN ORION CAN BE FOUND JUST BELOW AND TO THE LEFT OF THE EASILY IDENTIFIABLE BELT OF THREE STARS in the popular constellation Orion. This fuzzy patch, visible to the unaided eye, contains one of the closest stellar nurseries, lying at a distance of about 1,500 light-years. This picture highlights red light emitted by the nebula's hydrogen gas. Dark dust filaments punctuate regions of this glowing hydrogen gas and reflect light from the nebula's brightest stars. Observations of the Orion Nebula by the Hubble Space Telescope have located solar system–size regions that are thought to be planet-forming circumstellar disks.

CREDIT & COPYRIGHT: ROBERT GENDLER

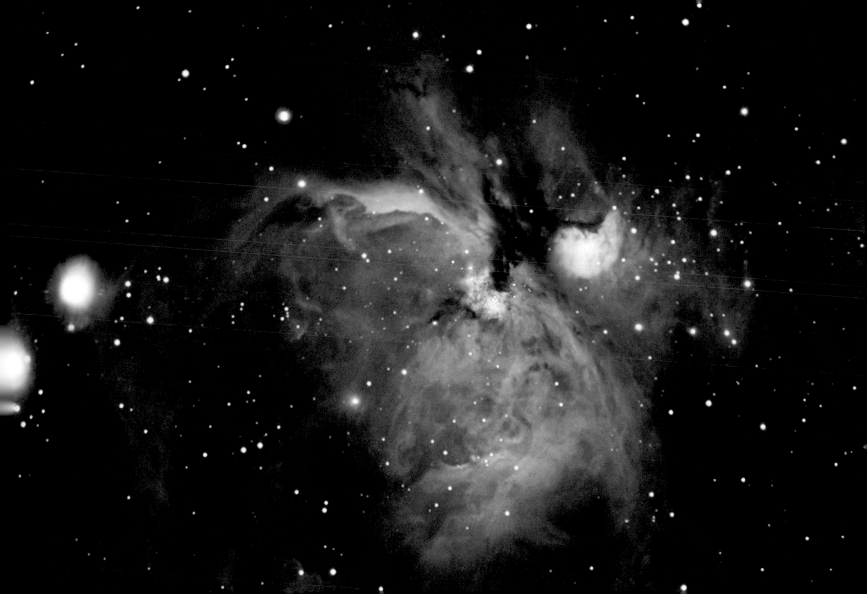

+ **Leonids above Torre de la Guaita**

IN 1999, THE LEONID METEOR SHOWER CAME TO A TREMENDOUS CRESCENDO. OBSERVERS IN EUROPE SAW A SHARP PEAK IN THE number of meteors visible around 02:10 Universal Time during the early morning hours of November 18. Meteor counts then exceeded 1,000 per hour—the minimum needed to define a true meteor storm. At other times and from other locations around the world, observers typically reported respectable rates of between 30 and 100 meteors per hour. This photograph is a 20-minute exposure that ended just before the beginning of the main Leonids peak of 1999. Visible are at least five Leonid meteors streaking high above the Torre de la Guaita, an observation tower used during the twelfth century in Gorina, Spain. CREDIT & COPYRIGHT: JUAN CARLOS CASADO

+ **Saturn's Moon Tethys**

DISCOVERED BY GIOVANNI CASSINI IN 1684, TETHYS IS ONE OF THE RELATIVELY LARGER AND CLOSER MOONS OF SATURN.

It was visited by both Voyager spacecraft—Voyager 1 in November 1980 and by Voyager 2 in August 1981. Tethys is now known to be composed almost completely of water ice. An enormous trench named Ithaca Chasma extends from the left side of this image to the upper center. The fissure is about 65 km wide, several kilometers deep, and extends across three-fourths of Tethys's circumference. Tethys also has a large impact crater (not visible in this view) that nearly circles the planet. That the impact that caused this crater did not disrupt the moon is taken as evidence that Tethys was not completely frozen in its past. Two smaller moons, Telesto and Calypso, orbit Saturn just ahead of and behind Tethys. In 1997, NASA launched a spacecraft named Cassini to Saturn. It will arrive in 2004. CREDIT: VOYAGER PROJECT, NASA; COPYRIGHT: (DIGITAL W/COLORTABLE): CALVIN J. HAMILTON

+ **Two Hours before Neptune**

TWO HOURS BEFORE ITS CLOSEST APPROACH TO NEPTUNE IN 1989, THE VOYAGER 2 ROBOT SPACECRAFT SNAPPED THIS PICTURE.

Long, light-color, cirrus-type clouds floating high in Neptune's atmosphere were clearly visible for the first time. Shadows of these clouds can even be seen on lower cloud decks. Most of Neptune's atmosphere is made of hydrogen and helium, which is invisible. Neptune's blue color comes from smaller amounts of atmospheric methane, which preferentially absorbs red light. Neptune has the fastest winds in the solar system, with gusts reaching 2,000 km per hour. Recent speculation holds that diamonds may be created in the dense, hot conditions that exist under the cloudtops of Uranus and Neptune. CREDIT: VOYAGER 2, NASA

01
02
03
04
05
06
07
08
09
10
11
12
13
14
15
16
17
18
19
20
21
22
23
24
25
26
27
28
29
30

+ **Earth's North Magnetic Pole**

A MAGNETIC COMPASS DOES NOT POINT TOWARD THE TRUE NORTH POLE OF EARTH. RATHER, IT MORE CLOSELY POINTS TOWARD

the North Magnetic Pole of Earth. The North Magnetic Pole is currently located in northern Canada. It wanders in an elliptical

path each day, and moves, on the average, more than 40 meters northward each day. Evidence indicates that the North Magnetic

Pole has wandered over much of Earth's surface in the 4.5 billion years since Earth was formed. Earth's magnetic field is created by

its partially ionized outer core, which rotates more rapidly than Earth's surface. Indicated in this picture is Ellef Ringes Island,

the location of Earth's North Magnetic Pole in the year 1999. CREDIT: NOAA

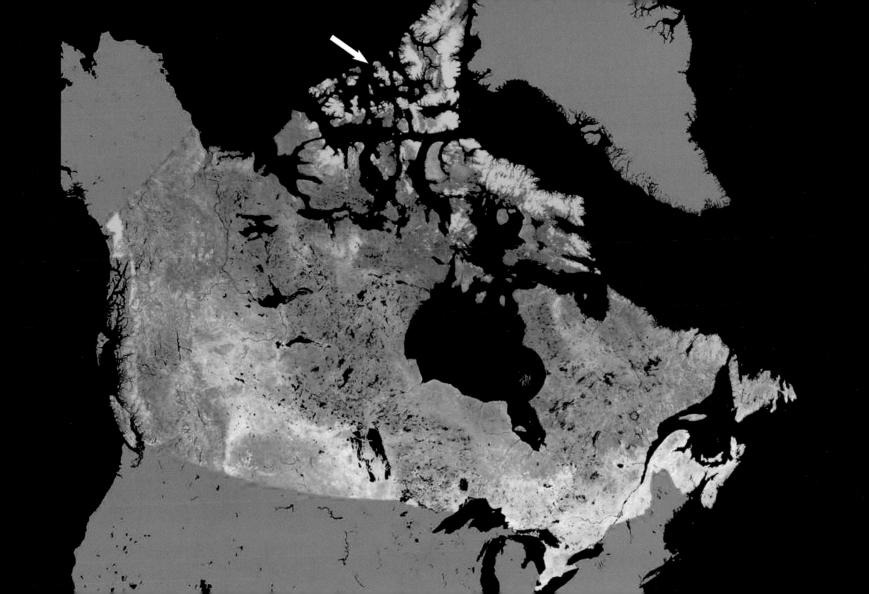

01
02
03
04
05
06
07
08
09
10
11
12
13
14
15
16
17
18
19
20
21
22
23
24
25
26
27
28
29
30

+ **Earth at Night**

THIS IS WHAT EARTH LOOKS LIKE AT NIGHT. CAN YOU FIND YOUR FAVORITE COUNTRY OR CITY? SURPRISINGLY, CITY LIGHTS MAKE this task quite possible. Man-made lights highlight particularly developed or populated areas of Earth's surface, including the seaboards of Europe, the eastern United States, and Japan. Particularly dark areas include the central parts of South America, Africa, Asia, and Australia. This image is actually a composite of hundreds of pictures made by the orbiting Defense Meteorological Satellite Program satellites. CREDIT: C. MAYHEW & R. SIMMON (NASA/GSFC), NOAA/ NGDC, DMSP DIGITAL ARCHIVE

+ **Shadow at the Lunar South Pole**

IN 1994, THE SPACE PROBE CLEMENTINE SPENT 70 DAYS IN LUNAR ORBIT MAPPING THE MOON'S SURFACE. SHOWN HERE IS a dramatically detailed composite view centered on the Moon's South Pole, constructed from 1,500 Clementine images. The top half shows the part of the Moon that faces Earth; the bottom half is the lunar far side. The images reveal a major depression very near the South Pole itself, probably caused by the impact of a comet or asteroid. The shadow region near the impact site is extensive and may be permanent—creating an area cold enough to trap water deposited by comets as ice. CREDIT:

CLEMENTINE, BMDO, NRL, LLNL

+ **The Galactic Ring of NGC 6782**

DO SPIRAL GALAXIES LOOK THE SAME IN EVERY COLOR? NGC 6782 DEMONSTRATES COLORFULLY THAT THEY DO NOT. IN VISIBLE light, NGC 6782 appears to be a normal spiral galaxy with a bright bar across its center. In ultraviolet light, however, the central region blossoms into a spectacular and complex structure highlighted by a circumnuclear ring, as shown in this representative-color Hubble Space Telescope image. Many of the young stars that formed in a recent burst of star formation emit the ultraviolet light. Astronomers are studying possible relationships between the central bar and the ring. Light we see today from NGC 6782 left approximately 180 million years ago, while dinosaurs roamed the planet. The galaxy spans about 80,000 light-years and can be seen with a telescope toward the constellation Pavo. CREDIT: ROGIER WINDHORST (ASU) ET AL., HUBBLE HERITAGE TEAM, NASA

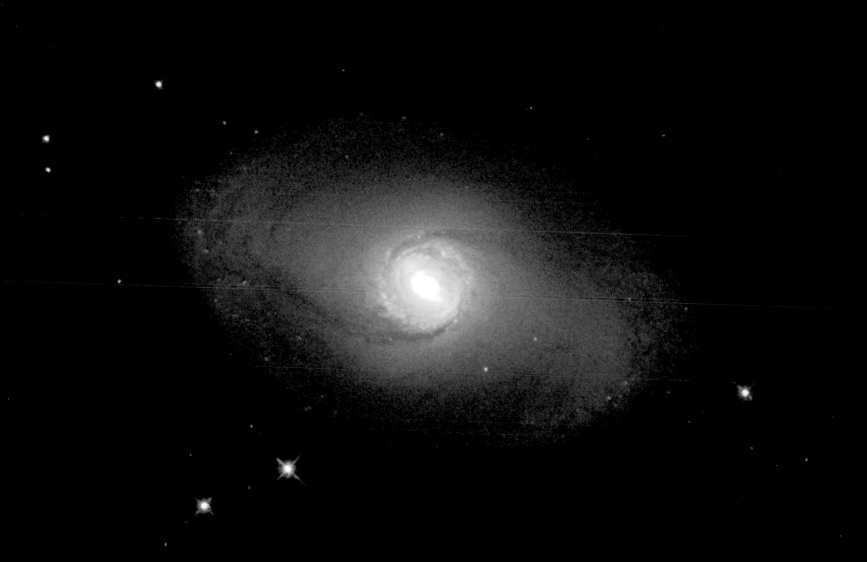

+ **Europa Full Face**

WHAT MYSTERIES MIGHT BE SOLVED BY PEERING INTO THIS CRYSTAL BALL? THE BALL IS QUITE UNUSUAL BECAUSE IT IS actually a moon of Jupiter, the crystals are ice crystals, and the ball is not only dirty and opaque but also cracked beyond repair. Nevertheless, speculation is rampant that oceans exist under these tortured ice plains that could support life. Europa, the smallest of Jupiter's galilean moons, was photographed in October 1995 in natural color by the robot spacecraft Galileo. The brown patches are what one might think: dirt that is tainting an otherwise white ice crust. Europa, nearly the same size as Earth's moon, similarly keeps one face toward its home planet. The hemisphere of Europa shown here is the one that always trails in its orbit. Why is Europa's surface the smoothest in the solar system? Where are Europa's craters? CREDIT: GALILEO PROJECT, JPL, NASA

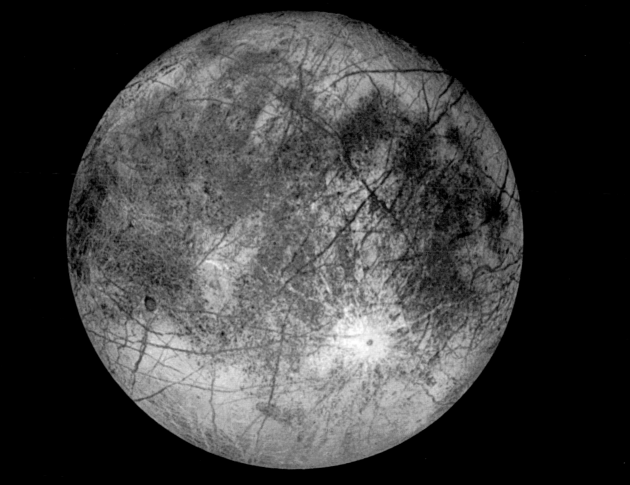

+ **Hale-Bopp and the North America Nebula**

COMET HALE-BOPP'S RECENT ENCOUNTER WITH THE INNER SOLAR SYSTEM ALLOWED MANY BREATHTAKING PICTURES. HERE, comet Hale-Bopp was photographed on March 8, 1997, in the constellation Cygnus. Visible on the right in red is the North America Nebula, a bright emission nebula observable from a dark location with binoculars. The North America Nebula is about 1,500 light-years away, much farther than the comet, which was about 8 light-minutes away. Several bright blue stars from the open cluster M39 are visible just above the comet's blue ion tail. CREDIT & COPYRIGHT: JUAN CARLOS CASADO

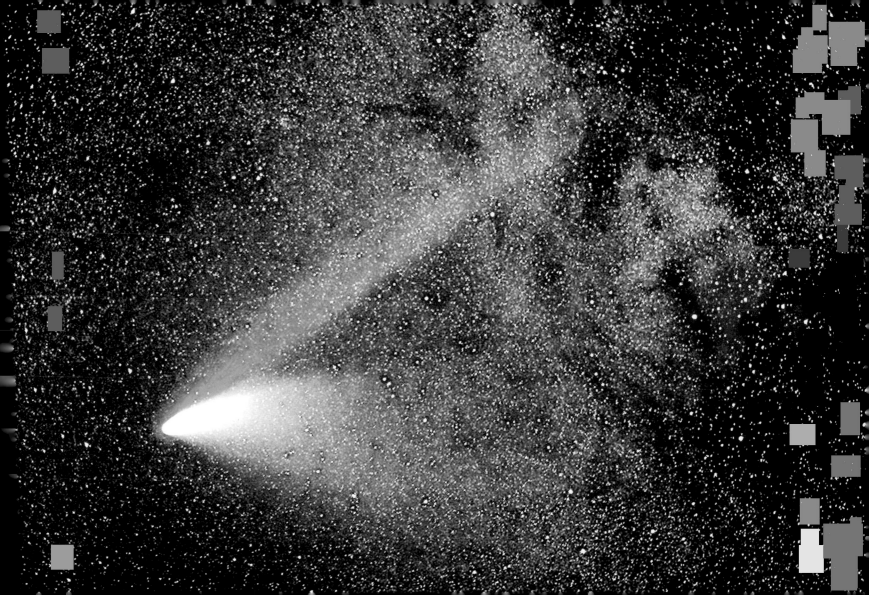

+ **The Magnetic Carpet of the Sun**

THE SUN HAS A MAGNETIC CARPET. ITS VISIBLE SURFACE APPEARS TO BE COVERED WITH TENS OF THOUSANDS OF MAGNETIC north and south poles joined by looping field lines that extend outward into the Solar Corona. Researchers have mapped large numbers of these small, magnetic concentrations using data and images from the space-based SOHO observatory. This computer-generated sunscape illustrates the magnetic concentrations, with white and black field lines drawn in joining regions of strong magnetism. These small, magnetic regions emerge, fragment, drift, and disappear over periods of only 40 hours or so. Their origin is mystifying and their dynamic behavior is difficult to reconcile with present theories of rotationally driven large-scale solar magnetism. Is some unknown process at work? Possibly, but the source of this mystery may well be the solution to another—the long-standing mystery of why the Sun's outer corona is over 100 times hotter than the sun's visible surface. The SOHO data reveal that energy released as these loops break apart could be heating the Solar Corona. CREDIT: SOHO CONSORTIUM, ESA, NASA

+ **Rhea: Saturn's Second-Largest Moon**

RHEA IS THE SECOND-LARGEST MOON OF SATURN, BEHIND TITAN, AND THE LARGEST WITHOUT AN ATMOSPHERE. IT IS composed mostly of water ice, but has a small, rocky core. Rhea's rotation and orbit are locked together (just like Earth's moon) so that one side always faces Saturn. A consequence of this is that one side always leads the other around Rhea's orbit. Rhea's leading surface is much more heavily cratered than its trailing surface. This photograph was taken with the Voyager 1 spacecraft in 1980. CREDIT: VOYAGER, NASA; COPYRIGHT: CALVIN J. HAMILTON

+ **AE Aurigae: The Flaming Star**

IS STAR AE AURIGAE ON FIRE? ALTHOUGH SURROUNDED BY WHAT MAY LOOK LIKE SMOKE, THE OBJECT KNOWN AS THE FLAMING star creates energy primarily by nuclear fusion, like other stars. Fire, typically defined as the rapid molecular acquisition of oxygen, happens at much lower temperatures and pressures. The material that appears as smoke around AE Aurigae is mostly interstellar hydrogen, but does contain smokelike dark filaments of carbon-rich dust grains. The AE Aurigae region was imaged by the KPNO 0.9-meter telescope and is shown here in false but representative colors. The star AE Aurigae itself is very bright, young, blue, and thought to be a runaway star, ejected from the Orion Nebula region approximately 2.7 million years ago. CREDIT: T. A. RECTOR & B. A. WOLPA, NOAO/AURA/NSF

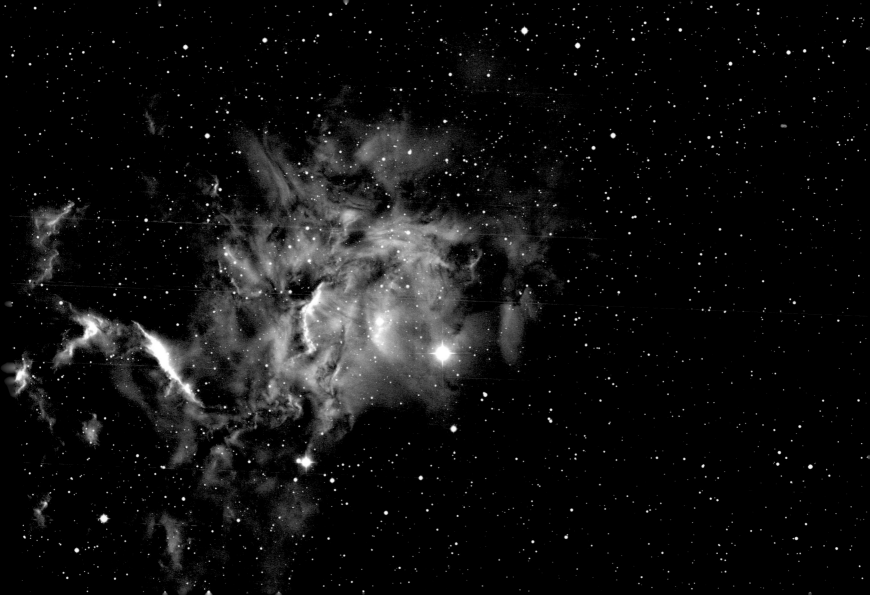

+ Layered Mars: An Ancient Water World?

PICTURED HERE, LAYERS UPON LAYERS STRETCH ACROSS THE FLOOR OF WEST CANDOR CHASMA WITHIN THE IMMENSE MARTIAN

Valles Marineris. Covering an area 1.5 × 2.9 km, the full image from the Mars Global Surveyor spacecraft shows over a hundred

individual beds. Each strikingly uniform layer is smooth, hard enough to form steep edges, and is 10 to 11 meters thick. In a press

conference on December 4, 2000, scientists Michael Malin and Ken Edgett presented this and other new images that show that

the layered patterns exist at widespread locations near the martian equator. Their results indicate that some of the layered regions

may be 3.5 billion years old. On planet Earth, layered patterns like these are formed from sediment deposited over time by large

bodies of water. Likewise, the layered beds on Mars may be sedimentary rock formed in ancient lakes and seas. The researchers

caution, however, that other uniquely martian processes may be responsible for the layering. Did life arise on ancient Mars?

Because of their possible association with water, these layered regions would be a prime location for future searches for fossil

remains of martian life. CREDIT: MALIN SPACE SCIENCE SYSTEMS, MGS, JPL, NASA

+ **M83: The Southern Pinwheel Galaxy from VLT**

M83 IS ONE OF THE CLOSEST AND BRIGHTEST SPIRAL GALAXIES IN THE SKY. VISIBLE WITH BINOCULARS IN THE CONSTELLATION Hydra, M83's majestic spiral arms have prompted its nickname, the Southern Pinwheel. Although discovered 250 years ago, only in this century was it understood that M83 was not a gas cloud but a barred spiral galaxy much like our own Milky Way galaxy. M83, pictured here in a photograph from one of the European Southern Observatory's 8.2-meter Very Large Telescopes, is a prominent member of a group of galaxies that includes Centaurus A and NGC 5253, all of which lie approximately 15 million light-years distant. To date, six supernova explosions have been recorded in M83 and an unusual double circumnuclear ring has been discovered at its center. CREDIT: FORS TEAM, 8.2-METER VLT, ESO

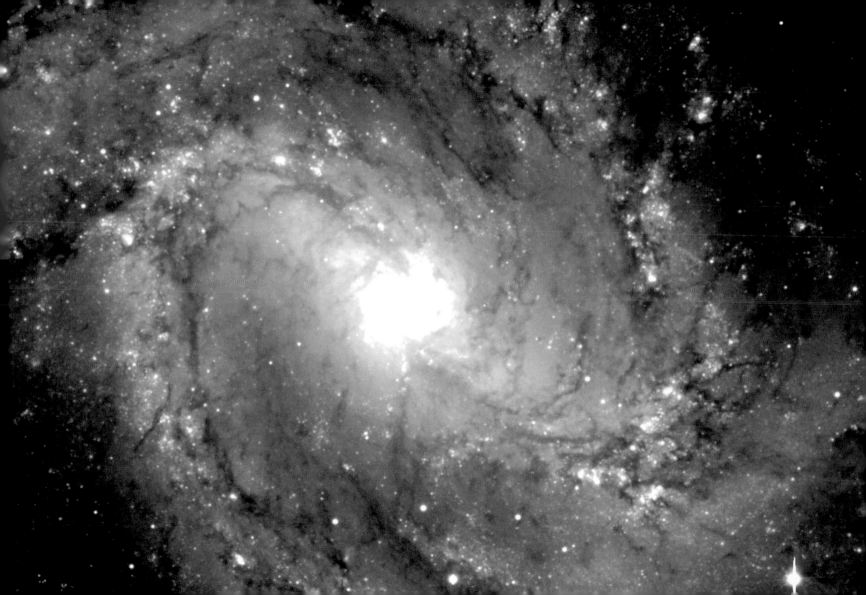

+ **Dueling Auroras**

WILL IT BE CURTAINS FOR ONE OF THESE AURORAS? A QUICK INSPECTION indicates that it is curtains for both, as the designation "curtains" well categorizes the type of aurora pattern pictured. Another informal type is the "corona." These auroras resulted from outbursts of electrically charged particles from the Sun during the last week of September 2001. A polarity change in the solar magnetic field at Earth then triggered auroras over the next few days. This picture was taken on October 3, 2001, as fleeting space radiation pelted Earth's atmosphere high above the Yukon in Canada. CREDIT & COPYRIGHT:

PHIL HOFFMAN

+ **Giant Emission Nebula NGC 3603 in Infrared**

NGC 3603 IS THE LARGEST REGION OF GLOWING GAS IN OUR MILKY WAY GALAXY. SPANNING OVER 20 LIGHT-YEARS ACROSS, THE emission nebula (HII region) is home to a massive star cluster, thick dust pillars, and a star about to explode. NGC 3603 was captured here in infrared light by a Two Micron All-Sky Survey (2MASS) Telescope. The young star cluster near the center heats the region's mostly hydrogen gas. Many stars in the cluster are estimated to be approximately 1 million years old, much less than the 5 billion-year age of our sun. NGC 3603 lies approximately 20,000 light-years away toward the constellation Carina.

CREDIT: 2MASS PROJECT, UMASS, IPAC/CALTECH, NSF, NASA

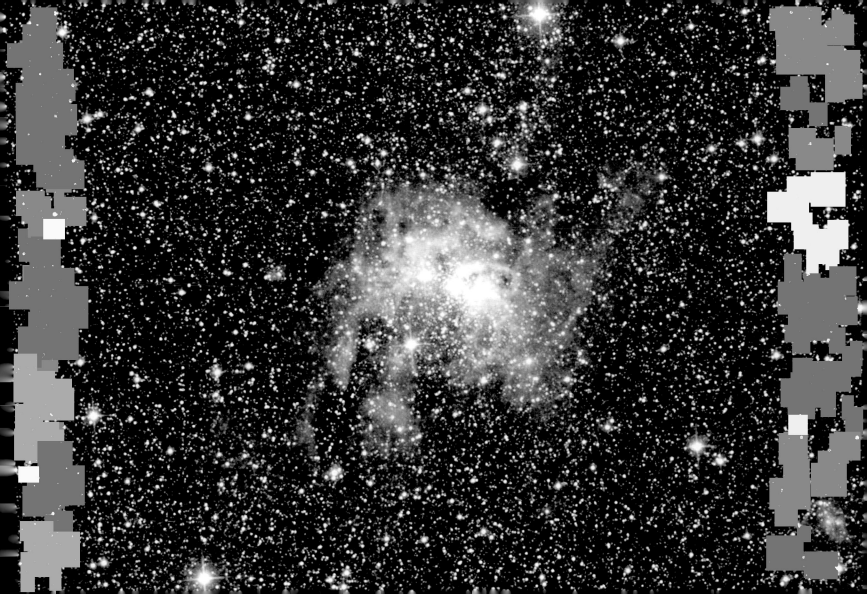

+ **Apollo 17 Lunarscape: A Magnificent Desolation**

BUZZ ALDRIN, APOLLO 11 LUNAR MODULE PILOT AND THE SECOND HUMAN TO WALK ON THE MOON, DESCRIBED THE LUNAR landscape as "a magnificent desolation." Dramatic pictures from the Apollo missions to the lunar surface testify to this apt turn of phrase. For example, near the Apollo 17 landing site, Family Mountain (center background) and the edge of South Massif (left) frame the lunarscape in this photograph of astronaut Harrison Schmidt working alongside the lunar roving vehicle. Schmidt and fellow astronaut Eugene Cernan were the last to walk on this magnificent desolation. CREDIT: APOLLO 17, NASA (IMAGE SCANNED BY KIPP TEAGUE)

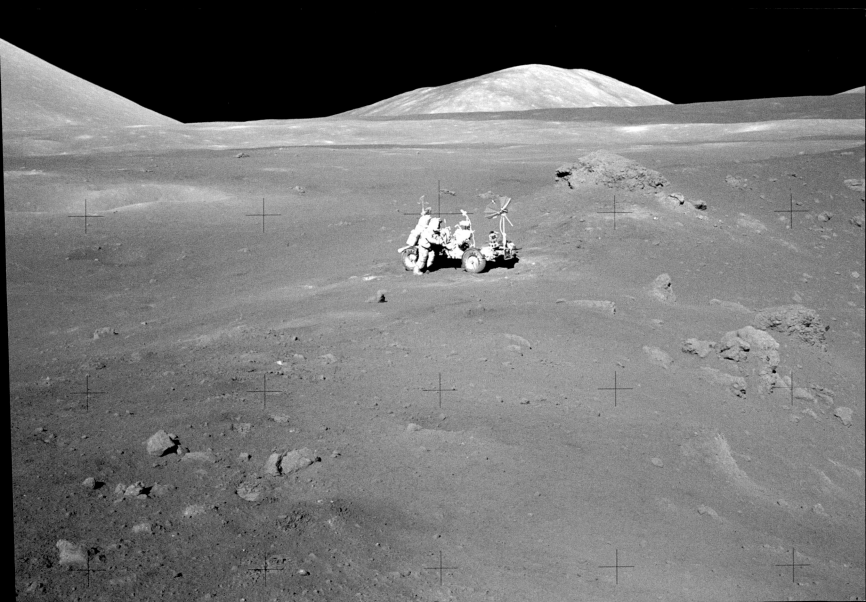

+ **The Antennae Galaxies**

A GROUND-BASED TELESCOPIC VIEW OF THE COLLISION BETWEEN THE GALAXIES NGC 4038 AND NGC 4039 (BELOW) REVEALS LONG, arcing insectlike "antennae" of luminous matter flung from the scene of the accident. Investigators using the Hubble Space Telescope to sift through the cosmic wreckage near the two galaxy cores have recently announced the discovery of over a thousand bright young clusters of stars—the result of a burst of star formation triggered by the collision. Opposite is a higher-resolution Hubble image. A pixel in this image corresponds to about 15 light-years at the distance of the Antennae galaxies, approximately 63 million light-years away. Dust clouds around the two galactic nuclei give them a dimmed and reddened appearance, and newly formed star clusters full of massive, hot, young stars are blue. How do colliding galaxies evolve with time? Determining the ages of star clusters formed in galaxy collisions can provide significant clues. CREDIT: B. WHITMORE (STSCI), F. SCHWEIZER (DTM), NASA

+ **Reflecting Merope**

IN THE FAMOUS PLEIADES STAR CLUSTER, A STAR'S LIGHT IS SLOWLY DESTROYING A PASSING CLOUD OF GAS AND DUST. THE star, Merope, lies just off the upper left edge of this Hubble Space Telescope picture. The cloud, known as IC 349, and Merope have been in existence for millions of years. In the past 100,000 years, however, part of the cloud has by chance moved so close to the star—only 3,500 times the Earth-to-Sun distance—that the star's light affects the cloud's dust in an unusual manner. Pressure of the star's light significantly repels the dust in the reflection nebula, with smaller dust particles being repelled more strongly. Eventually parts of the dust cloud have become stratified and point toward Merope, with the closest particles being the most massive and so the least affected by the radiation pressure. A longer-term result is the general destruction of the dust by the energetic starlight. It is not known whether the cloud will survive this encounter. CREDIT: GEORGE H. HERBIG & THEODORE SIMON (IFA, U. HAWAII),

HUBBLE HERITAGE TEAM, NASA

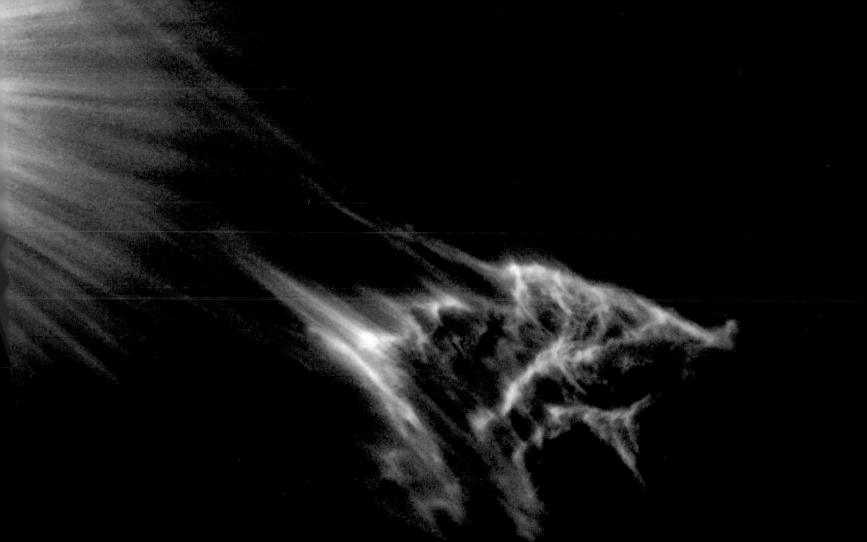

+ **Driving to the Sun**

+

HOW LONG WOULD IT TAKE TO DRIVE TO THE SUN? BRITTANY, AGE 7, AND D.J., AGE 12, PONDER THIS QUESTION OVER DINNER ONE evening. James, also age 7, suggests taking a really fast racing car and Christopher, age 4, eagerly agrees. Jerry, a really old guy who is used to estimating driving time on family trips based on distance divided by speed, offers to do the numbers. "Let's see . . . the Sun is 93 million miles away. So, if we drove 93 miles per hour the trip would only take us 1 million hours." How long is 1 million hours? One year is 365 days times 24 hours per day, or 8,760 hours. One hundred years would be 876,000 hours, still a little short of the 1 million-hour drive time—so the Sun is really quite far away. Christopher is not impressed, but as he grows older he will be. You've got to be impressed by something that's 93 million miles away and still hurts your eyes when you look at it. CREDIT: EIT - SOHO CONSORTIUM, ESA, NASA

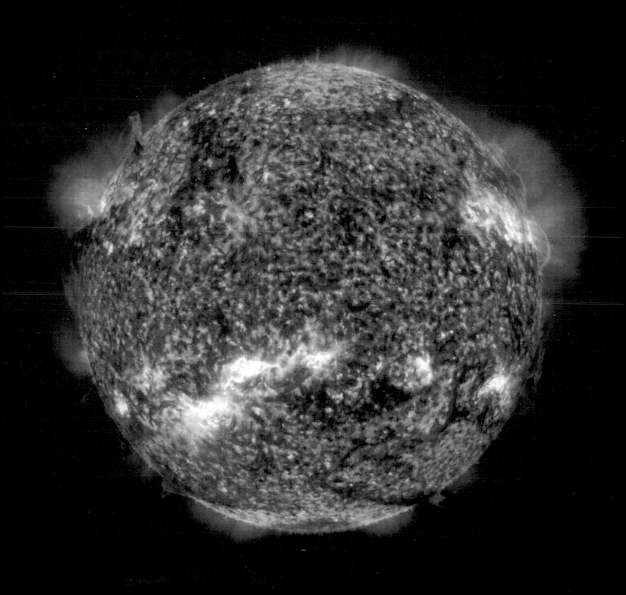

+ 3-D Mars' North Pole

+

THIS DRAMATIC THREE-DIMENSIONAL VISUALIZATION OF MARS'S NORTH POLE IS BASED ON ELEVATION MEASUREMENTS MADE by an orbiting laser. During the spring and summer of 1998, the Mars Orbiter Laser Altimeter flashed laser pulses toward the martian surface from the Global Surveyor spacecraft and recorded the time it took to detect the reflection. This timing data has been translated to a detailed topographic map of Mars' north polar terrain. The map indicates that the ice cap is approximately 1,200 km across, a maximum of 3 km thick, and cut by canyons and troughs up to 1 km deep. The measurements also indicate that the cap is composed primarily of frozen water with a total volume of only about 4 percent of planet Earth's Antarctic ice sheet. In all, it represents at most a tenth of the amount of water some scientists believe once existed on ancient Mars. Where did all the water go? CREDIT: MOLA TEAM, MGS PROJECT, NASA. IMAGE: GREG SHIRAH (SVS)

+ **Utopia on Mars**

THE VIKING 2 SPACECRAFT WAS LAUNCHED ON THE ROAD TO UTOPIA IN SEPTEMBER 1975. IN AUGUST 1976, AFTER MAKING the second successful martian landing, Viking 2's lander began recording data used to produce this exquisitely detailed image of the martian surface in the area of Utopia Planitia (the Plain of Utopia). Visible at the lower right is the protective shroud that covered the lander's soil collector head, ejected after the descent. Seen near the center are shallow trenches dug by the sampler arm. Mars looks red because its surface is covered with reddish iron oxide dust (rust). This dust, suspended in the thin carbon dioxide atmosphere, also filters the sunlight causing surface views to take on a reddish tinge. The Vikings made the first successful landings on Mars quite some time ago. What does Mars look like today? CREDIT: THE VIKING PROJECT, M. DALE-BANNISTER WU STL, NASA

+ **Sher 25: A Pending Supernova?**

NO SUPERNOVA HAS EVER BEEN PREDICTED. THESE DRAMATIC STELLAR EXPLOSIONS THAT DESTROY STARS AND DISPERSE THE elements that compose people and planets are not so well understood that astronomers can accurately predict when a star will explode—yet. Perhaps Sher 25 will be the first. Sher 25, designated by the arrow, is a blue supergiant star located just outside the star cluster and emission nebula NGC 3603. Sher 25 lies in the center of an hourglass-shaped nebula much like the one that surrounds the last bright supernova visible from Earth: SN1987a. The hourglass-shaped rings around SN1987a were emitted before that blue supergiant exploded. Maybe Sher 25 has expelled these bipolar rings in a step that closely precedes a supernova. If so, Sher 25 may be within a few thousand years of its spectacular finale. CREDIT & COPYRIGHT: W. BRANDNER (UIUC), ET AL., ESO, 1.54-M TELESCOPE, CHILE

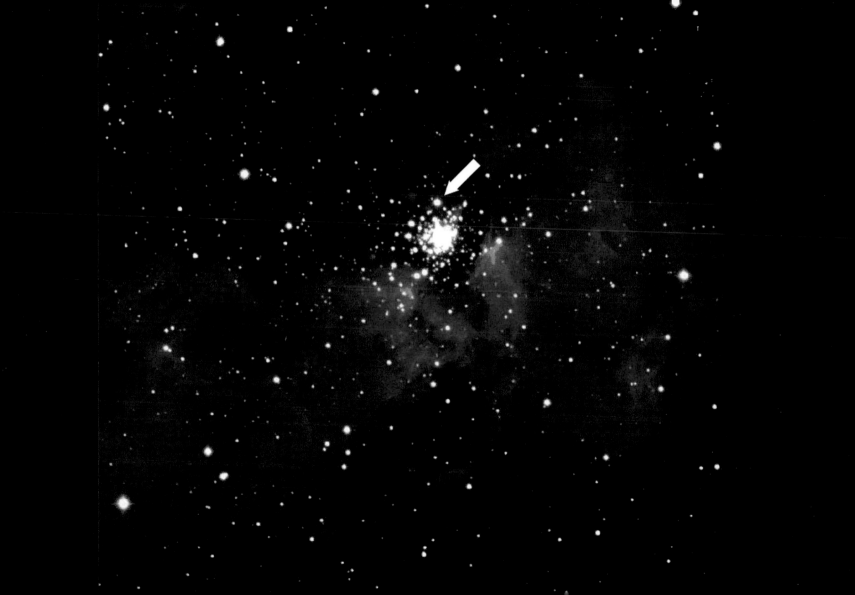

01
02
03
04
05
06
07
08
09
10
11
12
13
14
15
+ 16
17
18
19
20
21
22
23
24
25
26
27
28
29
30
31

+ **NGC 3603: From Beginning to End**

FROM BEGINNING TO END, DIFFERENT STAGES OF A STAR'S LIFE APPEAR IN THIS EXCITING HUBBLE SPACE TELESCOPE PICTURE of the environs of emission nebula NGC 3603. For the beginning, eye-catching "pillars" of glowing hydrogen at the right signal newborn stars emerging from their dense and gaseous nurseries. Less noticeable, dark clouds or "Bok globules" at the top right corner are likely part of a still-earlier stage, prior to their collapse to form stars. At the picture's center lies a cluster of bright, hot blue stars whose strong winds and ultraviolet radiation have cleared away nearby material. Massive and young, they will soon exhaust their nuclear fuel. Nearing the end of its life, the bright supergiant star Sher 25 is seen above and left of the cluster, surrounded by a glowing ring and flanked by ejected blobs of gas. The ring structure is reminiscent of Supernova 1987a, and Sher 25 itself may be only a few thousand years from its own devastating finale. But what about planets? Check out the two teardrop-shaped objects near the bottom of the picture. Although larger, these emission nebulas are similar to suspected planet-forming disks seen around stars in that well-known star-forming region, the Orion Nebula. CREDIT: WOLFGANG BRANDNER (JPL/IPAC), EVA K. GREBEL (U. WASH.), YOU-HUA CHU (UIUC), NASA

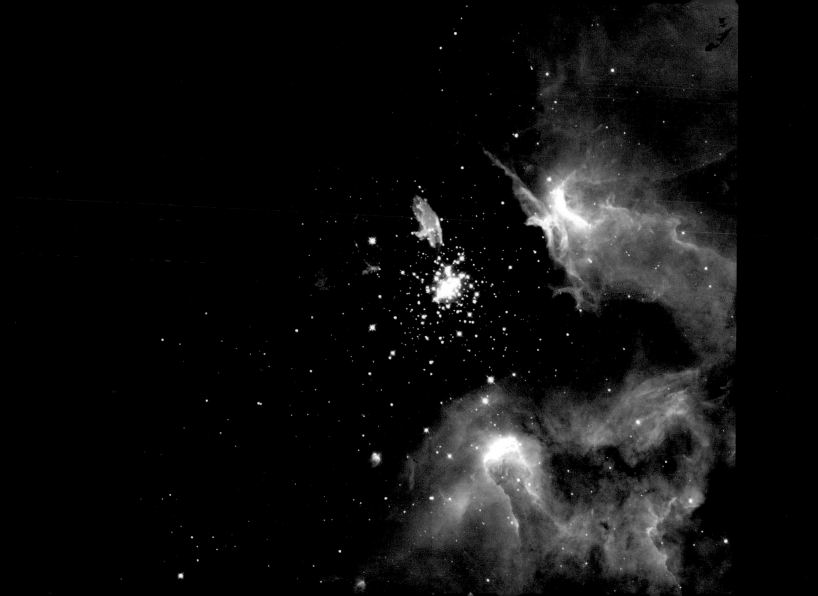

+ **NGC 7023: The Iris Nebula**

LIKE DELICATE COSMIC PETALS, THESE CLOUDS OF INTERSTELLAR DUST AND GAS HAVE BLOSSOMED 1,300 LIGHT-YEARS AWAY IN the fertile star fields of the constellation Cepheus. Sometimes called the Iris Nebula and dutifully catalogued as NGC 7023, this is not the only nebula in the sky to evoke the imagery of flowers. Still, this beautiful digital image shows off the Iris Nebula's range of colors and symmetries in impressive detail. Within the Iris, dusty nebular material surrounds a massive, hot, young star in its formative years. Central filaments of cosmic dust glow with a reddish luminescence as some dust grains effectively convert the star's invisible ultraviolet radiation to visible red light. Yet the dominant color of the nebula is blue, characteristic of dust grains reflecting starlight. Dark, obscuring clouds of dust and cold molecular gas are also present and can lead the eye to see other convoluted and fantastic shapes. Infrared observations indicate that this nebula may contain complex carbon molecules known as polycyclic aromatic hydrocarbons. As shown here, the Iris Nebula is about 6 light-years across. CREDIT & COPYRIGHT: BRIAN LULA, HEAVEN'S GLORY OBSERVATORY

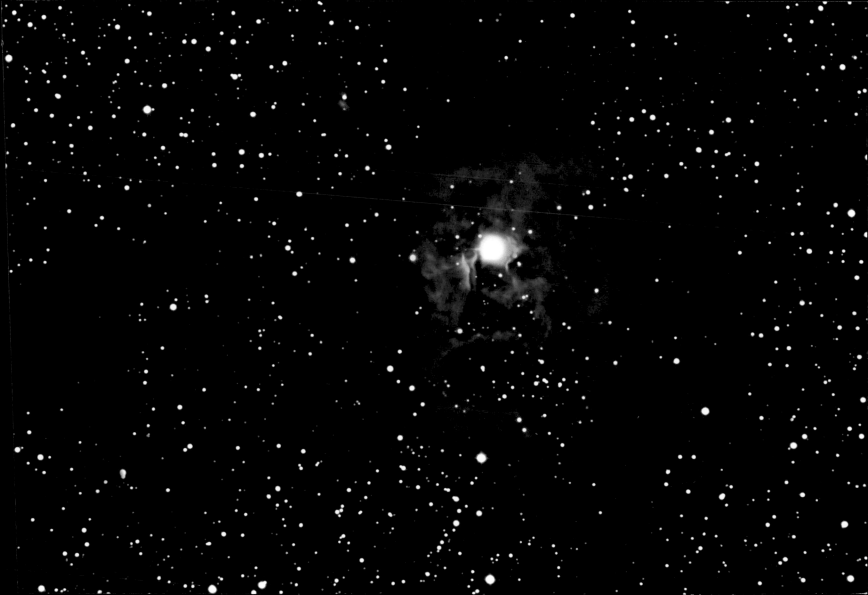

+ **CG4: A Ruptured Cometary Globule**

THE ODD-LOOKING "CREATURE" TO THE RIGHT OF CENTER IN THIS PHOTOGRAPH IS A GAS CLOUD KNOWN AS A COMETARY GLOBULE.

This globule, however, has ruptured. Dusty heads and elongated tails typically characterize cometary globules. These features cause cometary globules to have visual similarities to comets, but in reality they are very different. Cometary globules are frequently the birthplaces of stars, and many show very young stars in their heads. The reason for the rupture in the head of this object is not completely known. The galaxy to the left of center is very far in the distance and is only placed near CG4 by chance superimposition.

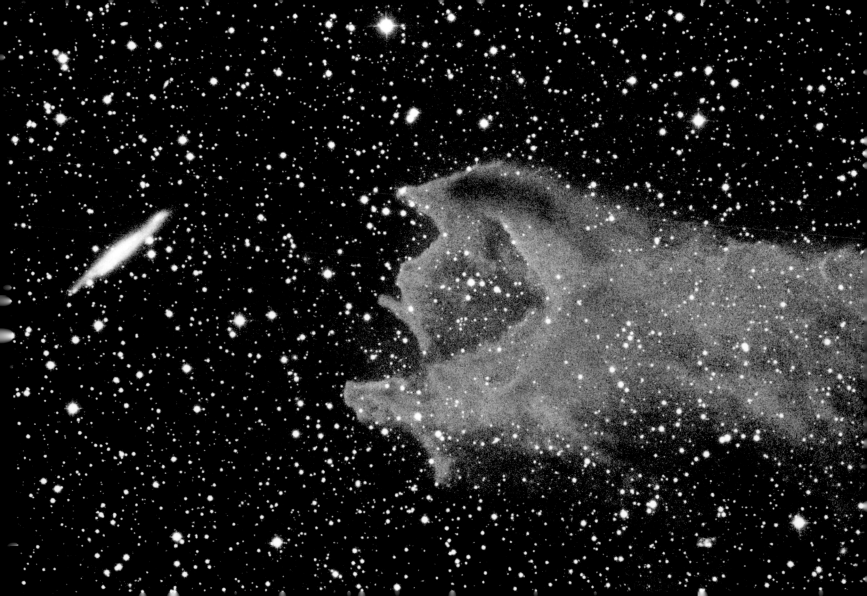

+ **Cartwheel of Fortune**

BY CHANCE, A COLLISION OF TWO GALAXIES HAS CREATED A SURPRISINGLY RECOGNIZABLE SHAPE ON A COSMIC SCALE—

The Cartwheel galaxy. The Cartwheel is part of a group of galaxies about 500 million light-years away in the constellation Sculptor. Its rim is an immense ring-like structure 100,000 light-years in diameter, composed of newly formed, extremely bright, massive stars. When galaxies collide they pass through each other, their individual stars rarely coming into contact. However, the galaxies' gravitational fields are seriously distorted by the collision. In fact, the ringlike shape is the result of the gravitational disruption caused by a small intruder galaxy passing through a large one, compressing the interstellar gas and dust and causing a star-formation wave to move out from the impact point like a ripple across the surface of a pond. In this case the large galaxy may have originally been a spiral, not unlike our own Milky Way, transformed into the wheel shape by the collision. But what happened to the small intruder galaxy? CREDIT: KIRK BORNE (STSCI), NASA

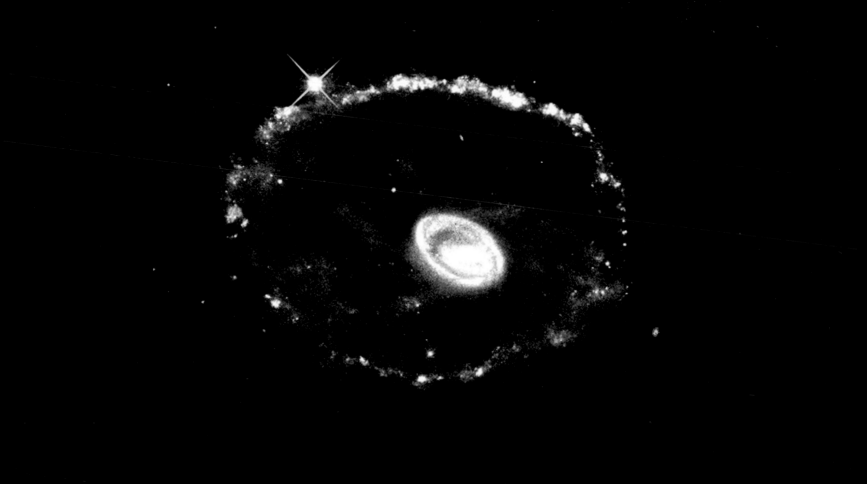

+ **Hot Stars in the Trifid Nebula**

IN THE CENTER OF THE GLOWING RED GAS OF THE TRIFID NEBULA LIES AN OPEN CLUSTER OF YOUNG, HOT STARS. IN THE surrounding nebula, energetic light from these stars strikes hydrogen atoms, composed of one proton and one electron, causing them to lose their electrons. When an electron finds its way back to a proton, it emits light at very specific colors—one of which is the red color of the nebula seen here. The red glow is thus indicative of an emission nebula. The dramatic dark sheets are made of interstellar dust grains, tiny needle-shaped pellets that are thought to be created and expelled in the atmospheres of cooler stars. CREDIT: ANGLO-AUSTRALIAN TELESCOPE PHOTOGRAPH BY DAVID MALIN. COPYRIGHT: ANGLO-AUSTRALIAN TELESCOPE BOARD

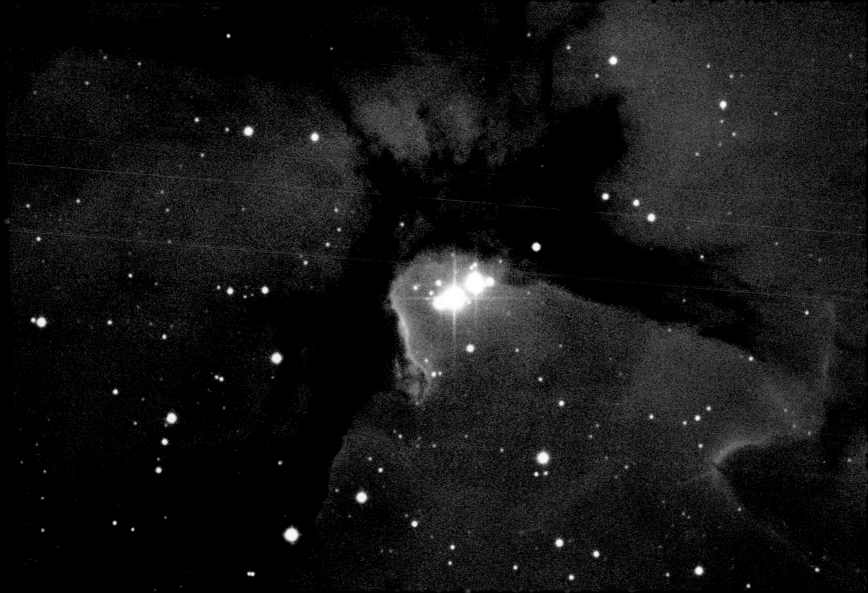

+ **Roque de los Muchachos Observatory**

ABOVE THE CLOUDS, ATOP AN ISLAND OFF THE COAST OF AFRICA, A GROUP OF CUTTING-EDGE TELESCOPES INSPECTS THE universe. Pictured here are telescopes at Roque de los Muchachos Observatory on La Palma, one of the Canary Islands, Spain. The site is one of the premier observing locations on Earth. The telescopes pictured are, from left to right, the Carlsberg Meridian Telescope, the 4.2-meter William Herschel Telescope, the Dutch Open Telescope, the Swedish Solar Tower, the 2.5-meter Isaac Newton Telescope, and the 1.0-meter Jacobus Kapteyn Telescope. Pioneering observations made recently by these telescopes include stars and galaxies forming early in our universe, comets breaking up, and evidence for planets around sun-like stars. CREDIT: NIK SZYMANEK (ING), IAC, ENO

+ **Nebula Nova Cygni Turns On**

OLD PHOTOGRAPHS SHOW NO EVIDENCE OF THIS NEBULA. BUT IN 1992, A WHITE DWARF STAR IN CYGNUS WAS SEEN TO BLOW off its outer layers in a classic nova explosion: an event called Nova Cygni 1992. Light flooded the local interstellar neighborhood, illuminated this existing gas cloud, excited the existing hydrogen, and hence caused the red emission. The only gas actually expelled by the nova can be seen as a small, red ball just above the photograph's center. Eventually, light from the nova shell will fade, and this nebula will again become invisible. CREDIT: P. GARNAVICH (CFA), 1.2-M TELESCOPE, WHIPPLE OBSERVATORY

+

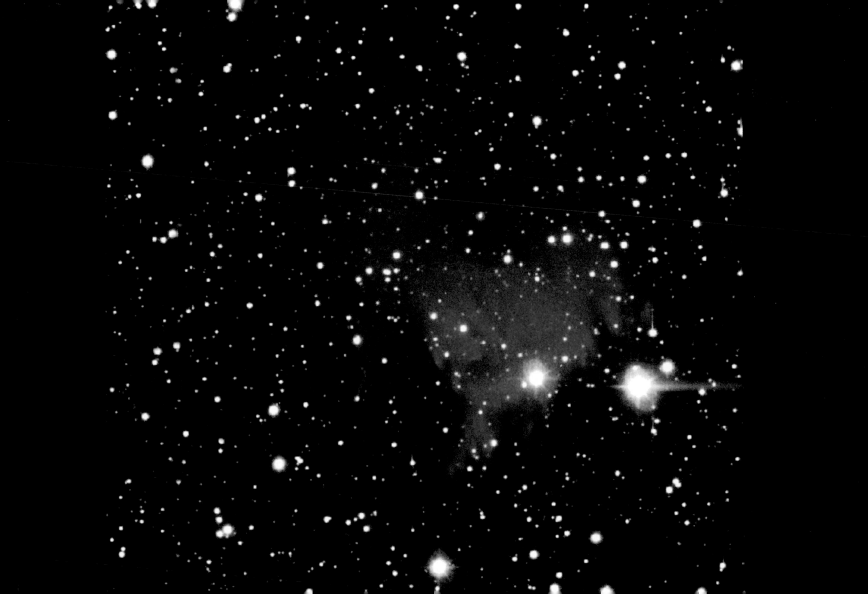

01
02
03
04
05
06
07
08
09
10
11
12
13
14
15
16
17
18
19
20
21
22
23
24
25
26
27
28
29
30
31

+ **Earth in True Color**

HERE ARE THE TRUE COLORS OF PLANET EARTH. BLUE OCEANS DOMINATE OUR WORLD, ALTHOUGH AREAS OF GREEN FOREST,

brown mountains, tan desert, and white ice are also prominent. Oceans appear blue not only because water itself is blue but also

because seawater frequently scatters light from a blue sky. Forests appear green because they contain chlorophyll, a pigment that

preferentially absorbs red light. This image is a composite generated predominantly through data from Moderate Resolution

Imaging Spectroradiometer, an instrument mounted on Earth-orbiting Terra satellite. Subareas were imaged only when experienc-

ing cloud-free daylight when it occurred from June through September 2001. Earth looks very different at night. CREDIT: RETO STOCKLI

(IACETH), MODIS, GSFC, NASA

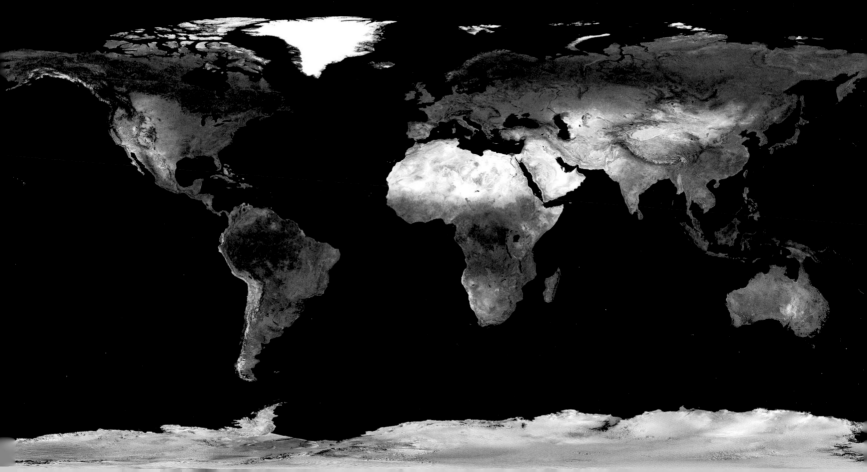

+ Valles Marineris: The Grand Canyon of Mars

THE LARGEST CANYON IN THE SOLAR SYSTEM CUTS A WIDE SWATH ACROSS THE FACE OF MARS. NAMED VALLES MARINERIS, the grand valley extends over 3,000 km long, spans as much as 600 km across, and delves as much as 8 km deep. By comparison, the Earth's Grand Canyon in Arizona, is 800 km long, 30 km across, and 1.8 km deep. The origin of the Valles Marineris remains unknown, although a leading hypothesis holds that it started as a crack billions of years ago as the planet cooled. Recently, several geologic processes have been identified in the canyon. This mosaic was created from over 100 images of Mars taken by Viking Orbiters in the 1970s. CREDIT: VIKING PROJECT, USGS, NASA

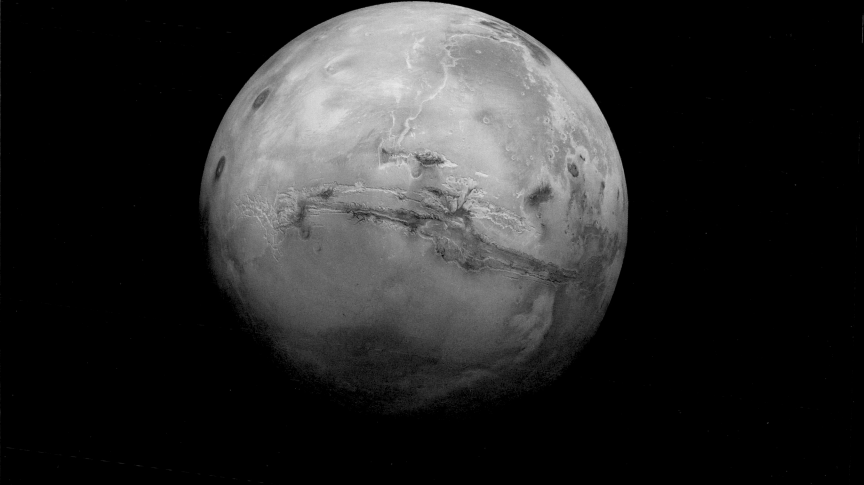

+ **NGC 1316: After Galaxies Collide**

ASTRONOMERS TURN DETECTIVES WHEN TRYING TO FIGURE OUT THE CAUSE OF UNUSUAL SITES LIKE NGC 1316. A PRELIMINARY inspection indicates that NGC 1316 is an enormous elliptical galaxy that started devouring a smaller spiral galaxy neighbor approximately 100 million years ago. Supporting evidence includes the dark dust lanes uniquely indicative of a spiral. What remains unexplained are the unusually small globular star clusters, visible as faint dots in this photograph. Most elliptical galaxies have more and brighter globular clusters than evident in NGC 1316. Yet the observed globulars are too old to have been created by the recent spiral collision. One hypothesis therefore holds that these globulars survive from an even earlier galaxy that was subsumed into NGC 1316.

CREDIT: C. GRILLMAIR (IPAC/CALTECH) ET AL., WFPC2, HST, NASA

+ **NGC 7009: The Saturn Nebula**

THE LAYERS OF THE SATURN NEBULA GIVE A COMPLEX PICTURE OF HOW THIS PLANETARY NEBULA WAS CREATED. THIS PICTURE, taken in April 1996, allows a better understanding of the mysterious process that transformed a low-mass star into a white dwarf star. A computer model indicates that the central star of NGC 7009 first expelled the green gas that now appears barrel-shaped. This green gas confines stellar winds flowing from the central star, creating a jet that forms the reddish handle-shaped extensions. Much remains unknown, including why the gas has not become turbulent. CREDIT: B. BALICK (U. WASHINGTON) ET AL., WFPC2, HST, NASA

+

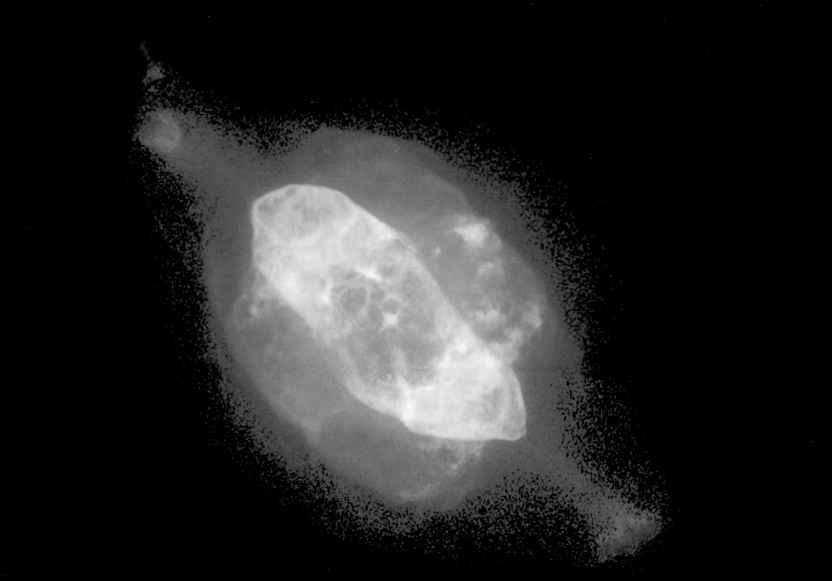

+ **Moon Mare and Montes**

THIS ARRESTING IMAGE OF THE THIRD QUARTER MOON IN THE SKIES above the pine crest farm observatory, dell prairie, Wisconsin, was recorded with a 24-inch telescope and digital camera on October 19, 2000. Marvelously detailed, especially along the terminator, or shadow line, between lunar night and day, this cropped version of the full, mosaicked image shows the cratered north polar region (top) and the broad, smooth Mare Imbrium (Sea of Rains). Notable at the northern edge of the Mare Imbrium is the 95-km-wide, dark crater Plato, while the dramatic, straight "cut" to the right of Plato is the Vallis Alpes (Alpine Valley). The long, graceful arc of the lunar Montes Apenninus (Apennine Mountains) in the lower portion of the image sweeps southward along the boundary of the Mare Imbrium toward the left and ends near the bright ray crater Copernicus at the picture's edge. In 1971, Apollo 15 landed near the gap beyond the opposite (northern) end of the Montes Apenninus arc. CREDIT & COPYRIGHT: PETER ARMSTRONG

+ **Trifid Pillars and Jets**

DUST PILLARS ARE LIKE INTERSTELLAR MOUNTAINS. THEY SURVIVE BECAUSE THEY ARE DENSER THAN THEIR SURROUNDINGS, but they are being slowly eroded by a hostile environment. Visible in this picture is the end of a huge gas and dust pillar in the Trifid Nebula, punctuated by a smaller pillar pointing up and an unusual jet pointing to the left. The pink dots are newly formed low-mass stars. A star near the small pillar's end is slowly being stripped of its accreting gas by radiation from a tremendously brighter star situated off the picture to the upper right. The jet extends nearly a light-year and would not be visible without external illumination. As gas and dust evaporate from the pillars, the hidden, stellar source of this jet will likely be uncovered, possibly over the next 20,000 years. CREDIT: J. HESTER (ARIZONA ST. U) ET AL., WFPC2, HST, NASA

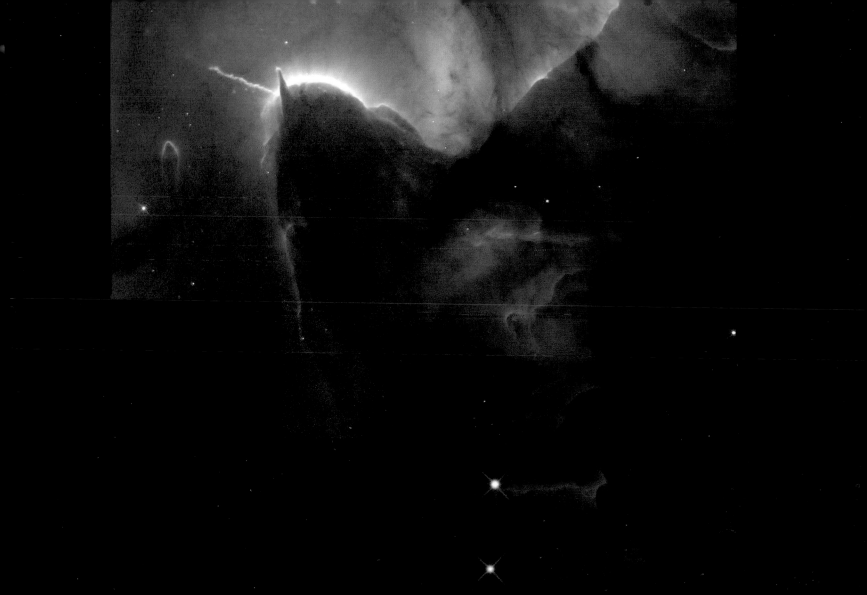

+ **The Millennium That Defined Earth**

WHEN THE SECOND MILLENNIUM BEGAN, PEOPLE GENERALLY KNEW THAT PLANET EARTH WAS ROUND, BUT FEW SAW MUCH OF IT beyond their local village. As the millennium progressed, humans mapped the continents, circumnavigated the globe, and determined the composition of Earth. Earth started as the center of everything, but became a planet placed in the solar system, which became placed in a galaxy, which became placed in the local group of galaxies, which became placed in an expanse so vast we call it just the universe. As the third millennium begins, people generally know what Earth looks like from afar, and how it is that all of humanity is confined to the surface of this fragile and watery globe. CREDIT: APOLLO 8 CREW, NASA

+ **Hoag's Object: A Strange Ring Galaxy**

IS THIS ONE GALAXY OR TWO? THIS QUESTION CAME TO LIGHT IN 1950 WHEN ASTRONOMER ART HOAG CHANCED UPON THIS unusual extragalactic object. On the outside is a ring dominated by bright blue stars, while near the center lies a ball of much redder stars that are likely much older. Between the two is a gap that appears almost completely dark. How Hoag's Object formed remains unknown, although similar objects have now been identified and collectively labeled as a form of ring galaxy. Genesis hypotheses include a galaxy collision billions of years ago and perturbative gravitational interactions involving an unusually shaped core. This photograph taken by the Hubble Space Telescope in July 2001 reveals unprecedented details of Hoag's Object and may yield a better understanding. Hoag's Object spans approximately 100,000 light-years and lies about 600 million light-years away toward the constellation Serpens. Coincidentally, visible in the gap (at about 1 o'clock) is yet another ring galaxy that likely lies far in the distance. CREDIT: R. LUCAS (STSCI/AURA), HUBBLE HERITAGE TEAM, NASA

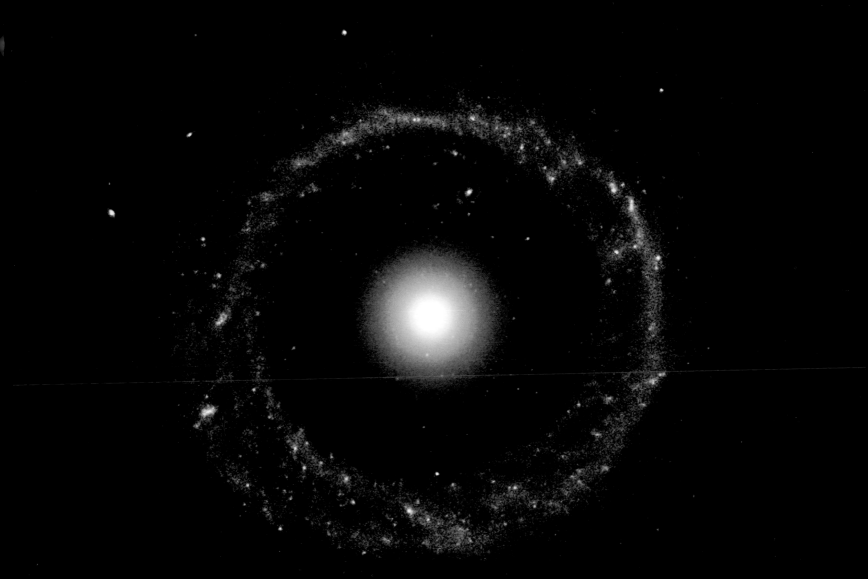

01
02
03
04
05
06
07
08
09
10
11
12
13
14
15
16
17
18
19
20
21
22
23
24
25
26
27
28
29
30
31

+ The Pelican in the Swan

THE PELICAN NEBULA, ALSO KNOWN AS IC 5070, LIES APPROXIMATELY 2,000 light-years away in the high and far-off constellation Cygnus, the Swan. This picture spans a portion of the magnificent nebula approximately 30 light-years wide. Fittingly, this cosmic pelican is found just off the east "coast" of the North America Nebula, another surprisingly familiar-looking emission nebula in Cygnus. In fact, the Pelican and North America Nebulas are part of the same large star-forming region. The two glowing nebulas appear separated from our vantage point by a large obscuring dust cloud running across the left in this gorgeous color view. Within the Pelican Nebula, dark dust clouds also help define the eye and long bill, while a bright front of ionized gas suggests the curved shape of the head and neck. Even though it is almost as close as the Orion Nebula, the stellar nursery marked by the Pelican and North America Nebulas has proven complex and difficult to study. CREDIT & COPYRIGHT: ROBERT GENDLER

GLOSSARY

ASTEROID + A large rock in our solar system that is smaller than a planet. Some asteroids may contain much water and/or ice and act as way stations for future astronauts.

BLACK HOLE + An object so compact that light cannot escape its gravity. If our sun could be compressed inside 3 km, it would become a black hole.

COMA + The gas and dust that surround the head of a comet as it nears the Sun. Comas can extend up to a million miles from the nucleus. The coma and tail of a comet are the easiest parts to see.

COMET + A chunk of frozen gasses, ice, and rocky debris that orbits the Sun. When a comet nears the Sun, heat vaporizes the icy material producing a cloud of gaseous material surrounding the nucleus, called a coma. As the nucleus begins to disintegrate, it also produces a trail of dust or dust tail in its orbital path and a gas or ion tail pointing away from the Sun. Comet tails can be millions of miles long. There are thought to be literally trillions of comets in our solar system out past Neptune and Pluto, but only once per decade or so does one become near and bright enough to see easily without binoculars or a telescope.

COMET NUCLEUS + The actual iceberg in the center of a comet that melts and fragments when it nears the Sun. A comet nucleus is about the size of a mountain on earth.

CONSTELLATION + A historically recognized grouping of stars often thought of as representing a person or object. There are 88 constellations that cover the entire sky.

CORONA + The hot, tenuous outer atmosphere of the Sun. The solar corona is most easily seen from Earth during a total solar eclipse.

CREPUSCULAR RAY + Sunlight that pours through a gap in the clouds.

DISK (OR GALACTIC DISK) + The flattened band of stars and gas that surround the center of a spiral galaxy. We live in the disk of the Milky Way galaxy.

EDGE-ON + When the disk of a spiral galaxy is seen with its edge pointing to the observer. A piece of paper seen edge-on is hard to see.

GALACTIC CENTER + The center of our Milky Way galaxy. The more we learn about the galactic center, the stranger it appears.

GALACTIC CLUSTER + A cluster of 10–10,000 stars that is relatively young and blue. Synonymous with "open cluster."

GALAXY + A system of about 100 billion stars. Our sun is a member of the Milky Way galaxy. There are billions of galaxies in the observable universe. Exactly when and how galaxies formed in the universe is a topic of current astronomical research.

ELLIPTICAL GALAXY + A football-shaped galaxy

that can appear as an ellipse on the sky. Elliptical galaxies typically have little or no dust and gas.

SPIRAL GALAXY + A galaxy of stars, gas, and dust, having a disk with prominent spiral arms. Our Milky Way galaxy is a spiral galaxy.

GAMMA RAY + The most energetic form of light. Gamma rays are hazardous to living organisms but are stopped by the Earth's atmosphere. Gamma rays are produced in energetic, violent environments in the universe and can be detected by orbiting spacecraft.

GLOBULAR CLUSTER + A spherical grouping of 10,000–1,000,000 stars. Globular clusters are among the oldest objects known in our galaxy.

INFRARED + A band of the electromagnetic spectrum between the visible and the microwave—light that is so red humans cannot see it. Photons of infrared light are less energetic than photons of visible light.

ION + An atom or group of atoms that carries an electric charge.

JOVIAN PLANETS + A giant planet composed mostly of gas. Jovian planets include Jupiter, Saturn, Uranus, and Neptune. Jovian type planets have now been discovered orbiting other stars.

LOCAL GROUP OF GALAXIES + The group of galaxies to which our Milky Way galaxy belongs. The Local Group is dominated by the Milky Way and M31, the Andromeda galaxy.

M + The identifier for objects in Charles Messier's 1774 catalog of nebulas and star clusters. For example: M 31 is the 31st entry in this catalogue.

NEBULA + A cosmic cloud of gas and dust.

ABSORPTION NEBULA + Also "dark nebula." A type of nebula consisting of dense clouds of interstellar dust viewed against a bright background. The dust absorbs background light and appears dark in pictures.

EMISSION NEBULA + A type of nebula that shines primarily by emitting light when electrons recombine with protons to form hydrogen atoms. Emission nebulas typically appear red in pictures.

PLANTETARY NEBULA + An emission nebula produced by a sun-like star near the end of its life. Planetary nebulas are so called because they often appear round and planet-like in a small telescope.

REFLECTION NEBULA + A type of nebula that shines primarily by interstellar dust reflecting starlight. Reflection nebulas often appear blue in pictures.

NEUTRINO + A type of elementary particle that has no electric charge and is suspected of having an extremely small mass. Neutrinos can pass through enormous amounts of material unaffected. Neutrinos are produced in nuclear reactions at the centers of stars and in stellar explosions known as supernovas.

NGC + The identifier for objects in the New General Catalog of Nebulae and Clusters of Stars by Sir John Herschel, revised in 1888 by J. L. E. Dreyer. For example: NGC 1232 is the 1,232nd entry in this catalogue.

PHOTOSPHERE + The part of the Sun's atmosphere that we see most easily.

PLANET + A spherical ball of rock and/or gas that orbits a star. The Earth is a planet. Our solar system has nine planets. These planets are, in order of increasing average distance from the Sun: Mercury, Venus, Earth, Mars, Jupiter, Saturn, Uranus, Neptune, and Pluto.

QUASARS + Contraction of QUASi-stellAR object. Quasars appear star-like in pictures. They actually lie at cosmological distances and are thought to be supermassive black holes at the centers of active galaxies. Among the brightest sources in the universe, quasars are likely powered by material falling into the central black hole.

SOLAR SYSTEM + The system of objects that surrounds our sun. The Earth is a member of the solar system in good standing.

STAR + A ball of mostly hydrogen and helium gas that shines extremely brightly. Our sun is a star. A star is heated by nuclear reactions that occur in its dense, hot, interior.

STELLAR NURSERY + A place where stars are forming. These places are violent, energetic, and frequently very beautiful.

SUPERGIANT + A bright star tens to hundreds of times the size of the Sun. Hot, massive supergiant stars are extremely bright and will likely explode as a supernova after only a few million years.

SUPERNOVA + The death explosion of a massive star, resulting in a sharp increase in brightness followed by a gradual fading. At peak light output, supernova explosions can outshine a galaxy. The outer layers of the exploding star are blasted out in a radioactive cloud. This expanding cloud, visible long after the initial explosion fades from view, forms a supernova remnant.

ULTRAVIOLET + A band of the electromagnetic spectrum between the visible and the X ray— light that is so blue humans cannot see it. Photons of ultraviolet light are more energetic than photons of visible light.

WHITE DWARF + The end state for low-mass stars like our sun. Most white dwarfs have a mass near that of our sun but a size near that of our Earth.

X RAY + A type of light that is more energetic than the visible light humans can see but less energetic than gamma rays. X rays are just energetic enough to travel through human skin but not human bone, making them useful medically.

N.B.: all entries are listed according to dates (month/day)

First published in the United Kingdom in 2003 by Thames & Hudson Ltd, 181A High Holborn, London WC1V 7QX

First published in the United States of America in 2003 by Harry N. Abrams

British Library Cataloguing-in-Publication Data
A catalogue record for this book is available from the British Library

ISBN 0-500-51121-7

Printed and bound in China